INTIMATE VIOLENCE

Intimate Violence

HITCHCOCK, SEX, AND QUEER THEORY

David Greven

OXFORD
UNIVERSITY PRESS

OXFORD

UNIVERSITY PRESS

Oxford University Press is a department of the University of Oxford. It furthers
the University's objective of excellence in research, scholarship, and education
by publishing worldwide. Oxford is a registered trade mark of Oxford University
Press in the UK and certain other countries.

Published in the United States of America by Oxford University Press
198 Madison Avenue, New York, NY 10016, United States of America.

© Oxford University Press 2017

Library of Congress Cataloging-in-Publication Data
Names: Greven, David.
Title: Intimate violence : Hitchcock, sex, and queer theory / David Greven.
Description: Oxford : Oxford University Press, 2017. | Includes bibliographical references and index.
Identifiers: LCCN 2016027885| ISBN 9780190214166 (cloth : alk. paper) |
ISBN 9780190214173 (pbk. : alk. paper) | ISBN 9780190214197 (Oxford scholarship online)
Subjects: LCSH: Hitchcock, Alfred, 1899–1980—Criticism and interpretation. | Women in motion
pictures. | Homosexuality in motion pictures. | Violence in motion pictures.
Classification: LCC PN1998.3.H58 G74 2017 | DDC 791.4302/33092—dc23
LC record available at https://lccn.loc.gov/2016027885

9 8 7 6 5 4 3 2 1

Paperback printed by Webcom, Inc., Canada
Hardback printed by Bridgeport National Bindery, Inc., United States of America

For Alex, as ever.

One need not be a chamber to be haunted,
One need not be a house . . .

Ourself, behind ourself concealed,
Should startle most;
Assassin, hid in our apartment,
Be horror's least.

The prudent carries a revolver,
He bolts the door,
O'erlooking a superior spectre
More near.

—EMILY DICKINSON

Contents

Acknowledgments

EARLIER, AND IN all cases quite distinct, versions of some of the chapters have been previously published. An earlier version of chapter 1 was published as "Hitchcock and Queer Sexuality" in *The Cambridge Companion to Alfred Hitchcock*, edited by Jonathan Freedman (Cambridge University Press, 2015). An earlier version of chapter 4 was published as "Making a Meal of Manhood: Revisiting *Rope* and the Question of Hitchcock's Homophobia" in *Genders* (Issue 56, Fall 2012). Chapter 6 was originally published as "The Death-Mother in *Psycho*: Hitchcock, Femininity, and Queer Desire" in *Studies in Gender and Sexuality* (15:3, 2014). Chapter 7 was originally published as "Intimate Violence: *Marnie* and Queer Resilience" in *The Hitchcock Annual* (Vol. 18, 2013). I gratefully acknowledge the publishers and their permission to reprint these materials. I am grateful as well to the editors and the anonymous readers who provided such cogent and incisive feedback in all cases.

I remain awestruck by the brilliance and kindness of Hitchcock scholars. Having worked before with Richard Allen and Sidney Gottlieb, I am greatly indebted to their editorial finesse, scrupulousness, insightfulness, and deep knowledge of Hitchcock's work. Their support, tough-mindedness, and selflessness have been inestimable. I thank Jonathan Freedman for his expert editing and great generosity; what a pleasure to work with a scholar who is as supportive as he is erudite. Tony Williams, Susan White, and George Toles are inspiring commentators, and I thank Tony for his invaluable feedback on the *Rope* chapter. I am deeply grateful to Julie Grossman and Cat Keyser for their exhaustive and amazing feedback, respectively, on two of the chapters; their generosity is

matched only by their incisiveness. Most of all, I want to thank Tania Modleski for her friendship and her unfailing openness to discussion about Hitchcock and gender matters and their attendant controversies. It was my honor to have an interview I conducted with Tania published in the third edition of her superb book on Hitchcock, *The Women Who Knew Too Much*, which remains a critical touchstone. I thank Tania Modleski, Susan White, Lee Edelman, and Joseph Litvak for participating in the panel I organized, "Hitchcock, Women, and Queer Sexuality," for the *Society for Cinema and Media Studies* Conference held in Seattle, March 19–23, 2014. It was an honor to work with such superlative scholars who have taught me so much about Hitchcock and good criticism. The editorial staff at Oxford University Press has been extremely supportive every step of the way. My warmest thanks go to Brendan O'Neill, Norm Hirschy, Lauralee Yeary, and the entire production team. I am also extremely grateful to Tony McLawhorn, the computer support manager in my department, for his expert and incredibly patient help with images for this book.

The great film critic Robin Wood's extraordinary intellectual example has been galvanizing for many of us. Robin published my first essay on film (on Brian De Palma's *Snake Eyes*) in *CineAction*, and having had the chance to develop a friendship with him remains very meaningful to me. I pay tribute to him here.

The students in my Hitchcock classes over the years at Connecticut College and the University of South Carolina have been inspiring, passionate, and brilliant readers of the films. It's been my deep honor to be part of their conversations about the director and the art of film generally. With many people to thank, I especially want to acknowledge Lyman Creason, Tristan O'Donnell, and Brian McCarthy. And James Bogdanski is, I hope, well aware of how much I rely on and appreciate his friendship and support.

I was fortunate enough to grow up in a movie-loving household, in which Hitchcock reigned supreme. The re-release of five Hitchcock films, held back from circulation for legal reasons, in the 1980s was a momentous event for me. My father took me to see *Rear Window* and *Vertigo* at the D.W. Griffith Theater in New York City, and my memory of the first viewings of those films, on the big screen where they belong, remains as keen as ever. I thank my parents for nurturing my love of movies, my brother Mike for his love of Lisa Freemont (Grace Kelly), and my family generally for their love and support throughout my life, and I acknowledge my Edmonton Beecroft/Coffin family with love as well. No acknowledgements would be complete without loving thanks to my best friend Viki Zavales, who has been characteristically supportive of every stage of this manuscript. My partner Alex Beecroft is the model of love and generosity, and his presence in my life makes everything possible.

INTIMATE VIOLENCE

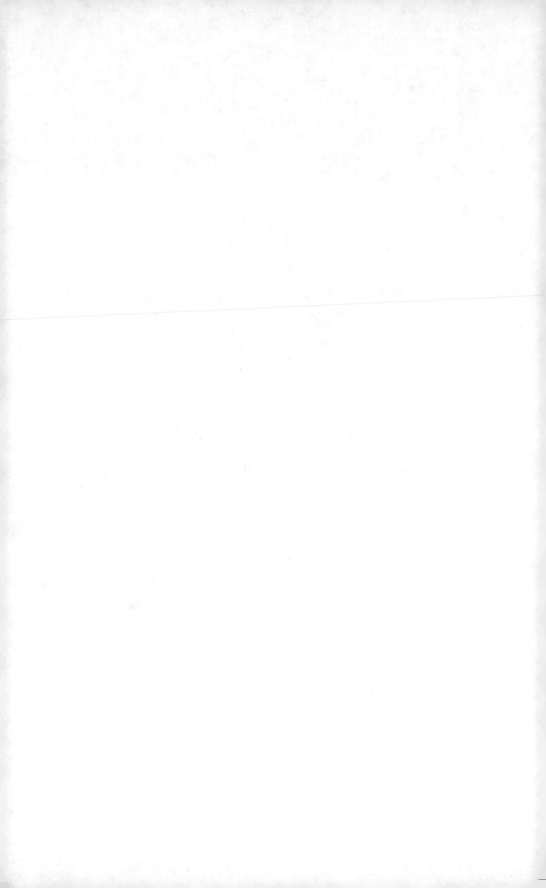

Introduction

INTIMATE VIOLENCE

ONE OF THE ironies of cinema history is that the films of Alfred Hitchcock, a body of work not only organized around mayhem and murder but also well known for its controversial portraits of women and queer characters, have proven to be such tantalizing and fertile terrain for feminism and queer theory. I argue that Hitchcock's films lend themselves to such inquiries because they decenter and therefore call into question the rule of the male protagonist, which allows new kinds of connections and conflicts to develop between other personae. These connections and conflicts chiefly involve heterosexual women and queer characters, who struggle for self-expression and narrative control. I call this struggle the *feminine versus the queer*. Typically, the feminine-versus-the-queer pattern pits the straight woman against a non-normative male. This struggle occurs in films such as *Murder!* (1930), *Secret Agent* (1936), *Jamaica Inn* (1938), *Shadow of a Doubt* (1943), *Spellbound* (1945), *Notorious* (1946), *The Paradine Case* (1947), *Rope* (1948), *Strangers on a Train* (1951), *The Man Who Knew Too Much* (1956), *North by Northwest* (1959), and, especially, *Psycho* (1960). The feminine-versus-the-queer thematic holds true for films such as *Rebecca* (1940), *Stage Fright* (1950), and *Marnie* (1964), where conflicts between two female characters evince queer tensions. And in *The Birds* (1963), the dynamic takes an abstracted form, if we read the titular creatures as a queer menace.

The heterosexual males of Hitchcock's films often encounter a surprisingly seductive male figure who challenges their dominant position in narrative and threatens their

heterosexual security by drawing them into disorienting queer situations and possibilities. I call this ongoing pattern in Hitchcock's work *homoerotic antagonism*. Many of the films on the list above feature this antagonism, especially *Rope, Strangers on a Train*, and *Psycho*, as do several other works such as *The Lodger* (1927), *The Manxman* (1929), *Rear Window* (1954), *Torn Curtain* (1966), and *Frenzy* (1972). These thematics intersect at various points, bleeding into one another.

Hitchcock's aesthetics reinforce and extend the complex, push-pull dynamics of sexual identity and desire in his works, which, in their overall ambivalence toward sexuality and disarming sympathy for the discarded and the perverse, verge always on a radical revision of normative expectations. The violence in Hitchcock films incites his formal imagination. At the same time, it expresses the emotional conflicts of the characters and the narrative. Violent impulses in Hitchcock intersect with those toward love and longing, hence the concept that I develop throughout this book of *intimate violence*, by which I mean to suggest the intimacy of violence, the potential violence within intimacy, but also the duality and co-presence of intimacy *and* violence in Hitchcock's work. Its intimate violence almost always proceeds from the basis of a close personal relationship that has gone awry, as when Ray Milland's Tony Wendice arranges for his wife Margo (Grace Kelly) to be murdered in *Dial "M" for Murder* (1954), or indicates the dark side of a perilous affinity, such as the mutual obsession with the titular character in *Rebecca* that binds the second Mrs. de Winter and Mrs. Danvers, and the undeniable allure Bruno Anthony holds for Guy Haines in *Strangers on a Train*.

Drawing on psychoanalytic theory, principally Freud and Melanie Klein, and Eve Kosofsky Sedgwick's reworking of Kleinian theory, I pursue a reparative reading of Hitchcock. His work, I argue, should be read as a relay between desires to destroy and to repair the desired object. My reparative reading seeks neither to ignore nor diminish the misogynistic and homophobic aspects of the director's output, but rather to explore its feminist and queer concerns and potential radicalism.

Hitchcock's films have emerged as something of a battleground for debates in feminism and queer theory. Attempting to reconcile warring claims and find a new ground for feminist and queer parity, I analyze the uncannily prescient staging of conflicts between heterosexual female and sexually non-normative characters that recurs in the director's movies. I first offer an overview of relevant critical treatments and then discuss the ways in which feminist and queer theory approaches have at times opposed one another in Hitchcock criticism. Next, I address "the antisocial thesis" in queer theory and, by offering a counterargument, lay the groundwork for my reparative approach. My psychoanalytic approach to Hitchcock includes a component that I refer to as *queer paranoia* and that has relevance to both male and female sexualities in the Hitchcock oeuvre. The issue of paranoia is a key dimension of Hitchcock's work, especially in terms of the intersection of feminist and queer concerns, as evinced, respectively, by Jacqueline Rose's and Jack Halberstam's treatments of *The Birds*.[1] I discuss queer paranoia below.

HITCHCOCK, FEMINISM, AND QUEER THEORY: A BRIEF HISTORY

Laura Mulvey's view of Hitchcock's work in her widely cited 1975 essay "Visual Pleasure and Narrative Cinema" established his films as emblematic of the patriarchal male gaze that sexually objectified women.[2] Mulvey's framing of Hitchcock's work as sadistic and misogynistic resounds in many subsequent years of feminist critique. Revising and enlarging Mulvey's view, Tania Modleski's pivotal study *The Women Who Knew Too Much* treated Hitchcock as a director with ambivalent, rather than wholly misogynistic, attitudes toward women.[3] Critics such as Susan White, Paula Marantz Cohen, Marian Keane, Michelle Piso, Florence Jacobowitz, and Mulvey herself in her later work have also offered treatments of Hitchcock that emphasize the complexity of his treatments of women.[4]

Paralleling the trajectory of feminist analyses, a wide range of gay male critics have charged Hitchcock with a pervasive homophobia—Manny Farber, John Hepworth, Vito Russo, and D.A. Miller in his essay on *Rope*.[5] And, at the same time, several have found much that is resonant in it, beginning with Robin Wood, whose early work *Hitchcock's Films*, first published in 1965, later emerged as an opportunity not only for a revisionist critical project but also a midlife coming-out story. Appreciative queer readings of Hitchcock have been offered by Alexander Doty, Patricia White, Lucretia Knapp, and several others.[6]

Hitchcock has been crucial to what we can call high queer theory, as exemplified by the work of Miller again, Lee Edelman, Jonathan Goldberg, and Halberstam. Miller and Edelman use Hitchcock films as a model of cinematic practice that reifies associations between homosexuality and images of negativity and nullity.[7] Such images make Hitchcock's work representative of the antisocial thesis, as it has been called. This thesis achieves its most dramatic articulation in Edelman's study *No Future. Strangers on Train, North by Northwest* (1959), and, especially, *The Birds* (1963) play a central role in Edelman's argument about queer theory and its relationship to the death drive. As I will establish here and in chapter 1, while I admire Edelman's work greatly, I dispute some of its central tenets. My analysis of Hitchcock's work is centered in psychoanalytic feminist and queer theory and aims to offer a reparative alternative to Edelman's reading.

Debates over a gay/queer Hitchcock have proven both contentious and stimulating. Both Thomas Elsässer and Richard Allen have made brilliant cases for understanding Hitchcock's view of male homosexuality as a version of the Wildean dandy.[8] Hepworth and Wood's debates over a homophobic versus a non-homophobic Hitchcock, Modleski's responses to Patricia White and Edelman in the 2005 afterword to *The Women Who Knew Too Much*,[9] and White's takedown of the Edelman-Miller position as a version of what Luce Irigaray negatively describes as "*hommosexuality*" (an erotically charged consolidation of male power that excludes the feminine) form a subgenre of queer film theory. Halberstam has also criticized Edelman and gay male critics for

focusing on a high culture gay male canon. Lucretia Knapp's 1993 *Cinema Journal* essay "The Queer Voice in *Marnie*" was extremely significant for both its innovative acuity and as an intervention within its historical moment. Her reading of lesbian desire in *Marnie* (1964) offered one of the first challenges to Raymond Bellour's exclusively heterosexual and heterosexualizing treatments of Hitchcock texts as narratives of the male protagonist's oedipal development. Patricia White's chapter on lesbian desire in *Rebecca* (1940), in which she critiques feminist film theory's blindness to the presence of lesbian figures in classical texts, was also a central critical intervention that broadened the meanings of a queer Hitchcock.[10]

The temporal borders of the debates over homosexuality in Hitchcock criticism from the early 1950s to the late 1980s are significant. While auteurists of the 1950s, such as Eric Rohmer and Claude Chabrol in their famous book *Hitchcock: The First Forty-Four Films* (1957), and 1960s, such as Robin Wood and Andrew Sarris, reframed Hitchcock as a serious artist of surpassing moral vision and consistent creative integrity whose films could be studied individually and as a whole for recurring themes, preoccupations, motifs, stylistic penchants, and philosophical stances, critics of the 1970s and early '80s were critiquing his work for its misogyny and homophobia. But by the late 1980s and during the early '90s, a sea change in gay and lesbian criticism occurred as "queer," once a term of abuse, emerged as not only a preferred term but a powerful theoretical lens, as exemplified by the work of Sedgwick, Judith Butler, Teresa de Lauretis (credited with having invented the term "queer theory"), Michael Moon, David Halperin, Bersani, Goldberg, Halberstam, Doty, Miller, and Edelman, among others. Queer theory consistently targeted stable constructions of gendered and sexual subjectivity as not only illusory but also ideologically pernicious.

Robert J. Corber has situated Hitchcock films of the 1950s and '60s within the Cold War paranoia over the anti-American threat of homosexuality. For Corber, Hitchcock's depictions of homosexuals in films like *Strangers on a Train*—which includes an extreme long shot of the incessantly present villain Bruno Anthony (Robert Walker) framed menacingly against the Jefferson Monument as panicked Guy Haines (Farley Granger) notices him from afar—troublingly correspond to the era's McCarthyite tendencies.[11] In *Cold War Femme*, Corber uses Jess Stearn's bestselling book *The Grapevine: A Report on the Secret World of the Lesbian* (1965) as an index to homophobic attitudes of the period.[12] Hitchcock's *Marnie* features a blonde femme whose desire is ultimately "realigned" with normative heterosexuality in its institutionalized forms, especially marriage. I discuss Corber's reading of *Marnie* in chapter 7.

Although I share Corber's sense of the embedded nature of Hitchcock's films' engagements with Cold War era sexual politics and homosexual panic, my effort here is to demonstrate that Hitchcock films can be resistant even as we acknowledge the ideological wounds they inflict. I keep closer company with critics such as Alexander Doty who have found Hitchcock's films bracing alternatives to the overwhelming heterosexism of both Hollywood and American culture generally. As Jonathan Goldberg observes in

his analysis of Hitchcock's homoerotic and, for some, homophobic film *Strangers on a Train*: "Queer theory gets us beyond the question of whether either Bruno or Guy, or both of them, really is gay without having to posit the possibility that one or the other is or isn't. From this vantage point, the question of Hitchcock's homophobia ceases to be a central concern, and we can do more than condemn his films."[13]

Robin Wood, especially in *Hitchcock's Films Revisited*, frequently discussed the homosexual/gay/lesbian elements in Hitchcock's work.[14] While Wood addressed the question of "Hitchcock's homophobia," he generally found Hitchcock's films to be a contribution to an anti-homophobic project. For Wood, the value in Hitchcock's work is its penchant for puncturing the myth of heterosexuality as inherently natural and desirable, with homosexuality cast in the role of inferior copy. In Wood's treatment, films like the bleak *Rope* (1948), inspired by the real-life Leopold and Loeb murder case, offer an oppositional critique. While not taking a *positive* view of homosexuality, linked here to depravity and murder, *Rope* nevertheless critiques a culture of homophobia and its effects, psychological and social, on gays and lesbians. For Wood, it is the hatred that the thrill-killing male lovers feel toward one another that is significant, for it reflects their self-loathing or what we would now call their internalized homophobia. My own reading of *Rope* shares perspectives that match Wood's. Wood's work has been deeply influential on my own thinking, though I would note that I am not a partisan of Wood's "therapeutic" framework for reading Hitchcock's films, as I will explain at further length, and I strongly disagree with his later reading of *Marnie*.

Echoing the early writing of Manny Farber,[15] who condemned Hitchcock for presenting homosexuals negatively (in what was therefore also a notable example of early anti-homophobic film criticism, even if one disagrees with Farber), John Hepworth makes a vociferous case for "Hitchcock's Homophobia" in his essay of that name.[16] The question of Hitchcock's homophobia was addressed in an essay that marked a crucial turning point for queer theory. D.A. Miller published "Anal *Rope*" in 1990, as the AIDS crisis was still raging in the United States without any effective treatment for it, and American homophobia was at its height. Miller's essay evinces an intense suspicion of structures of power, with Hitchcock emerging as the ultimate source of power over the classical film text. In his essay "*Rear Window*'s Glasshole," Edelman draws on Miller's formulations in order to counter Mulvey's early paradigm that classical Hollywood cinema is organized around and dominated by the male gaze. Edelman argues that it is the anus that cannot be acknowledged in Hollywood technologies of the visual—therefore, an issue of equal salience to the sexual spectacularization of female bodies is this phobic ban against the visualization of the anus and concomitant acknowledgment of its existence. Hitchcock's mastery of film techniques such as montage, Edelman posits, work to blind us to the presence of this nether domain that is rendered unrepresentable. Miller's and Edelman's essays remain essential reading. Critics like Patricia White and Tania Modleski have critiqued the ease with which these gay male critics discuss Hitchcock films with an exclusive emphasis on issues of queer male sexuality, ignoring the roles of women in the films

and larger feminist issues. These critical debates are central to this book, and I explore them in further depth in the next section.

Jonathan Goldberg argues that the queer potentialities of Hitchcock's *Strangers on a Train* exceed those in the source material, Patricia Highsmith's 1950 novel, from which the film is quite distinct. In the novel, the presumably "normal" heterosexual protagonist Guy Haines does fulfil his side of the bargain and murders the "psycho" Charles Anthony Bruno's father, after Bruno murders Guy's inconvenient first wife Miriam. In the film, Guy does not murder Bruno's father and, indeed, helps to bring him to justice for the murder of Miriam. In their famous book *Hitchcock: The First Forty-Four Films* (1957), Eric Rohmer and Claude Chabrol, critics for the French film magazine *Les Cahiers du Cinema* who would go on to become leading directors of the French New Wave, influentially read Hitchcock as an auteur. They also positioned Hitchcock as a director who took a strong moral stand against homosexuality, in keeping with his Catholic upbringing and sensibility.[17] Goldberg strikingly retools Rohmer and Chabrol's argument for newly queer purposes: "Rohmer and Chabrol open Hitchcock's work to a homosexuality without limits. Rather than a world of persecuted gays, Hitchcock would seem to offer queer films, displaying not so much a minoritarian logic as a queer universalism. . . . It's there, I think, that we can take our pleasure in Hitchcock."[18] As Goldberg remarks, he values *Strangers* "precisely for the ways in which its apparent distinction between Guy and Bruno houses insidious suggestions of identification between them that are perhaps even more provoking than Highsmith's outrages."[19] Goldberg's monograph is notable for being a queer theory reading from a gay male critic that explores relationships between women in the film. In this, he echoes Sabrina Barton's excellent discussion. "*Strangers on a Train*," she writes, "seems fascinated by the inevitability of coming to grief, by the inevitability of paranoia in a society that requires the repression of all 'abnormal' desires."[20]

In his recent book *Must We Kill the Thing We Love?* William Rothman, building once again on the work of Stanley Cavell, reads Hitchcock's films as Emersonian comedies of remarriage.[21] Along similar lines, Lesley Brill has argued that Hitchcock films belong to the category of the "comic romance" that culminates in the happy marriage of the couple, drawing on the myth of Demeter and Persephone to develop this thesis and applying it to Hitchcock films as early as *The Lodger* (1926).[22] All of these critics offer considerable, nuanced insights. But their work gives the issue of queer sexuality a cursory treatment.[23] Hitchcock's most characteristic maneuver in his films is to call into question the very normative standards that allow for a positive valuation of "the Hitchcock romance."

"A DEADLY BINARY": CRITICAL DEBATES BETWEEN FEMINISM AND QUEER THEORY

In her 2005 afterword to *The Women Who Knew Too Much*, Tania Modleski critiques several commentators for failing to consider issues of feminist importance to Hitchcock,

among them Slavoj Žižek, Robert Kapsis, Susan Smith, and Lee Edelman.[24] (She also rebuts Patricia White's earlier critique of her here.) "I welcome analyses," she writes, "that complicate even further the complex workings of desire and identification" that her own work demonstrated to be at work in Hitchcock's films, "but I am concerned when such analyses scapegoat women or feminist theory or when they reproduce the very misogynist and 'matrophobic' attitudes found in Hitchcock's work."[25]

Modleski is, along with Robin Wood, the critic whose work has been most influential on my own thinking about Hitchcock; the precision and acuity of her insights are invaluable. I could not be more in agreement with her critique of high queer theory's treatment of and larger avoidance of femininity. I am going to focus on her critique of Edelman because it crystallizes these debates. While the 2005 afterword is a tour-de-force of critical engagement, it missed a chance, as I see it, to bring feminist and queer perspectives together.

Modleski takes Edelman to task in his reading of *The Birds* (1963) (in the last chapter of Edelman's book *No Future*) for substituting the violated, suffering body of the woman— in this case the heroine of Melanie Daniels (Tippi Hedren)—for that of the murdered Matthew Shepard, an American student at the University of Wyoming who was tortured and murdered near Laramie, Wyoming, in October 1998 and became the rallying point for a new wave of queer activism focused on antigay violence. While Modleski's point is one that impels my current argument, I am concerned with the way that she frames it: "Edelman invokes Shepard early in the essay and then again at the end, when, after describing how the film's 'family' drives 'through danger,' the audience presumably rooting for its survival, he writes, 'Somewhere, someone else will be savagely beaten and left to die. . . .'" In response to Edelman, Modleski writes,

> Yes, and that someone could be a battered wife, just as much as it could be a gay man. I feel affinity with some of what Edelman has to say [here]. Feminist analyses of the family have seen it as a locus for women's oppression, and there is plenty of reason to think that, for all their differences, feminists (straight and lesbian) and gay men have a common stake in loosening the hold of the ideology of the family. But why is Edelman so intent on erasing the representation of a woman's suffering to redirect our sympathies to the suffering of a gay man? Edelman creates a new and deadly binary, pitting one set of victims against one another, and in the process colludes with the powers that have made women into scapegoats representing the evils of the patriarchal institution of the family.[26]

The deadly binary that Modleski charges Edelman with creating is, indeed, a troubling one. I would put the matter somewhat differently: His attention to the suffering of women and their significance as narrative agents are both insufficiently addressed. Redressing this gap in Edelman's thinking as reflective of a larger one in queer theory is one of my goals. Modleski rightly exposes the evacuation of issues of feminism from

Edelman's argument, specifically the critic's relegation of issues of misogynistic violence to rhetorical oblivion. She also passes over an explicit engagement with the real-world horror story of Shepard's murder and also its larger, political queer significance.

If there's one thing that women and queers have historically shared, it's our vulnerability not only to patriarchal power but also to real-world menaces. What must be further explored are the valences between the misogynistic imagination that allows for, indeed demands, that Melanie Daniels's confrontation with the titular birds, filmed as a classical rape, is the climactic portion of this film and the cultural logic that informs the desire to kill someone because they inhabit a gender and sexual identity seen as threateningly aberrant. To be clear, I do not believe that Hitchcock's films are on balance either misogynistic or homophobic, even though such attitudes are clearly present in his work at times. One cannot escape the misogyny in Melanie's climactic confrontation in *The Birds*, but one would also have to ignore the overall power and complexity of this work, especially its explorations of femininity, female sexuality, and female relationships, to denounce it as misogynistic. (I address these aspects of *The Birds* in the epilogue.)

Patricia White has also valuably called our attention to the strangely unself-conscious ease with which prominent gay male critics such as Edelman and Miller discuss Hitchcock films with an exclusive emphasis on issues of queer male sexuality, ignoring the roles of women in the films and larger feminist issues. "Miller is not obliged," writes White, "to offer a feminist analysis of Hitchcock's film [in this case, *Rope*]."

> Yet Miller's metaphor of (male) anus as cut cuts feminist film theory and its considerable insights out of the picture as well. Homosexuality is reserved for the same sex, the male. Implicitly, the woman can represent only difference, that is, heterosexuality. The anus deconstructs sexual difference (the opposition phallus/lack), but access to this supplement is reserved for male members. . . . [Comparing Lacanian queer theorist Lee Edelman's similar arguments to Miller's, we can deduce that the] two theorists have found the ultimate master of "anality" in Hitchcock himself.[27]

I return to the question of anality and its centrality to Miller's reading of *Rope* in chapter 4; for now, I want to establish that I share White's view of the matter. My focuses on orality and the role of women in epistemological structures of sexual knowledge in *Rope* seek to move beyond the confinements of Miller's argument, which remains salient.

Fascinatingly, and troublingly, the seeming impasse between feminism and male-oriented queer theory finds a complement in Hitchcock's work. These theoretical debates shed light on the impasse between the heterosexual female and queer characters in his films—which at times becomes a battle to the death, as in *Shadow of a Doubt*, *Spellbound*, *Notorious*, and *Psycho*. As I elaborate in chapter 2, which focuses on *Shadow of a Doubt*, these struggles exemplify what I call *sexual hegemony*, a system that pits sexual and other kinds of minorities against one another while motivating those at the top levels of social power to maintain their hierarchical positions at any cost.

HITCHCOCK AND THE ANTISOCIAL TURN

My reparative project attempts to offer an alternative to the antisocial thesis that has become a prominent aspect of queer theory ever since the publication of Leo Bersani's 1995 study *Homos*. In this regard, I draw inspiration from Sedgwick and scholars such as Ann Cvetkovich.[28] Drawing on Jean Genet's novel *Funeral Rites*, Bersani developed a theory of anti-relationality that defies cultural demands for "positive" experiences of sexual intimacy, always already cast as heterosexual. The antisocial turn in queer theory, as it has been called by Jack Halberstam and others, is extremely problematic, however.[29] Its emphasis on negativity as the proper response to homophobia is constrictive and politically questionable. Both Bersani's theory of gay male self-shattering (focused on the passive sexual partner) in *Homos* and Edelman's theory of a queer death drive in *No Future* are highly debatable.[30]

Following Bersani and taking his paradigms even further, Edelman in *No Future* critiques the social and cultural demands for reproductive futurity, embodied by the figure of the child, and argues that, given society's wide-ranging associations of queerness with death, the properly queer response to such associations is to embody the death drive, offering a grotesque counter-mirror of nullity and death back to the social order. The queer subject thereby resists a regime of reproductive futurity.[31] In his *Cruising Utopia: The Then and There of Queer Futurity*, José Esteban Muñoz offers a respectful but thorough counter-response to the queer antisocial thesis that critiques, in particular, Edelman's disregard for nonwhite queer aesthetic productions.[32] Following up on Eve Sedgwick's reparative hermeneutics, discussed in the next section, Muñoz, in reference to the work of artists such as Eileen Myles and Samuel Delaney, notes that he does not strive to dismiss the negative entirely, stating that radical negativity can have a place in the new queer utopianism he promulgates. Instead, Muñoz argues on behalf of "a surplus that is manifest in the complexity of . . . moments of contact," "the mood of reception," the "being singular plural of queerness," those moments in which we can "see the anticipatory illumination of the utopian canceling the relentless shadow play of absence and presence on which the antirelational thesis rests."[33]

Jack Halberstam notably critiques the Edelman-Bersani position in her essay "The Anti-Social Turn in Queer Theory." She locates her chief dissent from the Bersani-Edelman position in their gay white male canon of artists that excludes women and nonwhite artists. "The gay male archive preferred by Edelman and Bersani oddly coincides with the canonical archive of Euro-American literature and film . . . it includes, in no particular order, Tennessee Williams, Virginia Woolf, Bette Midler, Andy Warhol, Henry James, Jean Genet, Broadway musicals, Marcel Proust, Alfred Hitchcock, Oscar Wilde, Jack Smith, Judy Garland, Kiki and Herb, but it rarely mentions all kinds of other antisocial writers, artists and texts like Valerie Solanas, Jamaica Kincaid, Patricia Highsmith, Wallace and Gromit, Johnny Rotten, Nicole Eiseman, Eileen Myles, June Jordan, Linda Besemer, Hothead Paisan, *Finding Nemo* [!], Lesbians on Ecstasy, Deborah Cass, Sponge

Bob, Shulamith Firestone, Marga Gomez, Toni Morrison, Patti Smith, and so on."[34] Far from overturning negativity, Halberstam reenergizes by associating it with her alternative, more expansive canon.

Given his argument that the cult of reproductive futurity is embodied in the child and that queers should embody the death drive, Edelman fittingly recuperates images from Hitchcock's work such as the moment in which the homicidal Bruno Anthony pops a little boy's balloon at the fairground in *Strangers on a Train* or the one in the climactic portion of *North by Northwest* when Leonard, the homosexual henchman of the villain, uses his foot to crush the hero Roger O. Thornhill's hand on Mount Rushmore. The source of the power in Hitchcock's images of negativity, it would appear, lies not in his films' resistance to the normative social order and its program of endless sexual normalization, but instead in his amoral perversity. To illuminate this point, Edelman quotes comments from the director himself that were reportedly made over a dinner with Ernest Lehman, the screenwriter of *North by Northwest*. Hitchcock described his effectiveness at completely manipulating the audience as the basis for the future of cinema: "someday we won't even have to make a movie—there'll be electrodes implanted in their brains, and we'll just press different buttons and they'll go 'ooooh' and 'aaaah' and we'll frighten them, and make them laugh. Won't that be wonderful?"[35]

Having cited Hitchcock's commentary, Edelman remarks:

> With this quasi-pornographic fantasy of manipulating people through electrical stimuli, Hitchcock, always eager to maximize directorial control, imagines a cinema of neuronal compulsion exempt from the burden of having to deal with subjectivity at all. This view of the end of cinema . . . reads the spectator's sense of compassion, of emotional investment in the image on screen, with so little compassion of its own, that it fully acknowledges film as a form of Imaginary entrapment in which the filmmaker mobilizes identification with a totalizing image as surely "implanted in [viewers'] brains" as electrodes themselves would be.[36]

For Edelman, such moments as Thornhill asking Leonard for help as the hero hangs from the crag while holding Eve Kendall with his other hand cannot be read as evidence of emotional connection between director and narrative/character. "Such control of the viewers' emotions produces compassion but does not reflect it."[37] To the extent that Hitchcock's work is admirable at all in Edelman's eyes, it is precisely because he does not succumb to the regime of compassion—is indeed incapable of inhabiting or expressing this affectional mode authentically, which Edelman, in his customary counterintuitive manner, reads as the sign of tyrannous and unrelenting normalization.

Edelman portrays Hitchcock as the cold prankster cinema magician without any "genuine" investment in his narratives, purely a technician. Granted, this is a longstanding negative view of Hitchcock in traditional critical quarters, a familiar one from critics like Pauline Kael and David Thomson. The twist is that Edelman presents this

essential inability or refusal on Hitchcock's part to offer authentically felt representation as a model of queer negativity even as he implicitly associates Hitchcock with the homophobic. The same holds true in Edelman's reading of *The Birds*, which both recuperates its anti-child politics and associates it with homophobia. (The birds and their threat to children emanate from San Francisco, the breeding ground for the homosexual menace.)

While, to be sure, Hitchcock's work is rife with ideological disturbances, I believe that his work's value lies in his steady exploration of the cost of living in the social order. Moreover, his consistent empathy for the socially despised and discarded makes Hitchcock's films valuable as well. Hitchcock's work teems with outsider characters who find no secure place in the world, sometimes no place at all. Marnie is an especially poignant and representative example. Yet Hitchcock's films also thematize a profound desire for connection. To arrive at something like a queer understanding of Hitchcock, we must first consider the motives for refusing the demands of the social order on the part of his characters and works, and, second, disentangle the questions of desire and the longing for intimacy from their conventional, if not altogether binding, associations with normative heterosexual desire. Once again, I want to establish that, despite my disagreements with several of their positions, I have found a great deal of Bersani's and Edelman's work helpful to my own thinking, especially Bersani's framing of Freud as a theorist of sexuality's disturbing aspects.[38]

REPARATIVE CRITICISM: HITCHCOCK'S INTIMATE VIOLENCE

Melanie Klein's theories illuminate a persistent thematic in Hitchcock, one that is best summarized in Oscar Wilde's aphorism, used recently by William Rothman as the title for a book on Hitchcock: "Must we kill the thing we love?"[39] Klein writes in terms redolent of the horror genre of our relationship to the first would-be object of our desires, the mother's breast. "When a baby feels frustrated at the breast, in his phantasies he attacks the breast. . . . In his aggressive phantasies he wishes to bite up and to tear up his mother and her breasts, and to destroy her also in other ways."[40] Jacques Lacan likened the phantasmatic world of the unconscious in Klein to "a witch's cauldron."[41] Her depiction of the infant's world, full of violence and ravening—she could be describing the monster baby of Larry Cohen's great horror film *It's Alive* (1974)—links infancy to primal savageries. But there also exists in the (normal) child a "reparative impulse" to heal the desired, loved object of (imagined) violence or desecration.

A most important feature of these destructive phantasies, which are tantamount to death-wishes, is that the baby feels that what he desires in his phantasies has really taken place; that is to say that he feels that he has really destroyed the object of his destructive impulses, and is going on destroying it. . . . If the baby has, in his

aggressive phantasies, injured his mother by biting and tearing her up, he may soon build up phantasies that he is putting the bits together again and repairing her.[42]

Analogously, Hitchcock films enact a perpetual relay between aggressive and reparative impulses, desires to destroy the loved object and restore her—sometimes him—to full integrity. I call this dynamic in Hitchcock's films intimate violence.

Eve Kosofsky Sedgwick's model of reparative reading is drawn from Klein's work and explicitly challenges the hermeneutics of suspicion—in a word, paranoia—in queer theory. (Some in the field have dissented from Sedgwick's reparative model, to be sure.[43]) Sedgwick notes that "among Klein's names for the reparative process is love."[44] My Kleinian-Sedgwickian reading of Hitchcock is that his films register the inescapable desire to injure the loved object and the search for love, at once.

Sedgwick finds a value in Klein's "concept of *positions*—the schizoid/paranoid position, the depressive position—as opposed to, for example, normatively ordered *stages*, stable *structures*, or diagnostic *personality types*."[45] As Sedgwick argues, to "read from a reparative position is to surrender the knowing, anxious paranoid determination that no horror, however apparently unthinkable, shall ever come to the reader as new; to a reparatively positioned reader, it can seem realistic and necessary to experience surprise. Because there can be terrible surprises, however, there can also be good ones." She continues later in the essay: "The desire of a reparative impulse . . . is additive and accretive. Its fear, a realistic one, is that the culture surrounding it is inadequate or inimical to its nurture; it wants to assemble and confer plenitude on an object that will then have resources to offer to an inchoate self."[46]

Esther Sánchez-Pardo's description of Klein's project illuminates why she provides a particularly apt paradigm for Hitchcock's work:

Paranoid-schizoid and depressive images are overlaid in a rich texture of phantasies that finally, in Klein's later work, are resolved in reparation, in the healing of open wounds, and in the destruction and dereliction that we ourselves have caused. Splitting, scotomization [the repression of traumatic experience], and mania give way to our melancholic landscapes of depression. In the remainders, in the interstices of all these ruins, the subject strives to make repairs out of love for the damaged object . . . the melancholic longings for a peaceful state in which we, as subjects, may come to terms with the shadows of our troubled and most turbulent interior landscapes.[47]

Hitchcock's work offers blistering evocations of the need to damage the loved object, as well as the love-motivated efforts to repair the damaged object. I also believe that his films offer resources for this repair-making work if we read the films as themselves theoretical, centered in the exploration of the costs of and fissures in the maintenance of normative forms of identity. Conforming to, maintaining, and, to evoke Judith Butler,

achieving a normative sexual desire and life becomes the visible, verifiable marker that one is indeed a "normal," functioning person and that one has not only conformed to but is also able to embody a prescribed gender role. As Butler writes, "masculine and feminine are not dispositions, as Freud sometimes argues, but indeed accomplishments, ones which emerge in tandem with the achievement of heterosexuality."[48] The reparative approach I take to Hitchcock proceeds from the basis of a belief that his work illuminates and at times exposes the strenuous efforts of his characters to secure such "achievements."

QUEER PARANOIA

In *Between Men*, Sedgwick offered a now-classic theory of "the paranoid Gothic."[49] Her essay on reparative criticism, as its title adumbrates, considers the role of paranoia in criticism at length.[50] Considering the relationship between the reparative and paranoia proves productive for the analysis of Hitchcock's representations of female and queer sexuality.[51]

The main basis for paranoia theory remains Freud's work, especially his analysis of the 1903 memoirs of Daniel Paul Schreber, a German judge who suffered from what was at the time diagnosed as *dementia praecox*.[52] (Freud read Schreber's memoirs but never met him personally.) The psychotic Dr. Schreber, as Freud refers to him, developed paranoid tendencies as a defense against knowledge of his homosexual desires. "The exciting cause of his illness . . . was an outburst of homosexual libido; the object of his libido was probably from the very first his doctor, Flechsig; and his struggles against the libidinal impulse produced the conflict which gave rise to the symptoms."[53] Freud postulated that the underlying mechanism of paranoia is the transformation of homosexual love into hate, an important idea for several Hitchcock films.

Guy Hocquenghem argued that Freud's theory of paranoia should be redeployed as a critique of a larger social homophobia. He quite rightly challenged the prescriptive normalization of Freud's theory in psychiatric practice. "Freud's famous 'persecutory paranoia' is in actual fact a paranoia that seeks to persecute. The reversal of meaning which Freud's concept has undergone in this respect is enlightening. Freud states that persecutory paranoia is generally connected with the repression of the libido's homosexual component. Social man's fear of his own homosexuality induces in him a paranoiac fear of seeing it appear around him."[54] But in contemporary society and its deployment of Freudian theory for often murderously normative ends, "paranoia becomes the cause of homosexuality, reversing Freud's schema in the crassest possible way."[55]

While a proper analysis of paranoia's history far exceeds this discussion's scope, I want to establish, with Hocquenghem's critique in mind, that Freudian theories of paranoia, when reparatively read, give us a psychoanalytic basis for interpreting the sexual conflicts rife in Hitchcock, one that complements the Kleinian one. As I have elsewhere established, the feminine-versus-the-queer pattern has its roots in Freud's theory of

female paranoia.[56] Hitchcock preserves the political value in Freud's theory of paranoia, and he does so by linking, as Freud does, paranoia to jealousy, as well as homosexuality. Hitchcock thereby defies, and at times also capitulates to, society's homophobic classifications of paranoia.

Freud's essay "Some Neurotic Mechanisms in Jealousy, Paranoia and Homosexuality" (1922) established that there are three kinds of jealousy: competitive, or normal; projected; and delusional. "Normal" jealousy is also competitive jealousy, and "essentially it is compounded of grief."[57] I argue that Freud's evolving views of paranoia—the persecutory paranoia associated with the Schreber case and the idea that jealousy as linked to paranoia and homosexuality proceeds from the basis of grief—are crucial to Hitchcock's representation of homosexuality. Persecutory paranoia informs *The Lodger, Rebecca, Shadow of a Doubt, Spellbound, Rope, Stage Fright, Strangers on a Train, I Confess* (1953), *North by Northwest, Psycho, Marnie,* and *Frenzy.* In several of these films, a homoerotic antagonism—exemplified by the relationship between the lover-killers Brandon and Philip in *Rope* and with their former prep schoolmaster Rupert Cadell; Jane Wyman's and Marlene Dietrich's characters in *Stage Fright*; Guy Haines and Bruno Anthony in *Strangers*; Father Logan and Otto (O.E. Hasse) in *I Confess*; Leonard and Roger O. Thornhill in *North by Northwest*; Norman Bates and Sam Loomis in *Psycho*— ineluctably leads to violence and a confrontation with the law hastened by a "persecutory" zeal. These films foreground fissures in gender and/or sexual identity that can be interpreted as forms of grief, mourning, and melancholia, to merge Freud and Judith Butler. The attendant forms of intrigue, duplicity, plotting, and, perhaps above all, the desire to expose and punish criminality, all lend a punitive as well as competitive edge to the struggles between the characters. Paranoia emerges as a defensive response to these often excruciatingly difficult negotiations, a form of violent acting out when faced with incommensurate demands. Within the logic of paranoia is a desire that must be silenced, a narcissism that protects its integrity at any cost. At the same time, Freud's theory of female paranoia, which I discuss at length in chapter 5, for all of its limitations nevertheless sheds light on what we can identify as the heterosexual woman's paranoid position in the Hitchcock text specifically in relation to male homosocial enclaves and homosexual desire and epistemologies. In *Rope* and *Strangers on a Train*, the woman's stance toward male-male desire is one of paranoid knowledge; she threatens to penetrate the realm of male intrigue as she is threatened by the males whom she increasingly regards with suspicion.

PATTERNS THAT BLEED

If Hitchcock's films oedipalize (i.e., heterosexualize) their subjects, they also register and explore the queer tensions that buck this narrative system. These tensions take the forms of recurring themes that I call homoerotic antagonism and the feminine versus the queer.

As patterns, they are not strictly cordoned off from one another, but rather intersect. The Guy Haines/Bruno Anthony conflict typifies homoerotic antagonism, in that the men's battle to the death is undergirded by an undeniable sexual tension and even chemistry. The feminine-versus-the-queer pattern emerges through antagonism as well, but does not necessarily include sexual attraction between the antagonists. The second Mrs. de Winter is mesmerized by the haunting absence/presence of the titular Rebecca, but her battle to the death with Mrs. Danvers, the craven custodian of Rebecca's memory, is marked by sexual revulsion on the heroine's part and, more than anything else, a blankness in the villainous housekeeper's sexuality (these points are debatable, to be sure). Similarly, the battle to the death that ensues between the psychoanalyst Dr. Constance Petersen and her mentor Dr. Murchison in *Spellbound* specifically eschews a sexual dimension.

Yet, at the same time, the feminine-versus-the-queer pattern frequently does involve a vexed sexual frisson. Brandon, the more flamboyantly confident of the gay male pair in *Rope*, once had a romantic relationship with Janet Walker, the all-but-fiancée of David Kentley, the man the lovers have murdered. Her stance toward the gay men is increasingly marked by suspicion; moreover, she wields a penetrating insight that threatens to pierce their veneer of intrigue. Brandon's treatment of her exudes both misogyny and sadism, attitudes deepened rather than ameliorated by their prior sexual intimacy. Marnie's relationship to the tartly ironic, manipulative Lil Mainwaring is similarly charged with an erotic dimension ("Who's the dish?" Lil comments when spying on the heroine for the first time). These conflicts foreground unknowledgeable and palpable levels and forms of loss. And it is loss, specifically, that links female and queer characters in Hitchcock's films.

It is important to distinguish loss from the more ideologically suspect term "lack." As E.L. McCallum observes, "Loss indicates a singular sense of being without something one once had (or at least believed in) whereas lack implies a normative standard of plenitude against which one comes up short."[58] While femininity has been misogynistically framed as a form of lack in Lacanian theory and in Freud's notorious concept of penis envy, it is more helpful, and also more accurate, to see in Hitchcock an analysis of gendered and sexual loss that binds together male and female, straight and queer characters. This loss has ties to mourning and melancholia. In Freudian theory, mourning is the normal response to grief, an intense emotional and physical outpouring of emotion that fatigues the sense of bereavement. Melancholia, however, is an interminable state of mourning, one that can take the forms of blankness and numbing.[59]

Judith Butler's reframing of Freud's theory of mourning and melancholia for queer theory purposes has been influential on my thinking. Gender identification itself—founded in an identification with the same-sex parent that must be strictly differentiated from desire—is a form of melancholia. This process is crucial to what Judith Butler, in her reworking of Freudian theory for queer purposes, calls *the melancholia of gender identification*.[60] In an essay in *The Psychic Life of Power* entitled "Melancholy Gender/Refused Identification," she explores the "predicament of living within a culture which can mourn the loss of homosexual attachment only with great difficulty."[61] Hitchcock's films shed

light on these predicaments. Films such as *Rope, Psycho,* and *Marnie* thematize the queer-inflected inability to grieve; the difficulties of achieving a coherent gender identity inform *The Lodger, Downhill, Secret Agent, Jamaica Inn, Rebecca, Suspicion, Shadow of a Doubt, Spellbound, Vertigo,* and many other works, aligning Hitchcock's cinema with the concerns of contemporary queer theory.

QUEERNESS: TERMS, CONFLICTS, METHOD

The use of the word "queer" as a critical term emerged from, or alongside with, the development of queer theory as a methodology in the 1980s, spearheaded by Eve Sedgwick's deeply influential study *Between Men*. Once a term of abuse, the term was appropriated as a rubric for the study of non-normative sexualities and a rallying cry for post-gay identity. As Heather Love writes, "When queer was adopted in the late 1980s it was chosen because it evoked a long history of insult and abuse—you could hear the hurt in it."[62] Throughout this book, I will be using queer to describe a range of non-normative sexualities, identities, gender performances, situations, and concepts. Such a maneuver is not without losses and slippages and therefore necessitates some elucidation, even at this point—precisely because we *are* at this point, when queerness has become so capacious a term as to have lost a great deal of its intrinsic coherence, if it ever possessed it at all.

In her still-excellent methodological survey *Queer Theory*, Annamarie Jogose writes, "queer describes those gestures or analytical models which dramatize incoherencies in the allegedly stable relations between chromosomal sex, gender, and sexual desire . . . and focuses on mismatches between sex, gender and desire."[63] "Or queer may be used to describe an open-ended constituency, whose shared characteristic is not identity itself but an anti-normative positioning with regard to sexuality."[64] More recently, Elizabeth Freeman has illuminated the temporal unwieldiness of queer—and the creative possibilities of this unwieldiness: "At one point in my life as a scholar of queer culture and theory, I thought the point of queer was to be always ahead of actually existing social possibilities. . . . this version of queering the text now strikes me as somewhat akin to Eve Sedgwick's notion of paranoid criticism. . . ." Freeman reports that now she feels "the point may be to trail behind actually existing social possibilities: to be interested in the tail end of things, willing to be bathed in the fading light of whatever has been declared useless."[65] Heather Love makes a similar argument in her *Feeling Backward*.

The most perspicacious case for the appropriateness of using the queer rubric to interpret Hitchcock's films was made consistently by Alexander Doty. In his *Flaming Classics*, Doty wrote, "'Queer': as in not clearly identified as homosexual, bisexual, or heterosexual, while also, in certain, usually gender, particulars, not fitting into current understandings of normative straightness."[66] Doty observes that this definition applies to both characters such as Buffalo Bill, the serial killer in Jonathan Demme's 1991 thriller *The Silence of the Lambs,* and *Psycho's* Norman Bates. In *Making Things Perfectly Queer,*

Doty established that his "uses of the terms 'queer readings,' 'queer discourses,' and 'queer positions'" are "attempts to account for the existence and the expression of a wide range of positions within culture that are 'queer' or non-, anti-, or contrastraight."[67]

My use of the term closely follows Doty's. Like some other commentators, I worry about the overuse of queer, which prefaces a broad range of specific studies today (eco-studies, animal studies, et al.). Nevertheless, queer is useful to me because of its flexibility as a critical approach, as adumbrated in Doty's descriptions of both Norman Bates and Jame Gumb (a.k.a. Buffalo Bill). When I call a character in the pre-Stonewall Hitchcock text queer, I mean to evoke a variety of possibilities, primarily non-normative sexuality and/or gender performance. I am not, then, attempting to offer an argument about the historical emergence of gay, lesbian, bisexual, or transgendered identities in U.S. film, though my readings are informed by studies across a range of disciplines that do precisely that. Rather, I am attempting to offer an argument about Hitchcock's American films that says something useful and interesting about a recurring set of dynamics in them centrally related to twentieth-century articulations of female and non-normative sexualities. And these articulations inform the English films no less urgently.

ENGLISH HITCHCOCK

I have made the decision to focus on specific Hitchcock films in each chapter. This book focuses on feminism, queer theory, and their debates over the genealogy of gay/queer identities in twentieth-and-twenty-first-century Hollywood as well as Hitchcock's films. My argument is concerned with the representation of gender and sexuality in the context of classical Hollywood, what was possible in that era, the studio system, and film aesthetics in relation to these topics. For these reasons, my analysis chiefly concerns Hitchcock's body of work from his 1939 arrival in the United States at David O. Selznick's behest to his mid-1960s films. Hitchcock's first American film *Rebecca* was doubly significant in establishing his predilection for female melodrama (which he defensively denigrated in interviews) and the feminine-versus-the-queer dynamic (the second Mrs. de Winter's taut, agonized relationship with the housekeeper Mrs. Danvers, once Rebecca's maid and her fierce devotee). My choice of films reflects the Americanness of this dynamic. Nevertheless a strong interest in both non-normative sexualities and the heroine's sexuality marks Hitchcock's English output, which attests to longstanding concerns with these matters on the director's part.

As I discuss in chapter 3, *The Lodger*, starring the homosexual actor and matinee idol Ivor Novello, is particularly significant in almost innumerable ways, as Hitchcock himself indicated by calling it the first Hitchcock film. The brooding and melancholy titular figure played by Novello is the template for so many of Hitchcock's dark-haired, dark-eyed, pale-skinned, ambiguous, and beautiful young men. They are physically beautiful and physically similar, the tremulous brunet in contrast to Hitchcock's more famous

cool blonde. It is also significant that for most of the film, we suspect that the vulnerable Lodger is the Avenger, a Jack-the-Ripper-like serial killer of women, anticipating Hitchcock's slew of sympathetic male characters who murder, such as dark-haired Philip in *Rope* and Norman Bates in *Psycho. The Lodger* is the embodiment of the concept that I call "male suspenseful mystery." Novello is also very fine in an understudied early Hitchcock film, *Downhill* (1927). He co-wrote the screenplay with his friend Constance Collier, based on their play. (Collier would later shine as the murdered David Kentley's humorous gravel-voiced aunt who attends the grisly dinner party thrown by his killers in *Rope.*) *Downhill*, with *The Lodger*, established an early pattern of morally suspect, suffering young men who undergo brutalization and, in the later films, brutalize others.[68] The miasmic male descent into loss of self here is replayed in *The 39 Steps* (1935), *Spellbound, I, Confess, The Wrong Man* (1956), *Vertigo, Psycho*, and *Frenzy.*

Murder! sets the stage (appropriate for a movie set in the theater and circus worlds) for the often fatal conflict that repeatedly ensues in Hitchcock's films between a nonnormative character, usually though not always male, and the heterosexual heroine. The villain Handel Fane (Esme Percy) is both a cross-dresser and a "half-caste," meaning that he is of mixed race; these dimensions of his persona contribute to his sexual otherness. And like so many sexually ambiguous Hitchcock villains, he is dark-haired and tremulous. The heroine Diana Baring (Norah Baring), a young actress, is convicted of murdering another young actress, Edna Druce. The famous actor-manager Sir John Menier (Herbert Marshall) is on the jury that convicts Diana of the titular crime, but he has misgivings. Convinced that Diana is innocent, Sir John investigates the crime himself. Paul Duncan writes that Hitchcock's emphasis on gender ambiguity transcends the conventional plot: "There are women in male roles (the female barrister and the jury women as experts in psychology), men in female roles (Handel Fane does a trapeze act in drag), and great emphasis on people changing clothes/identities."[69] Of most significance to us are the genderqueer aspects of Fane, the fact that he kills Edna so that she will not reveal his secret, the suffering of the heroine who loves Fane, and Sir John's role as investigator and punitive enforcer. As Richard Allen observes, "Sir John tries to trap Fane into a confession, but he resists and instead stages his own glorious death in the circus ring in a scene of drag performance that suggests something that Sir John fails to recognize," namely, the possibility that Fane's secret may refer to his sexuality as well as his race.[70] While a great deal more work on Hitchcock's complex and understudied attitudes toward race, ethnicity, and racial intermixing needs to be done, I want to emphasize here that *Murder!* provides a narrative template for many key Hitchcock films, especially the feminine-versus-the-queer dynamic and the heterosexual male's staunch and steady effort to expose queer crime. Variations on these themes can be found throughout Hitchcock, especially in *Psycho.* But *Psycho* crucially innovates *Murder!*'s plot. For one thing, Sir John's detective-figure role is largely taken up by a female character, the murdered Marion Crane's sister Lila. Moreover, the heterosexual male character Sam Loomis, Marion's boyfriend, is both a less forceful and less sympathetic identification figure than Sir John. And while the

possibility that the appealing young man revealed to be the killer, Norman Bates, might rescue Marion Crane from her troubles (and from Mother), the romantic dimensions of their relationship are insinuations only, in contrast to the Diana/Fane relationship in *Murder!*, which is presented as a ruined romance; this is to say that *Psycho* features strong female characters with narrative agency, makes the heterosexual male lead a distinctly secondary character, and comes close to articulating its sympathetic villain's gay identity.

While subversions of normative gender and sexual roles abound in Hitchcock's English films, one work merits further attention. *Secret Agent*, based on W. Somerset Maugham's 1928 *Ashenden: Or the British Agent*, a collection of stories linked by the titular figure, makes perverse human relationships the norm of its disordered espionage world. The war hero Edgar Brodie (John Gielgud), his funeral having been faked and now pretending to be the spy Ashenden, is dispatched to Switzerland by his superior R to locate and stop a German agent who threatens to undermine the 1916 British intervention in the Middle East. Ashenden is accompanied on his mission by a bizarre ally alternately called the General, even though he is not one, and the Hairless Mexican, even though the curly-haired fop is neither hairless nor Mexican. Played by Peter Lorre, the General preys on all available women yet seems quite sexually ambiguous. In Switzerland, both men meet Elsa Carrington (Madeleine Carroll), a blonde woman assigned to play Ashenden's wife. They also meet the American Robert Marvin (played by American actor Robert Young), Elsa's would-be paramour. Young, smooth, and charming, Marvin exudes 1930s urbanity. Elsa, the model of the triangulated woman through whom men mediate their own desires, is frequently depicted in shots with two other men, either Ashenden and Robert (see figure I.1) or Ashenden and the General (see figure I.2). As it turns out, Robert is the

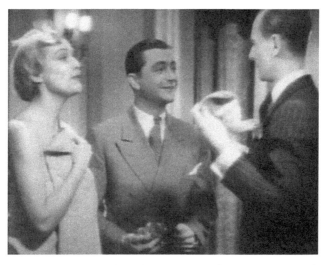

FIGURE I.1 The sexually ambiguous Robert (Robert Montgomery) stands between the heterosexual couple in *Secret Agent* and, despite the woman's provocative pose, has eyes only for Ashenden (John Gielgud).

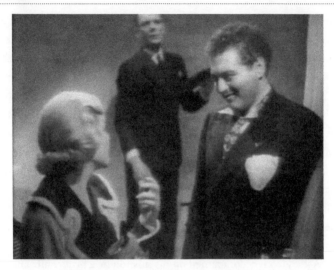

FIGURE I.2 Elsa (Madeleine Carroll) is triangulated between the diabolical dandy (Peter Lorre) and the hero Ashenden.

nefarious German agent. In one of Hitchcock's most chilling scenes, Ashenden watches, through a telescope, the General killing the wrong man, a genial Englishman named Caypor, whose dog howls in anguish back in the apartment he shares with his wife, who is entertaining Elsa at the time (both women look uncannily stricken).

Donald Spoto finds Hitchcock's treatment of homosexuality here better integrated than it is in films like *Rope, Strangers on a Train*, and *North by Northwest*. Though I do not agree, I think Spoto makes a compelling point about the relevance of *Secret Agent* to an analysis of this aspect of Hitchcock's work. For Spoto, the "morally gray, ambiguous" world into which Ashenden and Elsa plunge "is carried forward by a subtheme of sexual ambivalence and exploitation." (Elsa transforms, as do many Hitchcock personae, from a shallow person craving excitement to an earnest one stricken with the gravity of their assigned tasks, such as killing the enemy.) "A leading romantic figure in American cinema at the time, Young is cast as the villain. Apparently infatuated with Elsa, he is associated with a veiled homosexuality."[71] Or he appears to be her gay best friend. Numerous jokes reinforce Robert's sexual ambiguity, such as the moment when Elsa puts Ashenden on the phone when talking to Robert and he ends up blowing kisses through the phone to Ashenden. (Ashenden's own sexual ambiguity, especially as he is played by Gielgud, another one of the many gay actors with whom Hitchcock worked, adds to the queer suggestiveness of this humorous moment.) In a typically Hitchcockian scenario, the fake marriage Ashenden and Elsa must maintain for cover transforms into a marriage of genuine love. Robert, the enemy masquerading as the appealing friend, performs the equally typical Hitchcockian role of the villain whose charm and kindness make him a better romantic fit for the heroine than the ostensible hero. For these reasons, the climactic action, set on a train hurtling toward Constantinople (the English spies must prevent Robert

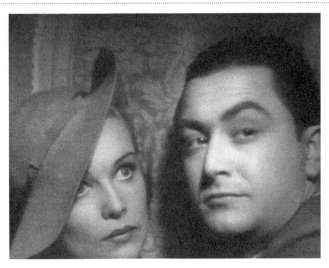

FIGURE I.3 Robert intimately tells Elsa, "Too bad I didn't love you. I never did. You know that, don't you?"

from getting there), is particularly significant. Elsa, morally awakened, does not want to allow Ashenden to kill Robert because doing so would destroy Ashenden's soul; while Ashenden and the General search the train for Robert while also trying to avoid being detected by him, Elsa joins Robert in his train car, quieting his suspicions by proclaiming that she has been in love with him the entire time. As happens in several Hitchcock works, the heroine's initial sympathy for and friendship with the queer male transmutes into their opposite. While Elsa does not want to kill Robert, she more emphatically does not want Ashenden to kill him because of her love for Ashenden. Robert himself means very little to her. As we see in films such as *Spellbound*, the queer/homosexual male friend feels very little for his female friend either; once she too is unmasked, her role as his retribution is revealed. In one of the most haunting and disorienting moments in the film, Robert intimately tells Elsa, "Too bad I didn't love you. I never did. You know that, don't you?" before planting a Judas kiss on her lips. Hitchcock films this scene in an overbearingly intimate close-up of the actors as if to register a surge in romantic ardour, which Robert's dialogue about seeming to be Elsa's "chivalrous" protector openly mocks (see figure I.3).

For Spoto, homosexuality and sexual ambiguity here apply no less to the General's equal-opportunity pansexual appetite and threat ("A ladykiller," Ashenden remarks of the General to R, who responds, "Not only ladies") and reflect the shadowy social relations and ethical crisis of *Secret Agent*'s espionage world. This view accords with Lesley Brill's in *The Hitchcock Romance*, which frames homosexuality as normative sexuality's negative image. While these critical estimations certainly have a point, I believe it is fairer to say that what Hitchcock's films register is the constant vulnerability of the normative social order, organized around the figure of the successful heterosexual couple, to the

forces of dissolution and challenges that not only undermine it but reveal it as a binding-but-fractured fantasy; which is to say that personae such as Robert and the General resist and subvert the normative sexual and social order, but the heterosexual couple is itself depicted as hardly representative of this order's internal coherence and stability. The gamesmanship, masquerades, and sudden emotional reversals that define their marriage link them to the perverse manipulations and attitudes of the antagonistic queer couple of sorts, Robert and the General. (Robert, dying in the wreckage of the train, shoots the General, allowing them to share death if nothing else.)[72] What is significant here is that Ashenden plays little role in the climactic exposure of Robert's villainy and his self-presentation as the villain. These moments occur almost exclusively between Robert and Elsa. Though she too is a spy, Ashenden is the protagonist, and one might have expected a final confrontation between the two men most directly pitted against one another.[73] In Hitchcock, however, such a confrontation most typically occurs between the heterosexual heroine and the queer villain. Exploring this pattern and considering its implications is the major project of this book.

CHAPTER SUMMARIES

The trajectory of *Intimate Violence* is as follows. Chapter 1 focuses on *Psycho* and, at greater length, *North by Northwest*. I begin with an analysis of the marked differences between Robert Bloch's novel *Psycho* and the film adaptation, arguing that the changes Hitchcock made to the source material reveal his queer sensibility. My discussion of *North by Northwest* allows me to work through the opposing views of Modleski and Edelman and consider the importance of the heterosexual heroine to Hitchcock's queer schemes. I establish the relevance of Christian/Catholic themes to the feminine/queer conflict and demonstrate the ways that Hitchcock's use of male stars like Anthony Perkins and Cary Grant extends the queer meanings of his films.

Chapter 2 explores the social implications of the feminine-versus-the-queer thematic through an analysis of *Shadow of a Doubt* (1943), notable for the director's close collaboration with the film's screenwriter Thornton Wilder. Reconsidering Gramsci's theory of hegemony, I develop a theory I call *sexual hegemony*, a system that keeps a privileged gender and sexual class insecurely at the top while inciting rivalrous violence among the sexually abnegated. In Hitchcock, the abnegated are centrally embodied by the female and queer characters, a struggle that *Shadow* foregrounds in the battle to the death between the heroine and her murderous uncle.

Chapter 3 closely analyzes *Spellbound* in terms of the feminine/queer conflict. The film pits its psychoanalyst heroine against the older male character Murchison, her supervisor at a psychiatric institution. The battle to the death that ensues between them is extremely illuminating—Hitchcock and the screenwriter Ben Hecht specifically eschewed the question of a romantic/sexual dimension to their relationship, heightening the queer

possibilities. At the same time, I consider the hero's phobic regard for his own masculinity and develop a concept that I call *male suspenseful mystery*. This chapter examines two crucial concerns of Hitchcock's films: the decentering of male authority on the one hand, and the interest in female sexuality and agency on the other.

Hitchcock's 1948 film *Rope* is the central subject of chapter 4. Considering Hitchcock's identification with his queer subjects, I propose that *Rope* thematizes what I call *queer anguish*—the emotional torment of the closet and homophobia. I argue that the focus on the anus in *Rope* criticism obscures a no less interesting and developed thematic in the film: the film's construction of orality as a contested zone of gay male sexuality. The film's interest in orality disrupts the popular association between sodomy and gay sexuality that has been reified in critical treatments of *Rope*. The questions of orality and the film's representation of homosexuality—itself a difficult, controversial question—allow us to consider the exploration of queer anguish, rooted in a competitive struggle with normative masculinity and a profound sense of loss.

Chapter 5's analysis of *Strangers on a Train* begins with a consideration of female paranoia, theorized in Freud's 1915 case study "A Case of Paranoia Running Counter to the Psychoanalytic Theory of the Disease." I elaborate on female paranoia as a crucial dimension of the feminine-versus-the-queer dynamic, rooted in the simultaneous framing of the woman as paranoid and yet accurate in her suspicions. I also explore the film's depiction of the villain Bruno Anthony's masochism in contrast to the narcissism of the hero Guy Haines. The chapter tracks the parallelism in the depictions of an illicit female sexuality and a queer male sexuality, and the ongoing inability of the heroine and the queer male to achieve mutual recognition. Further, the film allows us to consider the figure of the *queer mother*, who collaborates with the queer male and aligns herself with him against the woman.

In chapter 6, I propose that a crucial aspect of *Psycho*, one that relates to Hitchcock's work as a whole, is its thematization of a concept that I call the *death mother*. I develop the concept from the writings of Freud, Nietzsche, and André Green and from feminist psychoanalytic theory, especially Barbara Creed, in her reworking of Julia Kristeva's theory of abjection, and Diane Jonte-Pace's analysis of suppressed maternal figures in Freud's work. A distinction between Mrs. Bates/Mother on the one hand and the death mother on the other hand impels this discussion. The death mother relates primarily to aesthetics and as a concept can only be understood through an analysis of the work as a whole. At the same time, the figure has great relevance for issues of femininity and queer sexuality.

Chapter 7 treats *Marnie* (1964) as one of the cinema's richest explorations of what I call *queer resilience*: a continuous level of self-reliance and fortitude within structures of stifling social conformity that emphasize visible manifestations of gender and sexual normativity. I argue that, while lesbian overtones are certainly present, the film is more interested in presenting its solitary heroine's sexuality as onanistic. The forms of intimate violence that Hitchcock's films frequently depict find a newly politicized urgency in

Marnie. The chapter includes an analysis of the shipboard rape scene and its relevance to queer as well as feminist theory.

The epilogue treats *The Birds* as an index of several concerns in Hitchcock and this study. Specifically, I focus on the ambivalence with which the film regards its heroine. The feminine-versus-the-queer dynamic's relationship to this ambivalence is further considered. I explore the possibility that Melanie and the birds, an abstracted form of queerness, may in their final union unto death represent a resolution of the feminine-versus-the-queer conflict.

Queer Hitchcock

PSYCHO AND *NORTH BY NORTHWEST*

ALEXANDER DOTY PROVIDED a helpful schema of Hitchcock's queer-themed characters and films in his essay "Queer Hitchcock." "If we use a definition of queer that includes all sex, gender, and sexuality non-normativity, the Hitchcock films with the most consistent critical and audience queer quotient have been (in chronological order) *The Lodger, Murder!, Rebecca, Shadow of a Doubt, The Paradine Case, Rope, Strangers on a Train, Vertigo, North by Northwest, Psycho,* and *Marnie.*"[1] While I would add several more films to the list, especially *Secret Agent, Spellbound, Stage Fright,* and *I Confess,* the 1956 version of *The Man Who Knew Too Much, Psycho,* and *North by Northwest* are particularly indicative of two major components of Hitchcock's queer themes: first, a fascination with the attractiveness of homosexuality and/or queerness, or, to put it another way, a tendency to depict such characters as attractive; second, the pattern that I call the *feminine versus the queer,* the rivalrous, deeply invested, complex relationships in the director's films between heterosexual female and gay/lesbian/queer characters, who are often male but can be female as well.

Queerness in Hitchcock's films is largely organized around an unsettling attraction to the villain. In most cases, this villain is male and suggestively "queer," if by queer we mean non-normative but also associated with qualities typically linked to homosexuality in the gay male imaginary. Robin Wood pointed to Bruno Anthony in *Strangers on a Train* as

a "link in a chain of fascinating, insidiously attractive Hitchcock villains who constantly threaten to 'take over' the films in which they appear, not only as the center of interest but even, for all their monstrous actions, as the center of sympathy." Wood names Uncle Charlie in *Shadow of a Doubt*, the U-boat commander Willy in *Lifeboat* (1944), Brandon in *Rope* (but oddly not Philip), Norman Bates in *Psycho*, and *Frenzy's* (1972) necktie-murderer Bob Rusk as examples, though Wood does so in order to make the larger point that gayness "is by no means an *essential* attribute of the Hitchcock villain."[2] As we have noted, Wood offers this catalogue within a larger critique of reading many Hitchcock villains as gay.

As I discussed in the introduction, this study emerges from the sense that a power-ful, untapped source of queer potentialities in Hitchcock movies lies in the question of the relationships between his heterosexual female and queer characters. The debates that have centered on and been conducted among critics such as Lee Edelman, D.A. Miller, Tania Modleski, Patricia White, and Jack Halberstam shed a great deal of light on these potentialities while also being an indication of their theoretical and political difficulty. While Modleski, White, and Halberstam cannot be said to share the same positions gen-erally, each is critical of a perceived bias toward an emphasis on male homosexuality in Hitchcock by Edelman and Miller, who are seen as failing to address or examine the issue of femininity. I concur that this is an alarming gap in Edelman's and Miller's work, and I find much to disagree with in their arguments, as I will develop in this chapter and chapter 4 on *Rope*. At the same time, I contend that a failure to integrate the relevance of queer issues into feminist analyses of Hitchcock makes the feminist take, if it excludes such issues, less incisive than it might be.[3]

I believe these critical debates point, intentionally or not, to the actual presence in Hitchcock's films of a maddening and riveting dialectic: a queerness struggling to define itself against the feminine on the one hand, and a femininity that has come to view queer-ness as a threat to its own assertion of autonomous will and desire, with each struggle pro-ducing attitudes of sympathy, hostility, genuine aggression, and, overall, ambivalence. The positions taken by these critics have tended to emphasize one side of the debate. My effort here is to consider femininity and queerness in Hitchcock in relation to one another, an effort that, even if I am in disagreement with them at times, has been informed and indeed made possible by the efforts of these brilliant theorists.

As I outlined in the introduction, an opposition between femininity and queer sexu-ality emerges as a distinctive pattern that can be found in several Hitchcock films: An independent young woman vies against a sexually ambiguous character, usually typed as fathomlessly evil, for screen dominance, a struggle appropriately rendered as a battle to the death. That it occurs so frequently in the American films is highly significant; yet it is a theme already present in Hitchcock's 1930 *Murder!*[4] Hitchcock's American films consistently stage a war between heterosexual female desire and queer desire. There are variations on this general theme, of course, but in several significant Hitchcock films from *Rebecca* to the underappreciated *Torn Curtain* (1966), the conflict I call the

feminine versus the queer informs the narrative. Often, this conflict occurs between the heroine and a queer-typed male (gay Brandon taunting Janet in *Rope*; Leonard striving to expose Eve Kendall's secret identity as a spy in *North by Northwest*, one of the main topics of this chapter), but it also occurs between same-gender characters (e.g., the killer hounding the priest in *I Confess* and Lil Mainwaring tormenting Marnie). In *No Future*, Lee Edelman has suggested (more or less) that the titular menace of *The Birds* represents queer sexuality, and their opposition to the heroine's desire for the hero fits into the feminine-versus-the-queer pattern as well.[5] (I return to Edelman's reading of this film in the epilogue.)

As we noted in the introduction, Tania Modleski contends that Lee Edelman, in his reading of *The Birds* as an allegory of homophobic violence, creates "a deadly binary" by pitting the suffering of the queer male against the suffering of the woman.[6] I propose that the divisive debates in feminist and queer theory approaches have their roots in Hitchcock's films themselves, a place *within* the texts. A consistent conflict between heterosexual female and queer characters structures the films' sexual dynamics and illuminates these critical debates. To elucidate these claims, I discuss *Psycho* and *North by Northwest*. *Psycho* is revealing for its distinctions from its source material, Robert Bloch's 1959 novel of the same name, regarding the depiction of the heroine and the queer male. Both are far more appealing and sensitively drawn, and drawn to one another, in Hitchcock's film adaptation. *North by Northwest* affords us several opportunities for the development of a theory of queer Hitchcock. I discuss the conflicts between femininity and male queerness, the Christian symbolism of Hitchcock's work and its relationship to the feminine versus the queer, the evocations of the primal scene in the heterosexual romance here and its implications for queer spectatorship, and Hitchcock's uses of Cary Grant's sexually ambiguous screen persona.

PSYCHO, PERKINS, AND BLOCH

Psycho, if not the greatest of Hitchcock's films, is in many ways the most definitive—it clarifies and exemplifies Hitchcock's oeuvre while being an inexpressibly despairing work about modernity, capitalism, and gender trouble. *Psycho* views America as a wasteland, an empire of death. As *Vertigo* (1958) did before, it critiques American life as a system that promises pleasure and produces death. As Donald Spoto writes:

> *Psycho* postulates that the American dream can easily become a nightmare, and that all its facile components can play us false. . . . He shatters the notion that intense filial devotion can conquer death and cancel the past, and he treats with satiric, Swiftian vengeance the two great American psychological obsessions: the role of Mother, and the embarrassed secretiveness that surrounds both lovemaking and the bathroom.[7]

Hitchcock's career-long squeamishness over (and fascination with) impropriety and his equally consistent heterosexual ambivalence inform the treatments of gender and sexuality in *Psycho*.

The action of the film, in brief, is as follows. Marion Crane (Janet Leigh) steals $40,000 from her boss Mr. Lowery, who asked her to deposit it; the money belongs to his client, an odious Texas businessman named Cassidy. Marion's lover Sam Loomis (John Gavin), who owns a hardware store, claims that he cannot marry her—which she desperately wants him to do—because of longstanding debts. Marion's mad plan to use the money to give them both a fresh start hits a snag when, on the second night of her journey to Sam, she checks into the Bates Motel, run by a seemingly charming, sensitive young man named Norman Bates (Anthony Perkins). Norman makes her a dinner of sandwiches and milk, and they talk, chiefly about "private traps," Norman's being his role as caretaker for Mother, the harridan Mrs. Bates who, though unseen, audibly wields a tyrannical power over her son. We overhear her berating him about the women who stimulate his "cheap, erotic appetite." Marion's discussion with Norman takes an unsettling turn when he snaps at her for suggesting that he put his mother into a facility of some kind ("Why don't you put her . . . somewhere . . . ," Marion falters). In any event, the conversation prompts Marion's decision to return the money she stole. While taking a cleansing shower, she is horrifically murdered, stabbed to death, it would appear, by Mother. Our narrative allegiance shifts to Norman, whose careful disposal of Marion's body arouses our sympathetic interest. The dutiful son, Norman seems pitiable. We also shift, however, to identifying with Sam and especially Marion's sister Lila (Vera Miles), who is searching for her missing sister. Eventually, Sam and Lila find their way to the Bates Motel once the private investigator Arbogast (Martin Balsam) also goes missing (he too has been murdered by Mother). As Sam distracts Norman in the motel office, Lila explores the Bates house looking for clues and perhaps even Marion. In the cellar of the Bates house, she discovers Mother herself, or rather the corpse of Mrs. Bates, which has been preserved by Norman, who killed her. Norman not only impersonates but effectively *is* Mrs. Bates. Garbed in a dress and a wig, Norman as Mother attempts to kill Lila, but Sam rescues her just in time. After a suspect, lengthy explanation of Norman's psychosis from a psychiatrist, we move to the prison cell in which Norman is being held. Now, Mother's persona has completely dominated Norman's mind, and her chilling monologue, in which she exculpates herself for all of his crimes, concludes with a close-up of Norman's eerily grinning face with Mrs. Bates's skull-face superimposed over it. "The dominant personality has won," the psychiatrist explains, and the final shots of the film attest to that.

The queerness, as well as proto-feminism, of Hitchcock's cinema can be seen with new clarity if we consider Hitchcock's use of Anthony Perkins in *Psycho* and the distinctions between the director's version of the characters of Norman Bates and Marion Crane and those in Bloch's novel. The Norman Bates of Hitchcock's film does not exactly fit the model of the dandy, but he is analogously presented as an artistic figure, his stuffed birds artfully hung on the walls as signature works of art. Indeed, the mummified corpse of

his mother is a grisly art installation, a central prop in his mater-centered performance that involves masquerade, ventriloquism, and tableau vivant. For a proprietor at a nearly unfrequented motel that time and progress have largely forgotten, Norman is also quite modishly dressed in black turtleneck and corduroy slacks when the private investigator Arbogast stops by to question him about the missing Marion Crane (Mary in the novel).

Perkins was a matinee idol of the 1950s who played such roles as the son of a pacifist Quaker family who goes off to fight in the Civil War in *Friendly Persuasion* (William Wyler, 1956) and Jimmy Piersall, a real-life major league baseball player who struggled with mental illness in *Fear Strikes Out* (Richard Mulligan, 1957). Hitchcock seized on the hidden depths beneath Perkins's all-American gangly, sensitive persona. As David Thomson describes Perkins in *Psycho*, it is

> not only one of the best performances in a Hitchcock film, but very influential in the way that it mixed the horrors and sly attractiveness. Robert Walker had done some groundwork in *Strangers on a Train* (51), but Perkins' Norman is more refined, more truly feminine, and more confusing of comedy and melodrama. The details of the sidling walk, incipient stammer, chewing jaws, and snake-quick smile are marvelously organized. Above all, in that cold-supper sequence with Janet Leigh, Perkins showed us that Norman Bates is a sensitive, humane man in a world that has brutalized those virtues.[8]

Hitchcock more than achieved his goal to represent the 1950s-style American male youth in all of his slightly feminized, troubled, winning awkwardness and then to take this image and deconstruct it, to reveal it as a mask for monstrousness, one fully exposed in the final shots of the mother-possessed Norman's eerie grin, an effect enhanced by Bernard Herrmann's terrifyingly bleak score. Alexander Doty aptly described the finale of *Psycho* as a "queer apocalypse."[9] I discuss the implications of these effects in chapter 6 on the death mother in *Psycho*.

In Bloch's 1959 novel (which Hitchcock, with merciless shrewdness, anonymously bid on and bought the rights to for under $10,000), when Mary meets Norman on the dark, rainy night she checks into the Bates Motel, she notices his "fat, bespectacled face" and "soft, hesitant voice."[10] Earlier, when Norman tensely talks to Mother, she says to him, "You're a Mama's Boy. That's what they called you, and that's what you were. Were, are, and always will be. A big fat, overgrown Mamma's Boy!"[11] Clearly, the long, lanky, and youthful body of Perkins's Norman, and his winsome handsomeness, could not be more distinct from Bloch's original conception, though both Bloch (reworking the notorious Ed Gein case) and Hitchcock deploy the by-then normalized Freudian view of homosexual males as narcissistically fixated on their mothers.

Even more telling differences occur in the big scene between Marion/Mary and Norman. In Hitchcock, the two have a cold-sandwiches-and-milk supper in Norman's parlor behind the "officious," as he puts it, motel office; in Bloch, the two are actually in

Norman's kitchen within the dreaded Bates house. Hitchcock frames the Bates house as the Gothic genre's Terrible House par excellence, a place unimaginable as a scene of conviviality, only to be entered clandestinely, as Lila Crane, Marion's sister, does at the climax. Hitchcock also frames the dinner conversation between Marion and Norman as an extraordinary series of shared intimacies, parries, odd disclosures, defensive maneuvers, silences, eruptions into violence, and seeming restorations of stability. It is one of his most important sequences, superbly realized by the actors, Joseph Stefano's script, and Hitchcock's tight shot/reverse shot cinematic plan. The glaring, ominous stuffed birds preside over all, especially in a striking low-angle, side-view shot of the seated Norman, waving his arms in direct proximity to the stuffed owl, its wings extended, that bears down on him from above as if ready to strike at any moment.

Bloch writes in a style that evokes the naturalist fiction of Frank Norris, especially his 1898 *McTeague*, with its sense of inevitably grim fate for all the major characters and its rampant sexual essentialism. The tête-à-tête between Mary and Norman, however, lacks any sense of intimacy, especially on Mary's part. Rather, Mary reveals little of herself and brusquely informs Norman that his mother-centered hermit's life is headed for disaster: "Mr. Bates, you'll pardon me for saying this but how do you intend to go on this way? You're a grown man. You certainly must realize that you can't be expected to act like a little boy all the rest of your life. I don't mean to be rude, but—."[12] In the film, Marion's remarks along these lines seem more genuinely motivated by compassion for Norman derived from her sense of a commonality between them, one that is enhanced by Norman's own extraordinary acuity into both of their situations as evinced by his famous speech about "private traps" within which we are all caught. "We bite and claw, but only at the air, only at each other, and for all of it, we never budge an inch," Norman says in Stefano's script. (Norman articulates the desire to tear apart the subject that Melanie Klein theorized without the complementary need to repair and restore it.) Indeed, far from feeling compassion for Norman, Bloch's Mary gains in self-esteem when she compares herself to Norman. "*He* was the lonely, wretched, and fearful one, really. In contrast, she felt seven feet tall." This surge of comparative pride leads her to provoke her host even more directly: "You aren't allowed to smoke. You aren't allowed to drink. You aren't allowed to see any girls. Just what *do* you do, besides run the motel and attend to your mother?"[13]

Hitchcock/Stefano/Leigh's Marion is never this brusquely direct. Rather, she tentatively suggests to Norman that his sense of devotion to his mother has prevented him from seeing that it has robbed him of a life. Perhaps her insights into Norman's predicament are what allow her to realize that her own actions have been irrational, that her theft of the $40,000 from her boss's odious client, the Texas oil man Tom Cassidy, stemmed from her desire to change her vacillating lover Sam Loomis's (John Gavin) mind about marriage. (Sam claims he cannot marry Marion because of his dead father's crippling debts and the alimony payments he owes to his first wife "living on the other side of the world," as almost all of the film's women harrowingly do or will.) She excuses herself from dinner, having resolved to return to Phoenix and get out from her own private trap.

The horrific murder of Marion represents both the annihilation of a woman and a grotesque literalization of betrayal. This betrayal results from the broken bond between a lonely man and a lonely woman who momentarily shared bread and mutual despair. (That Norman does not eat the meal along with her and manipulates her into believing that his mother is actually a living burden rather than a figure of fantasy speaks volumes about the inherent distance between a queer and a female figure even in this scene of intimacy.) While Norman famously takes down the painting of the biblical story of Susannah and the Elders (a scene of attempted rape) in order to peep at Marion as she undresses in cabin one, it is not clear what Norman sees when he looks at her—if he is inflamed with erotic desire or feels revulsion or, indeed, if he feels anything at all. He may be possessed by what Edelman, following Lacan, in *No Future* calls *sinthomosexuality*, a drive toward meaninglessness and antisociality, embodied for him in characters like Robert Walker's Bruno Anthony and Martin Landau's Leonard. That no clear erotic, sexual, and/or romantic drive impels his responses to her reinforces the queerness of his character, as does the arsenal of feminizing devices, as noted by Thomson, that Perkins, probably in collaboration with Hitchcock and Stefano (who has spoken empathetically of Perkins's difficulties with the closet), brought to his interpretation of the role.

The sundering of bonds, or potential bonds, between queers and heterosexual women—a violent break that occurs in *Murder!*, *Secret Agent*, *Rebecca*, *Shadow of a Doubt*, *Notorious*, *Rope*, *The Paradine Case*, *Strangers on a Train*, and *North by Northwest*— throughout Hitchcock's oeuvre reaches its terrifying apotheosis in *Psycho*, as Norman Bates destroys the woman whose situation solicited his insights and who offered him insightful sympathy. *North by Northwest* offers us an opportunity for a further elaboration and exploration of the feminine versus the queer, one informed by the critical debates that I outlined in the introduction.

"LEONARD?": NORTH BY NORTHWEST

Made just after the devastating *Vertigo*, *North by Northwest*, while filled with dark themes, is ultimately a comedy that ends in heterosexual fulfilment, and as such it is an apt complement to the tragic aspects of the previous film. Roger O. Thornhill (Cary Grant) is a successful advertising executive in New York City who is mistaken by the spy Phillip Vandamm (James Mason) for "George Kaplan," a secret American agent who does not actually exist but has been fabricated by the CIA. Kidnapped by Vandamm's men, Thornhill is taken to the Long Island estate of politician Lester Townsend, whom Vandamm impersonates. Vandamm's chief aide Leonard (Martin Landau) is introduced at the estate, and Vandamm leaves it to Leonard and his other henchman to kill Thornhill, first by pouring vast quantities of booze down his throat and then putting him in a car so he will drive himself off the road to his death. Thornhill manages to escape and contacts his mother (Jessie Royce Landis) and his lawyer in an effort to expose Vandamm, but no one

believes the (apparently louche and ne'er-do-well) Thornhill's story. When Thornhill discovers that the real Lester Townsend is a United Nations diplomat, he attempts to contact him there, but Vandamm's men kill Townsend, throwing a knife in his back as Thornhill begins to speak with him. Now believed to have killed Townsend, Thornhill, the classic Hitchcockian "wrong man," flees the authorities as well as Vandamm. Remembering that Vandamm will be in Chicago the next day, Thornhill furtively boards a train headed there on which he meets an attractive, stylish, and confident blonde woman named Eve Kendall (Eva Marie Saint). She flirts with him and diverts the police searching the train. Eve, however, is Vandamm's mistress, and informs him and Leonard, in another compartment, that Thornhill is with her. Once they get to Chicago, Eve offers to contact George Kaplan to set up a meeting between him and Thornhill. Instead, she calls Leonard, from whom she gets information to pass onto Thornhill, misleading him into believing that he will meet George Kaplan, whom he does not yet know is a fictional entity, at an obscure place out in the country. Once Thornhill gets off a bus, he finds himself in a vast, largely barren location surrounded by countryside. A crop-dusting plane appears, mysteriously "dusting crops where they ain't no crops." It suddenly heads for Thornhill hiding in a cornfield, fires at him, and engulfs the field with pesticide. Somehow, Thornhill escapes, and in doing so, sends the plane careening into an oil truck that explodes on impact. Thornhill, dust-covered but alive, seeks out Eve in her hotel room. Relieved to see him but anxious and distracted, Eve eludes him while he showers (which he only pretends to do, given his suspicions of her). Eve escapes and heads to an art auction; Thornhill follows her there and finds her with Vandamm and Leonard; Vandamm purchases a pre-Columbian statue. Thornhill, after verbally attacking Eve, realizes that Vandamm and his men will dispatch him right there. In an ingenious maneuver, Thornhill makes a spectacle of himself, disrupting the auction by placing ridiculous bids. The police are called to the scene, and when they escort him away, thus saving his life, Thornhill finally meets the Professor (Leo G. Carroll), the head of the CIA group that created George Kaplan to conceal the identity of their real operative—Eve. Now knowing that he has endangered Eve, Thornhill wants to help her, and agrees to let her "murder" him in front of Vandamm and Leonard at the Mount Rushmore visitor center the next day. Eve shoots Thornhill with fake bullets. When Thornhill learns that Eve will not only continue working undercover but also accompany Vandamm and Leonard on a plane to Soviet territory, he escapes from the hospital where the Professor has incarcerated him and breaks into Vandamm's house overlooking the Mount Rushmore monument in order to rescue Eve. Eve grabs the pre-Columbian statue, which contains top-secret microfilm, just before boarding Vandamm's getaway plane and runs to Thornhill. They eventually find themselves on the top of Mount Rushmore, climbing down the presidential faces to elude the villain and his men. Leonard pushes Eve off a cliff, but she manages to hold onto a stony ledge. Thornhill holds onto her and tries to pull her up, while holding onto a crag with his other hand. Seeing Leonard, Thornhill asks him for help, but the henchman crushes Thornhill's hand with his foot. But then Leonard is shot by the park rangers enlisted by

the Professor to rescue Thornhill and Eve and capture Vandamm, and falls to his death. ("That wasn't very sporting of you, using real bullets," Vandamm says in the characteristically droll manner of the Hitchcock villain even when he's been caught.) Thornhill and Eve, now married, return to the compartment of a train, the scene of their first intimacy. As he did on Mount Rushmore, Thornhill hoists Eve up, this time to the top bunk of their train cabin. In the last shot of the film, the roaring train enters a tunnel.

In a chapter titled "Compassion's Compulsion" in his *No Future*, Edelman focuses on the ethical dilemma represented by Leonard crushing Thornhill's hand with his shoe-clad foot. Edelman counterintuitively values Leonard as the embodiment of the queer death drive, "rescuing" Thornhill from Eve Kendall's promise of (and entrapment into?) heterosexual marriage.[14] While I find Edelman's argument exciting and daring, I want to redirect our critical attention to the figure that Edelman spends the least time discussing, Eve Kendall.[15] While queer members of the audience may identify with Leonard or Vandamm, I believe that they are likelier to identify with Grant/Thornhill or Saint/Eve for the simple reason that they are attractive, appealing characters, played by attractive, appealing stars, who are put into perilous situations. Heterosexuality may be excruciatingly constrictive when deployed as a universalizing sexual program for all audience members, but its relationship to conventional film narrative, inherently heterosexist, is also standard, even cliché.[16] In other words, we desire, whatever our sexual orientation, to see the romantic couple find fulfilment—or we radically make a break with this institutionalized response to narrative. And queer viewers may very well develop a sufficient resistance to conventional narrative and its heterosexual design and impetus to experience it consistently from the position of resistance, as a *refused* act of engagement. Nevertheless, an immersion in the narrative of *North by Northwest* is most typically going to involve identification with the leads and the romantic couple regardless of the sexual orientation of the viewer. As Virginia Wright Wexman observes, "Hollywood's romantic ideology of the idealized heterosexual couple has governed its creation of actors as symbols of romantic desirability."[17]

Stanley Cavell, in his well-known theory of the screwball comedy as the comedy of remarriage (many of which films in this subgenre starred Cary Grant), has famously read *North by Northwest* along these lines. For Cavell, the point of these films involves the man's transformation through the "assault" of the woman's emotional and sexual power, but more importantly, the man must "educate" the woman.[18] Whether or not we should take Cavell as simply exposing the narrative design of such films for what they are, or imposing a misogynistic sensibility on screwball comedy, we would do well to remember that, as Pauline Kael (not a feminist by any stretch) argued in her review of Jonathan Demme's *Something Wild* (a film with Hitchcockian overtones), the women of screwball comedy "perform a rescue mission" on the male, waking him up out of his sexlessness and repression.[19] And as the great gay critic Andrew Britton wrote in his 1986 essay "Cary Grant: Comedy and Male Desire," Grant often starred in films in which "the woman appears . . . as the educator of the male and of his pleasure," and in the screwball comedy,

a subgenre synonymous with Grant's screen presence, "that process takes on . . . [a] radical character."[20]

I want to suggest that the queerness of *North by Northwest* lies in Hitchcock's denaturing of what heterosexual desire and romance mean, and his interest in depicting Thornhill as a man transformed into a complex human being through the development of his love for Eve. What sounds like a fairly typical sexual narrative is actually a queer experiment. To begin with, when Thornhill meets Eve on the train and has dinner with her in the dining car, the entire scene has a stylized, almost eerie languor that takes it outside of time (as if the world were now in slow motion) and social convention. In terms of the latter, Roger's predicament allows Eve a surprising amount of reciprocal agency, including the right to request if not demand sex. Moreover, these demands are silkily conveyed through verbal wit ("I don't particularly like the book I've started . . . know what I mean?"). We learn that Eve is actually a double agent, performing the role of Vandamm's mistress but really working with the U.S. government (embodied here in the form of the bespectacled and taciturn elderly Professor played by Hitchcock stalwart Leo G. Carroll, not in the least discomfited by Thornhill's or Eve's endangerment) to learn information about his treasonous sale of information to the other side.

Hitchcock's shaping of Eva Maria Saint's performance and stylized blonde appearance, and the gendered politics of this shaping, are well worth considering. Hitchcock commented in response to a question from Francois Truffaut about Saint, "Well, I did my best to make her attractive. I, you know, watched every look and every, I did almost the same job with her that I did with Hedren in *The Birds*. . . . They were all retakes in that dining car scene, because I couldn't get the right understatement and all the sex. . . . You know, little details like when she's given a light from a lighter, to lean with her cigarette, and look into the man's eyes, and not with the cigarette."[21] Hitchcock emphasized his investments in constructing the woman from the outside in, of getting Saint to *simulate* sex. While misogynistic aspects to this construction doubtlessly inhere, there is also another dimension to it, one that achieves its most powerful articulation in *Vertigo*— Hitchcock's creation of the couple and the woman as the embodiment of idealized desire is transparently artificial, palpably a creation, subverting and refusing any understanding of such figures as inherently or essentially natural, authentic, or original.

When Thornhill and Eve are back in her compartment, Hitchcock provides his most striking version of a love scene that looks like a murder scene (Truffaut observed that Hitchcock's love scenes look like murder scenes and his murder scenes look like love scenes), as Thornhill, with his immense hairy hands, grasps Eve's neck rather forcefully as they make out against a wall.[22] In a brilliant effect, Hitchcock films the couple in this amorous intimacy from a posterior view as well, rendering the wall behind them invisible, as if their passion had obliterated any barrier, but also to emphasize the covert access to their bodies, sensations, and emotions we are granted as invisible voyeuristic viewers. Indeed, the invisibility of the wall behind them from this posterior view not only allegorizes our seeming invisibility as spectators but also, crucially, places us in Eve's position,

making us, in effect, *Eve* kissing and being kissed—and grasped and overpowered—by Grant/Thornhill. Hitchcock feminizes the viewer and puts all viewers, male or female, straight or gay, in the position of being ravished by Cary Grant.

Richard Millington observes of this scene that "[t]here are too many elbows and hands . . . the shots are often quite unflattering, lampooning." As he suggests, from the "awkward physicality of their embrace emerges a countercurrent to the emptiness of the encounter. These two simulacra . . . suddenly discover themselves as bodies, and out of this moment of incarnation . . . emerges the possibility of a form of character not fully driven or determined by the collection of ideological narratives in which they have been embedded."[23] Millington provides a cogent corrective to Raymond Bellour's and Lesley Brill's readings. The progression toward romantic fulfilment for the couple effects their oedipal normalization, but Millington demonstrates how much of this process derives here from associations with the advertising and television world that Thornhill embodies. The film simultaneously works toward the "full unfolding of the masterplot of the television commercial," the achievement of that "moment in which one's extraordinary desirability, enhanced or produced by whatever scenario has been applied or ingested, is, at last, acknowledged," and the lead characters' acquisition of an enlarged understanding of themselves as subjects in relation to another, of their lived experience of subjectivity and relation.

My own reading of the film dovetails with Millington's, though the critic does not discuss the film's queer dimensions, which I find to be crucial. Hitchcock's understanding of this screen couple as its own simulacra stems from his view of institutionalized heterosexuality as a master plot with hollowness built into its very design. When Thornhill and Eve discover love, they transcend the hollowness but not the brutalizing machinery of the master plot, and their tentative and halting—if manifestly joyous in the final image—journey toward self- and mutual recognition is what makes the film so powerful, and, as I will show, so Miltonic.

North by Northwest offers a particularly acute elaboration of the feminine-versus-the-queer paradigm. In one of the most striking visual touches of the film, Hitchcock pans across a row of connected telephone booths in the Chicago train station once Thornhill and Eve have arrived there. Thornhill has ventured to Chicago intent on meeting the mysterious government agent George Kaplan whom he has been mistaken for by Vandamm. Ostensibly, Eve is on the phone because she is calling Kaplan—who does not actually exist, of course—at his hotel (see figure 1.1). The pan across the phone booths reveals that Leonard is talking in one of them (see figure 1.2) and Eve, on the phone several booths down, is talking to Leonard, who is giving her the directions for the highway in the cornfield where Thornhill will encounter the infamous crop-dusting plane, the agent of death by which Vandamm will attempt to eradicate Thornhill once and for all. There is an extraordinary shot of Eve and Leonard both exiting their respective phone booths after their exchange of information—neither looks at the other, both stand stock still for a moment, and each goes on their own way. Interestingly, a well-known publicity still of

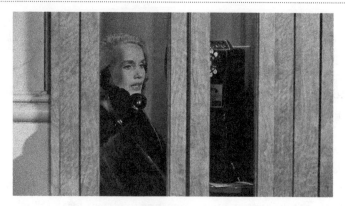

FIGURE 1.1 Eve Kendall (Eva Marie Saint) on the phone ostensibly calling the mysterious George Kaplan.

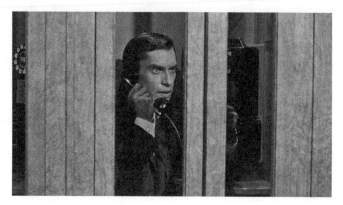

FIGURE 1.2 Leonard (Martin Landau) receives her call. Their anonymity and physical distance convey an aching disconnection.

the film features this very scene but shows Leonard/Landau, having emerged from the telephone booth, staring at Eve/Saint as she looks ahead, not noticing him looking at her. This is a wonderfully evocative still, suggesting Leonard's fixation on Eve, but it does not emerge from the film itself. Leonard and Eve pointedly exit the booths without looking in the other's direction, adding to the sense of mutual disconnection and alienation.

Hitchcock's favored technique of pure cinema (his use of the visual, not the screenplay to convey meaning) makes the shot of the distant phone booths an affecting metaphor. Eve and Leonard are each characters who work for nefarious men—Vandamm, the Professor, and on some level, Thornhill as well—yet cannot work *together*, must work against one another while maintaining, for a time, the ruse of collaboration. Their silent voices (we see them speaking but cannot hear what they say); their physical distance from one another in the bland, conformist, commercial, industrialized row of anonymous phone booths; their physical distance and inability to recognize the other when they stand outside the phone booths—the components of this brief but thoughtfully

visualized scene all work together to suggest something of these characters' subject positions within the social structures of the diegetic world. The woman and the homosexual male—as Leonard is quite thoroughly typed and as Landau has recently disclosed he played the character, with Hitchcock's knowledge and consent[24]—are alike adrift in a world of conformity, powerlessness, subservience to questionable father figures, and can never recognize or acknowledge one another. I call this visual motif in Hitchcock *the thwarted gaze*—it occurs again in *Strangers on a Train* and *The Birds*.

Interestingly, when Eve finds Thornhill and delivers the false information to him, he *is* able to recognize her—he detects that something is wrong, that she is troubled. Whatever occurred between them in the train compartment has given him access of some kind to an understanding of her. While Bellour's oedipal schemas for the maturation of the heterosexual male protagonist in Hitchcock exhaustively detail this protagonist's development of properly directed (i.e., heterosexual desire), what Bellour fails to recognize is the emotional intimacy—which is also a shared vulnerability—that Thornhill and Eve develop.[25] For she is indeed troubled because she knows she is giving him directions to his own death.

Such moments showcase the manner in which *North by Northwest* boldly builds on *Vertigo*, reflecting and extending its themes. In a justly famous effect much discussed by feminist critics, *Vertigo* breaks with its male protagonist's point of view to give us Judy Barton's (Kim Novak) flashback, which establishes an identification with her that competes against the identification with the male protagonist Scotty (James Stewart). In her flashback, we learn what really happened when Madeline seemed to fall from the tower: Gavin Elster had murdered his real wife and thrown her off the tower, and used Scotty as a patsy witness to Madeline's suicide, Judy having pretended to be the real Madeline, all part of Elster's diabolical ruse. *North by Northwest* goes even further in giving the woman much greater knowledge of and agency in the man's death plot. Eve's palpable discomfort, if not despair, in giving Thornhill the murderous information and Thornhill's recognition of her discomfort both convey a sense of empathy between these unlikely would-be lovers (who eventually become a married couple) that allows each to see past the obstructions of the social order, its insistence on strictly maintained gender roles, and even, perhaps, its insistence on heterosexual normalcy.

The man must be stoic, taciturn, unfeeling, and certainly never feminized by feeling; the woman must be artfully seductive, narcissistically obsessed with her own image in order to incite a reciprocal sexual hunger in the man for access to the source of her own narcissistic libidinal investment (to parse Freud on narcissism); sexual difference must be maintained as the absolute code and plan for relationships between men and women, and for same-gender relationships as well, organized around the logic of compulsory heterosexuality in a culture no less decisively than relations between those of the opposite sex. All of the binding social strictures organized around normative gender roles and sexual difference dissolve, if only momentarily, in the scene of partial yet palpable empathy between Eve and Thornhill.

Leonard exposes Eve as a double agent to Vandamm in his house near Mount Rushmore after Eve has gone upstairs to get ready for the journey overseas, behind the Iron Curtain, where Eve will continue to do her spying for the Professor. As Leonard begins to make his case against Eve to his superior, he effectively outs himself with the reference to his "woman's intuition," adding a touch of near explicitness to the homosexual characterization of Leonard that is only deepened by Vandamm's response. Comically chiding Leonard for being jealous, Vandamm, in James Mason's peerlessly suave tone, responds, "Now, Leonard, I'm touched, I really am." This exchange renders comedic the *real* trauma of sexual silence in the film, in this case the closeted homosexual's non-access to expressive desire. Leonard's paranoia about Eve's loyalty turns out to be an accurate reading, just as the heroine's paranoia will frequently turn out to be about the queer character's designs. Leonard's paranoid distrust of Eve has its basis in competitive jealousy, which, to follow Freud, has its basis in grief.[26] The feminine-versus-the-queer dynamic reworks Freud's tripartite schema of paranoia, homosexuality, and grief by making the heterosexual woman and the queer figure dark mirrors for one another.

Here the film offers an acute commentary on disordered emotional bonds. Leonard, probably in love with the rich, powerful, and witty Vandamm, but unable to express his love directly, engineers Eve's death as the only possible expression of this love. The homosexual male, himself entrapped in a culture of homophobia that borders on the murderous, can only mirror back the culture's worst aspects, specifically its misogynistic view of woman as whore, a view taken by Thornhill, Vandamm, and even the Professor, implicitly in his callousness. He also embodies his culture's investments in the closet, which makes it impossible for Leonard—or Eve—to speak. Indeed, Leonard lets Eve's gun speak *for* him. Without explaining what he is about to do, or why, Leonard points it at Vandamm, who says, in one of his few moments of unguarded human response, "*Leonard?*" Leonard shoots him. Vandamm flinches and then punches Leonard, even though it has become clear that only blank bullets have been fired.

What is especially interesting is that Vandamm seems almost childlike with wonder here—"*Leonard?*" For a moment, Leonard is utterly unknown to him, truly a foreign agent. What could be a moment of, for lack of a better term, bonding between these admittedly nefarious men becomes instead a depiction of male-on-male violence even though they are both on each other's side, even though Leonard is acting in loyal subservience to Vandamm, and Vandamm knows this, or comes to know it when he realizes that he has been fired at but not shot.[27]

I want to suggest, to echo earlier points in this chapter, that Leonard is much more interesting and poignant in relation to Eve Kendall than he is to Roger Thornhill. Indeed, Thornhill's body literally obstructs the relation between homosexual male and heterosexual woman at the climax, which renders Thornhill both a link in a human chain and a barrier between Eve and Leonard: These agonized physical positions literalize the symbolic impasse at the heart of personal relations in the film. At one point, Eve Kendall asks Roger O. Thornhill, "What does the O stand for?" and Roger responds, "Nothing."

That Thornhill will be mistaken by Vandamm and his men for George Kaplan, a fake government agent concocted by the Professor and his team, reinforces the idea that, as Tom Cohen riffs, Thornhill exemplifies Hitchcock's "O-men," who "are emptied as ciphers and couriers of something to come, something of which they know nothing, and do not, in any case, arrive intact. . . . If anything, the supposed nothing or nobody named 'George Kaplan' . . . signifies too much . . . anticipating, in his nonexistence, not only the giant faces of Mount Rushmore, whose personification appears to fall away before a deanthropomorphized rockscape—heads (*capo*) of the earth (geo[rge])."[28] It is precisely Thornhill's O-man quality, his lack of persona, his open-endedness, his near nonbeing that make him so malleable as a metonym for Eve's own subject position. His precarious state at the climax models and mirrors her own. Moreover, it models and mirrors that of the female subject position in the social order generally, hanging for dear life beneath the pitiless blankness of patriarchal power, symbolized by the Symbolic icons of the Mount Rushmore presidential stone faces. (In the Lacanian scenario, the Symbolic is the order of the Name and the Law of the Father, his realm of language and law. The Mount Rushmore setting in its craggy, monumental officiousness appositely reflects this order.)

In killing off Thornhill, Leonard is actually showing him compassion of a sort, argues Edelman: The sinthomosexual Leonard "refuses the tragedy of desire that Thornhill's cry portends." And he "might interpret Thornhill's tragedy as his newfound sincerity in the face of this threat to Eve and thus as [Thornhill's] ceasing to stand for nothing, his turning away from the empty 'O' that turns the globe to rot, in order to stand for the law of desire to which we properly owe our standing as subjects of the Symbolic. Leonard thus stands opposed to the desire for which Thornhill solicits support by standing on the hand that Leonard refuses to lift in order to help him"; in refusing Thornhill's cry of "Help me," Leonard paradoxically helps the hero to "slip free of fantasy and the clutches of desire, free of the hold by which love holds off his access to jouissance while offering, instead, the promise of totalization and self-completion, the Imaginary One of the Couple and its putative sexual rapport, in a future that's unattainable because always still to come."[29]

To think through Hitchcock's conceptualization of this scene in Edelman's terms, this homo-intimate union in death, or attempted murder, isolates Leonard and Thornhill as the only actors of relevance in a frieze of nearly immobile figures that frames, from an extreme low angle, Leonard as the only active agent onscreen. Leonard stands above Thornhill and Eve, a tumescent figure to whom we look up from Thornhill's perspective. He rises triumphantly if cravenly above the helpless and defeated heterosexual *couple*. Edelman essentially expulses Eve from this queer garden. Hitchcock, however, gives us a panic-inducing shot of Eve in peril hanging from a crag herself (see figure 1.3).

This discrete shot emphasizes Eve's independent presence and endangerment within the suspense tableau. She cannot simply be assimilated into the Imaginary One of the hetero-couple for several reasons, one of which is that she is given a certain amount of autonomous screen space/development independent of Thornhill. Her role exceeds his

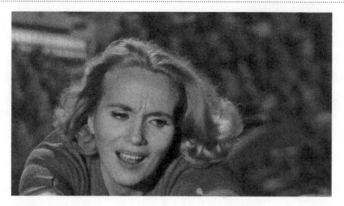

FIGURE 1.3 Eve's autonomy and peril are emphasized in this discrete shot of her hanging from a Mount Rushmore cliff.

gaze, his problems, and his relationship to both Vandamm and Leonard. Hitchcock's rivalrous, ambivalent, but urgent identification with the woman must be incorporated into his depiction, such as it may be called, of homoerotic relations between men, shot through here (as it always is in Hitchcock) with rancor and not only the threat but the real presence of violence.

FEMINIST AND QUEER CHRISTIAN ALLEGORIES

The Catholic Hitchcock's stunning reorganization and revision of Judeo-Christian myth demands an analysis it has not so far received.[30] In Genesis, when God, whose voice echoes in the Garden of Eden and frightens the newly guilty Adam and Eve, confronts the human couple about their sexual shame as a result of having eaten of the fruit of the Tree of Knowledge, Adam immediately lays the blame on both God and Eve, the woman God made on his behalf, accusing her of giving him the fruit and tempting him to eat it. Eve, for her part, in answer to God's question, responds, "The serpent beguiled me, and I did eat."

> And the LORD God said unto the serpent, Because thou hast done this, thou art cursed above all cattle, and above every beast of the field; upon thy belly shalt thou go, and dust shalt thou eat all the days of thy life:
> And I will put enmity between thee and the woman, and between thy seed and her seed; it shall bruise thy head, and thou shalt bruise his heel.
> (Genesis 3: 14-15, *King James Bible*)

Hitchcock's ruined Eden of the present is a postlapsarian garden of rubble. Stanley Cavell aptly notes that this tableau foregrounds the nonliving: Thornhill and Eve might be on "an alien planet. There is no longer nature on the earth; earth is no longer an artifact by

FIGURE 1.4 The satanic Leonard looms above the hapless heterosexual couple.

analogy, imitating God: it is literally and totally artifact, petrified under the hands of mankind." Indeed, the Mount Rushmore setting is a "place of absolute spiritual isolation" that threatens those desperately clinging to its surface with falling off the earth itself, "down the vast drear edges of the world."[31] The snake, satanic Leonard, looms triumphant, bruising the hand of a hapless contemporary Adam and by extension a woefully powerless, nearly untethered Eve (see figure 1.4).

Eve never undergoes a transformation into the Virgin Mary who tramples, in redemptive triumph, the serpent beneath her heel, although her marriage to Thornhill is certainly a different kind of redemption, a rebirth into normative heterosexuality. Given the ineluctably normalizing closure that Hitchcock gives to the nightmarish Mount Rushmore scene in the comic, romantic "Come along, Mrs. Thornhill" coda that restores Eve, and Thornhill, to safety, it is nevertheless an effect that Hitchcock renders as perverse and unsettling a transition as possible (I will elaborate on this point).[32]

Discussing the historical Catholic representations of Jesus' mother Mary as the new Eve who defeats Satan, Sarah Jane Boss observes, "Thus, in the usual Catholic reading it was the woman, rather than her seed, who would be at war with the serpent. . . . In both art and theology, the motif of the woman trampling the serpent underfoot was applied to Mary's immaculate conception, since her freedom from sin was a sign of the devil's total defeat."[33] We have, then, in Christian iconography and mythology a surprising historical-religious-art-history intersection with Hitchcock's gendered schemas. The woman's enmity with the seductive and duplicitous serpent, and their mutual antagonism resolved in the good, redeemed woman's ultimate eradication of the conniving creature prefigure the feminine-versus-the-queer pattern in Hitchcock. Indeed, it is the elision of the central male figure—Adam and Jesus, respectively—that is particularly salient here. The real battle is not between the woman and the man against the serpent, or between the woman and the man, or, especially, between the man and the serpent, but instead between the woman and the serpent, bypassing masculinity's otherwise

central role in normative gendered, sexual, and moral schemas. In *Paradise Lost*, Milton emphasizes in Book 9 Eve's encounter with Satan in the form of the serpent (here a mythic, dazzling creature that rises to human height). Adam and the serpent make no contact. In Book 10, however, Adam curses Eve as a "Serpent":

> Out of my sight, thou serpent, that name best
> Befits thee with him leagued, thyself as false
> And hateful; nothing wants, but that thy shape,
> Like his, and colour serpentine may shew
> Thy inward fraud. . . . (10.867–870)[34]

Adam, disgusted with his own wanton fall into sinfulness, projects his self-hatred and guilt onto Eve. Following a pattern of representation in Western visual art, Adam associates Eve herself with the serpent/Satan, emphasizing that her very visual presence stains his consciousness ("Out of my sight, thou Serpent"). In Hitchcock's film, however, Satan never makes direct contact with the woman. Barriers, impediments, substitutions, telephone booths, the geographical distance between ground and upper floors, the body of Thornhill: All block Eve and Leonard from direct contact. While Thornhill, the embodiment of heterosexual screen masculinity, is ostensibly the protagonist and therefore the audience's central identification figure, it may be just as accurate to see him not as monolith but as suture, connecting the gaping identity holes in the narrative, providing connective tissue rather than being the central body.[35]

THE FEMININE VERSUS THE QUEER

To follow Raymond Bellour's readings, our identification with Thornhill should mean that we, as viewers, generally see and experience what he does, want what he wants, and develop, along with him, into a properly oedipalized subject. But what if we were to see this as a no-man's film, one that decenters the heterosexual male hero and leaves narrative up for identificatory grabs? Perhaps it might be more accurate to say that Thornhill is a prop, the economy the other characters trade in to pursue and realize their own desires, something of a gender and sexual MacGuffin. His plight provides and establishes a normative premise within which queer negotiations can occur, a cover story for covert queer struggles. While critics like Mulvey and Bellour frame Hitchcock narratives as oedipalizing plots designed to produce a normative heterosexual male subject by the end, it is remarkable how frequently his films place this subject in a lesser, indeed an inferior, position by the end. As I discuss in chapter 3, Hitchcock films radically decenter the heterosexual male subject and thereby enable the conflicts between relatively ancillary characters to rise to prominence.

Leonard attempts to annihilate Thornhill, yet the true object of Leonard's ire may very well be Eve, which would make Thornhill her stand-in, extension, and substitute. In attempting to crush the life out of Thornhill, Leonard also attempts to obliterate Eve; perhaps that may even be the overriding goal. To return to this earlier scene, in shooting Vandamm with blank bullets from the same gun that Eve used to convince her lover and his henchman that she shot Thornhill, Leonard makes an implicit statement about both his own desire and its linkages to Eve's: He "shoots" Vandamm in order to save him from Eve just as she shot Thornhill to save them both from Vandamm and Leonard. Leonard puts himself in Eve's place and reenacts her Gestapo trick of shooting one of your own in order to convince Vandamm that he, Leonard, is loyal and Eve is not. In proceeding from the basis that Eve is the enemy who must be stopped, Leonard all but explicates his fundamental opposition to her, but he also takes a bizarre and telling risk, one appositely exposed and confirmed by Vandamm's angry punching of Leonard in the face. In reenacting Eve's gesture, Leonard phallicizes himself, at least for a moment, wielding and firing the gun at his superior who is also, perhaps, his desired object. He phallicizes himself, that is, by appropriating Eve's own prior display of phallic violence, which is inextricable from what it also simulated, a scene of "hysterical" female overreaction. (Such tensions are treated as authentic in the 1956 version of *The Man Who Knew Too Much* when the husband tranquilizes his wife in order to preempt her hysterical reaction at the news that their son has been kidnapped. It is clear that he is attempting to prevent her potential reaction from harming *him*.) No sooner has Leonard done so than he has been placed in a passive position—the receiving end of Vandamm's angry punch, much like the one Bruno Anthony receives from Guy Haines in *Strangers on a Train* after not only causing a scene at Senator Morton's party but also confessing, "But Guy, I like you." Homoerotic antagonism, as I call it, charges male relations in Hitchcock films with levels of menace marked by loss.

Inadvertently, then, Leonard has placed himself within the same scene of endangerment that he so cunningly places Eve. Her endangerment, however, greatly exceeds his: While Leonard suffers Vandamm's momentary violence, Eve will actually be killed by him. The homosexual male who attempts to usurp, by imitating, the woman's own role and her gender-variant performance of her femininity simultaneously co-opts her own fleeting access to phallic power (symbolized by the gun and ironized by its blanks) and is punished for her feminine wiles and weakness before once again being reabsorbed into the master's orbit and power. "What was that noise?" Eve asks after she hears the fake but credible-sounding gunshot. "We wondered the same thing," Vandamm without missing a beat calmly answers, in a response that shows that he and Leonard are the Imaginary One of the proto-homosexual couple that pointedly excludes, through duplicity and cunning, both Eve and Thornhill. If Leonard had attempted to extinguish Thornhill's threat by drowning him in copious amounts of alcohol—Leonard and Vandamm's other henchmen force liquor down Thornhill's throat, a homosocial tableau run amok, akin

to a homosexual gang rape—it is much less clear that Thornhill is the chief object of Leonard's interest when he grinds his foot onto Thornhill's hand. Rather, Thornhill serves as the triangulated figure in the scene of murderous oppositional desire between Eve and Leonard, rivals, in effect, now for the body of Thornhill, to which both of these anguished and aggressive foes are, respectively, pitifully and potently attached.

"To embrace the impossibility, the inhumanity of the sinthomosexual: that, I suggest, is the ethical task for which queers are singled out," Edelman writes in the conclusion to his reading of *North by Northwest*. "Leonard affords us no lesson in how to follow in his footsteps, but calls us, beyond desire, to a sinthomosexuality of our own—one we assume, at the price of the very identity named by 'our own.'" Leonard represents "a formalization of a resistance to the constant conservation of forms, the substantialization of a negativity that dismantles every substance."[36] Although this is a plausible reading of snakelike Leonard, played with such coiled, debonair aplomb by the young Martin Landau, it does not satisfy as a summarization of the film's queer positions. Edelman ignores one of the chief aspects of Hitchcock's suspense allegories, which is the endangerment and fate of the woman. While this topic is all too readily and easily assimilated into the larger issue of the heterosexual couple and their fate, which is almost always framed as our fate as spectators, it is also distinct from it. Thornhill and his life and future with Eve hang in the balance. But very decisively, *she* hangs in the balance, and hangs alone, as the discrete, vertiginous shot of her desperate predicament evinces.

A frustrating tendency in queer readings of films is to see a one-to-one relation between the queer spectator and the "queer" figure in representation.[37] Edelman's discussion falls into this identificatory trap. Leonard is so thoroughly, exclusively presented here as *the* site of queer identification—and therefore all of his qualities, or perhaps lack thereof, as essential queer qualities, which in this case must be of a thoroughgoing brazen nullity—that all other questions of identification and ethics are relegated to the sidelines and remain pointedly silenced. That Eve may be a representation or an allegorical version of or a stand-in for the queer viewer—gendered male or female, for that matter—must be incorporated into Edelman's analysis in order for it to have a truly resonant value.

As Leonard's foot crushes his hand, Thornhill winces in pain. The perversity that runs rife throughout this entire sequence—which replaces compassion and empathy with cold, calculating sadism (we can practically see the idea to crush Thornhill's hand forming in Leonard's elegant cranium)—has, perhaps, its locus in the multiplicity of interpretations to which the constructions of these images lend themselves. To begin with, Thornhill's look of silently endured but intensifying pain might also be a suggestion of premonitory orgasmic sensations and imminent release. Foot-to-hand violence, a nontraditional or parodistic version of a handshake, might also be read as a figure for homosexual sex (sodomy and/or mutual masturbation), a symbolic association carried over from *Strangers on a Train*, when Bruno stomps on Guy's hand with his foot as Guy desperately holds onto a phallic pole in the madly whirling, out-of-control merry-go-round at the climax.

As noted, Martin Landau confirmed longstanding suspicions that he played Leonard as gay and that Hitchcock approved the choice and thereby collaborated in this homosexual portrayal. Yet sexual ambiguity extends to the other characters as well, to Eve, Thornhill, Vandamm, the Professor, and even Thornhill's droll, curiously unemotional mother, played by Jessie Royce Landis. A perverse humor suffuses the elevator scene in which Thornhill and his mother ride along with the menacing henchmen, and she asks, "You boys aren't really trying to kill my son, are you?" After an uncomfortable silence, the henchmen and the fellow riders begin giggling, and Thornhill's mother joins in the merriment, everyone laughing except the stony-faced hero who escapes, leaving his mother behind. Thornhill's mother relinquishes maternal ministrations for caustic crowd-pleasing. If we consider Eve as a queer figure, she can be seen as a woman outside of and in control of the female masquerade, to argue along the lines of Joan Riviere that femininity is a masquerade, a performance that the woman finds uncomfortable, even injurious.[38]

I want to propose a theory that Eve is not just a queer figure but a stand-in for the homosexual male. Laura Mulvey has argued for the woman's masochistic and "transvestic," as she puts it, relationship to the cinema—masochistic in that the female spectator's response to the gender politics of conventional narrative film is rooted in suffering; transvestic in that, as part of this masochistic spectatorial position, she identifies, along with the male spectator, with the male protagonist who dominates the narrative.[39] Although I am not fully in agreement with Mulvey here, or her theory of the dominance of the male gaze over the classic film text, I believe that her work illuminates queer spectatorship, even though Mulvey herself makes almost no mention of queer issues.

Rhona J. Berenstein speaks to the heart of cross-gender and other forms of identification across set lines.

> The concept of viewing based on social categories raises an important question: to what degree do the sexual and social identities of spectators determine the identifications and desires deployed in viewing? Although recent gay and lesbian work has focused on homosexual subjectivity, the thorny question of the equivalence of a spectator's everyday identity with viewing positions has yet to be addressed fully. . . . is it possible for a heterosexual male to both identify with and desire a hero? While it is important to theorize a cinematic and social space in which gays and lesbians access and are accorded the rights to express same-sex desire, doing so does not exhaust all possibilities for the viewer, gay or otherwise.[40]

While the feminine-versus-the-queer dynamic is fascinating to track across the expanse of the Hitchcock world, it would be disastrous to maintain the conflict in our spectatorial and critical practices. Moreover, recognizing that we identify not only with our like but also our opposites, and even at times against ourselves, is a key dimension of this developed alertness and attentiveness to the complexities of spectatorial desire.

QUEERING THE PRIMAL SCENE

Reinforcing the sexual metaphorization of this scene of fairly graphic violence, Hitchcock manipulates the sound and visual design of the sequence to suggest that Thornhill's rescue of Eve should be, or at least could be, read as an allegory for sexual intercourse, suggestions concretized by the sleeping car coda. The coda reveals that Thornhill and Eve are indeed now married and concludes with the hilarious Hitchcock joke of the train triumphantly entering the tunnel as the final credits roll. ("It's a phallic symbol, but don't tell anyone," he once said.[41]) As scholars have increasingly shown, Hitchcock's sound designs in his films of the 1950s and '60s were crucial sites for his experiments with film form and its ideological meanings, which have implications for gendered and sexual representation and queer readings all at once.[42]

Leonard is shot by the authorities, a homosocial group of police officers seen at a distance and presided over by both the Professor and Vandamm. As Leonard plummets to his death from the mountainous ledge, Thornhill begins to pull Eve, precariously poised between life and death on the rocks below, up to the ledge and safety. Hitchcock's use of close-ups is always pointed and deliberate: He isolates Eve's face in the frame as Thornhill drags her up, saying, "Come along, you can do it," as she continues to gasp, "I can't make it." Hitchcock creates an extraordinary expressionistic effect. The dialogue between the lovers suddenly jumps ahead, an aural acceleration that outpaces the visual: The dialogue from the future, exceedingly brief scene of Thornhill and Eve reunited on the romantic train, and Thornhill now hoisting Eve up to the upper berth of their sleeping car as he says, "Come along, Mrs. Thornhill," infiltrates the scene of the lovers on the mountainous ledge as Thornhill drags Eve up to safety, a resolution that Bernard Herrmann scores as magical release.

Though this scene occurs in the present, Eve's rescue by Thornhill is rendered a prior event *even as it is occurring* through the startling manipulation of sound design. The effect created here is an uncanny one, defamiliarizing the expected union between dialogue and narrative action.[43] Creating this out-of-sync effect as Thornhill's rescue of Eve morphs into the scene of their marital bliss, Hitchcock blurs the lines between an agony bordering on death and the pleasurable anticipation of imminent sex. The latter is implicit in the comedic happy ending that, in conventional narrative, is synonymous with marriage, a pattern maintained in *North by Northwest*. Just as Thornhill's stoic endurance of pain can be read as sexual in nature, so does Eve's face in agony suggest, at the same time, a sexual anticipation and release. Somehow the woman's rescue from death is also her orgasmic release, as Thornhill learns how to give Eve pleasure at last, and from Leonard's sadistic tutelage at that.

That Hitchcock renders this transition from violent climax to heterosexual and marital denouement in so *oneiric* a fashion suggests the presence of Freud, and in particular Freud's case history *From the History of an Infantile Neurosis* (1918 [1914]), more commonly known as *The Wolf-Man*, in which Freud theorizes the interconnected

relationships among the child's psychosexual development, the scene of parental intercourse (the now-mythic primal scene), and memory. As viewers of conventional narrative films, we are always placed in the position of the child witnessing parental sexual intercourse; the heterosexual couple in film symbolizes and allegorizes the parental pair and the primal scene, hence the mythic underpinnings of screen representations of heterosexuality.

The subject of Freud's case history was Sergei Pankejeff, a Russian-born aristocrat from a St. Petersburg family, suffering from various physical and emotional crises. Interpreting the adult Pankejeff's drawing of a dream that he had when he was "three, four, or at most five years old" in which he saw out of his bedroom window one night the terrifying image of "six or seven" white wolves sitting in a barren, denuded tree, Freud posits that "some . . . unknown scene" from much earlier in the child's life must lie behind the content of the wolf dream.[44] As Freud, after more rumination, put it, "I have now reached the point at which I must abandon the support I have hitherto had from the course of the analysis. I am afraid it will be the point at which the reader's belief will abandon me."

> What sprang into activity that night out of the chaos of the dreamer's unconscious memory-traces was the picture of copulation between his parents, copulation in circumstances which were not entirely usual and were especially favorable for observation.[45]

Freud posits that the child Pankejeff witnessed his parents having sexual intercourse, specifically coitus *a tergo*, Latin for "intercourse from the rear." Seeing and hearing this scene provided the latent content for his wolf dream. Freud used the term *Nachträglichkeit* ("deferred action") to describe the young Wolf-Man's experience. The scene of sex between his parents witnessed by the one-and-a-half-year-old Pankejeff comes to active life only when he is on the verge of his fourth year. Based on his patient's account, Freud argued that the experience of trauma's full effects could be deferred, becoming manifest in greater intensity later.

In *Homographesis*, Lee Edelman observes that Freud's placement of coitus *a tergo* in his analytic reconstruction of the Wolf-Man's primal scene "allegorizes both the retrospective understanding whereby the primal scene will generate its various effects, and the practice of psychoanalysis itself. . . . Psychoanalysis, in other words, not only theorizes *about*, but also bases its practice on, the (re)construction or reinterpretation of earlier experiences . . . as a result of what Laplanche and Pontalis describe as the 'unevenness of its temporal development,' human sexuality constitutes the major arena in which the psychic effects of deferred action, or *Nachträglichkeit*, come into play."[46]

If human sexuality constitutes such a major arena, and I concur that it does, Hitchcock's films proceed from such a basis; they constitute an arena of sorts, a spectator-filled zone in which primitive and violent rites are performed or, perhaps more aptly put, simulated,

in the name of sexual knowledge and acculturation. Hitchcock frequently depicts sexuality as an act of violence, and vice versa. The sexualized imagery of the sadistically abused Thornhill and Eve's suffering connotes the primal scene, often experienced by the child as an act of violence ("Daddy is hurting Mommy and making her cry," and so forth). What I want to suggest is that the manipulations of the sound design, which have the principle effect of blurring "before" into "after," as well as the reverse, render heterosexuality a memory of itself, or a memory with no event to generate it. The scene of violence is inextricable from the scene of bliss for the heterosexual couple.

Securely undergoing the process of being normalized into properly marital sexuality along with the couple, the spectator is rendered anything but secure as he or she is forced to inhabit the memory of the violence behind and *within* this process of normalization. We are happily made to come along with Mrs. Thornhill—in queer fashion, *made* Mrs. Thornhill—but this coming along runs along the same track as sadism, suffering, and the threat of obliteration. And even though it is indeed a "joke," the image of the train pounding into the tunnel is an image of terror, as the infernal machine penetrates the unknowable darkness. This abrupt shift of signifiers transmutes the human couple—Eve and her sunny blondeness, Thornhill and his debonair handsomeness, their mutual playfulness—and heterosexual intercourse into a mechanistic metaphor.

THINK THIN: HITCHCOCK AND CARY GRANT

Cary Grant's star persona has a crucial importance to Hitchcock's body of work and its queer aspects. He made four films for the director, three of which are among his most significant—*Suspicion* (1941), *Notorious*, and *North by Northwest*—and another of which, *To Catch a Thief* (1955), merits careful critical attention. Pauline Kael succinctly described Grant's appeal in her famous essay "The Man From Dream City": "Willing but not forward, Cary Grant must be the most publicly seduced male the world has known, yet he has never become a public joke—not even when Tony Curtis parodied him in *Some Like It Hot*, encouraging Marilyn Monroe to rape."[47] Kael theorized that a large part of Grant's inexhaustible screen appeal lay in his being a sexual object, the pursued, not the pursuer. A droll lassitude characterizes the Grant screen persona—as Kael argued, Grant's persona was not desexualized, but rather a fantasy of an urban, civilized male sexuality that substituted wit for aggression. Grant was the dandy par excellence.

North by Northwest deftly demonstrates that Grant's sexual appeal lies in his being the desired, not the desirer. Thornhill, intent on rescuing Eve, escapes an anonymous government hospital presided over by the Professor. When Thornhill sneaks into a woman's hospital room, she initially says, "Stop!" Then, putting on her glasses, she repeats, but now in erotically languorous tones, "*Stop* . . ." to which ready-and-waiting signal Grant

responds, in comically scolding fashion, "Ahhh . . .," waving his finger at her to reinforce the remonstrative gesture. This moment is a nod to the scene in *Suspicion* in which the bespectacled, repressed Lina (Joan Fontaine) first lays eyes on sexy, suspect playboy Johnnie (Grant) in her railcar—true strangers on a train. In *Notorious*, we are made to pine along with Ingrid Bergman for an undemonstrative, nearly sexually inviolate Grant. Vis-à-vis Grant, we are consistently put into these desiring women's conventionally feminine subject position and, as I argue, the queer one as well.

We must ask, how did Hitchcock feel about Grant? "Grant prized his relationship with the director. . . . Shortly before Hitchcock died, he told [George] Barrie, 'Knowing Cary is the greatest association I've had with any film actor. Cary's the only actor I ever loved in my whole life.' "[48] This ardent affiliation charges the screen with queer significance. In contrast, we can consider the other truly crucial, recurring male presence in Hitchcock's films, particularly his American ones. As important as James Stewart was to Hitchcock's body of work, never once are we made to feel this desperate desire for erotic connection to him; indeed, we feel the reverse most deeply, *his* erotic and emotional desperation in *Vertigo; his* rage at the desire for connection from others in *Rear Window* and in *Rope*. Grant was who Hitchcock wanted to be; Stewart was who he was.

Hitchcock's uses of Grant undermine Bellour's and Mulvey's normalizing oedipal structures because of the disruptive, destabilizing levels of female and/or queer desire his screen persona generates, blurring the lines of normative identification with the onscreen protagonist.[49] Given how closely psychoanalytic film theory, in its major phase from the mid-1970s to the mid-1980s, followed classical psychoanalysis, it is helpful to rehearse Freud's theory of the Oedipus Complex. The (male) child in his pre-oedipal phase experiences homoerotic desires for the father. These homoerotic feelings for the father cannot be tolerated; adding to the child's difficulties, he begins to develop sexual feelings for his mother and consequently sees his father as a hated rival. The process of *identification* allows the child to resolve these complex and agonizing conflicts.[50] While psychoanalytic film theory, exemplified by Laura Mulvey's early work, has posited that the spectator, always gendered male (whatever gender the spectator might happen to be), joins in with the onscreen male protagonist in a kind of narcissistic covenant that grants each a shared omnipotent control over the diegetic film text, Hitchcock's cinema disrupts these normalizing patterns while seeming definitively to embody them. His uses of Grant are a key component of this disruption. Rather than identifying with Grant, in the sense that identification forecloses desire, we desire him and identify with him at once (i.e., those of us who have such a response to Grant do so; clearly, those who disaffiliate with the Grant persona, or with the onscreen protagonist generally, will have a different reaction).

There have been many challenges from a queer perspective to the Mulvey (and at times Bellour) stronghold on spectatorship theory; for example, Chris Straayer's *Deviant Eyes, Deviant Bodies* makes a crucial point that lesbian desire in the cinema defies the subject/object hierarchies of Mulveyan gaze theory, arguing for the reciprocity and mutuality in the lesbian exchange of looks.[51] Along similar lines, Lucretia Knapp's essay on lesbian

desire in *Marnie* overturns Bellour's reading of the film, making the case that a female/ lesbian circuit of desiring looking exceeds the strictly heterosexual and male-centered forms of looking in the film. Works by critics such as Richard Dyer, Alexander Doty, Thomas Waugh, Michael DeAngelis, and Brett Farmer have, in distinct ways, made similar cases for queer viewing, and queer male viewing specifically.[52] All of these critics have productively problematized the politics of the screen gaze and opened up the possibilities of queer spectatorial agency.

Thinking through Hitchcock's uses of Grant and also his disposition toward him yields interesting insights into *the factors that make queerness possible* in the Hitchcock text. I attempted to demonstrate that Hitchcock's queer sensibility can be seen in his creation (along with Joseph Stefano and Anthony Perkins) of the character of Norman Bates. Hitchcock's cinematic construction of Grant's persona merits further reflection. As Graham McCann puts it in his biography of the star, "It was not that Hitchcock had been the first to glimpse the hidden depths in Grant's screen persona.... What was intriguing about Hitchcock's use of Grant was the extent of this emphasis upon his intimate strangeness."[53] Hitchcock estranges Grant from Grant, emphasizing the potential aggression and even violence, and also the lack of certainty, beneath the dandified aplomb. And as I suggested earlier, part of this denaturing of the Grant persona was the discovery of a complex and empathetic vulnerability within it.

Donald Spoto reports in *The Dark Side of Genius* that Hitchcock frequently tormented his homosexual and/or queer stars with sadistic practical jokes.[54] On some level, what Hitchcock did in his collaboration with *North by Northwest* screenwriter Ernest Lehman was to inflict such brutal jokes on Grant while he was in character as Thornhill. McCann notes:

> As he had done before, Hitchcock conceived some additional in-jokes, such as obliging his scrupulously fit ("Say, do I look *heavyish* to you?") and glamorous ("he's a well-tailored one, isn't he?") leading man to ruin several of his own bespoke suits by diving in the dirt before suffering the even greater indignity of being obliged to wear the cheap and ill-fitting suit of an imaginary man who, he complains, "has dandruff." The playfulness, further complicating a story that already was more gnomic than even Hitchcock was used to, underlined the confidence the director had in the actor.[55]

Confidence perhaps, but one mixed with desire, envy, and even aggression. "Think thin," Grant tells his secretary to jot down on the list of memos she compiles for him. Hitchcock, always publicly struggling with his weight and frequently derided as a result, went through periods of drastic weight gain and loss. It is likely that the director contemplated what it would be like to be "thin" in the Grant sense, unencumbered by bodily and emotional weightiness. Anticipating Leonard's cruelty to helpless Thornhill, Hitchcock puts Grant through sadistic paces, making Grant a soiled and somatic screen being.

Discussing Grant's performances for Hitchcock, Andrew Britton notes that the roles feature

> an urbane amoralism and irresponsibility, issuing in the exploitation of women; but "irresponsibility"—which turns out to be a key word in discussing Grant—can be defined in more than one way. . . . Alicia and Lina [the heroines of *Notorious* and *Suspicion*, respectively] are subtly complicit in their exploitation. Significantly, both women see the Grant character as a means of detaching themselves from, and rebelling against, the father they hate, only to discover that they have become subject to another form of patriarchal oppression, to which they then succumb out of a masochistic fascination (Lina) or self-contempt which the man relentlessly exacerbates (Alicia).[56]

The same can be said of Eve Kendall, so expertly played by Saint as a woman of enigmatic needs and desires. In finally cleaving to Thornhill, she can escape Vandamm and also the heartlessly efficient Professor. If Thornhill is a queer figure, his relationship to Eve threatens to replicate the feminine-versus-the-queer dynamic. Normalizing heterosexual relations rescues both Eve and Thornhill from queer nothingness, metaphorized by the barren, nonliving expanse of Mount Rushmore, which receives Leonard's plummeting body as tribute. But then again, as John Orr points out, the couple may have "known" each more intimately before their desires were fixed by the revelation of Eve's true identity—in this manner, their climactic (re)union signifies their further fall into "non-identity," as Orr puts it. To find out who Eve "really" is, Orr argues, "is to limit the openness of possibility."[57] It is precisely the sense of open possibilities that makes the initial dining-car scene between Thornhill and Eve so erotic, and also so queer—a model of cruising.

Grant, who embodies "male femininity" as Britton put it, blurs the lines of identification, the screen protagonist who elicits queer desire while pursuing, and being pursued by, the woman.[58] But if this is overwhelmingly the case with Grant, it is also the case for Perkins/Norman Bates, for Ivor Novello in his films with Hitchcock, the Gregory Peck of *Spellbound* (though not of *The Paradine Case*, where Peck is stolidly only the pursuer), the Montgomery Clift of *I Confess* (1953), and Farley Granger in *Rope* (1948) and *Strangers on a Train*. As Jonathan Goldberg notes in his monograph on the latter film, Hitchcock blurs the lines between identification and desire, disrupting the normative patterns of spectatorial response to the main text and its male leads.

But if Grant, in Hitchcock's uses of him, makes the queerness of heterosexuality especially palpable, a deeper level of disconnection also exists—a profound alienation—between queer personae and the heroine, relations that do not offer the respite and the bliss of erotic satisfaction. Norman Bates and Marion Crane fit this model, but the sharpest indication of this profound impasse occurs in *Shadow of a Doubt* (1943), to which we now turn.

"You're a Strange Girl, Charlie"

SEXUAL HEGEMONY IN *SHADOW OF A DOUBT*

SHADOW OF A Doubt (1943) is one of Hitchcock's most important films. The director's high regard for it and his close relationship with Thornton Wilder, who wrote the screenplay, attest to its significance in his body of work.[1] The film provides a remarkably lucid template for the feminine-versus-the-queer thematic that may stem from Hitchcock's investments in the material and his collaboration with a gay/bisexual playwright with whom he felt a deep bond.[2] Hitchcock included a special acknowledgment to Wilder in the opening credits; when asked why by Francois Truffaut, the director responded, "It was an emotional gesture; I was touched by his qualities."[3]

The heroine of *Shadow*, Charlie Newton (Teresa Wright), is a young woman who lives with her family in suburban Santa Rosa, California; her uncle Charles Oakley (Joseph Cotten), called Uncle Charlie by the Newtons, pays a visit to the family in an effort to elude the detectives who were tailing him in Philadelphia. Bored, restless, and consumed by existential angst, Charlie is overjoyed by Charles's visit and its promise of excitement and change. But Charles is a serial killer whose murders of rich widowed women have earned him the moniker the "Merry Widow Killer." When one of the two detectives who appear at her home (using the cover story that they are conducting a "national poll" on the typical American family) reveals Charles's perfidy to her, Charlie transitions from innocence to experience. As her uncle's hypnotic hold on her devolves, her desire to annihilate him grows. The narrative narrows down to a series of deadly parries between these well-matched foes: He rigs the backstairs so that she will fall down them and traps her

in a locked garage to kill her with carbon monoxide from an idling car. She comes down the main stairs wearing the present he gave her, a dead woman's emerald ring, signaling her threat to expose him to her family and the women's group honoring him that evening. His departure hastened by Charlie's threat, Charles boards a train the next day. As her uncle tells her goodbye, Charlie tries to get off the train as it begins leaving the station, but he grips her violently and his murderous intentions become obvious. The two struggle; just as he is about to throw her off the train, she manages to push him off it, to his death.

As we have thus far established, Hitchcock films such as *North by Northwest* and *Psycho* suggest that a potential affinity between the heterosexual woman and the queer man is unrealizable due to the social structures that make them adversaries. *Shadow of a Doubt* explores the possibilities of a genuine bond between the heroine and her uncle, whom I read as a queer male, a mutually enhancing affiliation. Yet the very intensity of their intimacy instigates the violent rupture of it. The film crystallizes the struggle that has emboldened the present study—feminist and queer theory readings of Hitchcock at cross purposes even as both strive to understand and critique the effects of patriarchal ideology on those it marginalizes and conscripts.

The feminine-versus-the-queer thematic in *Shadow of a Doubt* has political implications. To address these implications in theoretical terms, I first introduce a concept that I call *sexual hegemony*. From there, I discuss the reasons why I believe we should read Charles as a queer character, arguing that his queerness stems from his lineage to the Wildean dandy and to nineteenth-century phobias about the rogue sexuality of the bachelor. Having established Charles as queer, I consider the implications of Charlie's potential queerness and the ways in which tropes of female initiation, the female Gothic, and the incest theme intersect with the film's depictions of a menacingly seductive queer sexuality. The twinning/incest motif deepens in resonance when considered in light of Emma Newton's (Patricia Collinge) relationships with both her brother Charles and her firstborn daughter Charlie. Emma has been described as Hitchcock's last positively drawn mother character, and while support for this reading exists in the film, ambiguities in her depiction—by Hitchcock, Wilder, and also Collinge, who wrote some crucial bits of Emma's dialogue—make her a more difficult and challenging character than often allowed.[4] Through an analysis of the sexual politics of Emma's characterization, I extend the feminine-versus-the-queer thematic to Emma's relationship to Charles, liminally poised between the sisterly and the maternal.

SEXUAL HEGEMONY

In his writings on paranoia beginning with the Schreber case, Freud explored the transformation of love into hate. This theme informs *Shadow*. While one roots for Charlie, the heroine's campaign against the queer villain has more than a whiff of persecutory

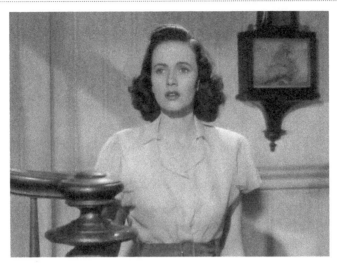

FIGURE 2.1 Charlie, the heroine, as played by Teresa Wright. Her campaign against the queer villain has a paranoid dimension.

paranoia, as the frequent shots of her in a state of mingled resolve and anxiety convey (see figure 2.1).

Charles's appreciation for Charlie's singular qualities almost immediately shifts into his own campaign to kill her once she learns the truth about him. No empathy between them is possible once their mutual admiration for each other—which is inextricable from their narcissistic satisfaction in seeing their own best qualities *reflected* in each other— is disrupted. These failures of empathy, as I see it, illuminate the inability of sexual minorities—here the independent woman and the queer male—to make common cause. The film thus offers an allegory to feminism and queer theory: Work together or remain radically opposed; learn more about the needs and goals of the other in order to find common ground.

Sexual hegemony is the social system that privileges heterosexual marital and familial sexuality while relegating all other, and necessarily deviant, forms of desire to secondary positions at best. Heterosexual sexuality dominates, but it does not wield dominance securely and stably; it must forever defend its hegemonic status against opposing forces and the apparently seductive challenges of queer sexuality. In terms of gender hegemony, heterosexual masculinity insecurely and combatively occupies its dominant status, defending itself against opposition while developing strategies to demonstrate its awareness of other desiring possibilities and positions (thereby confirming, or asserting, that it is neither misogynistic nor homophobic).

Femininity has historically occupied a lesser status in the chain of social power. Milton offers a succinct account of the history of average misogyny in Satan's appraisal of the wondrous but hierarchical beauty of the first humans Adam and Eve as he voyeuristically gazes on them in the prelapsarian garden: "Not equal, as their sex not equal seemed;/For

contemplation he and valour formed,/For softness she and sweet attractive grace; He for God only, she for God in him" (IV.296–99). Adam's devotion is to God; Eve's devotion is to Adam in whose authority a perfect model of godly power exists. But those gendered female and typed as heterosexual have also, on certain levels, wielded a social power that exceeds what has been conceded to the homosexual/gay/lesbian/queer classes. Feminists of color have challenged mainstream feminism as an exclusive enclave of white female power, and the homo/queer relationship to ostensibly heterosexual femininity has been riven with similar conflicts. (More recently, these debates have extended to battles between feminism and transgender rights.) Hitchcock's films, as I argue, depict tensions that can develop into truly disquieting conflicts between heterosexual female and queer characters. Though a certain level of intimacy and affiliation between heterosexual female characters and homosexual men does exist, relations between heterosexual and lesbian women are shown to be (even) more fissured.[5]

Taken from the prison writings of Antonio Gramsci between 1927 and 1935, the term "hegemony" as Gramsci meant it is famously murky and controversial, but many important thinkers have found the concept useful. Raymond Williams distinguishes hegemony from ideology. In hegemony, we see "the relations of domination and subordination, in their forms as practical consciousness, as in effect a saturation of the whole process of living—not only of political and economic activity, nor only of manifest social activity, but of the whole substance of lived identities and relationships, to such a depth that the pressures and limits" of a particular cultural system can seem like the wholly ordinary experiential reality of day-to-day existence.[6]

Hegemony theory sheds light on the asymmetrical complexities of social relations: the socially abnegated war with those in power but also with others who are socially abnegated; social abnegation is not experienced uniformly; some members of the oppressed classes may be closer to positions of dominance than others; the oppressed can also oppress others; the dominant classes very likely also experience forms of oppression, real or perceived. Of great relevance for queer theory, hegemony incorporates the efforts and contributions of the marginalized, who participate in an ever-shifting, dynamic social system.[7]

Ernesto Laclau and Chantal Mouffe observe that "hegemony supposes the incomplete and open character of the social. . . ."[8] They also posit that the capitalist "commodification" of social relations, imposed at the beginning of the twentieth century and "stepped up" in the 1940s, "destroyed previous social relations, replacing them with commodity relations through which the logic of capitalist accumulation penetrated into increasingly numerous spheres."[9]

Today it is not only as a seller of labor-power that the individual is subordinated to capital, but also through his or her incorporation into a multitude of other social relations: culture, free time, illness, education, sex and even death. There is practically no domain of individual or collective life which escapes capitalist relations.[10]

Hitchcock's films intersect with hegemony theory in their development of the following ideas: Dominant forms of power, such as heterosexual enclaves populated by white and upper-middle-class personae, are never secure but instead riven by anxieties and incoherencies that threaten to topple them; capitalism has freezing effects on social relations, denaturing and constricting them[11]; social experience proceeds as a contest over dominance and subordination that is, especially among the subordinated, neither organized around a clearly defined set of goals nor enacted through a clearly defined set of roles; gender and sexuality are privileged sites for these forms of social contest and struggle. As Robin Wood wrote in the context of *Shadow*, "the key to Hitchcock's films is less suspense than sexuality . . . sexual relationships in his work are inevitably based on power, the obsession-with-power/dread of impotence being as central to his method as to his thematic."[12] This transition from affinity to animosity in the Charlie/Charles relationship, and for similar kinds of interactions in Hitchcock's oeuvre, seems to me a crucial allegory for the ways in which the social order pits the sexually abnegated against one another.

QUEERING UNCLE CHARLIE

Robin Wood strove to debunk the gayness of Hitchcock's personae. "Some have sought, with far less incontrovertible evidence, to extend the list to include the Uncle Charlie of *Shadow of a Doubt* and Norman Bates, in which case we may as well add the Bob Rusk of *Frenzy*. These latter instances seem to rest on little except popular (and generally discredited) heterosexist mythology," which associates being gay with effeminacy, a male's close relationship to his mother, and hatred and murder of women.[13] While I take Wood's point, I also think that popular films—and for all of their greatness, Hitchcock's works are thoroughly in this vein—traffic in precisely such stereotypes and perpetuate them. Further, no matter how nuanced some portraits of non-normative characters might be, they are frequently taken by the mainstream audience as solicitations to indulge in the crudely homophobic. (*Psycho* slyly tweaks that anticipated response in the legendary moment when, for no obvious reason, Norman swings his hips swishily when walking up the stairs to Mother's bedroom.) Wood's resistance to accepting stereotypes is commendable but, in my view, also delimiting, leading us to reject or overlook an archive of queer-tinged moments and portrayals because of an earnest opposition to what these moments and portrayals may reveal.[14]

As Leo Bersani writes in his classic essay "Is the Rectum a Grave?": "To want sex with another man is not exactly a credential for political radicalism. . . . The logic of homosexual desire includes the potential for a loving identification with the gay man's enemies." And here is the especially salient point: "An authentic gay male political identity therefore implies a struggle not only against definitions of maleness and homosexuality as they are reiterated and imposed in heterosexist social discourse, but also against those very

same definitions so seductively and so faithfully reflected by those (in large part cultur-
ally invented and elaborated) male bodies that we carry within us as permanently renew-
able sources of excitement."[15] Published in 1987, this essay was written in a period in
which AIDS was a likely death sentence and legalized gay marriage was unthinkable; its
opposition to pietistic stances still resonates. While I disagree with the antisocial thesis
put forth by Bersani and Lee Edelman, I believe that Bersani is persuasive here. The image
repertoire of negative depictions and icons of gayness in a homophobic culture have no
less relevance or potency than the positive ones; moreover, and this is more specific to
Bersani's point, desire does not always behave in a self-affirming manner, and rarely in a
politically sensitive and resistant one.

While one generally hopes for a broad and meaningful range of representations and
one must critique homophobic—and misogynistic and racist—portrayals, the morbid-
ity and perversity and, yes, antisocial behavior of Hitchcock's queer personae reflect a
larger view of the social order and its carefully crafted gender and sexual mythologies
as inherently duplicitous, fragile, and unsustainable. Although certainly a controversial
aspect of Hitchcock's work, the homosexual-as-psychotic-murderer figure that recurs in
his films is usually attractive and debonair. The stereotypical aspects of this depiction
are inextricable from the considerable appeal the figure holds for the director and many
in the audience. (When Bruno Anthony in *Strangers on a Train* pops the balloon of the
little cowboy-hatted boy who mock-shoots him at the fairgrounds, the audience laughs at
Bruno's subversive gesture—laughs *with* it.) Given that so many of Hitchcock's murder-
ous queer personae are physically and personally alluring (and funny), and that the direc-
tor's identification with them is as palpable as it is disturbing, we might consider that
they are wish-fulfilment figures, enacting forbidden and desirable fantasies, reprehensible
on the one hand, irresistible on the other.

To describe Charles Oakley as queer is to register the character's sexually non-normative
qualities, linked to his inscrutable psychology. Charles is a liminal figure, caught between
a less defined period of sexual classification and an emergent gay identity; his queerness
stems from this liminality and fluidity. Charles evokes sexually polyvalent nineteenth-
century figures such as the dandy and the bachelor and signals a newly articulated homo-
sexual awareness verging on explication.

Charles's clearest associations with the homosexual lie in his comportment and his
dress. In a well-known reading, Thomas Elsässer interprets Hitchcock's representation of
masculinity through the historical figure of the dandy.[16] Richard Allen links Hitchcock's
consistent fascination with homosexuality to the cultural afterlife of the Victorian dandy
and Oscar Wilde's indelible real-life performance of this role.[17] Charles is very much a
Hitchcockian dandy figure, like Bruno Anthony in *Strangers on a Train* with his flashy
two-toned shoes, lobster-patterned tie, and "Bruno" tiepin. Charles's sartorial aplomb
solicits the riveted attention of women in the film, ranging from Charlie's avid-eyed
school friends who marvel, much to Charlie's delight, at the handsome man with the
fancily embroidered tie, to the widow Mrs. Potter who eyes Charles provocatively upon

meeting him at the bank, and again on the train at the climax (she comes close to being his next victim).

Charles emblematizes the Hitchcockian type that Allen calls the criminal-dandy, and his associations with the incest theme deepen his relationships with both his niece Charlie and his sister Emma. "The hidden incestuous wish often seems to inform the criminal-dandy's particular relationship to knowledge. The incestuous violation of nature at once manifests a form of 'supernatural' thinking that involves the effort to reorganize the world, magically and murderously," writes Allen. Uncle Charlie "demonstrates preternatural tendencies informed by incestuous desires" for both his sister Emma and his niece. "These incestuous desires both inform and are informed by the telepathic affinity between the two Charlies."[18] Incest has had a longstanding function as a metaphor for homosexuality when the latter subject could not be explicated. Like homosexuality, incest is socially forbidden and often criminalized.[19] Charles's associations with both the historical dandy and incestuous desire queer him.

Charles's problematic status as a bachelor merits discussion. Though Richard Allen links the Wildean dandy to Hitchcock's homosexual characters, he is also at pains to distinguish Charles from this line. "Uncle Charlie in *Shadow of a Doubt* dresses like a dandy and is a psychopathic criminal who hates women, but unacknowledged homosexuality could only be inferred on the slim grounds of his bachelor status, unless we assume that Hitchcock equates unacknowledged homosexuality with misogyny."[20] Again, queerness as a category complicates matters: While he may or may not be gay, Charles, outside of the family and heterosexual relationships, poses a sexually non-normative threat. I argue that his bachelor status is a key aspect of this threat and more important than the "slim grounds" Allen allows. Historically, American culture has regarded the bachelor as sexually suspect. One's "bachelor status and, indeed, the term bachelor itself, may well have functioned as suggestive cultural code, if not specifically for the antebellum inchoate gay male subject, then for an essential sexual vagueness," observes one critic.[21] Katherine V. Snyder's illuminating study of the bachelor in nineteenth-century America addresses what she calls "the queer excesses of bachelor narratives."[22] What made the bachelor's sexuality problematic was its unsupervised, lawless nature; not tethered to marriage, the bachelor was free to pursue too great a range of sexual as well as social possibilities.

While a highly controversial aspect of American sexual history, an explicit homosexual and gay identity was many decades in the making. (It was the Oscar Wilde trials of 1895 for "gross indecency" that fused the dandy with the homosexual persona; before the trials, dandies were often considered rapacious seducers of women, hence the "diabolical dandy.") In the 1940s, as the leading historian of gay history John D'Emilio observes, "homosexuality assumed significantly greater visibility."[23] It would be hard to overestimate the ways in which the '40s restructured gay life. "The war years allowed the almost imperceptible changes of several generations, during which a gay male and a lesbian identity had slowly emerged, to coalesce into a qualitatively different form." What had been a private individual experience transmogrified into "a widely shared collective

phenomenon."[24] Alfred Kinsey's reports on human sexuality in 1948 (male) and 1953 (female) both caused controversy and indicated the paradigm-shifting emergence of a newly visible gay America. Craig Loftin notes that "Kinsey's research demonstrated the wide gulf between sexual ideals and practices in American society. Kinsey's data showed, for example, that homosexuality was much more prevalent than commonly believed—more than one-third of surveyed men admitted to adult homosexual behavior."[25] Met with the opposite of fanfare, gay America faced scorn, social shaming, and, in the Cold War context, not only moral condemnation but also political attack. The McCarthy era's witch-hunts for Communist sympathizers expanded to include gays and lesbians working in the government and universities, the Lavender Scare complementing the Red Scare, impelled by the view that gays were prime targets for blackmail by enemy forces. At the same time, the homophile movements, such as the Mattachine Society and the Daughters of Bilitis, strove to secure gay rights and safe havens for gays and lesbians.

Loftin has charted gay and lesbian history from the 1940s to the '60s through his research on *ONE* magazine, the first openly gay publication in the United States, which was affiliated with the Mattachine Society. He argues that *the closet* came into prominence as a commonly understood metaphor only in the late 1960s and early '70s. In the archive of letters to *ONE* that Loftin studies, correspondents most frequently wrote of feeling that they wore *masks*.

> The mask was both liberating and tragic: liberating because it allowed many people to avoid job discrimination and police harassment, tragic because it was necessary at all. . . . The closet metaphor implies that gay people consciously denied their authentic selves, and it eliminates the historical agency of an entire generation of gay men and lesbians to define their own sexual identities. In contrast, the mask metaphor restores agency because gay people controlled when to put on or remove their masks depending on the context or situation. . . . Passing, ironically, brought their homosexual identities into sharper focus.[26]

If we accept the mask as a historically sensitive metaphor to describe gay/lesbian/homosexual experience from the 1940s to the '60s, which was also the period of Hitchcock's Hollywood heyday, we can better understand queer as an apt paradigm for the social *performance* of self in this homophobic but complex and shifting period. (Queer scholars have given renewed attention to the work of sociologists such as Erving Goffman, who focused on social performance and used theatrical metaphors to describe human interaction.[27]) Queer speaks to the moments when established patterns of gender and sexual performance break down and are destabilized, the moments when the mask slips, is left askew, or pulled off altogether. Perhaps queerness speaks most eloquently to what Julia Erhart, discussing the uses and difficulties of queerness in media theory, calls "the mutability of identity."[28] Erhart notes, "If queerness could emerge from particular practices and moments regardless of the identities or experiences of viewers, it could just as

easily be apprehended—maybe even performed—by 'heterosexuals' as by 'homosexuals.' Queerness could materialize regardless of the self-termed identity of a viewer or the socially recognized gayness of the object viewed."[29] It is along these lines that we can consider many Hitchcock works and characterizations as queer.

In his history of homosexuality in Hollywood, Richard Barrios observes that the paranoid policing of the Production Code in the 1940s banished any cinematic appearances of effeminate homosexuality, which had been on greater display in the previous decade. "The new type of gay man onscreen" in the mid-1940s "was not a subject for ridicule. . . . In fact, he did much of the mocking himself, being acerbic, witty, and (to use a word of the time, not necessarily negatively), bitchy."[30] The newspaper columnist Waldo Lydecker (Clifton Webb) in the swanky murder mystery *Laura* (Otto Preminger, 1944) embodies this cultivated air of disdain. Uncle Charlie's well-traveled air and disdain for suburban normalcy, his mocking attitudes toward the family, community, and especially ethics link him to Lydecker and similar figures. There is an important difference, however: As played by Cotten, Charles's gender demeanor is unimpeachable—he is conventionally hetero-masculine and not in any way bitchy.[31] Nevertheless, charming Charles, for all his ready graciousness, always verges on an explosive break with propriety, the moment when the public mask slips. Such a moment occurs at the bank where Charlie's father Joe Newton (Henry Travers) works. Charles's irreverent comments (encouraging Joe to steal from his employer) mortify Joe and discomfit Charlie, who scolds him. (This scene occurs before she learns of his crimes.) In Hitchcock, urbanity thinly conceals a potential murderousness. (While this can also be said of *Laura*, in which Lydecker is revealed to be the villain, his unmasking, in keeping with whodunit form, is climactic, as opposed to the periodic, steady slippages of the mask in *Shadow*.)

In terms of 1940s Hollywood cinema, the bachelor figure takes on a disciplinary and euphemistic function. Richard Barrios notes that the impact of the impositions placed on film content by the Legion of Decency and the Production Code in the 1930s was profound. If previous decades had featured transgressive sexualities, by "1934 it all seemed to stop." A series of transformations occurred: "the buzz words, too, were gone," such as pansy, fairy, and mentions of the color lavender. And "the once flamboyant gay men and women became, basically, dowdy spinsters and nervous bachelors." Nevertheless, anyone looking for them could spot and decode hidden references to alternative forms of sexuality because "movies were functioning as an extension of the gay subculture, broadcasting the messages to those in the know and in the life."[32]

"I like to think of the bachelor as a figure who stands in the doorway, looking in from the outside and also looking out from within," Katherine Snyder writes.[33] Snyder could be describing Charles Oakley as well the nineteenth-century bachelor. The singular, nonconformist young woman occupies a similar liminal position. While Charlie is hardly a spinster, she is a young unmarried woman whose sexuality is not fixed; she cultivates her apartness from both her family and her surroundings while contemplating, with some ambivalence, the marriage question and its possible erasure of her singular

personality. (Emma's speech about marriage near the end of the film, in response to Charles's announcement that he will be leaving Santa Rosa, articulates this ambivalence powerfully.) Moreover, Alexander Doty has raised the possibility that Charlie might be one of Hitchcock's queer personae.[34] Doty also argues that, in *Psycho*, Marion Crane's sister Lila is a "brash, heroic dyke" set against the queer Norman Bates.[35] If we read Charlie this way, the commonplaces about the dynamics of her relationship to Charles undergo a shift. *Shadow* may prefigure *Psycho*'s meticulous staging of a confrontation between a queer male *and* a queer woman. Both Charlie and Charles stand apart from the family by being unassimilable into its program of sexual normalization. That Charlie's attraction to him is so wholly plausible suggests that, in being his comeuppance, she is also disciplining herself and her own wayward desires.

INITIATION AND ILLUSION

As Eve Sedgwick demonstrated in *Epistemology of the Closet*, a "crisis of homo/heterosexual definition, indicatively male, dating from the end of the nineteenth century" defines twentieth-century thought and cultural practices.[36] Sedgwick offers a famous list of binarisms, categories indicative of this crisis of definition:

> secrecy/disclosure, knowledge/ignorance, private/public, masculine/feminine, majority/minority, innocence/initiation, natural/artificial, new/old, discipline/terrorism, canonic/noncanonic, wholeness/decadence, urbane/provincial, domestic/foreign, health/illness, same/different, active/passive, in/out, cognition/paranoia, art/kitsch, utopia/apocalypse, sincerity/sentimentality, and voluntarity/addiction.[37]

Shadow of a Doubt, chiefly organized around the category of innocence/initiation, is a female coming-of-age narrative. The movie foregrounds qualities associated with initiation that prove crucial to the feminine/queer dynamic: seduction, illusion, and knowledge. *Shadow*'s narrative binds together the traditional rites of wooing and seducing the chaste and sexually uninformed woman on the one hand, and prevalent images of the seductive homosexual on the other, reimagining female courtship ritual as an incestuous seduction of the woman by a queer male. (It thereby revises *Rebecca*'s scenario, in which another woman seduces, in a manner of speaking, the heroine.)

"Charlie, what do you know?" Charles says to his niece, sad and angry now that she knows of his evil nature. He shatters her illusions: "The world's a hell. What does it matter what happens in it?" As William Rothman has shown in his masterly extended analysis of *Shadow*, the evil in which Charles schools Charlie is knowledge of the world.[38] This theme has a sturdy provenance in representation; for female characters, it connotes the entrance into adult and/or marital sexuality. As I suggested in chapter 1, Milton's poem *Paradise Lost*, particularly Satan's successful seduction of Eve, who eats from the fruit of

the Tree of Knowledge, is a crucial precedent. (Satan perversely reeducates Eve, formerly tutored by her husband Adam, in God's stead.) In Hitchcock, the woman's relationship to knowledge is mediated through the queer figure with superior access to it. Certain films make relationships along these lines between women prominent (*Rebecca, Stage Fright,* and *Marnie*), but the majority pair or contrast the woman and the homosexual/queer male (*Murder!, Secret Agent, Shadow, Spellbound, Notorious, The Paradine Case, Rope, Strangers on a Train, The Man Who Knew Too Much* [1956], *North by Northwest,* and *Psycho*). *Shadow* further establishes that queer sexuality casts a spell over the heroine, a series of seductive illusions that she must and *will* shatter.

Hitchcock's queer personae have access to and wield a knowledgeability the other characters are barred from. And they are hypnotic seducers. Most critics have agreed that Mrs. Danvers in *Rebecca*, played with cobra-like intensity by Judith Anderson, should be read as a lesbian character. Danvers manages the domestic staff and runs the household of the patriarchal English mansion Manderley; as becomes increasingly apparent, she maintains an erotically tinged obsession with the dead title character, the magnetic and, by all accounts, spectacularly beautiful first wife of Manderley's scion, the rich aristocrat Maxim de Winter.[39] The film charts the emotional development of the unnamed heroine, from fumbling uncertainty about now being "the second Mrs. de Winter" and a profound sense of inadequacy in comparison to the legendary dead Rebecca to the more proper deportment of the patriarchal wife. While not presented as an attractive figure, Mrs. Danvers nevertheless wields a power over the heroine, even coming close to tempting her into suicide. "Why don't you?" she whispers in her ear as she peers down into the sea (a definitive symbol of female sexuality) from the dead Rebecca's bedroom window.[40] Mrs. Danvers's program of initiation forces the heroine to recognize evil and confront lesbian sexuality. In Daphne du Maurier's novel, the heroine transitions from fumbling and vulnerable to hard, tough, and even ruthless; she helps Maxim cover up his murder of Rebecca. Hitchcock softens the heroine's disquieting transformation, yet in both versions, she remains complicit with the cover-up of Rebecca's death. (The film also softens the details of Rebecca's death at Maxim's hands.) The heroine's maturation leads to her more successful identification with the patriarchal husband.

Worldly, fallen knowledge and the seductive, pernicious use of illusion inform Oscar Wilde's work, as we have established an important precedent for Hitchcock's. Jack Halberstam writes of *The Picture of Dorian Gray*, "Wilde associates homosexuality with illusion and heterosexuality with reality." Dorian, who stays young and handsome as his portrait rots with his accumulated evils, rejects the actress Sybil Vane "when he discovers his own preference for illusion and artifice over reality." Engaging with Eve Sedgwick's theory of homosexuality's central role in the paranoid Gothic, Halberstam notes that in works such as *Dorian Gray* and Robert Stevenson's *Dr. Jekyll and Mr. Hyde*, male sexuality "is both homoerotic and paranoid—paranoid because of the panic unleashed by the recognition of desire between men."[41]

I want to introduce another literary precedent for understanding the queer politics of initiation in Hitchcock: Herman Melville's novella *Billy Budd, Sailor* (1891). I will have frequent occasion to refer to this work. Left unfinished at the time of Melville's death, *Billy Budd* was discovered in manuscript form in 1919 by Raymond M. Weaver and became a key work of the Melville revival of the 1920s. Crucial to the development of twentieth-century homosexual aesthetics, the novella was an object of fascination for artists such as W.H. Auden, Benjamin Britten (who wrote the famous 1951 opera based on it with its libretto co-written by the gay English novelist E.M. Forster), and Thornton Wilder, who speculated at length about Melville's sexuality, even arguing in his journals that Melville "almost lost his story through his own infatuation with Billy Budd."[42] Eve Sedgwick notably called the master-at-arms Claggart, who falsely accuses the honorable and beautiful young sailor Billy of mutiny, the first homosexual character in literature.[43] Sedgwick links Melville's novella to the Oscar Wilde sodomy trials of 1895, and I believe that a case can be made for the Claggart-like quality of Hitchcock's villains, who perform, as Claggart does, cheerful and companionable affinities with their envied and detested objects while plotting their destruction.

What concerns me here is the woman's role in systems of queer knowledge, an embedded and intimate one tied to an ultimately punitive program. In Melville, the homosexual male figure is associated with knowledge that can be opportunistically and sadistically wielded; in Hitchcock, the woman wields knowledge that cuts through the thick air of homosexual intrigue. Hitchcock's villains evoke Melville's homoerotic Satan in *Billy Budd*, "the urbane Serpent" who "wriggles" into Adam's company with no mention of Eve.[44] As I noted in chapter 1, the Christian gender politics of Satan's seduction of Eve and the battle between Mary, Christ's mother, and Satan, whom she vanquishes, resonate in the Catholic Hitchcock's gendered schemas. Hitchcock reinserts the Eve-like woman into Melville's Eve-less Genesis, making her seduction by the beguiling serpent newly urgent. Charlie, as will be true of many Hitchcock heroines, is both the seduced victim and the vanquisher, the only person, in the end, who can eradicate her uncle's satanic threat.

As Tania Modleski has shown, Hitchcock's women know too much—they are also *known* too much.[45] The heroine Alicia Huberman in *Notorious*, a promiscuous and alcoholic woman whose father's Nazi connections make her an ideal candidate to be a U.S. spy, falls in love with her handler Devlin. He also falls in love with her but cannot tell her so. Modleski interprets Alicia's masochism as an expression of anger. She notes Devlin as being a self-described "fat-headed guy full of pain," but argues that the woman must undergo not only emotional but also life-threatening physical pain. *Notorious* explores the woman's relationship to knowledge, evoking Charles Perrault's 1659 fairytale "Bluebeard" when Alicia searches her Nazi husband's mansion for clues and is allowed to open all doors except the one that hides the wine bottles with uranium ore. Charlie's relationship to knowledge is of a different order; for one thing, the heterosexual relationship, so central to *Notorious*, is radically deemphasized in *Shadow*. The tentative romance between Charlie and Jack Graham, one of the detectives investigating the Merry Widow

killer, is significant largely for the additional dialogue that Patricia Collinge wrote for the scene in the barn when Graham confesses his love for Charlie.

Emma, as I will show, staves off knowledge of her brother's evil. Charlie's burden is that she not only learns the truth about Charles—Graham informs her of her uncle's crimes—but also *wants* to know the truth, as her nighttime trip to the library at closing hours attests. "It can't be anything too terrible," she says as she looks for the story in the newspaper that Charles excised. But then it turns out to be more terrible than she could possibly have imagined, as the shocking cut to the blaring headline about the Merry Widow Killer, accompanied by a thunderous reprise of Franz Lehar's "Merry Widow Waltz," confirms.

KILLING THE THING SHE LOVES

In investigating her uncle, Charlie becomes suspect herself. Her mother Emma wonders aloud, "What's wrong with Charlie?" The singular Charlie eventually declares allegiance with the only character who truly understands her, their bond forged in a mutual propensity for violence. Charlie warns Charles one night on the back porch, "I don't want you here, Uncle Charlie. I don't want you to touch my mother. So go away, I'm warning you. Go away or I'll kill you myself. See? That's the way I feel about you." Hitchcock ends this scene as soon as Charlie utters the last syllable, but it effectively imparts a terrifying truth: Both share a ruthless singularity of purpose.

In his interview with François Truffaut, Hitchcock described Charlie's killing of her uncle as "accidental"; her climactic act of pushing him out of the train was not even self-defense but a circumstantial gesture.[46] Yet, as he depicts the heroine, Charlie transforms into an avatar of death, as if her chief role is to kill her uncle herself. Indeed, it as if her absorption into the fallen world of knowledge had the effect of transforming her into a figure of divine, unyielding justice, a Fury.[47] Once she has learned what kind of a man her uncle really is, she takes immediate action to oust him from her home.[48] (In *Psycho*, Lila Crane announces that "[p]atience doesn't run in my family" and searches for Marion with the greatest alacrity.)

Hitchcock emphasizes Charlie's increasingly prominent role as a force of retribution in other scenes as well. She stands—resolute, silent, unflinching—in the doorway staring up at Uncle Charlie as he triumphantly strides up the stairs that lead to the bedrooms. He is elated because he has just learned that the other suspect for his murders has been caught and killed. He turns around at the top of the stairs to look down at her sentinel-like presence as if it exerts an uncanny influence on him. In the train at the climax, she is dressed in black like an angel of death, apt attire for the sequence in which she does, inadvertently or otherwise, finally slay her uncle.

The film registers the emotional costs of the woman's retributive role, however. In one of the most affecting moments in Hitchcock's work, Charlie, alone on the front porch,

weeps as she watches her family during nighttime rituals, her hapless father Joseph Newton suddenly a vital member of the family as he gives her little sister, the droll, bespectacled Ann (Edna May Wonacott), a piggyback ride up the stairs. Charlie's bitter tears are, in Rothman's view, an appeal to God.[49] But Charlie develops an appreciation for the Devil. In threatening Charles, she enunciates not only her complicity with his murderous ways but her ability to emulate and match them.

Before the narrative narrows down to a murderous battle of wills, it foregrounds niece and uncle's unsettling intimacy. In the first dinner scene, Charles offers gifts for the family members, but when it comes time to give Charlie hers, she demurs, saying that she doesn't need any gifts and that Charles's visit is more than enough. Interestingly, her two younger siblings Ann and Roger scoff at her protest, alternately calling her crazy and suggesting that she is manipulating the situation to get more attention. In the scene that follows between Charlie and Charles in the kitchen, Hitchcock frames the two on opposite sides of the screen, she on the right, he on the left, suggesting the gulf as well as the parity between them. (Hitchcock will frame the courtship scene between Charlie and Graham in the garage, and, later, Norman and Marion on the porch outside her motel room in *Psycho* in the same way.) When Charlie explains that the happiness her uncle has brought—which largely centers on Emma's experience of fulfillment at seeing her brother again—is sufficient for her, Charles remarks, "You're a strange girl, Charlie." Once again, Charlie's "strangeness," her potential queerness, links her to Charles. Charlie begins to speak explicitly about knowledge. "We're not just an uncle and a niece. It's something else. I *know* you." After her uncle encourages her not to try to find out too much about him, and people in general, Charlie remarks, "We're sort of like twins—we *have* to know."[50]

Teresa Wright, in her wonderfully nuanced performance, gives Charlie's probing a daring as well as playful intensity; Joseph Cotten, in his considered and subtle interpretation, gives Charles an air of cautious reserve, a languid stillness, as Charlie attempts to penetrate his enigmas. These shadings in the actors' spellbinding portrayals give the scene—private and hidden from the rest of the family—an erotic intensity. Charles gives Charlie her present, which she refused at first to even look at: an emerald ring that, like a suitor or a fiancé, he places on her finger. "Here, let me show you," he says, lifting up her hand, taking off the ring, and praising the emerald's qualities. Charlie discovers the hidden truth within the dandy's course in aesthetic appreciation—the inscription already engraved on the ring, which, Charlie will discover, contains the initials of one of Charles's victims and her dead husband.

That Charlie pierces Charles's captivating deceptions with her deductive knowledge exemplifies the pattern that emerges throughout a number of Hitchcock works (and in Hitchcockian films like *The Silence of the Lambs* [Jonathan Demme, 1991]) in which queerness is associated with a world of seductive and compelling illusion. In addition to Mrs. Danvers coaxing the heroine to drown herself, we think of *Rope*'s stylish homosexual hosts and their dinner party organized around the hidden body of a murdered

young man; Bruno Anthony's charm at Senator Morton's party, evinced by his ability to seduce a society lady (and nearly strangle her) in *Strangers on a Train*; and Norman Bates and his winsome appeal. In contrast, heterosexual femininity is associated with a rational practicality that punctures the queer masquerade. The worm turns when the second Mrs. de Winter announces to Mrs. Danvers, "I am Mrs. de Winter now," a defiant declaration that does not preclude her ensnarement in future deceptions from the housekeeper; Janet Walker begins to unravel the tightly coiled dinner-party plot in *Rope*; Guy Haines's fiancée Anne Morton deduces that Bruno has killed Guy's wife Miriam, albeit at his behest ("How did you get him to do it?"); Lila Crane discovers the real Mrs. Bates; and so forth.

If, following Joan Riviere and Mary Ann Doane, we understand femininity to be a masquerade that is painful to the woman, the conflict between queerness and heterosexual femininity in Hitchcock—usually rooted in a palpable connection that will be severed—assigns the masquerade to the queer seducer while figuring the heterosexual heroine as the embodiment and the custodian of phallogocentric order, an icon of rationalism.[51] If homosexuality has historically been treated as supplementary to heterosexuality, its inferior and imitative substitute, the queer figures in Hitchcock remind us that what undergirds these sexual mythologies is a hysterical reaction to the irresistible allure of perverse, seductive queer entrancement. In Hitchcock, the woman saves herself, even if by accident, and allows the audience to save itself from queer illusion. In so doing, she kills the thing she loves and in loving knows so well.[52]

Hitchcock himself read *Shadow* through a Wildean lens. As recorded in his interview with Truffaut, he observed: "There is a moral judgment in the film. He's destroyed at the end, isn't he? The niece accidentally kills her uncle. What it boils down to is that villains are not all black and heroes are not all white; there are grays everywhere. Uncle Charlie loved his niece, but not as much as she loved him. And yet she *has* to destroy him. To paraphrase Oscar Wilde: 'You destroy the thing you love.'"[53] In associating his film with the most famous of homosexual artists, Hitchcock provided an invitation to read the film with a Wildean appreciation for Charles's wit and attractiveness. But Hitchcock uses the paradigm as a disquieting lens. Configurations of sexual and social identity that not only allow Charlie to kill Charles, but also make it necessary that *she* be the one to do so have their basis in a considerable social violence. Profoundly intimate bonds must be sundered for the sake of narrative closure and the restoration of heterosexual and familial order, hence the concept of sexual hegemony.

EMMA'S NOSTALGIA AND THE CHILD CHARLES

The feminine-versus-the-queer thematic expands to include relationships between the queer villain and maternal women. These bonds, fraught with difficulty but forged in blood, blend familial loyalty and incestuous complicity, and as such, contrast with those

between the heroine and her queer double, which more typically "belong" to the social. The struggle between Charlie and Charles is deepened and confused by incestuous family ties. Much like Mrs. Sebastian in *Notorious*, Bruno Anthony's mother in *Strangers on a Train*, and the famous Mrs. Bates, Emma is a maternal figure in league with the queer villain. At the very least, the film suggests her unconscious tie to villainy.

Sensitively played by Collinge, Emma is an exceedingly sympathetic presence. Collinge wrote some of the devastating lines of dialogue that Emma delivers upon learning that Charles is leaving: "But you see," she explains through tears, "we were so close growing up. And then Charles went away, and I got married, and. . . . Then, you know how it is. You sort of forget you're you. You're your husband's wife. . . ." These achingly poignant lines give Emma a mournful autonomy. At the same time, she nevertheless represents the conformity of both Santa Rosa and a larger domestic ideology that seeks to eliminate difference.[54]

Eerily paralleling the dynamics of the Charlie/Charles relationship, what both unites and estranges Charles and Emma is their relationship to knowledge. In terms of knowing the plot, Emma verges on deductive clarity (in the scene after Charles almost manages to murder Charlie by carbon monoxide poisoning in the garage), but she only comes close. On some level, she does not want to go further; she does not want to know. If Emma has a fraught relationship to knowledge, she appears to find solace and refuge in nostalgia. Knowledge cuts through layers of self-protective repression, but nostalgia provides cover for murderous and incestuous desires. Charles especially but also Emma resort to nostalgia as a defense against a disappointing and degenerate contemporaneity.

Charles believes that all that is good in the world has *already happened* and cannot be recaptured. After dinner on Charles's first night of his visit, after giving the children their presents, he gives Emma hers, a fur stole and a pair of portraits of their parents from 1888, which Charles claims he kept in a safe deposit box. Charlie examines the daguerreotypes, calling the images "sweet" and noting of her grandmother in her youth, "My, she was pretty." Charles immediately responds, "Everybody was sweet and pretty then. The whole world. A wonderful world. Not like the world today. Not like the world now. It was great to be young then." In the conversation he has with Emma and Charlie the next morning, as he enjoys breakfast in bed courtesy of his sister who wants to "spoil" him, he also remarks that there is no "use" in looking backward or forward, and that his only interest is in the present, "today." Later, in the 'Til Two Bar, Charles further explains his understanding of the world to his niece, inducting her into his realm of nihilistic knowledge.

Emma joins Charles in the nostalgic defenses at the heart of his psychopathology. The incest theme in the Charlie/Charles relationship also informs the relationship between Charles and Emma—"Emmie," as her brother calls her. When newly arrived Charles sees Emma in the doorway of her home, he remarks, "Standing there, you don't look like Emma Newton. You look like Emma Spencer Oakley of 46 Burnham Street, St. Paul, Minnesota. The prettiest girl on the block." While Charles appears to revere the past, he

also categorizes both past and future as meaningless, claiming to hold only today important. Emma more consistently treats the past as an occasion for the intimacy she seems to lack in her everyday life.

The male's relationship to his own image is a crucial dimension of Hitchcock's explorations of male sexuality. Here, this motif intersects with the explorations of Emma's desires, and I want to pay particular attention to the scene in which Emma, Charlie, and Charles contemplate a photo of Charles as a child. In bed the morning after his arrival, Emma in motherly fashion serves Charles breakfast as she marvels that he can sleep in for so long. She contrasts his pleasure at eating breakfast in bed with her own postpartum convalescence: "I had to have my meals in bed for a while after the children came, but I never liked it." She thus appears to regard his sensuality as suspect. As she watches him eat, she informs him that some men will be interviewing and photographing them for a national poll on the typical American family. Charles loses his temper—"Emmy, women are fools! They'd fall for anything." Calming down a bit, he insists to Emma that he's never been photographed and isn't about to let these con men do so. Charles's hostility to his own captured image is significant.

Emma then asks Charlie, who has entered the room, to show Charles the picture from his childhood that her mother gave her. In a small photograph in a prettily designed frame held in Charles's outsize hands, a little boy in a sailor's suit hauntingly returns our gaze (see figure 2.2). "Uncle Charlie, you were beautiful!" Charlie exclaims as they all look at the photo.

"46 Burnham Street," Charles remarks, both a confirmation of the photo's authenticity and a means of detachment from any identification with it, as if the photo were of his childhood home and not himself. Emma confirms: "It was taken the Christmas you got your bicycle. Just before your accident." His father had given him a bicycle as a present,

FIGURE 2.2 Portrait of the serial killer as a beloved child.

but it was a dubious one: "Papa shouldn't have got you that bicycle. You didn't know how to handle it." Charles had taken the bicycle out onto an icy road and skidded into a streetcar. Emma recalls: "We thought he was going to die." The photograph was taken on the day of the accident, and when the film was developed and sent back to them, their mother wept. "She wondered if he'd ever look the same. She wondered if he'd ever *be* the same."

Charles in relation to his own image as a child and to Emma's incestuously charged desire for him—which Charlie's own desire replicates—is worth considering in terms of Lee Edelman's argument in *No Future*, which we discussed at length in chapter 1. Edelman posits that the child is the iconic image of a future-oriented society, like ours, that privileges reproductive futurity. Moreover, these ideologies are organized around a culturally central myth: the innocence of children, presented as the ultimate good of society and in need of perpetual defense.[55] Beyond Emma's recollection of him, the child Charles exists only as a photo, and given that her brother repudiates both the memory and the photo (proclaiming that both past and future are irrelevant), the child has only a fleeting reality. But as an entity itself, staring back at us in close-up as we stare at it, the photo of the child Charles both accommodates, by signifying Emma's amber-like nostalgia, and resists it by undoing her wished-for reclamation of that idealized child-self. Emma's nostalgia is an attempt to preserve her idealized image of her brother and, poignantly, a version of herself in relation to that idealized version of *him*. As such, her nostalgia is a conservative project, rather than feminist memory work, in Gayle Greene's term.[56]

The image of the child in Hitchcock self-reflexively critiques the ideologies organized around the child's role as cynosure of reproductive futurity. By inserting a material image of a distinct and unrecapturable version of Charles into the narrative, the film suggests an unknowable dimension in Charles's identity—unknowable to himself as well. In other words, rather than signaling an "innocent" version of the self now lost or longed for, the image of his child-self only further complicates and confuses Charles's already enigmatic and impenetrable persona.

Emma's fixation on the child Charles centers on his image, which seemingly captures his innocence before the accident that may have changed him irreparably.[57] Charles's opposition to being imaged in any way reinforces the idea that Emma's insistence on preserving him in visual form has a defiant edge. This is her little boy, *her* Charles, even if he refuses to recognize his photographic rendering. I do not mean to suggest that Emma's desire to preserve the child Charles is pernicious, only that the strategy of nostalgia is a means of preserving love and dis-acknowledging loss—and awareness of the potentially sinister.

The child-image Charles exists in an enigmatic relation to both the child Charles became after his accident and the man he is now, whom we know to be a monster even if his family does not yet. This photographic child images an idealized boyhood, an imagined version of a child who only exists in fantasy. As Steven Bruhm notes in his brilliant

work on the "counterfeit child," "to celebrate the ideal of childhood is to consign adulthood and childhood to the status of the dead. It is to freeze each of us into a subject where no subject can be and to proliferate, under the banner of 'love,' a system of counterfeit signs taken for childhood wonders."[58] Bruhm notes that "the child is its own counterfeit further imbricated in the world of counterfeits. It is always a signifier, a stand-in for something it isn't."[59] I argue that the child Charles in the image stands in for Emma's own lost vitality and for the false reality that Charles is a respectable member of society, a prime candidate for marriage to one of the widows in Emma's ladies' club. The image child is the doorway to an alternate life never realized.

Charles must account for himself in relation to a repudiated image that impinges on the desires of the women around him; this relates to important themes in this film and other Hitchcock works, especially *Spellbound* and *Psycho*. Both of these films thematize disturbances in male sexuality through symbolic ruptures in and conflicted relationships to vision. (*Rear Window* goes even further in this regard, making male-to-male violence an explosion of visual assaults. When the villain Thorwald invades the hero Jeff's apartment at the climax, Jeff uses his photographer's skill as a weapon, blinding Thorwald with flashbulbs that turn the screen red. These bursts of red light link this climax to *Spellbound*, in which the villain's suicide-by-gunshot momentarily turns the screen red, and to the heroine's sexual trauma in *Marnie*, visualized through scarlet suffusions of the screen.)

Moreover, both *Spellbound* and *Psycho* extend *Shadow*'s theme of childhood as the site of a life-altering trauma for the male.[60] In doing so, all three movies portray the woman's role as central to the excavation of the male's childhood trauma. Extending the idea of Emma's investment in Charles's accident, the psychoanalyst heroine of *Spellbound* discovers that the root causes of the male protagonist's guilt complex lie in childhood trauma (harrowingly depicted in a flashback, the hero accidentally killed his younger brother when both were children); *Psycho* features a key scene in which the female investigator Lila Crane explores Norman Bates's childhood room.

"AND HIS LOADED CANE?"

The "loaded cane" scene is notable for giving Emma access to subversive, sexually risqué pleasure along with Charles. Emma's recourse to nostalgia takes on a surprisingly ribald tone at the dinner table scene famous for Charles's frightening monologue about his hatred of widows ("fat, greedy women"). As Emma and her brother reminisce about the past, one wedding in particular, their conversation links them by their distance from other family members and confirms their incestuous rapport.

Reminiscing at the dinner table, Emma is a teenager once again. When Charles serves wine (quoting Saint Paul: "Take a little wine for thy stomach's sake"), noting that it is "sparkling burgundy," Emma becomes positively giggly, true to her words: "Well, one sip

and *I'll* be calling it 'sparkling burgledy'!" The siblings' intimacy leaves her husband Joe out of the loop, and they take little notice of Charlie as she puts dinner on the table. As I argue throughout this book, the decentering of male rule—here the relegation of normative masculinity to the sidelines—is crucial to the sexual politics of Hitchcock films. The diminished, ineffectual paterfamilias of *Shadow of a Doubt* (evoking the buffoonish father who falls off a stool in *The Lodger* [1927]) allows for the proliferation of new connections and interactions while alerting us to the questionable status of the heterosexual familial male.[61]

Charlie's demeanor, now that she knows of her uncle's crimes, is reserved and distant, even dryly imperious. She pointedly comments to her uncle about the newspaper, "We don't need to play any games with it tonight." Hitchcock gives Charles a reaction shot in which he looks genuinely worried, perhaps even hurt (or perhaps beginning to plot his next move). The fact that Charlie, now aware of the danger her uncle poses, can make such barbed comments to him prefigures her threat to kill him if he remains in Santa Rosa.

Joe makes a reference to the fact that the wine is imported, which leads Emma, taking no notice of Joe himself, to make a reference to the past. She asks Charles if he remembers the wedding of "the oldest Jones girl," where champagne was served. Hitchcock cuts to a shot of Joe then, visibly if quietly miffed at being ignored. She asks Charles if he remembers someone who must have been a guest at the wedding. "'Imported' Frankie and his tweeds?" Charles responds, "And his loaded cane?" She adds with even more giggling abandon: "His loaded everything!"

A loaded cane was an item a gentleman sported as both a fashion statement (a decorative object, not a walking support) and a potential weapon (given that the lower end was weighted with lead). That he imported his tweeds (presumably from Scotland) implies that Frankie aspired to be a dandy, which makes him the butt of a joke between the siblings. The whole exchange has the air, in its obscurity, of a *sexual* joke, especially Emma's surprisingly risqué line, "His loaded everything!" The anecdote's very obscurity complements its off-color humor.[62] The scene prefigures the moment in *Strangers on a Train* in which Bruno Anthony displays his fluency in French as he banters with a French couple. His exchange with them, centered in off-color humor as well, signifies his cultural sophistication and apartness from other Americans.[63]

The Frankie anecdote has ominous overtones given the truth about Charles. The dandified Frankie stands in for the unspeakable subject of Charles's own sexual potency—or lack thereof. Previous moments in the film reinforce the idea of Charles as dandy. Emma pauses in mid-dialogue to admire her brother's fancy dressing gown as she helps him unpack, and Charlie's female friends gape at Charles's dapper attire. Frankie and his loaded cane condense Charles's own qualities. The slang term "loaded" dates back to the nineteenth century, referring to both being drunk and being "full" of semen. Therefore, it is likely that the term "loaded" connotes male sexuality.[64] It is probable that, with his love of off-color humor, Hitchcock added these lines. It is worth noting that this entire exchange does not exist in Wilder's original screenplay where Emma insists that they've

all taken the "pledge" not to drink, and do not drink, *"never, never."* [65] The motif of the loaded cane signifies Charles's potential for violence and calls attention to his sexual potency—or lack thereof, a nod to *Macbeth* and its protagonist's "barren scepter."[66] Imported Frankie's loaded cane makes a mockery of Charles's impotent rage and his suspect lack of wife and family, of any sons to succeed him.[67] Indeed, his only true successor is Charlie, his symbolic, bloodletting daughter. Confirming the phrase's associations with violence, when Joe and Herb swap theories of the perfect murder for the first time in the film, Joe dismisses Herb's recommendations of poison, offering instead a fatal thwack on the head with a "loaded cane." Again, this dialogue in the film is distinct from that in Wilder's original screenplay, in which the first conversation between Joe and Herb contains no reference to "loaded cane," further suggesting this language was added later by Hitchcock.

Along with his fancy dressing gown and clothes, his appreciation of decadent breakfasts in bed, and his childhood beauty, quietness, and habit of reading, Charles's gift of "imported" wine makes him stand out. He introduces this louche substance to a family not accustomed to drinking and moreover serves it in Santa Rosa, situated at the northwestern gateway to the Sonoma and Napa Valleys, regions literally overflowing with domestic wine. (Hitchcock was well aware that Santa Rosa was situated in wine country as confirmed by Hume Cronyn in a 2000 documentary on the making of the film *Beyond Doubt*. Cronyn reports that Hitchcock lauded the beauty of the area and told him, "Miles and miles of vineyards. After the day's work we can romp among the vines, pluck bunches of grapes and squeeze the juice down our throats."[68]) The foreign wine heightens Charles's air of artificiality and decadence and status as urban outsider.

Confirming that this scene at the dinner table portends something sinister, it leads to the most famous and unsettling moment in the film: Charles's monologue about the rich, greedy widows, "fat, wheezing animals," "useless women." The houses whose denuded exteriors reveal only "swine" within must teem with these widows, who "eat" and "smell of" posthumous money earned by hardworking husbands. Charlie, from offscreen, protests of the calumniated women, "But they're alive, they're human beings!" Hitchcock hones in on Charles's face in profile during his increasingly venomous speech. At his niece's protest, Charles turns to face his interlocutor, the camera, and the audience directly, responding, "Are they?"

As Murray Pomerance observes, "the camera swoops into a macro close-up that reveals his brittle (perhaps crumbling) façade, his inner vacuum, the soft and etiolated flesh that grew out of boyhood without guidance or purpose."[69] Significantly, Emma does not appear to register her brother's horrifyingly misogynistic attitude. She gently chides him, saying that her woman's club, which has invited Charles to give a lecture, would not be a receptive audience for such a speech. Emma adds that a widow, "that nice Mrs. Potter" (Frances Carson), was asking after him. Charles, accompanied by Charlie, met her when he was depositing a large amount of money in the bank where Joseph Newton works.[70]

Charlie embodies a contemporary version of femininity that holds the marriage question at bay. This is not to suggest that Charlie doesn't want to get married—"I don't mind," she emphatically answers, in close-up, when her mother asks if she'd like to show Jack Graham the town at night, as he suggests—only that pining for marital status isn't a project that defines her. She also has conventionally masculine traits that mark her as being, like her male-sounding name, atypically feminine, especially in contrast to her powerless, nebbish father. "You're the head of your family, Charlie. Anyone can see that," Charles notes.

In contrast to her first-born, Emma embodies a domestic ethos with roots in Victorian America.[71] Her values are firmly rooted in home, family, and kitchen; the central figure in the household, she signifies the family itself. Yet Emma has an eccentric air about her, in part because of Collinge's tremulous acting style.[72] The script and the director's treatment reinforce these aspects of Emma's personality; as Pomerance observes, she is a "woman for whom in virtually all things the eggs don't go into the cake until the butter and sugar have been creamed."[73] Graham and the other detective, Fred Saunders (Wallace Ford), posing as the poll-takers, get Emma to bake a maple cake for Charles ("his favorite") in front of them while Saunders takes photos—all a ruse to get a shot of the Dracula-like Charles, who refuses to be photographed. Emma's refusal to crack an egg out of the recipe sequence simply for the photographer's convenience suggests not only her rigidity (a quality that also characterizes Charlie's younger sister, the fact-focused, bespectacled little girl Ann), but also her understanding of the cracking of an egg as a momentous event. Emma wants nothing to be cracked open, certainly not the family's veneer of normalcy (though she does say in reference to the poll: "I told him we weren't a typical American family").

The broken-egg motif links Emma to another mother, Lydia Brenner (Jessica Tandy) in *The Birds*, who spies the row of broken teacups, an emblem of fragility, in the solitary farmer Dan Fawcett's house. (She also discovers his corpse, his eyes hideously pecked out.) Emma repeatedly asks what's wrong with her increasingly tense, angry daughter, now prone to outbursts, such as when she explodes at her father and his friend, the morbid milquetoast Herb (Hume Cronyn), for having one of their ghoulish conversations about the perfect murder at the dinner table.

Charlie's outbursts, more than any other moments in the film, suggest incestuous abuse. Emma does express great concern when Charlie falls on the backstairs, yet she seems chiefly motivated by a desire not to know. Emma and Charlie are never shown having a heart-to-heart talk about *why* Charlie has become so upset. Emma remains frozen in her liminal position between knowledge and its disavowal. This impossible position is visually rendered in the stunning close-up of Emma in the taxi as the family departs one evening for Charles's lecture at Emma's ladies' club. In one of several attempts to murder his niece, Charles trapped Charlie in a garage full of carbon

monoxide. Herb happened to be walking by and alerted the family, and Charlie was rescued with not a moment to spare. (Herb merits further consideration.[74]) In the taxi speaking out loud to no one but herself, Emma muses, "I just don't understand it. First the stairs and . . .," and verges on connecting the garage incident to Charlie's mysterious fall on the outdoor stairs (rigged by Charles), but the realization cannot become manifest. (The family's behavior during this entire scene is remarkably strange: Charlie has nearly died under extremely suspicious circumstances, yet everyone but Charlie still goes to the lecture. Why doesn't Joe notice any of this either? He is even more repressed, more determined not to know, than Emma, even though he remarks, as does his wife, that they should all skip the event.)

Later, back at home after the lecture, Emma busies herself with handing out hors-d'oeuvres: crustless little tomato sandwiches and cream-cheese and paprika sandwiches. Emma encourages the guests to eat the latter because the tomato always seeps through the bread. As is typical of Hitchcock's food imagery, this detail vaguely signals an emotional queasiness and hints of bloodletting. (The moment anticipates the hilariously grisly and inedible gourmet meals the chief inspector's wife prepares for him in *Frenzy*.) And the guest she encourages at this moment is "that nice Mrs. Potter," the widow who will most likely be Charles's next victim after he dispatches his niece. The hints of darkness in Emma's character prefigure the dark, dubious mother characters in Hitchcock's later works. But like many of these Hitchcock mothers, Emma's vulnerability makes her more pitiable than anything else; and however naïvely she loves her brother, it is difficult to fault her for this love.

DECENTERING AND DOUBLING

If the dominant gender in American society in the 1940s was indubitably the heterosexual male, and the white male at that, and if the dominant form of sexuality was indubitably heterosexuality, Hitchcock here (as elsewhere) radically decenters both of these structures. Heterosexual relations are depicted as awkward, tentative, and lackluster. Moreover, Graham is hardly the male hero who swoops in to rescue the endangered woman. Charlie cannot reach him on the phone after Charles has tried to kill her in the garage and everyone has gone to hear him give his lecture. Both Hitchcock's characteristic disdain for the police and indifference to typical heterosexual romance inform the film's treatment of this would-be romance. The *New Yorker* short-story writer Sally Benson, one of the film's screenwriters, added warmer touches to the family to make them more engaging and added new character, a boyfriend for Charlie, described in early drafts as a "scapegrace" and a "a John Garfield type." Hitchcock, however, cut the boyfriend out. As indicated by the choice of the lesser actor Macdonald Carey as Graham, the final incorporation of a standard heterosexual romance in the Charlie/Graham relationship was an afterthought—a "commercial concussion" in the director's own words.[75] In their

pre-production notes, Hitchcock and his wife Alma Reville, who also worked on the screenplay, emphasized Charles's incestuous allure for Charlie, a motif they retained.

Charlie's lack of heterosexual heat otherwise makes her attraction to Charles all the more palpable and powerful.[76] But it also has the effect of suggesting that, as Alexander Doty noted, she may be lesbian/queer herself. Although there are no moments in the film, to my mind, that suggest Charlie's attraction to women, that her own sexuality is somewhat of a blank is notable, especially in a winsome film era in which roles for young women, reflecting the wartime boom in marriage, usually revolved around their ardent desire to be married (the World War II era's rejiggering of traditional gender roles is a factor here as well, to be sure).[77] The blankness of her own sexuality—or, better put, its indeterminacy; blankness seems the wrong word to use for a presence as vivid as Wright's onscreen—makes Charlie a suggestively queer character. When Graham (who does not seem particularly sexually driven either) discusses the possibility of marriage with Charlie in the garage—and marriage rather than romance is what comes up here in dialogue written and/or revised by Collinge—her response is not an indifferent one, but it is notably circumspect, paling next to the intensity of her responses to Charles.

Charles not only gives his niece a goad to self-expression but also an opportunity for it, which here takes the form of inhabiting his magnetic narcissism. When walking with Charles to the bank where her father works, Charlie notices with barely containable pleasure how obviously and avidly her female friends ogle her dashing uncle. She gushes, "Did you see the way they looked at you? I bet they wonder who you are. Uncle Charlie, I love to walk with you. I want everybody to see you!" Inhabiting his narcissism and theatrical self-presentation (which she will realize in the bank for the first time has its dark side, as Charles humiliates her father with ostentatious, eye-raising talk of fraud and other scandalous topics), Charlie shares in the thrill of his attention-getting attractiveness. This attractiveness makes him a subversive persona, a man who connotes "to-be-looked-at-ness." Charlie, so it seems, vicariously and pleasurably inhabits Charles's subversive pleasure in his own sexual appeal. Perhaps she similarly channels his queerness, and in so doing, inhabits the possibilities of her own desirability and potential queerness. (As I discuss in chapter 4, the queer *male*'s relationship to the narcissistic male's sexuality is a masochistic one. I do not see Charlie's relationship to Charles as masochistic, a key difference; rather, she willingly offers herself as a pupil of his narcissistic tutelage in the hopes of developing such aplomb herself.)

What such moments speak to, I think, is the still-evolving nature of Charlie's own sexuality, one of the reasons why her uncle's seemingly fully formed persona holds such a fascination for her. Perhaps we can describe Charlie's sexuality as, rather than blank or indeterminate, amorphous. As Lillian Faderman writes in her study of twentieth-century lesbian American history, *Odd Girls and Twilight Lovers*, pertaining to the 1940s:

> For some young women, their war-related experiences helped them define amorphous feelings that they had been struggling with and for which they had no word

and no concept, terms such as "romantic friendship" or "smashing" being by now nonexistent. Young females in earlier eras might have explained their attractions with just those words, but by the 1940s such feelings were clearly seen as lesbian, and many women could and did learn to apply that term to their emotions during the war.[78]

While Charlie is not typed as a lesbian, the open-endedness of her desire, signaled by her lack of clear interest in Graham and by her fascination with her uncle, which could be as much a defense against erotic feeling as a suffusion of it, her amorphousness as a desiring subject intersects on some levels with developing cultural views of the lesbian. If Charlie is indeed a portrait of such a feminine type, her annihilation of her queer uncle—even if by "accident"—has even more alarming, poignant urgency.

Charlie and her potentialities appear to enflame Charles's own desires. Strikingly, while Charlie and Graham are having their talk in the garage, Charles (unseen) slams the door shut, leading them to struggle to open it. Is it possible that he is threatened by the heterosexual couple's intimacy and possibilities? It seems an oddly aggressive gesture, one designed to fail if it is meant to be the first phase of the plot to trap Charlie in the garage. When the couple finally breaks out of the garage, they find Charles pacing up and down the front lawn. Charles's reactions are interesting. He has been exonerated, for the moment, because the other suspect died while being pursued. When Graham explains that he will be returning not to conduct the poll (his cover story, which Charles has seen through) but instead to call on Charlie, Charles smiles with overabundant cheer and cups his niece's neck in one of his killing hands, one of those signature loving-yet-murderous gestures in Hitchcock. What lies behind the ferocity of this gesture—a desire to intimidate his niece? A competitive show of ownership designed to put Graham in his place? An expression of murderous hostility, in keeping with his animus against "the useless women" he kills? A helplessly passionate, awkwardly rendered expression of his own desire? Charles seems more like a mock older brother here, acting as the would-be father to whom his daughter's suitor wanly professes his romantic intentions (another displacement of the actual paterfamilias). The scene confirms Juliet Mitchell's observation that "[i]t is . . . not only jealousy but violence . . . which is an intrinsic possibility" in sibling relationships. "Violence is . . . always a potential of all sibling relationships and of sibling sexuality and incest."[79] Charles's status as a killer makes such a possibility an overdetermined one.

In the scene after Charlie stands unflinchingly in the doorway (a fateful location), silently challenging him with the force of her knowledge and judgment, Charles paces up and down in his room (Charlie's bedroom, significantly), and Hitchcock uses an array of expressionistic devices to suggest his furor and disorientation: canted angles, long jail-bar-like shadows, and Dmitri Tiomkin's brooding score, in which he "distorted the familiar melody" of Franz Lehar's "Merry Widow Waltz" from his operetta (which premiered in Vienna in 1905) "into a sinister tone poem."[80] As Charles looks down from the window

of the room at Charlie below, his hands clench menacingly, as if he were wringing her throat, and a phallic cigar drops from one of his hands. Given this suggestion that her authority and threats emasculate him, his overwhelming grip on her neck after Graham's announcement was an attempt to restore his phallic power in the face of the heterosexual couple-in-the-making—a competitive and pathetic gesture.

One of Hitchcock's most famous effects in *Shadow* is the Merry Widow montage of elegantly dressed couples, men and women, dancing to Lehar's waltz. As I have argued elsewhere, this motif, used in the opening credits and at other key points, provides a visual complement to Charles's psychosexual obsessions while also signifying institutionalized heterosexuality.[81] After Charlie leaves the kitchen wearing the emerald ring, Charles broodingly paces as the motif suffuses the screen. It recurs when Charles plummets from the train at the climax, another train roaring by in the opposite direction and obliterating him.

It is crucial that the Merry Widow motif also appears when only Charlie is onscreen. As she leaves the library after reading the newspaper story about her uncle's murders, the motif suffuses the image. It clearly signifies Charles's crimes and psychology, yet it also suggests the unrest in Charlie's mind, perhaps even an unraveling. The whirling procession of dancing couples, at once a parade of heterosexual normativity and an evocation of a vanished past, dwarfs her. Indeed, she is literally dwarfed in the frame, a solitary and diminished object in the famous high-angle crane shot that Hitchcock uses to show her lonely despair as she slowly walks out of the library. His visual design and Wright's body language convey Charlie's shock of recognition and her ensuing isolation. She is too disoriented to even fold up the newspaper and put it back on the rack.

Both Charles and Charlie are citizens of somewhere else (to paraphrase Hawthorne), much like Marion Crane and Marnie Edgar, adrift in a shadow world between the realities of the normative social order and the increasingly threatened, fragile fantasy life they have created as a bulwark against it. Significantly, Charlie and Charles refer to one another as "twins." In the end, the twin-like Charles and Charlie, so complicit in their mutual admiration and sense of apartness, can find neither recognition from nor reconciliation with the other. In political terms, what does their simultaneous likeness and estrangement reveal about Hitchcock's understanding of the place for both female desire and queer desire in the larger culture? Juliet Mitchell writes of twins: "In negotiating this split into two 'I's, it is all too easy to make one good 'I' and one bad one—then later 'I' will become the good 'I' and you will be the bad one—war looms."[82] Despite having two biological siblings, a younger sister and brother, Charlie finds her true sibling, her twin, in Charles. Speaking to the use of twin motifs in film noirs of the period such as *The Dark Mirror* (Robert Siodmak, 1946), Mitchell offers insights that illuminate *Shadow*: "When the other who has been identified with dies, reality makes it harder to perceive that we were dealing with the problem through fantasy: the problem, whether actual or imagined, becomes death: the dark mirror in which one is not reflected signifies death."[83] *Shadow* thematizes social patterns, apprehensive of Cold War era politics,

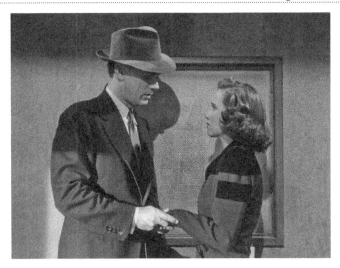

FIGURE 2.3 Dark mirrors: Uncle Charlie (Joseph Cotten) has murder on his mind, but it is Charlie who will send him to his death.

in which unevenly marginalized groups, in this case heterosexual women and queer men, perform the roles of such dark mirrors for one another. When Charles and Charlie face one another on the train at the climax, murderous intent assuming the visual appearance of a marriage vow, their matched physical positions and mutual gaze visually and symbolically reinforce the mirroring theme (see figure 2.3).

The next film we discuss deepens the shadows within the mirrors.

3

Mirrors without Images

SPELLBOUND

SHADOW OF A Doubt, as we have seen, stages a battle to the death between the heroine and her uncle that allegorizes the rivalry—and intimacy—between heterosexual female and queer characters in Hitchcock's films. (Disturbingly, it also allegorizes the conflicts between feminists and queer theorists in their readings of Hitchcock.) I theorized the political implications of the feminine-versus-the-queer thematic as *sexual hegemony*, which pits the socially abnegated against one another while leaving those at the top in a frenzied struggle to retain power. One of the reasons why sexual hegemony is both so visible and potent within Hitchcock films is its tendency to destabilize the structures of male dominance that typically characterize classical Hollywood narrative, allowing for other kinds of preoccupations to emerge. Hitchcock's heterosexual male protagonists' attempts to exert control often result in revealing failures; moreover, his films frequently make the male an object of sexual desire. Once the male is subjected to sexual scrutiny, the logic of mainstream film narrative undergoes a revision. The gendered hierarchies of classical narrative insist that the male looks at and dominates the visual field, which places objectified others in positions of submission; the reverse happens in Hitchcock films and has crucial implications. First, the man's seeming control over both narrative and objectified others, such as the sexually objectified woman and inferior male types (ethnic, raced, and sexually deviant), notably weakens. Second, as the man's power recedes, and the sexual gaze is redirected at him, heterosexual female and queer characters (and their struggles for narrative power) come into sharper focus.

In her famous essay "Visual Pleasure and Narrative Cinema," Laura Mulvey used *Vertigo* as representative of the male protagonist's voyeuristic determination to investigate the woman and penetrate her mystery. Films such as *Suspicion, Shadow of a Doubt, I Confess, To Catch a Thief, Psycho*, and *Frenzy*, however, revolve around a male character's inscrutable psyche. Even *Rebecca*, ostensibly devoted to the overwhelming enigma of the titular female character, could be placed in this category—the heroine is as perplexed and beguiled by her moody husband's emotional instabilities as she is by the alluring and maddening mystery of his dead first wife. I argue that the inscrutability of the male character's psychic life stands in for and insinuates the problematic and even more compelling inscrutability of the man's sexual identity. The recurring interest of Hitchcock films in exploring the interiorities of inaccessible males inevitably lends itself to the crisis of hetero/homo definition central, as Eve Sedgwick posited, to the twentieth century. I argue that Hitchcock's movies often revolve around a figure of *male suspenseful mystery*, to rework Richard Allen's concept.[1] Male suspenseful mystery intersects with the feminine-versus-the-queer thematic in its decentering and destabilization of male authority.

Hitchcock's silent film *The Lodger: A Story of the London Fog* (1927) is the foundation for these patterns. Its titular figure, played by the matinee idol Ivor Novello, embodies male suspenseful mystery. That the Lodger may be the serial killer of blonde women known as the Avenger adds to the threat of his eerie and enigmatic persona, as does his seeming horror when beholding images of blonde women in the paintings that adorn his rented room. His new landlady, suspicious of the Lodger right from the start, must then take them down from the wall. Her daughter, the blonde and attractive model Daisy Bunting, is much more sexually interested in the Lodger than she is in Joe, the more conventionally masculine police detective her parents prefer. She flirts and falls in love with the Lodger, caressing his bleeding face when he is attacked by the mob that mistakenly believes he is the Avenger, putting herself in danger along with him. She then marries him. The film's focus, however, is on neither the romance nor the hunt for the Avenger but rather on the sheer strangeness of the Lodger himself. Novello, with his odd, mournful beauty and idiosyncratic emotionalism, exquisitely embodies this strangeness. *The Lodger* prefigures the depictions of a murderous darkness within male hysteria in *Rope* and *Psycho*, frequently tricking us into believing that Novello's character verges on violent action. Hitchcock often cast leading men who were gay or bisexual, and usually young, handsome, and dark-haired, such as Novello, Farley Granger, John Dall, Montgomery Clift, Cary Grant, and Anthony Perkins. These men, tremulous brunets, offer a male counterpoint to the vaunted Hitchcock blonde.

In *Spellbound* (1945), the male is once again the source of suspenseful mystery. Before proceeding to a fuller analysis of the film, I want to take a moment to remind the reader of key details of the plot. Dr. Constance Petersen (Ingrid Bergman) anticipates, with her fellow psychiatrists at the Green Manors mental asylum, the arrival of Dr. Edwardes, the brilliant author of an acclaimed new psychoanalytic tome, *Labyrinth of the Guilt*

Complex. He is classically tall, dark, and handsome, and, as the role demands and Gregory Peck plays him, an unusually tremulous male lead who brings to mind Novello and anticipates Perkins in *Psycho*. Dr. Edwardes has come to the institution to replace the aging Dr. Murchison (Leo G. Carroll). Murchison has had some form of a nervous breakdown, although now appears to be completely recovered. Indeed, it is Dr. Edwardes who seems to be in need of help. Constance eventually discovers, after Dr. Edwardes's behavior grows increasingly erratic, that he is really an amnesiac named John Ballantyne, not a psychiatrist but a physician who was being treated by the *real* Dr. Edwardes for the guilt he has always felt for his younger brother's death. Dr. Edwardes, one of those analysts who believe that physical exercise and activity are important to psychiatric treatment, took his troubled, guilt-ridden patient on a skiing trip. Dr. Murchison killed Dr. Edwardes while he was on the slopes and has used the temporary amnesia of Ballantyne to his advantage. Due to his guilt complex, Ballantyne becomes convinced that he is the real Edwardes, allowing Murchison to continue on as the head of Green Manors. Constance, her faith in Ballantyne's innocence unshakeable, attempts to exonerate him while helping him discover the source of his guilt complex. Fugitives from the police, Constance and John visit her old mentor Dr. Alexander ("Alex") Brulov (Michael Chekhov). Though reluctant and skeptical, urging her to give John up to the police, Alex helps Constance in her treatment of Ballantyne. They work together to decode an elaborate dream he recounts that contains clues to the Edwardes mystery. Constance, believing that reenacting the scene of the crime will jolt Ballantyne into clarity, takes him to the ski resort Gabriel Valley where Edwardes was last seen. While their ski ride is fraught with potential menace, at the last possible moment, Ballantyne saves Constance (and himself) from plunging to their deaths, in the process remembering that when he was a child he accidentally killed his brother. His brother was sitting at the bottom of a slide; when John went down the slide, he pushed his brother off it, impaling him on sharp metal spikes. It appears that Constance has freed Ballantyne from both his labyrinthine guilt for *two* deaths (one he only accidentally caused, the other he never did) and charges that he murdered Edwardes. But when the authorities discover Edwardes's body, they also discover that it has a bullet in it. Ballantyne is convicted of murder and jailed, leaving Constance bereft. Back at Green Manors, where Constance, thanks to Alex's help, has been reinstated, Murchison makes a telling slip, saying that he "knew Edwardes slightly," which contradicts his earlier statement that he'd never met him. Constance, going back to the dream analysis, visits Murchison in his office later that night and confronts him with the knowledge she has gained through "psychoanalytic findings": Murchison killed Edwardes. Ultimately, Murchison kills himself after Constance confronts him. Constance and Ballantyne are then free to marry.

A crucial dimension of male suspenseful mystery is that the woman is shown to be the investigator who seeks and possesses knowledge. Constance's quest for knowledge has a dual goal: to provide empirical evidence for what she already intuitively believes, Ballantyne's innocence, and to help him uncover the source of his psychosexual maladies,

rooted in his childhood. Like *The Lodger*, *Spellbound* presents the woman as steadfastly loyal to the wrongly accused man. Here the woman exonerates the man of any criminal charges, and in *Shadow of a Doubt* she threatens to do the reverse, yet these narratives both share the position that only the woman can penetrate and solve the crime of male psychosexual instability. As I show throughout this book, the woman's relationship to knowledge is also inextricable from her involvement in a labyrinthine realm of intrigue related to male sexuality, homosexuality especially.

Of course, major Hitchcock works such as *Notorious*, *Vertigo*, and *Marnie* make the investigation of female sexuality the focal point. Yet the films in which the woman's sexuality is a central preoccupation sustain the interest in decoding and gaining access to enigmatic male sexuality. *Notorious* crystallizes these dynamics and has close ties to *Spellbound* (Ingrid Bergman starred in and Ben Hecht was the screenwriter for both). Cary Grant's government agent Devlin, or "Dev," is introduced, early on, from the back: a shadowy form sitting in a chair, his face hidden from us, a visual introduction of him *as* a mystery. And the narrative that follows makes the discovery or exposure of Dev's sexual and emotional truth—his actual feelings for Alicia, to begin with, but also his feelings toward the opposite sex ("I've always been afraid of women," he remarks)—one of the main sources of suspense.

In films such as *The Lodger*, *Shadow of a Doubt*, *I Confess*, and *Spellbound*, the woman's sexual obsession with the romantic male lead opens his character up to a queer reading. Ballantyne and, as I will show, the villain Dr. Murchison both embody a distinct version of queer masculinity, doubling one another. Analogously, the queer antagonist of *Notorious* is bifurcated in the villain Alex Sebastian (Claude Rains) and his mother Mrs. Sebastian (Leopoldine Konstantin), who plot to poison Alicia once they discover her spy identity. The mother-son duo doubles both the romantic leads Dev and Alicia and the controlling Murchison of *Spellbound*. The queer villains of these films are suspect personae whose questionability is alternately deepened by their lack of marital and family ties (*Spellbound*) or the overdetermined presence of them, such as the too-close bond between Alex and his mother in *Notorious*, a dynamic that is revisited in *Strangers on a Train* and, of course, *Psycho*. Moreover, both films crucially explore the dynamics and implications of an *active female sexual desire* in relation to a destabilized heterosexual male figure on the one hand, and a proto- or coded homosexual male figure on the other. This topic is one of the main points of my analysis of *Spellbound*.

Spellbound is important as the Hitchcock film in which psychoanalysis is explicitly foregrounded as a subject. Psychoanalytically oriented, Hitchcock's films dramatize one of the discipline's central tenets: We are strangers to ourselves, to take from the work of Julia Kristeva. Moreover, as Richard Allen writes, Hitchcock's films are Freudian in their interest in perversity—a challenge to the normative social order and its cynosure, the heterosexual couple—as well as the ways in which "sexuality is a source of profound anxiety" in them.[2]

The Freudian cast of Hitchcock's films is linked to the director's use of techniques from both Expressionism and Surrealism, artistic movements tied to the emergence of psychoanalysis. *Spellbound* illustrates the influences of both. When Constance and John kiss for the first time, Constance shuts her eyes, and the shot dissolves into one of doors endlessly opening in a corridor in an ethereal realm. For a few seconds, the two images, Constance's shut eyes and the doors opening, fuse, so it appears that Constance's eyes are on either side of the open door, forming a kind of face in which the open doors are a mouth, a Surrealist image par excellence (like the corridor of opening doors itself). This shot then dissolves into one of the lovers kissing, and the fusion of these images—the romantic couple kissing with the corridor of open doors at their center—is held for a duration, a swooning romantic effect greatly intensified by the love motif in Miklos Rozsa's score. Clearly, the effect is intended to suggest the transport of awakened love and desire in the heroine, as if we have gained access to her unconscious. As I will discuss, the motif of doors also allegorizes the opacity of male identity, linked to the question of sexuality, homosexuality in particular. The other famous image in the film, the drapes covered in huge, staring eyes in the dream sequence by the Surrealist artist Salvador Dalí, reinforces the idea of inscrutability within male subjectivity—and the desire to penetrate this mystery, as the shot of a man wielding enormous scissors and cutting into those eyes suggests.

There is a tendency in criticism of *Spellbound*, which usually treats the film as a failure, to see psychoanalysis as its MacGuffin, a motor for the plot that Hitchcock treats with an ironic (or embarrassed) distance.[3] Andrew Britton concludes his painstaking analysis of the film with the surprising assessment of its "grotesque uncertainty of tone," which stems from "Hitchcock's profound unease" with the material.[4] Yet from the outset, *Spellbound* presents psychoanalysis as a romantic and humane approach to "the emotional problems of the sane," to quote from the preamble. The psychoanalyst heroine's faith in her discipline mirrors the belief she maintains in her beloved's innocence. While neither Hitchcock nor Hecht evince a reverential attitude toward psychoanalysis—and in this regard their sensibilities were in conflict with the producer David O. Selznick, who was in analysis at the time and hired his own psychoanalyst, May Romm, as a consultant on the film—it is also a mistake to read *Spellbound* as a sustained ironic undercutting of its premise. Psychoanalysis, I argue, is one of the varieties of love in this film, an allegory *for* love and its ability to dissolve barriers between lovers.

At the same time, psychoanalysis, as embodied by the psychiatric institution Green Manors as an architectural entity, is presented as an enclosed and potentially sinister realm. This last point relates to *Spellbound*'s queer uses of the Gothic genre. If Murchison represents a revised Gothic mode (the haunted institution rather than castle or old, dark house), Constance's characterization signals valences with another genre. Hitchcock's first American film *Rebecca* fused the modes of the Gothic and the woman's film, hence its description as a "female Gothic." *Spellbound* does so as well, though less explicitly.

Constance's maternal quality has been read as clichéd, hokey, and overbearing. Pauline Kael scorned: "It was fitting that the actress who was once described as a 'fine, strong, cow-country maiden' should be cast as a good, solid analyst, dispensing cures with the wholesome simplicity of a mother adding wheat germ to the family diet, but [Ingrid] Bergman's apple-cheeked sincerity has rarely been so out of place. . . ."[5] Others have read the film as evidence of Hitchcock's ambivalence toward the professional woman, who can only be a true woman by giving up her job and becoming "motherly," like the bespectacled Midge (Barbara Bel Geddes) in *Vertigo*. For example, Mary Ann Doane argues that *Spellbound* incorporates psychoanalysis chiefly as a means of reinforcing sexual difference.[6] Doane contends that in most films of the period that showcase mental illness, psychological maladies adhere to strict gender lines, with male troubles linked to wartime trauma or some other specific, local cause, whereas, for women, psychological distress bespeaks an essential discomfort or inability to cope with the condition of femininity itself. E. Ann Kaplan argues similarly that the film displaces the real-world trauma of World War II onto the private, personal trauma of Ballantyne's childhood accident that resulted in the death of his brother, the source of his guilt complex; gender relations are similarly charged with these displaced disturbances. She reads Ballantyne's outbursts toward Constance as an indication of the film's own conflicted responses about representing war trauma, its impasse over these matters.[7]

I argue that these outbursts indicate Ballantyne's misogyny and, as such, deepen the implication that the central heterosexual relationship must be regarded with suspicion, an attitude consistent with Hitchcock's films generally. Ballantyne's expressions of anger toward Constance all stem from her active role as investigator; implicitly, being married to him will severely curtail her autonomy though, to be sure, it is also quite clear that being married to him is what she desires. Ballantyne's dread of woman is a key facet of the film's overall portrait of a disturbed relationship that nevertheless has positive value for the woman, in that she makes something positive for herself out of it, both romantically *and* professionally (his case affords her the opportunity to hone her craft).

If *Spellbound* presents Constance as being in conflict with her femininity, it also does not diminish or belittle her intellectual gifts. As I will discuss further, Constance's maternal tenderness toward John never diminishes her psychoanalytic deftness. The film explores the professional woman's conflicts between her career and her erotic desires. (Despite the number of women psychoanalysts in the history of the movement, such as Karen Horney, Melanie Klein, and Freud's own daughter Anna, Green Manors is an almost entirely male-homosocial place. Constance is the only female character, except for one patient, Mary Carmichael, and a hard-bitten nurse with an obtrusive stare. Britton argues that *Spellbound* is a film about invasive "looking.")

This chapter will explore several interrelated issues foregrounded in *Spellbound*: the relationship between homosociality, queerness, and the Gothic; *Spellbound* as a woman's film; lesbian panic; Hitchcock's and Freud's treatments of active female desire; masculinity and the blank image, which continues our discussion of Uncle Charlie's relationship

to his image in *Shadow of a Doubt*; and the feminine-versus-the-queer thematic. In terms of the latter, the last section will focus on *Notorious* and its overlaps with *Spellbound*.

"YOU ARE GREEN MANORS": GOTHIC VILLAINY AND THE HOMOSOCIAL

Spellbound's opening credits are set against a barren tree that is being bombarded by harsh winds that threaten to denude it even further—a poignant metaphor for the ravaged psyches on display. The epigraph that follows is an incomplete version of Cassius's lines to Brutus in Shakespeare's *Julius Caesar*: "The fault . . . is not in our stars, but in ourselves." As I will show, this canned piece of Shakespearean rhetoric nevertheless has some important valences.[8] We see, in a matte shot (a type of shot created by masking the background and then adding one later during the printing process), the psychiatric institution Green Manors from a distance. It appears imposing yet isolated. We cut to a shot of the front doors of the institution; before we venture in, a preamble scrolls down the screen extolling the noble goals of psychoanalysis. Regarding the patient, the analyst seeks only to "open the locked doors of his mind." Once disturbances have been brought to light, "illness and confusion disappear" and "the devils of unreason are driven from the human soul." That the preamble scrolls down against a shot of closed doors, doors being an important motif here, implies that Green Manors is a forbidding place, the secrets of which will be revealed. As an architectural entity, Green Manors increasingly takes on a sinister appearance: It looms darkly in the final nighttime shot of it, the Terrible House of the Gothic imagination. When Constance says to Dr. Murchison, "You are Green Manors," the line makes a particular association salient: "In Gothic fiction the central element is always the gloomy Gothic building which is inextricably associated with the villain."[9] The shut doors metaphorize the pursuit of knowledge, which *Shadow of a Doubt* and *Spellbound* depict as female-focused.

The source material, the 1927 novel *The House of Dr. Edwardes* by Francis Beeding, teems with Gothic motifs. As Leonard J. Leff parses the novel's plot: "High in the Alps, homicidal maniac Godfrey Godstone locks up Dr. Murchison, the real head of Chateau Landry and assumes management of this 'house of rest for the mentally deficient.' A new staff psychiatrist named Constance Sedgwick discovers Godstone's secret, but by herself cannot expose him and free Murchison. At the climax, Dr. Edwardes, a distinguished psychiatrist and the owner of the asylum, arrives and restores order," leaving Murchison free to wed Sedgwick.[10] Hitchcock and Angus MacPhail, in the first treatment of the material, shifted the romantic interest for Constance to the would-be Edwardes, who is actually Eric Hunter, a U.S. medical officer. Hunter mistakenly believes that he is Edwardes as a result of his guilt complex (an idea retained in the final film script). Fascinatingly, however, this earlier treatment ends with a caustic joke about the hero's supposed innocence: "The authorities clear him, and as 'Constance and Hunter leave the court together, he pulls a lock of hair over his forehead, scowls, and gives the Nazi salute!'"[11] "Hecht never read the novel, working instead from" the adaptation by MacPhail.[12]

The novel and the first Hitchcock-MacPhail treatment contain the seeds for important tensions in *Spellbound*, chiefly the enigmatic and suspect psychology of Ballantyne and the genuine bond between Murchison and Constance. The MacPhail treatment reveals the amnesiac hero to be a nefarious villain. Beeding's novel ends with Murchison and Constance getting married. The novel concludes, as it opens, with a letter by a character named Susan who tells us, "The most awful things happened. It appeared that the lunatic . . . was also a doctor, and that he kept the real doctor shut up for weeks, and ran the place by himself with the assistance of the pretty girl who was new to her job [Constance]. . . . in the nick of time, the old doctor to whom the establishment really belonged . . . turned up. . . . Well, the real doctor, who had been shut up by the lunatic, was, of course, released," and he and "the pretty girl" marry.[13]

As Leff notes in *Hitchcock and Selznick*, the director and Hecht defied Selznick's dictates (supported by his analyst May Romm) that Murchison, Ballantyne, and Constance be in a love triangle. Whereas Selznick insisted that the older Murchison should also be in love with the beautiful analyst and compete for her love against Ballantyne, Hitchcock's film leaves Murchison's sexuality an open question, thus evoking the "open secret" of homosexuality. Single and associated with neither a wife nor a family, Murchison, much like Constance's mentor Alex Brulov, is suggestively unattached.

The film establishes that Murchison and his younger colleague Constance have a bond. Constance is extremely fond of her now-departing superior, and he is respectful of her. The young woman's regard for her older boss may reflect something of the earlier possibility of a romantic interest between the two. What beckons a queer reading is that the film retains their bond yet makes it a nonsexual one. Their climactic confrontation, in which Constance presents Murchison with irrefutable evidence that it was he who killed Edwardes, is no less troubling for being a decisive rift between nonromantic intimates.

As the antagonist of the film, Murchison is associated with longstanding attributes of the Gothic villain, such as a paternalistic air, a sadistic yet shadowy personality, and associations with the Gothic house. Significantly, Murchison projects his own psychosexual obsessions onto Ballantyne. After Ballantyne has collapsed during a medical operation and Dr. Edwardes's secretary, five years in his employ, has alerted the authorities to the fact that he is not Edwardes, a detective comes to Green Manors to arrest the imposter, who has already fled before he arrives (not before leaving Constance a note telling her that he loves her and will be staying at the Empire Hotel in New York City). Talking to the detective, Murchison diagnoses Ballantyne as displaying the "short-sighted cunning that goes with paranoid behavior," accusing Ballantyne of having done what *he* has done—murdered Edwardes. We recall Freud's 1922 essay that drew connections among jealousy, paranoia, and homosexuality.[14] In his earlier analysis of the psychotic Dr. Schreber, Freud had postulated that the underlying mechanism of paranoia was the transformation of homosexual love into hate.[15] Further adding to the composite portrait of homosexual paranoia in the film, Brulov, in several respects Murchison's double, complains to the police about their relentless "persecution" of him in their efforts to

investigate Edwardes's death. (And Brulov and Murchison both reveal that they thought ill of the murdered man. Brulov found Edwardes's therapeutic techniques, such as participating in strenuous physical exercise with the mentally ill, repulsive. Edwardes was treating Ballantyne by taking him skiing when Murchison shot his rival. We'll return to Murchison's animosity.)

In her well-known theory of the "paranoid Gothic," as we discussed in the introduction, Eve Sedgwick—with Freud's Schreber case in view—argues that "paranoia is the psychosis that makes graphic the mechanisms of homophobia." Discussing a select archive that includes *Caleb Williams, Frankenstein, Confessions of a Justified Sinner,* and perhaps *Melmoth the Wanderer* and *The Italian,* Sedgwick identifies these works as being about "one or more males who not only is persecuted by, but considers himself transparent to and often under the compulsion of, another male. If we follow Freud in hypothesizing that such a sense of persecution represents the fearful, phantasmic rejection by recasting of an original homosexual (or even merely homosocial) desire, then it would make sense to think of this group of novels as embodying strongly homophobic mechanisms."[16] Patrick Brantlinger builds on Sedgwick's ideas in his argument that "the fundamental transgression is valenced homosexuality, with one (or both) of the twinned male protagonists playing the role of sadistic villain, and the other (or both) playing the role of masochistic villain."[17]

Hitchcock carries this "male double-going pattern" into the cinema, especially in works such as *Rope, Strangers on a Train, I Confess,* and *Psycho. Strangers,* as I show in the next chapter, foregrounds the villain's masochism. In contrast, *I Confess* focuses on the masochism of its hero, the Catholic priest Father Logan (Montgomery Clift). A murderer obsessively hounds the young priest after confessing his crime to him. Bound by religious doctrine, Logan is unable to reveal what he knows and falls under suspicion himself because of complications in his backstory. Murchison does not play so direct a role in Ballantyne's affairs, but the murder he commits triggers the afflicted younger man's guilt complex, resulting in his amnesia. In Brantlinger's terms, Murchison eschews the Gothic villain's typical pursuit of the imperiled woman in favor of pursuing and killing a male, Edwardes literally, Ballantyne indirectly. As Peck so nakedly plays the role, Ballantyne's vulnerability is striking, especially in contrast with Murchison's controlled and steady demeanor. Yet there are powerful overlaps between these characters: Ballantyne can be imperious and violent even in his helpless confusion, and Murchison reveals a surprisingly wearied and even pitiable side when his crimes come to light.

Though the older analyst is always represented as solitary, apart from the group, a consistent association is made between Murchison and homosociality. In the scene in which one of the staff shows Edwardes/Ballantyne his quarters, a large study with a bedroom behind it, and also introduces him to several of the male analysts gathered there, Murchison enters the room. He does so singly, walking up to his seeming successor and introducing himself. Notably, Constance is not present in this homosocial enclave. Murchison, as Leo G. Carroll plays him, gives the tiniest of double-takes upon seeing

"Edwardes." "You're much younger than I expected," he remarks, shaking hands with the tall young man. Murchison and Ballantyne walk across the room and join the male analysts on the other side of it. Saying a minimum of parting words, Murchison hands over the office to his successor, an awkward moment smoothed over by Murchison's dry aplomb. Strikingly, there is a cut to a master shot in which all present in the screen are visualized. From a distance, we can see the homosocial group centered around Ballantyne on the left, and Murchison, alone, walking across the room and exiting his former office. It's as if Murchison has brought Ballantyne—known by Murchison to be an imposter— into the homosocial realm and then singly exited it. This effect establishes Ballantyne as more traditionally masculine than Murchison can ever be. All of the men, including Ballantyne, stare at Murchison as he makes his singular way across and out of the room. In other scenes, such as those in the dining room, Murchison is frequently incorporated into shots of the homosocial group of male analysts at Green Manors. Yet in these shots, Murchison often stares in apparent incredulity at Ballantyne's erratic outbursts. The suggestion is that he blends in with the male group in order to scrutinize Ballantyne's actions while also simulating surprise at them. ("I actually felt alarmed," he tells the detective regarding Ballantyne.)

After Ballantyne has fled Green Manors, the men and Constance are shown relaxing after hours in what is now once again Murchison's study. Constance and Murchison are visually depicted as linked in their isolation. Each sits apart from the others as they read, a book in her case, a newspaper in his (shades of Uncle Charlie). Constance is absorbed in her private world of worry over Ballantyne's imperiled situation, while Murchison closely monitors her. He chides his fellow analysts for their crude comments over Ballantyne's predicament, which visibly affect Constance, especially their colleague Dr. Fleurot's "callous," as Murchison puts it, asides. These touches of affinity between Constance and Murchison are crucial to the eventual intensity of their standoff.

SPELLBOUND AND THE WOMAN'S FILM

As soon as she sees Edwardes/Ballantyne, the bespectacled and reserved psychoanalyst Constance Petersen visibly throbs with desire. Constance's transformation through love conforms to conventional modes of feminine behavior in the woman's film genre that was so important to classical Hollywood from the 1930s to the '60s.[18] Hitchcock unfairly, and defensively, denigrated the woman's film during his interviews with Francois Truffaut, using *Rebecca* as an example of a work that suffered from "novelettish" limitations.[19] Critics like Slavoj Žižek have attempted to distinguish Hitchcock from the apparently inferior genre.[20] As both Tania Modleski and Patricia White have argued, far from being an atypical and therefore lesser Hitchcock film, *Rebecca* is a highly significant one.[21] *Spellbound*, like *Rebecca* and *Suspicion*, makes the woman's relationship to her own desire a central concern.[22]

As Joan Fontaine's heroine in *Suspicion* and Bette Davis's in *Now, Voyager* do, Constance stops wearing her eyeglasses (though she does put them back on when the need arises), the shorthand for female sexual self-actualization familiar in the woman's film. The woman's film tracks the transformation of a repressed woman's sexuality once kindled by romantic love. While the pattern holds true for *Spellbound*, its emphasis on Constance's vigilant attempt to restore Ballantyne's sanity nevertheless makes the film's sexual politics unusual. If the role of caregiver is a highly conventional one in films of the era, Constance is also much more than a caregiver. Infatuated though she becomes with Ballantyne, she remains a professional doing her job; her psychoanalytic acumen frees Ballantyne from emotional and legal problems and solves the murder. Moreover, I believe that critical treatments place too much emphasis on Constance's purported sexlessness before Ballantyne's arrival.

Mary Ann Doane writes in *The Desire to Desire* that Constance "suffers from a frigidity constantly associated with intellectual women in the cinema."[23] While Doane makes several points that illuminate the sexual logic of films of this era, and Ingrid Bergman herself questioned the veracity of the portrait of an intellectual woman's sexuality, *Spellbound* resists this typing even as it conforms to it.[24] Many critics and viewers have argued that Constance is initially presented as frigid, but this is to take the attitude of her colleague Dr. Fleurot, who puts his arms around Constance as she sits at her desk. To her impassive response, he offers this verdict: "It's rather like embracing a textbook." "Then why do you do it, then?" Constance asks. In the face of Fleurot's campaign to sexualize her, Constance maintains a dryly amused demeanor. She smiles as she rebuffs him, saying that he senses only his own "desires and pulsations," which hers in no way resemble. Constance is just as appealing in her professional garb as she is in her later, freer sensuality. Calm and poised but hardly sexless or cold, the early Constance, thanks to Bergman's luminously empathetic performance, is professional and sensitive rather than detached and inhuman.

Constance, it should be remembered, contends with numerous boorish male colleagues, not only Fleurot. They join him in teasing her after the picnic outing with Ballantyne. Fleurot lewdly deduces, upon noticing the mustard stain on Constance's finger, that she and her new superior have been feasting on "hot dogs on the state highway"; another psychoanalyst, Galt, adds, with a knowing look, "Or lolling in a Briar Patch." Murchison's respectful attitude toward Constance, a telling contrast, reinforces the bond between the two. (The film suggests that psychoanalysis was one of the few fields that provided intellectually minded women with career opportunities; this only underscores the crudeness of her colleagues' behavior.)

The coarse, rumpled businessman who harasses the heroine in the lobby of the Empire Hotel as she waits for an appearance by the fugitive Ballantyne extends the general atmosphere of sexual harassment that the film recognizes as such. Throughout, Constance retains her wit and her self-confidence. She deflates the digs directed at her by her colleagues after the picnic (sarcastically apologizing to them for having to "leave this nursery") and wryly responds to the masher in the hotel lobby, who boasts of his social

connections in Pittsburgh, "Yes, I'm sure you're a great social success, given half a chance." And when he begins invading her space, she responds, "Do you mind not sitting in my lap in public?" In none of these scenes do we get any sense that Constance's sexual repression impedes the expression of her "actual" sexual feelings (i.e., *Spellbound* does not share Freud's interpretation of his famous analysand Dora[25]). One gets the sense that she hasn't found the right man yet, rather than pines away in desperate frustration for him. Further, it is possible that Constance feels ambivalent about heterosexual desire. And this point opens up another avenue of discussion for us.

"YOU AND YOUR DROOLING SCIENCE!": LESBIAN PANIC

In the opening scenes, Constance has a session with one of her patients, Mary Carmichael (Rhonda Fleming). Shortly thereafter, she meets with another patient named Mr. Garmes (Norman Lloyd). Mary and Garmes double Constance and Ballantyne both. Mary's nymphomania masks a deep-seated loathing of men, and her conflicts over her sexuality darkly mirror Constance's own, just as Garmes, who suffers from a guilt complex and insists that he murdered his father, mirrors Ballantyne's psychic woes.

Once told that Dr. Petersen wishes to see her, Mary, playing cards with fellow female patients, coolly gripes, "Had a perfect hand. Would have beaten the pants off you." Harry, the guard who escorts Mary to Constance's office, is stoic yet flirtatious with Mary—he doesn't so much rebuff her advances as defer them. His bland smile conveys a sense of sexual interest in her even as he maintains a professional demeanor. With concision, this early moment indicates the film's skeptical attitudes toward both masculinity and heterosexual presumption. Mary first speaks the conventional language of female nurture: "I'm worried about you, dear. You look a little bilious." She then shifts into a more sexually aggressive mode, propositioning Harry. As she looks up at him with seeming lasciviousness, the very model of the nymphomaniac, Mary scratches his hand with her nails, smiling seductively at him the entire time. Visibly injured, Harry wraps his hand in a handkerchief. The shot of the row of scratches on his hand is the first of several such images of vertical lines, a visual pattern that triggers Ballantyne's paroxysms. Mary's small-scale act of violence registers, on repeated viewing, as a kind of feminine protest, a fleshly inscription of her anger. This anger might stem from the very scene of heterosexual presumption she appears to inhabit so masterfully: Transforming her walk down the corridor with Harry into a scene of seduction, she makes it clear that sexual contact with her would be fatal.

When Mary walks into Dr. Petersen's office, we are introduced to Constance, seated at her desk, her hair pulled back, her eyeglasses on. Her look is calm but benign. Constance and Mary physically parry before she settles down on the couch. Hitchcock's blocking here visually conveys a social struggle, as the women negotiate their interpersonal roles in a culture in which each is disenfranchised. Once Mary assumes the proper analysand's

place on the couch, she actually does begin to open up, telling Constance her big secret. This analyst sits looking downward at the patient (she will do so with Ballantyne as well), not distantly behind them as in traditional psychoanalysis. "I hate men," Mary reveals. "When one of them so much as touches me I want to sink my teeth into his hand and bite it off. In fact, I did that once—would you care to hear about it?" Steadily, Constance responds, "Tell me anything that you can remember." Mary: "I sank my teeth into his moustache and bit it clean off." While Constance's look of alarm can be interpreted in many ways, it is possible that Mary voices Constance's own ambivalence toward sexual contact with men, perhaps even her anger toward male power. After Mary has allowed herself to be vulnerable before Constance, she accuses her analyst of really looking down on her: "You just want to feel superior to me!" Mary's rebuke, improbably sudden though it is, speaks to both female characters' struggles for self-expression within the masculine social order.

Mary sees Constance as the embodiment of the "drooling science" of psychoanalysis. The term "drooling" registers on more than one level—it will be repeated in the scene in which Fleurot and the other analysts discuss the burgeoning relationship between Constance and Ballantyne ("It's good for Constance to be drooled over.") The motivation behind Mary's hasty rejection of a possible connection with Constance may lie in her desire for her analyst. Constance may be a prohibited erotic object for Mary, someone she is *not* allowed to drool over. Constance's sexual ambiguity lends itself to the lesbian panic that flames up so abruptly.

"I detest you! I can't bear you!" Mary insults Constance. As she does so, her voice cracks. As I argue in the next chapter, in Hitchcock films, the sound of a voice cracking, indicative of an uncontrollable duress, is an expression of what I call *queer anguish*. Mary's agonistic language may indicate something of her thwarted desire: She cannot "bear," or bring to term, her desire for Constance or other women. (I use the pregnancy metaphor here in reference to her dialogue.) Mary next sidles up to Fleurot, who has walked in. "Dr. Fleurot, I want to speak to you alone. I can't stand that woman," she tells him. Mary's appeal to Fleurot is ironized by his derisive remarks about her after Harry escorts her out. Fleurot sees Mary and Constance as two sides of the same female coin, too much sexual ardor and not enough, but he is too obtuse to recognize the despair in Mary's sexual conflicts. If, as I am suggesting, *Spellbound*'s diegetic world is a remarkably queer one, Mary's performance of ravenous sexual hunger for men testifies to the pressures of maintaining a functional sexuality in the face of normative sexual strictures.

As Judith Roof observes, the twentieth century is marked by "a habitual distortion of lesbians as fake men, social misfits, alcoholics, and nymphomaniacs." Further, other "figures or moments—male homosexuality, colonized non-Westerners, the figure of the witch, the female body, Woman—serve as analogous but slightly different configurations in Western thought and culture."[26] Analogous figures of queer sexuality in the film range from the intellectual woman, the nymphomaniac, the unattached middle-aged man, to the troubled and vulnerable young man. Like Mary's, Constance's own relationship to

her sexuality, in her case a measured one, is constantly under surveillance. She acts on her desires when she feels them but also does so only when in private conversation with Ballantyne, refusing to conform to the leering demands of her colleagues.

As I discuss in the chapter on *Marnie*, lesbian panic intersects with another theme, a gulf between same-gender characters. The impasse between Mary and Constance exemplifies what Helena Michie has called "sororophobia," the antithesis of sisterly female bonds.[27] Unrepairable rifts prevent women from working together to escape or subvert the masculinist system. The feminine-versus-the-queer dynamic echoes and intersects with this kind of rift. Mary's term of abuse for Constance, "Miss Frozen-Puss," a lewd pun perhaps, speaks volumes about the balked nature of her desire for her analyst and, potentially, Mary's inability to trust and therefore derive any benefits from working with her. Mary's introduction occurs within an all-female card game. This touch links her to Ballantyne's dream, which is set in a gambling house in which his dream-self competes with male players in a card game that ends with accusations of cheating and the threat of homosocial violence. As she is taken to her appointment with Constance, Mary announces to the women that she had a perfect hand and could have "beaten the pants off of you." This line, charged with multiple levels of meaning, evinces the competitive attitudes that inhere in female homosociality as well as male. Taken literally, the lines express Mary's desire to remove the women's pants through violent means, thereby associating them with her own compulsory inclusion in the heterosexual sexual order she chafes against, or forcing them to submit to her sexual will. That Mary recycles her metaphor when challenging Constance—"Psychoanalysis bores *the pants off me*" (emphasis added)—links her competition with other women, including Constance, to her attitudes toward her own treatment and her sexuality.

Once Dr. Fleurot enters, he proceeds to ridicule Constance, albeit somewhat playfully. His initial rebuke manages simultaneously to impugn Constance and Dr. Murchison. Ironically anticipating the revelation of Murchison's villainy and its likely cause, Fleurot comments, "Dr. Murchison must be insane for having assigned a love-veteran like Carmichael to you." Rebuffed by an unperturbed Constance when he puts her arms around her, Fleurot admits to sharing Mary's desire to hurl an object at Constance, adding, "But I won't." (What a gentleman!) Fleurot's unprofessional behavior serves as a metonym for the sexist attitudes of men even in presumably enlightened fields like psychoanalysis.

Murchison's appearance in this scene, entering Constance's office as Fleurot exits it, offers a break from the latter's provocative demands. Andrew Britton, in his masterly but also problematic reading of the film, observes, "it is significant that Dr. Murchison should appear for the first time at the moment of Constance's denial of her sexuality and the arousal/frustration of Fleurot—the two elements which will characterize her relationship with Ballantyne."[28] I argue that Constance is not denying her sexuality here or at any point in the film, but is instead rightly rebuffing Fleurot's unwelcome advances and, perhaps more to the point, competitive jousts. His attempts to rile Constance might not

proceed from the basis of his own desire for her; indeed, as adumbrated, Fleurot may be another queer character in a film filled with them.

Aged but compact and composed, Murchison, as played by Hitchcock stalwart Leo G. Carroll, is urbanely English. His light banter with Constance bespeaks their cordiality. Ultimately, *Spellbound* will stage a decisive confrontation between them that conforms to the feminine-versus-the-queer pattern. In films such as *Rebecca*, such confrontations stem from enmity, but in works such as *Shadow of a Doubt* and *Spellbound*, they represent devolutions of a previous affinity. The first conversation between Constance and Murchison establishes her regard for him and, more generally, her inclination toward protectiveness of the misunderstood (see figure 3.1). "I am in no hurry to meet Dr. Murchison's successor," she remarks, smiling at Murchison. Constance is seen in full shot as she says this, from Murchison's point of view, so that in effect we are Murchison, experiencing the warmth of her loyal affection. During their conversation, she commiserates with him for being replaced by Edwardes. "You're very young in the profession," he tells her, explaining that "the old must make way for the new, particularly when the old is suspected of a touch of senility." Due to a mental collapse, Murchison has been let go from his position as director of Green Manors. As Bergman plays the scene, Constance is entirely on the older man's side. She sighs and raises her eyes in exasperation, "Ah, that's ridiculous. The Board of Directors should be able to see that you're doing much better." But she concludes, "I will always remember your cheerfulness today, as a lesson in how to accept reality." In one of those lines that take on a new significance in repeat viewings, he replies, "Don't be too taken in by my happy air, Constance." As we will see, the mutual respect, and perhaps even friendship, between these colleagues is crucial to the

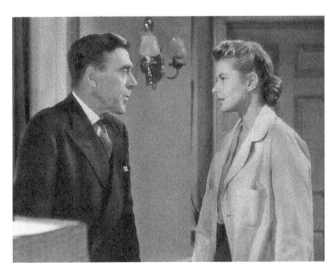

FIGURE 3.1 Constance (Ingrid Bergman) shares a warm moment with Murchison (Leo G. Carroll), who turns out to be the villain.

inevitable dissolution of their bond. At the same time, Murchison all but "outs" himself to Constance here, encouraging her to read him between the lines, beyond his "air."

ACTIVE FEMALE DESIRE: BERGMAN, HITCHCOCK, AND FREUD

In his beautiful essay "Star and Auteur: Hitchcock's Films with Bergman" in *Hitchcock's Films Revisited*, Robin Wood discusses "the natural" as an intrinsic facet of Ingrid Bergman's star image:

> If Garbo was aloof, Bergman was accessible: the radiance of the smile betokened an openness and generosity that dispelled any overt sense of a "feminine mystique." . . . if we accept Freud's "discovery" of constitutional bisexuality (and how, today, can we not?), it entails the expression of the woman's "masculinity," her active, assertive, energetic side that patriarchal culture has long striven definitively (but unsuccessfully) to deny. Activity, assertiveness, energy: Bergman's smile, and all the characteristics that go with it (appearance, stance, body language, speech), are the signs of precisely these qualities.[29]

Bergman's vigor suffuses *Spellbound* and finds chief expression in Constance's ceaseless efforts to cure and exonerate Ballantyne. What is especially notable about Bergman's "activity, assertiveness, energy" here, especially in a film attempting to situate itself squarely within the logic of psychoanalytic theory, is the prevailing view at the time of female sexuality as passive and masochistic. To a certain extent, this was the view that was established and upheld in Freud's theories of female sexuality. As Juliet Mitchell observes, female psychoanalysts at the time such as Helene Deutsch and even the more radical Karen Horney reinscribed the essentialisms in Freud.[30]

It should also be noted, however, that Freud's own thinking on the subject shifted. The intersections between Freudian theory and Hitchcock's films being one concern of this study, it behooves us to compare their treatments of female sexuality. Both Freud and Hitchcock are theorists of gender and sexuality whose thinking, though hampered by blind spots and biases, can innovate and challenge conventional assumptions. Psychoanalysis isn't *about* women, as Marcia Ian points out, though it presumes to speak for and to women. But as she also adds, it illuminates the processes of male fantasies about women, and is therefore valuable to feminist and, I would add, queer analysis.[31] One can say the very same of Hitchcock films, which, much more than Freudian theory, derive a considerable amount of their power and fascination from investments in femininity and female sexuality. (I would add, however, that Hitchcock films are most Freudian in their awareness of homosexuality as a continuous presence in the psychic makeup of sexual beings; the allure and horror of homosexuality in Hitchcock is inseparable from an insistence on making homosexual desire palpable.)

Freud's 1933 essay "Femininity" is especially relevant to thinking through the sexual politics of *Spellbound*, which reflects both Hitchcock's more skeptical and David O. Selznick's more zealous commitments toward psychoanalysis. "Throughout history," Freud writes, "people have knocked their heads against the riddle of the nature of femininity." Addressing the males in his audience, he informs them that they are no less vexed by this riddle than any others have been; addressing the distaff side of his readers, he writes: "to those of you who are women this will not apply—you are yourselves the problem." If femininity is an intractable enigma for men, women are not driven to contemplate this enigma.

When we meet a human being, Freud observes, "the first distinction you make is 'male or female?' and you are accustomed to make this distinction with unhesitating certainty."[32] Freud once again reminds his audience of the discomfiting fact that "the proportion in which masculine and feminine are mixed in an individual is subject to quite considerable fluctuations." Universal bisexuality has genuine manifestations in anatomical features—"portions of the male sexual apparatus also appear in women's bodies . . . and vice versa"—yet the emphasis Freud places is on the enigmatic, ungraspable quality of gender, one that transcends the somatic: "what constitutes masculinity or femininity is an unknown characteristic which anatomy cannot lay hold of."[33]

Freud argues that we usually fall back on "anatomy or convention" when attempting to theorize masculinity or femininity. While anatomy demonstrably corresponds at times to perceived views of males as the active sex and females the passive, Freud reminds us of the numerous examples from the animal kingdom in which the roles are spectacularly reversed. Moreover, he slyly suggests that achieving a "passive aim may call for a large amount of activity." It is "inadequate" to associate males with activity, females with passivity; women can be quite active in "various directions; men are not able to live in company with their own kind unless they develop a large amount of passive adaptability."[34] This last is one of Freud's most subversive points. In stark contrast to the "territorial imperative" theory of Robert Ardrey (an influence on the filmmaker Sam Peckinpah) and other thinkers who stress male-male competitiveness, Freud suggests that male homosociality requires an acquiescent passivity.[35] *Spellbound* associates homosociality with conventional male identity, but figures it as a cover that the manipulative Murchison can don at will. He blends into the homosocial, and from within this vantage point can observe Ballantyne freely. But he is also never *of* it, as some key elements in the visual design that we have already noted suggest.

While known for his lack of attention to the social dimensions of misogyny, Freud speaks to just these concerns here. We must not underestimate "the influence of social customs, which . . . force women into passive situations," Freud argues.

> The suppression of women's aggressiveness which is prescribed for them constitutionally and imposed on them socially favours the development of powerful masochistic impulses, which succeed, as we know, in binding erotically the destructive trends which have been diverted inwards. Thus masochism, as people say, is truly

feminine. But if, as happens so often, you meet with masochism in men, what is left to you but to say that these men exhibit very plain feminine traits?[36]

Queer and trans theorists make a similar point: Gender is not something fixed to biology but a quality, set of attitudes, or disposition that can manifest itself in any body. Gender is always already a construction; we are not born, we are *made*.[37] Very clearly, Freud says here that feminine behavior is something socially imposed on women. He then gives us a prescient sentence: "psycho-analysis does not try to describe what a woman is—that would be a task it could scarcely perform—but sets about enquiring how she comes into being, how a woman develops out of a child with a bisexual disposition."[38]

Echoing but amplifying his positions from earlier essays, Freud writes that "the development of a little girl into a normal woman is more difficult and more complicated" than a boy's into a man. Far from "intellectually backward," girls are also "more intelligent and livelier."[39] Moreover, as psychoanalytic research has shown, "the aggressive impulses of little girls leave nothing to be desired in the way of abundance and violence"; when girls enter the phallic phase, the similarities between the sexes "eclipse" the distinctions, and we have to acknowledge that "the little girl is a little man."[40] The realization of the valuation of the boy's penis over her genitals is a profound wound to her narcissism. "Her self-love is mortified . . . she renounces her masturbatory satisfaction from her clitoris, repudiates her love for her mother and at the same time not infrequently represses a good part of her sexual trends in general."[41]

I rehearse Freud's theories of female sexuality here in order to point out that *Spellbound*—beholden to classical Freudian theory though it is—liberates female sexuality from a "self-love [that] is mortified." Constance's sexuality is an almost primal force once stimulated into expression. Indeed, Ballantyne's chief contribution as a character is his ability to spark the passion that galvanizes Constance and allows her to merge the professional, romantic, and sexual elements of her life.

In chapter 1, I argued that Hitchcock queers heterosexual desire in *North by Northwest*, and that a corollary effect of this maneuver is to make the audience identify with the sexual position of Eve Kendall being ravished by Roger O. Thornhill—and by the star magnetism of Cary Grant. If anything, *Spellbound* makes this maneuver even more provocative and unsettling. We are thoroughly made to identify with Constance/Bergman, and this includes her inflamed desire. Queer possibilities abounding, the audience of both genders is made to desire the handsome young Ballantyne and to feel what desire feels like from Constance's perspective. Female desire drives this narrative, which puts the male lead in the feminine position of being desired for his beauty, a radical maneuver. As Laura Mulvey argued of classical Hollywood filmmaking practice in "Visual Pleasure," "[a]ccording to the principles of the ruling ideology and the psychical structures that back it up, the male figure cannot bear the burden of sexual objectification. Man is reluctant to gaze at his exhibitionistic like. Hence the split between spectacle and narrative supports the man's role as the active one of advancing the story, making things happen."[42]

While important challenges to Mulvey's analysis have been offered, and the sexual gaze has become infinitely more complex, she was certainly right to note that, historically, the sexualization of screen masculinity posed a problem for the classical Hollywood era, one that mainstream cinema still attempts to avoid, as many scholars have noted.[43]

Constance, assimilated into the male homosocial enclave at the communal table in the dining room where several early scenes are set, notes her intellectual interest in getting to know Dr. Edwardes, author of the acclaimed study *Labyrinth of the Guilt Complex* (which Murchison calls "an excellent work"). When, a moment later, she meets Ballantyne for the first time, the entire world of the film slows down so that we can feel the effect on her, surpassing any intellectual interests, of beholding Ballantyne as he walks across the room and stands before her. From her seated point of view, we look up at Ballantyne as he smiles at her and at us, and then we get a close-up of her face. This is not an idealizing close-up that presents her as the simpering, abashed female, "ready and waiting." Rather, her look is startled, intense, *fixed*. She is seized by desire, captured by it, the way Ballantyne is by his childhood trauma.

Keeping Freud's remarks in mind, we can say that Constance's desire restores her narcissism. And it is in her comfortable reclamation of her narcissism that the movie finds its métier. For example, the scene that first suggests that she and her new superior are falling in love, the picnic lunch the two take in the park grounds outside Green Manors, does not so much bring the lovers closer together as it emphasizes the pleasure that Constance feels within *herself* and her incipient desire. Much like the male protagonist of screwball comedy who announces his disinterest in love and sex and other distractions from the intellectual life (*Bringing Up Baby* [Howard Hawks, 1938], *Ball of Fire* [Howard Hawks, 1941], et al.), Constance dismisses the phenomenon of love as a myth dreamed up by bards: "I think the greatest harm done the human race has been done by the poets. . . . People fall in love—as they put it—because they respond to certain hair coloring, or vocal tones, or mannerisms that remind them of their parents. . . . people read about love as one thing—and experience it as another. They expect kisses to be like lyrical poems and—and embraces to be like Shakespearean dramas."[44] But as the two walk along a path, it becomes clearer and clearer that both feel progressively less fettered. Looking out at the vast vista before her, Constance says of the landscape, "Isn't this beautiful?" The directions in Ben Hecht's screenplay make it clear what kind of effect the moviemakers were seeking to produce:

> Her eyes are on the landscape below. Her voice is soft and happy as she speaks—and Edwardes watches her, held by her radiance.
> EDWARDES. Perfect.
> We get a semi-closeup of the two as Edwardes undoes the sandwiches.
> EDWARDES. Oh, lunch—lunch, what'll you have—ham or liverwurst?
> CONSTANCE (*her voice still full of mood*). Liverwurst.
> She takes the sandwiches and stares at the scenery; and as he eats and looks at her, the scene dissolves out.[45]

In the film itself, the scene closes with a rapturous close-up of Constance, staring out at the landscape, and on her equally rapturous delivery of the line "Liverwurst." Ballantyne stands behind her, lovingly looking at Constance as he repeats her assessment, "Beautiful." The mismatch between the humble meal and the elevated feeling gives the moment a playful quality. Of most significance is that Constance, "full of mood," basks in the glow of her own developing desires in a manner that emphasizes her experience. She is not looking at John—as she did in the dining room—but out into the world of possibilities, chief among these her own. Constance inhabits a private yet expressive realm of restored narcissism, which Ballantyne instigates in her but does not imperialize.

Adding to or springing from this investment in Constance's self-investment, the film pursues a reading of her character's desire as being direct and adamant. Most readings of the film describe Constance's relationship to Ballantyne as maternal, excessively so. Yet the film articulates an awareness of this excessiveness. As her mentor Alex Brulov chides her as she frets over her lover/patient, "You are not his Mamma. You are an analyst. Leave him alone. He will come out of this by himself." Moreover, Constance's maternal care for Ballantyne is not the full story. There are moments in which she comes across as the dominant partner to his submissive one. When she defies the authorities to seek out Ballantyne at the Empire Hotel, he greets her with surprise, saying that she doesn't owe him anything. She responds, tautly, "I am going to do what I want to do. Take care of you, cure you, and remain with you till that happens." (He then silently embraces her as she murmurs, "It has nothing to do with love . . . nothing.") And later, when they are both on the ski slopes, about to reenact the scene of the crime in order to trigger Ballantyne's forgotten memories about both Edwardes's death and his own childhood trauma, Constance hands him his skis and says, with the ice-cold authority of a dominatrix, "Put these on." The phallic nature of her desire contrasts starkly against the tremulous gender fluidity of Ballantyne as Peck so vulnerably plays him.

MIRRORS WITHOUT IMAGES

In the previous chapter, I described the heterosexual woman and the queer male as "dark mirrors" to one another in the Hitchcock text. Here I want to extend the crucial metaphor of the mirror in Hitchcock's work to its deconstruction of screen masculinity. Ballantyne's relationship to his own image is central to the queer dimensions of his characterization.

The early dialogue between Cassius and Brutus in Shakespeare's *Julius Caesar* contains other lines of relevance to *Spellbound*. In his attempts to rouse Brutus's revolutionary zeal, Cassius laments that his friend has ". . . no such mirrors as will turn/Your hidden

worthiness into your eye/That you might see your shadow" (I.2.56–58). As Phillipa Kelly observes,

> Cassius . . . implies that the dimensions of a "hidden worthiness," unseen by Brutus in himself, can be properly apprehended through reflection. . . . But this exhortation carries its own ambiguity. In the very act of looking into a mirror, you find not yourself, but, indeed, "your shadow," the shifting shape of what you seem to be in a moment of self-appraisal. This shadow will change with the shifting of the sun, the movement of the glass, and, by association, with the movement of the gaze.[46]

One of the goals of Americanized psychoanalysis is to see an authentic version of the self once the distractions of repression, neurosis, and so forth have been cleared away; so the preamble to *Spellbound* confirms. So too does Constance in her counsel to Ballantyne. When he speculates that the cause of his amnesia is "the horrible thing—behind a closed door," she counters, "We have to open the door."

Self-inspection in a mirror is an act typically associated in Western art with the vain woman; *Spellbound* associates it with Ballantyne. The ambiguities in Cassius's recommendations to Brutus take on a distinct character here. To locate a positive, underappreciated version of the self in one's own reflection is also potentially to apprehend a "shadow" self. (As *Shadow of a Doubt* thematizes, to look for this more positive image of the self in another person may involve seeing a reflection of one's own in their dark nature.) When Ballantyne scrutinizes himself in the mirror, he discovers not so much a "shifting shape" as he does a non-presence, akin to what I describe elsewhere as a "ghost face" (see figure 3.2).[47] Hitchcock's work, as Robert Samuels interprets it, evokes Lacan's

FIGURE 3.2 The beautiful young man, a stranger to himself: Gregory Peck as Ballantyne.

theory that the "ego is pure nothingness . . . the subject is narcissistically invested in all of its external representations . . . the subject represses any awareness of its own nothingness or its own lack of representation."[48]

Amnesia functions as an alibi of sorts for Ballantyne's inability to "know" himself. That he must come to know himself is precisely the curse that one of Narcissus's rejected suitors placed on him in Ovid's version of the myth, a lack of self-knowing being a blissful state.[49] (Ballantyne's idealized beauty evokes the classical tradition at certain points, particularly the several times when Constance stares at him lovingly as he is sleeping, like Selene the moon goddess contemplating the beauty of the sleeping shepherd Endymion.) Ballantyne's self-image crisis evokes Lacan's theory of the mirror stage, as if the male were once again a child learning how to desire through self-contemplation. Ballantyne's secondary mirror stage foregrounds the aggressiveness, rivalry, strife, and even suicidal despair that Lacan associated with the passage from the Imaginary to the Symbolic order.[50]

Ballantyne's lack of self-knowledge is a preexisting condition, one that Murchison's murder of Edwardes catalyzes but does not create; this is one of the main premises of the film. Unable to locate an authentic self in the mirror, Ballantyne instead lashes out: misogynistically at Constance, whose psychoanalytic acumen he alternately scoffs at and rails against (he accuses her, as Mary Carmichael does, of being smug and complains about her probing questions); competitively at Brulov, to whom he directs his most direct statement of disdain about the discipline: "I don't believe in dreams. That Freud stuff is a lot of hooey."

The idea of a mirror with no reflection in it will be indicative of a psychically anguished female subjectivity in *Vertigo*. Madeleine's speech resonates with Ballantyne's spectrophobic anguish.[51] "It's as though I were walking down a long corridor that once was mirrored, and fragments of that mirror still hang there. And when I come to the end of the corridor, there's nothing but darkness, and I know that when I walk into the darkness that I'll die." Similarly, a woman's confrontation with an absent presence of femininity will be dramatically staged in a mirror with no image—no image, that is, of the woman the investigating woman seeks—in *Psycho*, as I will discuss. In *Spellbound*, the mirror that produces no recognition reflects the blankness and unknowability of the male psyche.

Ballantyne's first encounter with the mirror occurs after he has come undone during the surgery on Garmes, who slit his own throat and whose guilt complex Ballantyne understands. Selene-like Constance stares at her troubled young Endymion as he slumbers. When Ballantyne awakens, she asks, "Who are you?" Ballantyne walks over to the mirror and looks at his reflection. Hecht's description of Ballantyne's self-inspection is revealing:

> The camera moves slowly up to a big closeup of Edwardes' face, and holds there. Edwardes is silent. There is a long pause as we see terror and doubt sweep over him—A closeup shows Constance looking at him tensely, following which we get a closeup of Edwardes.[52]

We are invited to contemplate the beauty of Peck's face in the mirror even as his visage conveys an enigmatic unknowability. The dialogue reinforces the visuals. "I have no memory," Ballantyne reveals. "It's like looking into a mirror—and seeing nothing but the mirror. Yet the image is there. I know it's there." In some ways, seeing a shadow self would be preferable to this blankness.[53]

Susan White observes that "some of the most powerful scenes in *Vertigo* . . . invoke [Kim] Novak's 'blankness' of expression—and these moments hold clues to the nature of Hitchcock's subversiveness in constructing character through acting. . . . Novak's trance-like state among the sequoias . . . speaks of the invasion of the present by the past, of Madeleine as an immutable object of desire."[54] As conveyed by Gregory Peck, Ballantyne's mode of blankness is equally affecting.[55] Ballantyne's moments of self-contemplation are, at once, devoid of expression and highly charged with affect—and this affect is one of self-repugnance, an idea reinforced by the prevalence of the guilt theme.

After finding him at the Empire Hotel, Constance brings Ballantyne to her old mentor Brulov's house; he invites them to stay over and, as we learn, already begins to formulate his suspicions that Constance is enmeshed with a mentally ill and possibly dangerous man. In the bathroom in Brulov's house after Constance has gone to sleep, Ballantyne stares, once again, at his image in the mirror. This self-confrontation in the mirror leads Ballantyne to pick up a straight razor and walk, like a somnambulist, downstairs, where he is greeted with apparent cheer by Brulov. Unbeknown to the young man, Brulov has been anticipating such a moment and has slipped a bromide into a glass of milk. In a famous trick shot, Ballantyne swallows the milk as the image itself appears to be swallowed up by the glass of milk. The blur of gendered signifiers—phallic razor, maternal milk—occurs significantly in this scene between men. The implication is that the very recognition of non-presence can spark both murderous violence and homoerotic desire (the latter suggested by Brulov's oddly touching line to the couple, who pretend to be newlyweds: "Any husband of Constance is a husband of mine, so to speak").

In one significant moment on the train to Gabriel Valley, where the couple will reenact the skiing trip during which Edwardes died (was murdered, as they will discover, by Murchison), Ballantyne and Constance are seated across from one another as she eats dinner. Her affect is one of playful, even coquettish, bliss, while he broods silently. This scene continues the trope of commensal ritual—food, shared eating—as fraught with menace, a theme present throughout Hitchcock's oeuvre, as I have argued elsewhere.[56] In an earlier scene in the dining room of Green Manors, Ballantyne reacted angrily to the yonic image of a swimming pool that Constance drew on the tablecloth (dark lines against a white background taunted him with memories of ski tracks in the snow, the scene of Edwardes's murder). Ballantyne used a knife to scratch out Constance's drawing; now he is transfixed by Constance's phallic knife.

Her dialogue conveys a longing on her part for a more conventional femininity (though, I would say, one that stems not from conflict or neurosis but rather from a sense

of security, despite Ballantyne's turmoil). Her self-pleasure contrasts (not for the first time) with his mingled attitude of remoteness and agitation. She reveals:

> I've always loved very feminine clothes—but never quite dared to wear them. But I'm going to, after this. I'm going to wear exactly the things that please me—and you. [She pauses when noticing him staring intently at her knife.] Even funny hats. You know, the kind that make you look a little drunk.

Constance seems aware of femininity and costume as a performance—"woman and the masquerade" if we employ the words of Joan Riviere—that one can choose to undertake. Unlike the female subject of Riviere's analysis, however, Constance derives pleasure from the choice (linking her to Grace Kelly's otherwise quite distinct fashion-plate Lisa Freemont in *Rear Window* [1954]). Ballantyne stares at her knife as the lights on the adjoining track flash across his face, giving it a lurid glow. Hitchcock's close-up of Peck/Ballantyne emphasizes, at once, the emptiness of his expression and its look of almost malevolent anger, hostility, and confusion. The expressionistic close-ups of Ballantyne as the two sit across from each other on the train depict his non-presence, his figurative looking into a mirror without an image. As Constance explores, mentally trying on styles of feminine identity, even as she notices his increasingly worrisome expression, he endures a bout with his own nothingness. The two are very much in different places (and revise traditional gender roles in the process[57]). The skiing trip the pair soon undertakes further images Ballantyne's blank/explosive visage. As he and Constance race down the slope, she looks increasingly worried, and he begins to look positively murderous, yet he will in fact rescue her from an imminent plunge. (*Spellbound* recalls *Suspicion*: Ne'er-do-well Johnnie Asygarth seemingly plots to kill his wife Lina McLaidlaw, but actually saves her as their car careens out of control at the climax. Much like Ballantyne, Johnnie is a dark-haired and outwardly charming and attractive young man, qualities enhanced by the casting of Cary Grant, with a tormented psyche. Instead of planning to kill Lina, he is actually planning to kill himself.)

That the man and the woman within the heterosexual couple maintain quite distinct positions is nothing new to the Hitchcock text. But *Spellbound* makes this gulf especially apparent. The reenacted skiing trip seemingly yields all the desired results: Ballantyne suddenly remembers, just as he and Constance are about to go over the cliff, both his accidental childhood killing of his brother and the fact that Edwardes died by plunging off a cliff while they were skiing. Yet, as they bask in their relief and love before a large, suggestive fireplace in the skiing lodge and Ballantyne proposes to her, the couple is suddenly confronted by detectives, who tell them that Edwardes's body has been discovered, just where Ballantyne said it would be. An initial feeling of relief is shattered when the detectives tell them that the matter isn't so simple—Edwardes's body had a bullet in it, and the charge is murder.

In an extraordinary effect, Hitchcock's camera now dollies in on Constance's stunned face. Ballantyne's face is never shown; any reaction he might have is totally absent from

the film. Hitchcock condenses the trial to a definitive example of pure cinema. This brilliantly brief montage sequence opens with a harrowing image of a prison door slowly swinging open and ends with a shot of Constance vowing her loyal determination to see that Ballantyne is exonerated.

Ballantyne's fears of non-presence transform into his literal non-presence, as his role in the film is ceded entirely to Constance. Indeed, we see the trial only through Constance's eyes—her shifting expressions and insistence, to him and to the authorities, on Ballantyne's innocence. The camera is only on her; Ballantyne disappears. (The images of her in the courtroom depict her as stylishly dressed, especially in contrast to her initial sensible comportment, in furs and various hats; the somewhat disquieting implication seems to be that she has managed to transform herself into a woman of fashion despite impediments to her romantic relationship.) In effect, we disappear as well, becoming the non-present Ballantyne as Constance speaks directly to his unseen presence and to us, first with impatience ("No, no, you mustn't say you killed him, darling!"), and then with depleted resolve ("Goodbye, my dear. We won't give up hope. I'm going to fight and fight and get you free"). Ballantyne is not seen again until the very end of the film when he and Constance, now married, are about to board a train. (Constance exonerates Ballantyne by exposing Murchison as the murderer. Customarily, Hitchcock implies the messy process of freeing Ballantyne has already occurred by cutting to the scene of the newly married couple boarding the train. They are seen off by Brulov, who, repeating his earlier humorous line, beams at them and says, "And remember what I say—any husband of Constance is a husband of mine, so to speak.")

North by Northwest thematizes the man's nothingness, a point explored in Stanley Cavell's and Tom Cohen's essays on the film. Roger O. Thornhill's initials spell ROT, which he has monogrammed on his matchbooks, obviously as a point of pride. When Eve Kendall asks what the "O" stands for, he responds, "Nothing." "Nothing," as used in *Much Ado about Nothing* and other works, is a Shakespearean double entendre, Elizabethan slang for vagina (the idea that a woman has "nothing" between her legs). The idea that a *man* is nothing links him to the condition of femininity (in a manner wholly inextricable from both misogyny and effeminophobia) and therefore deepens the destabilization of male authority in narrative. Ballantyne's hostile fascination with Constance's knife when they are on the train, we might say, is an expression of his fear of her phallic authority and, perhaps, his own fear of and desire for the phallus.

A DREAM OF HOMOSEXUAL PANIC

The famous truncated Dalí dream sequence in *Spellbound* illuminates several important dynamics we have thus far considered: Constance's sexuality and Ballantyne's disposition toward it, male homosocial violence, and the occlusion of male sexuality, which has implications for homosexual desire.[58] In his incisive reading, Andrew Britton notes that

the "most striking thing about the dream ... is the remarkable absence of the personality of the dreamer."[59] That quality is in keeping with the general pattern of the film's characterization of Ballantyne. But I argue that the dream reveals a great deal about the dreamer.

Constance and Brulov both decode Ballantyne's dream the morning after the aged analyst puts him to sleep with the bromide. In one dream tableau, a young barmaid serves drinks to Ballantyne in a casino. Both the heroine and her mentor interpret this "kissing bug" as a figure for Constance, who, Brulov says, reflects "pure ordinary, wishful dreaming." We could go further and surmise that as Constance has been gaining access to feelings of sexual liberation, Ballantyne has come to regard her as a sexual provocateur whose primary role is to serve him. (Of course, the barmaid figure may represent his carnal desires for Constance and his wish that she were more conventionally feminine.) Ballantyne erupts at Constance at one point: "If there's anything I hate, it's a smug woman!" Given that he seems suspicious of both her sexualized energies and her trained professionalism, it is little wonder that he dreams of her performing services for him rather than analysis. Fragile though he is, Ballantyne maintains a misogynistic disposition in his unconscious. These indications of hostility leave a residue of uncertainty on the couple's romantic future.

Ballantyne plays cards with an older bearded man. Britton notes that the psychoanalysts identify him as Edwardes but that he bears a striking resemblance to Brulov. "The bearded figure defeats Ballantyne with blank cards," and then the "proprietor appears and threatens the 'father' [the bearded man], telling him 'This is my place' and 'You can't play here.'" Britton first notes that "if the proprietor of the casino is simply Dr. Murchison, there is no reason whatsoever, apart from considerations of narrative suspense, why he should be masked in the dream, since Ballantyne has scarcely come in contact with him and there is no necessity for his identity to be repressed." But Britton interprets Ballantyne's dream as an oedipal dream. Therefore, the proprietor "is masked because he is Ballantyne's surrogate in the dream; the son can express his hatred and jealousy through him and deny his emotions. We then see the father falling from the roof of the house—the wish for his death fulfilled."[60]

Britton then argues:

The masked figure appears from behind the chimney carrying a wheel, which he drops onto the roof. The wheel suggests the vagina: with the death of the father, the mother is now sexually available to the dreamer. The camera tracks in on the hole in the hub of the wheel (a deeply suggestive image, given the doors and forward tracks in the film). Suddenly, the screen fills with billowing smoke, and we then see Ballantyne fleeing down a slope pursued by the shadow of enormous wings: seized by guilt and panic, the dreamer is unable to consummate the desired union with the mother and flees from the achievement of his crime.[61]

Britton's analysis is persuasive if we see this as an oedipal dream, which is in keeping with general interpretations of Dalí's work. If we see it, however, as an exploration of Ballantyne's triangulated position within a homosocial network of desire, it becomes something else as well. I concur with Constance and Brulov that the bearded figure is Edwardes, and with Constance and Britton that Murchison is the masked figure. If the dream indicates something of Ballantyne's inexpressible anxieties, these would appear to be that he felt his rapport with Edwardes to be questionable (the blank or, as Murchison later puts it, "spurious" cards) and also that he experienced Murchison's presence, however unconsciously, during the skiing trip that he took with Edwardes as threatening and out of control. (Indeed, as will be revealed, Murchison threatened Edwardes in the 21 Club in New York City, which Ballantyne may have witnessed, and therefore may have been aware of the possibility that Murchison would have followed them on the skiing trip.)

More importantly, why is this male figure masked? Ballantyne's visage, at once inscrutable and charged with violent affect, mirrors the ambiguities in his persona. These ambiguities were made explicit in the tagline "Will he kiss me, or kill me?" in the movie's poster, which shows the romantic couple embracing but reveals a straight razor in Ballantyne's hand. In keeping with the film's thematic visual motif of the male face as expressive of the psyche (faces being so crucial to Hitchcock, as Stanley Cavell argues), the opacity of Murchison's identity suggests some kind of sexual secret, an idea supported by the overall portrait of the character.[62] His masked face suggests the closet, his angry accusatory demeanor the paranoid defense against accusations of homosexuality (accusing someone else of it first) that were adumbrated in the real-life Murchison's description of Ballantyne as paranoid. (Projecting his paranoia onto Ballantyne is perhaps also reflective of his jealousy of his would-be successor's youth even if he knows him to be an imposter.)

The most suggestive image is the wheel that the masked figure, standing on the rooftop, holds up and then drops (see figure 3.3). (This image of a male figure, positioned on high and with an obscured visage, who threatens the protagonist with homoerotic knowledge prefigures the famous image of Bruno Anthony standing near the Jefferson Memorial, seen from a distance by the anxious Guy Haines in *Strangers on a Train*.) As the wheel rather languorously slides down, we track in on the hole in the hub of the wheel, as Britton notes. His reading of the wheel as a symbol for the vagina is arresting and debatable. For while the wheel is indeed a yonic symbol, *this* wheel is as much phallic as it is yonic. Its round shape sharpens into a protuberant tip, and as a symbol, it can be termed abstractly genital.[63] Moreover, the masked figure holds the wheel phallus suggestively against his own crotch, as if to indicate his sexuality's connection to it.

I am, however, going to suggest that the wheel is neither vagina nor penis, but instead a figure of the anus. The focus on the dark hole in the hub of the wheel suggestively insinuates that once the wheel falls (associated as it is with the masked figure; indeed, it almost seems an extension of his body), it is some kind of goad or invitation to the dreamer.

FIGURE 3.3 The masked figure holding the wheel in the Dalí dream sequence.

The masked figure laughs, or something like it, as he holds the wheel. Altogether, the imagery suggests a sexual proposition from one male to another, and if this idea has any validity, the wheel becomes an offer of sexual penetration, a gift both provocatively and assaultively presented. (Indeed, the filmmakers and Dalí evoke a folk/Gothic tradition that associates the wheel with both the anus and the thief who returns what he has stolen, as in effect the villain of this film will do.[64]) And the enormous wings giving chase further suggest a sexual ravishing from which the dreamer desperately flees. Of course, the wheel is an example of condensation par excellence—there is no need to believe that it exclusively represents either vagina or anus (and, it should be added, *both* could be symbols of female sexuality). Nevertheless, given the homosocial focus of Ballantyne's dream, the wheel-as-anus is suggestive. The masked menace refers, if we follow this reading, to the closeted nature of Ballantyne's desire and the desire for Ballantyne. As I posited earlier, the nighttime scene with Brulov and Ballantyne and its symbolism of phallic razor and milk (which can infer male sexual fluids as well as maternal nurture) can be read as a homoerotic tableau. The dream extends these suggestions into more intricate signage.

The conflict between Edwardes and Murchison, and Murchison's relationship to Ballantyne, occupy a shadowy realm of the movie. In many ways, Constance is the triangulated woman of homosocial desire as theorized by Eve Sedgwick, a screen for the men's inexpressible wishes.[65] Ballantyne's relationship with Edwardes is suggestive: Their strange ski trip together codes as a romantic getaway. Indeed, Ballantyne's nasty looks at Constance while they ski down the mountain might be an expression of hostility that she is not Edwardes. They may also express jealousy, the fear that she will take Edwardes away from him. Luckily for both, he snaps out of this villainizing of her just in time to save her. In functioning as the triangulated woman, Constance blocks any direct knowledge of

homosexual desire. Yet her role is also to expose male crime, which threatens to open the closet door, an inescapable interpretation for a movie in which masculinity's secrets are so consistently associated with barred doors.

THE MAN WHO WAS KNOWN TOO MUCH

As I have established, the climactic confrontation between Constance and Murchison derives its intensity from the carefully established evidence of a genuine bond of loyalty and appreciation between the two. Constance defends Murchison ("You were overworked!" she says regarding criticism he has endured for his nervous breakdown), and he defends Constance ("You are offending Dr. Petersen by your callousness," he chides Fleurot and others for their coldblooded comments regarding the fugitive Ballantyne's likely doom). The taut, unwavering intensity with which Constance painstakingly outlines the incontrovertible evidence she has assembled to prove him guilty of murdering Edwardes bears no trace whatsoever of her former affection for her superior. Indeed, she appeals only to his hubris, not his heart, when he threatens to kill her as well: "A man of your intelligence does not commit a stupid murder."

After Ballantyne has been convicted, Brulov persuades Green Manors—and Murchison presumably—to reinstate Constance. Brulov comforts her before he leaves, telling her as she weeps to place her energies in her work instead. Murchison shows Brulov out and walks Constance to her room. As he is saying goodnight to her, he lets it slip that—in contradiction to his earlier statement that he'd never met Edwardes— "I knew Edwardes only slightly. I never really liked him, but he was a good man in a way, I suppose." In her room alone with the door closed behind her, she is besieged by Murchison's telltale words: "I knew Edwardes only slightly . . . knew Edwardes slightly . . . Knew Edwardes . . . Knew Edwardes slightly . . . Knew Edwardes slightly . . . Knew Edwardes . . . Knew! . . . KNEW!"

As the non-diegetic audio track blares the word "knew," reaching a frenzied decibel level, the sexual secrets of the film reach a level of articulation. How well did Murchison know Edwardes, or want to know him? The biblical meanings of the verb "to know" inevitably color our interpretations (and we recall Tania Modleski's humorously punning title for her chapter on *Notorious*, "The Woman Who Was Known Too Much"). If this moment effectively "outs" Murchison, it also implicitly frames Constance's provocative confrontation with him as a punitive maneuver. In exposing his criminality and bringing him to justice, she embodies and implements normative sexuality's countermeasures against sexual aberration.

Reading her notes taken during Ballantyne's dream analysis to Murchison, who comes to several of the same conclusions that she and Brulov reached, she mentions the wheel and, interestingly, Murchison responds that the significance of this symbol escapes him. Constance then interprets it as the gun that Murchison left with his fingerprints on it at

the scene of the crime. Murchison, calling Constance "an excellent analyst but a rather stupid woman," disputes this aspect of her interpretation, for he now takes the gun out of his front desk drawer, holds it in his hand, and points it at Constance. Constance steadily documents the evidence that he committed the crime as she resolutely makes her way to the door, announcing that she will call the police.

In one of the most well-known and controversial effects of the film, we watch Constance exit from Murchison's POV—specifically from the barrel of his gun aimed at her, as if the POV shot belonged to his enormous hand. While Robin Wood criticized this shot—"it is one of the rare instances I can think of in Hitchcock of a pointless use of identification technique," since we do not want to shoot Ingrid Bergman and feel no connection to Murchison—Thomas Hyde observes that the subjective shot "forces us to query Murchison's reasons with a sense of urgency that no other treatment of the scene could provide."[66] I concur and would add that this shot forces us to rethink the importance of Murchison's subjectivity—in other words, to acknowledge its importance throughout.

Britton argues that the film ends with "normality and reconciliation": Constance's threatening potency and search for knowledge can be useful when conservatively deployed against the villain.[67] Though Britton makes no mention of any queer potentialities in this text, his findings do anticipate a queer reading. In effect, Constance and Ballantyne's union comes at the expense of Murchison's obliteration. And this obliteration carries the sting of the ruined bond between feminine and queer personae. Moreover, Murchison's turning of the gun on himself rather than Constance, his self-annihilation, is significant.

Britton links *Spellbound* to *Marnie* in that the protagonists of both films have an aversion to a particular color (white in Ballantyne's case, red in Marnie's).[68] In *Marnie*, the color red signifies the heroine's recollection of sexual trauma. I want to make the case here that Hitchcock begins to make these connections between theme and form in *Spellbound*. His much-discussed inclusion of a flash of red color when Murchison shoots himself anticipates *Marnie* both aesthetically and thematically, as we have noted. It is progress, of a sort, that Marnie's red "seizures," as Lucretia Knapp terms them, tormenting though they are, evince her resilience in the face of homophobia and misogyny, as I will discuss in chapter 7.[69] In *Spellbound*, the queer villain immolates himself in the face of an ineluctable narrative movement toward the normalization (of which the cynosure is the happily married heterosexual couple) that renders him extraneous. What imbues *Spellbound* with an enduring sting is the lack of empathy between Constance and Murchison at the climax, a lack that defines them both. We remember that Murchison gave Constance the letter that Ballantyne stuck under her door announcing his departure for the Empire Hotel. Inadvertently yet touchingly, Murchison facilitated their fugitive love and the blooming of Constance's desire; now he threatens to annihilate her as well. Neither of these former friends can reach beyond the wall of self and connect to the other. Neither can say, "We will work together to solve this problem; together, we can find a solution." That neither can do this for the other proves to be their deepest connection. The feminine-versus-the-queer pattern is a record of ruined bonds, lost affiliations, and sundered alliances.

"THAT'S YOUR HEADACHE": *NOTORIOUS*

Notorious comes much closer to typing its villain as homosexual than *Spellbound* does. Alicia Huberman (Ingrid Bergman in a tour-de-force performance of a role that is the antithesis of her Constance) is both sexually promiscuous and the daughter of a German émigré to America who secretly works for the Nazis and is sentenced to prison for treason at the start of the film. Alicia is enlisted as a Mata Hari-like spy by the U.S. government. The government agent Devlin (Cary Grant) recruits her to infiltrate a Nazi ring in Rio de Janeiro headed by the wealthy Alex Sebastian, who once tried to woo her. Eventually, Alex marries Alicia, but when he discovers that he has married a U.S. spy, both he and his mother conspire to poison her. Devlin rescues the nearly comatose Alicia, leaving Alex—and his mother—to face off against their now-quite-suspicious fellow Nazis.

In *Notorious*, the sexual woman and the homosexual male, as the villain Alex is coded to be, are shadow versions of each other, equally if asymmetrically viewed as socially monstrous.[70] In keeping with typical patterns in his films, Hitchcock makes Alex an appealing character, far more sympathetic than the heterosexual male lead. Moreover, the *real* Mrs. Sebastian, Alex's formidable mother, and Alex together serve as the queer doppelgangers for the central heterosexual couple of Alicia and Devlin. *Notorious* is a film in which, like so many others in the Hitchcock canon, heterosexuality itself is inherently queered by its arduous difficulty.[71] *Spellbound* much more directly stages the battle between the heterosexual woman and the queer male; in *Notorious*, this antagonism is mediated through the strong presences of Devlin and Mrs. Sebastian. And Devlin is clearly the rescuer of the woman, even if one might make the case that his very ability to rescue her hinges on him taking a big risk, which is to tell her, finally, that he loves her. (In one of the most moving moments in Hitchcock, Alicia responds, "Oh, you love me!") In contrast, Constance both slays the dragon and rescues the damsel in distress, so to speak.

While a great deal can be said about so rich a film, I want to make note of the brutality that gives *Notorious*'s climax its sting. Although we are deeply moved (as I believe most members of the audience are) when Devlin rescues the defenseless and dying Alicia, it is also true that his rescue and her emotional fulfilment come at the cost of annihilating the queer persona. Admittedly, both Sebastian and his mother forfeit our sympathies when they embark on their murderous plan to poison Alicia. Nevertheless, as the four make their way down the seemingly interminable staircase at the climax, Alex and Mrs. Sebastian seem especially vulnerable as well. Both pairs—Devlin clutching the poisoned Alicia, and the diabolical mother and son—are audience identification figures strongly contrasted against the menacingly watchful Nazi men led by the expressionless, frightening Eric. "Alex, talk to them, quick," Mrs. Sebastian desperately urges her recalcitrant son, who claims that he is not afraid to die. The pity we feel for Mrs. Sebastian in this moment is entirely characteristic of Hitchcock's humanizing treatment of his villains. When Devlin, having successfully gotten Alicia into his car, locks the door so that Alex cannot enter, Alex loses his tough demeanor and becomes frantic, desperately asking

Devlin to let him in while the Nazis coldly stare at his hapless situation. "Please, they're all watching me," Alex pleads, to which Devlin, securely the hero, responds, "That's your headache." Now we feel for Alex as well—it's impossible not to. Alicia gives Devlin a quiet, satisfied smile as he rejects Alex and drives away. Her gesture simultaneously conveys her hard-won fulfilment in Devlin's public display of his love for her and an unsettlingly pitiless attitude toward Alex and his imminent fate. Hitchcock and his extraordinary actors make it impossible for the audience to revel in Alex and his mother's destruction; he also makes it impossible for us to indulge in any fantasies of the rightness and inevitability of the romantic couple, whose successful unity can only be achieved through the destruction of queer energies. It is clear as well that the heroine, however embattled, has been throughout the film the metonymic representative of the heterosexual couple, and that in waging war against the film's queer personae, she has done so on the normative couple's behalf.

4

Making a Meal of Manhood

ROPE, ORALITY, AND QUEER ANGUISH

WHILE THEY MAY contain homophobic elements, Hitchcock's films more acutely critique homophobia as one of the strategies used to inculcate and reinforce the heterosexual economy of gender and sexuality. His directorial investments include, as I have been arguing, an identification with his queer subjects. *Rope* (1948) piercingly explores the ramifications of this identification. Here, Hitchcock limns the most explicitly homoerotic narrative up to this point in his career. It follows suit that this film is also his most explicit analysis of the social structures of homophobia. *Rope* thematizes an affective state that I call *queer anguish*—the emotional torment of the closet and the experiential impact of a culture of homophobia.

The conventional critical wisdom for some time has been that *Rope* is itself homophobic. Such a contention was influentially maintained in D.A. Miller's landmark 1990 essay "Anal *Rope*," an early classic of queer theory.[1] Miller argues that the anus functions as a zone of phobic repression within the formal design of the film. *Rope* is famous for being a film with no visible cuts (a myth long perpetuated by commentators). Hitchcock's formal experiment here was to create the illusion of one continuous long take without a cut; when the cuts do occur, they are masked, usually by focusing on the dark expanse of a character's backside. The cut, the editing technique that allows one shot to transition to another, embodies the practice of film editing that was so crucial to Sergei Eisenstein and his theory of montage, which, along with German Expressionism, exerted a powerful and enduring influence on Hitchcock. Miller's argument focuses on the queer significance

of the cut, which Miller associates with the anus, specifically within cultural fantasies of male homosexuality. In that the anus figures a cut, Hitchcock's refusal to make a film with any cuts (though of course several exist) aesthetically fuses, in Miller's view, the director's fears of castration and sodomy, understood as the defining practice of gay male sexuality. Similarly, Lee Edelman's essay "*Rear Window*'s Glasshole," published in 1999, reifies the notion of the indispensability of the anus to gay male sexuality.[2] Miller's 2013 essay on *Rope*, "Hitchcock's Understyle," focuses on the issue of errors, most intentional but some not, in the film, arguing that they ultimately reflect "an anal *jouissance*."[3]

Miller's and Edelman's incisive analyses always have a great deal to teach us; they are models of critical probity. For all of their value, they also distort and obscure the direc- tor's emotional investments in both his queer and female characters and his narratives of betrayal and estrangement. Hitchcock's complex concerns with gender and sexual- ity reach a particularly acute level in the recurring relationships between heterosexual women and queer characters, often marked by forms of violence. Neither Miller nor Edelman treat femininity in Hitchcock with the complexity they employ to attend to other aspects of his work, as critics such as Tania Modleski and Patricia White have also argued, and in so doing, they overlook female/queer relations.

As I discussed in the previous chapter, the anus is a significant figure in the visual and theoretical design of *Spellbound*. While certainly important to *Rope*'s multivalent design, the associations among sodomy, the anus, and gay male sexuality that have been reified in critical treatments of *Rope* only take us so far. I argue that another figure of male homosex- uality is crucial to this work: orality, which is central to the film's excavation of stereotypes of the homosexual, within both the pop-culture version of Freudian psychoanalysis that had taken hold of U.S. culture (as *Spellbound* evinces and challenges), and middlebrow culture, with its compensatory views of impeccable homosexual taste.[4] Moreover, orality is a vital component of queer anguish. In a critique that links Jonathan Demme's 1991 film *The Silence of the Lambs* and Freud's psychobiography of Leonardo da Vinci, Diana Fuss has argued that orality and anality define gay male sexuality in the popular imagination.[5] Though I do not share her view of Demme's film as preponderantly homophobic, I build on her analysis of orality to interpret *Rope*.[6] We would do well to think about the oral politics of *Rope*—what its fixation with mouths, ingestion, and the indigestible reveals.

In *Three Essays on the Theory of Sexuality*, Freud established infantile psychosexual development as a series of successive stages: the oral, the anal, the phallic, and the geni- tal.[7] The oral phase is, importantly, the first of these stages, and "might be called cannibal- istic pregenital sexual organization," Freud writes.

> Here sexual activity has not yet been separated from the ingestion of food; nor are opposite currents within the activity differentiated. The *object* of both activities is the same: the sexual aim consists in the incorporation of the object—the prototype of a process which, in the form of identification, is later to play such an important psychological part.[8]

Fuss understands Freud's linkage between homosexuality and orality as a homophobic maneuver, in that orality, being the first stage of psychosexual development, is associated with a primitivism that then maps onto homosexuality as a regressive, arrested sexual stage. Yet *Rope*'s thematization of homosexual male orality exceeds these constrictions. Here the male fears not that his body will be penetrated, but rather that it will be ingested; and the specific body offered for our collective, perverse delectation is not the queer but rather the heterosexual male body (at least ostensibly; this sexual status can also be called into question). The cannibalistic aspects of orality that Freud described inform the film's sexual themes and intersect with longstanding cultural associations between homosexuality and anthropophagy. (To bite into something or someone is, of course, as much an act of penetration as it is a prelude to ingestion. Slippages abound.) The literature of the nineteenth-century United States is rife with this motif, especially Melville's work, which, I argue, is an important precedent for Hitchcock's.[9] That it is the body of the ostensibly heterosexual male that exists to be devoured here is a key aspect of Hitchcock's queer critique of heteromasculinity.

A brief description of *Rope*'s plot will be helpful to a close analysis of it. Two young men who had been in the same prep school, Brandon Shaw (John Dall) and Philip Morgan (Farley Granger), now Manhattan socialites in a swanky apartment, kill a former classmate of theirs, David Kentley (Dick Hogan). With obscure fantasies that they embody the ideal of the Nietzschean Übermensch, sometimes translated as the Superman, Brandon and Philip believe that David is inferior to them and that they can murder him without repercussions. They kill him right before their lavish dinner party begins, placing his body in a long, rectangular chest, the *cassone* that Brandon remarks he bought in Italy. In Brandon's fiendish master stroke, they decide to serve the meal in the living room on the *cassone*. The guests include David's father, the quietly anxious Mr. Kentley (Sir Cedric Hardwicke); Janet Walker (Joan Chandler), an acerbically witty young woman who writes beauty columns for women's magazines and is, in addition to being Brandon and Philip's "chum," on the verge of being David's fiancée; Kenneth Lawrence (Douglas Dick), once Janet's fiancé and David's former best friend and schoolmate along with Brandon and Phillip; David's slightly daffy aunt, Mrs. Atwater (the marvelously gravel-voiced and stylized Constance Collier, a veteran of the British theater world who co-wrote Hitchcock's 1927 *Downhill* with its star, the gay actor Ivor Novello, who also starred that year in *The Lodger*); and Rupert Cadell (James Stewart), once the prep schoolmaster to all of the young men and the one who schooled them in Nietzschean philosophy. Another important but overlooked character is the housekeeper Mrs. Wilson (Edith Evanson). Having elegantly set the dining room table for the party, she is miffed at and confused by the young men's decision to serve dinner on the *cassone*. Over the course of the evening, it becomes increasingly obvious to Rupert that his hosts are hiding something and under duress. In the end, he exposes their crime, returning to their apartment after the other guests have left, flinging open the chest/coffin, seeing, to his horror, David's body there, condemning the killers, and, by shooting a gun outside of a window, alerting the authorities.

Inert in the chest but the fecund source of all the film's queasy tensions, David Kentley's body transforms into a ritualistically consumed sacrificial object. In a not-altogether-metaphorical form of cannibalistic frenzy, Brandon and Philip make a meal of straight manhood. *Rope*'s thematization of the male body as cannibal sacrifice provocatively dovetails with the Catholic themes saturating Hitchcock's work. The male body becomes the host—and the hosts'. Brandon himself articulates as much: defending his decision to serve the meal on the chest and responding to Mrs. Wilson's complaint that the candlesticks now look "peculiar" in that spot, he counters, "I think they suggest a . . . a ceremonial altar, which you can heap with the foods for our sacrificial feast." *Rope* overlaps with another classic homosexual text, Melville's novella *Billy Budd*, which figures a beautiful, much-loved young man who incites male desire as a sacrificial feast.[10]

Rope evokes and insinuates popular understandings of the homosexual as being at once hidden and omnipresent, and in my view, it does so in order to question and even undermine these understandings. The film links its epistemologies of the closet to a secret-yet-explosive world of insider knowledge that hinges on the *female* subject position as much as it does on the knife-edged tensions between straight and homosexual masculinities, the potential collapse of both strictly maintained modes always possible. The feminine-versus-the-queer thematic of central concern to this study provocatively informs the film, albeit in a distinct manner. In the previous two chapters, I discussed the tendency of Hitchcock's narratives to narrow into a fatal confrontation between the heroine and the queer figure, typically though not always male. *Rope* extends this schema in its depiction of the relationship between a woman (Janet, David's all-but-fiancée) and the homosexual killers, marked by a deep intimacy and fondness (and a previous romantic relationship with one of the killers) *and* a genuine hostility. Perhaps because *Rope* comes closer to establishing the sexuality of its villains as more explicitly homosexual than any previous Hitchcock film, and because of its committed critique of heteromasculinity, its climax occurs entirely *among men*, the male killers and the male upholder of the sexual status quo. Nevertheless, as I will show, Janet's role in the film is an important one that has been overlooked in criticism. Mrs. Wilson's role, even more overlooked, will be discussed as well.

Raymond Bellour only briefly mentions *Rope* in his famous work *The Analysis of Film*. Nevertheless, we can rework his important, if resolutely heterosexist, paradigms and understand *Rope* as a film in which the audience is encouraged to identify with the murderous couple and their role as "enunciators" who structure—or attempt to structure—the desires of the film.[11] Brandon takes the lead in this process, emerging as a grisly—yet ultimately pitiable—stand-in for Hitchcock, the mordant showman putting on a fiendishly calibrated show for his audience members, whether dinner guests or viewers. The diabolical plan to host the party evinces the "carnivalesque" aspects of Hitchcock's work, Brandon as directorial stand-in.[12] While James Stewart is presented as the star of the film, his Rupert Cadell is really a supporting character who grows into prominence in the final third of the narrative. As such, Rupert almost allegorically represents the forces of

normalization, repression, and containment. His role is to abolish the polymorphously perverse energies of both the murderous couple and the diabolically pleasure-focused film over which they preside.

Rope's chief suspense mechanism is the dinner party in which the guests eat over, near, and around what is essentially David's coffin. The various trays of hors-d'oeuvres and chicken and cake hover precariously over the barely concealed crime; each guest serving him or herself threatens to uncover the secret. In terms of sexual metaphor, David's body, as noted, metaphorizes the violated body of normative manhood. The eroticized murder stands in for unrepresentable homosexual sex—from outside of the apartment, we hear a man's cry, which is the cry of the man being murdered but could just as plausibly be the sounds of sexual release. It also suggests the heterosexual male's submission to male/male sex or a homosexual rape. Yet David's body in its placement in the chest also allegorizes the closet and the sexual criminal entombed therein.[13]

Eating and commensal ritual habitually function, as I have argued, in Hitchcock films as metaphorical registers in which characters both express and repress their desires. ("Commensal" comes from the Medieval Latin word *commensalis*, meaning "sharing a table.") Here they threaten to strip away the very fabric of the social order, to strip bare the artifices that provide fragile defenses against the eyes, hands, mouths, needs, demands, and desires of others.

Joseph Litvak argues that to "segregate" sophistications into hetero and homo forms is to deprive us "of the opportunity to understand the larger operations of culture as a highly elaborated food chain, where, if every act of eating is a speech act and every speech act an act of eating, we can mean only in relation to each other's tastes," only, that is, in relation to "our fantasies of what other people taste like."[14] Taking Litvak's caution under advisement, I believe that in *Rope*, Hitchcock explores the foundational cultural stereotype of gay males as connoisseurs and consumers. *Rope* offers an early critique— perhaps an anticipation—of the popular construction of the gay male as signal arbiter of aesthetic standards and the exemplary consumer. As Pauline Kael once wrote (in a pan of Blake Edwards's 1982 film *Victor/Victoria*), "when homosexuals were despised, there was a compensatory myth that they had better taste than anyone else."[15] Certainly, *Rope* was made in an era in which homosexuals were despised, and perhaps even more onerously, culturally silenced, although, at the same time, the film verges on a new cultural moment of increased public discussion of the threat of homosexuality. Moreover, the snobbery of the elitist killers makes them enemies of the "democratic-seeming anti-snobbery" of their ostensibly heterosexual guests.[16] The elaborate meal that the killers serve intersects with fantasies of the homosexual high culture that the killers wish to embody. As scholars such as Robert J. Corber and others have shown, the Cold War 1950s was an era that would make homosexuality, as well as homophobia, shockingly visible and discursively prominent. *Rope* uncannily anticipates a significant aspect of the shifting 1950s response to Cold War anxieties and programs, as well as the increasing visibility of a range of queer sexual identities: the normative American male's intensifying fear of a loss of self. As K.A.

Cuordileone argues, as "mid-century critics and experts scrutinized the male psyche, man became a victim as never before, his psyche malleable and unstable"; this gender crisis was "now a problem inseparable from national defense."[17] While a proper discussion of these cultural conflicts exceeds the scope of this chapter, it is worth noting that a loss of the male self, as well as the defense of the integrity and "wholeness" of it, were very much tied to the national construction of manhood and, indeed, to national identity itself. As I will show, *Rope* prefigures the 1950s incarnation of these anxieties.

Exemplifying his attraction/repulsion to homosexuality and consistent thematic use of images of food and eating, Hitchcock stages homoerotic desire as a perverse meal. (Donald Spoto documents this attraction/repulsion in *The Dark Side of Genius*, especially as it was manifested on the set through Hitchcock's penchant for practical jokes, which seem to have been frequently directed at beautiful young gay male stars like Ivor Novello in *The Lodger* [1927] and Montgomery Clift in *I Confess* [1953].[18]) The film evokes the infamous Leopold and Loeb case and is an adaptation of Patrick Hamilton's 1929 British play *Rope's End*, inspired by the case. Leopold and Loeb were two wealthy students at the University of Chicago; they kidnapped and murdered a fourteen-year-old named Robert "Bobby" Franks in 1924. The counsel for the defense was the famous lawyer Clarence Darrow, who succeeded in getting the young men sentenced to life imprisonment, avoiding the death penalty. Loeb was killed by a fellow prisoner in 1936; Leopold was released on parole in 1958.

Hitchcock's film is certainly a negative image of homosexuality, associated here principally with murder, but also sadism, grandiose narcissism, and polymorphous perversity, exemplified by the lovers/killers' excruciating dinner party. Hume Cronyn, an actor who performed in Hitchcock films, is credited with the adaptation; the gay playwright Arthur Laurents wrote the screenplay. (In *Shadow of a Doubt*, Cronyn's Herb, the friend of the heroine's father with whom he trades theories of the perfect murder, is readable as a queer character.) Nietzschean theories of the Übermensch haunt the rationale the killers offer for their decision to kill David. While Brandon specifically dissociates himself from Hitler, whom he ridicules, their insistence on being superior beings who can dispatch the inferior at will inevitably links the killers to German fascism and the Nazi Party, prefiguring cinematic images of Nazi decadence that will only grow more potent over the years.[19] Films as distinct as Kenneth Anger's *Scorpio Rising* (1964) and Luchino Visconti's *The Damned* (1969)—notable films made by gay directors—will render *Rope*'s inchoate homo-fascist aesthetic much more explicit, even as Hitchcock's film verges on their later explicitness.

It is important to note that the lovers' grotesque misapplication of Nietzsche flows from their obsession with their former teacher Rupert Cadell, from whom they learned their philosophical ideals and whose own moral positions raise suspicion. Rupert will investigate Brandon and Philip's crime, discover the truth of what they have done, denounce them as morally degenerate, and "help," as he himself puts it, to bring them to justice. He does so while also entirely exculpating himself from any complicity in their crime, despite

being their pedagogical inspiration for murder. The film crystallizes longstanding associations with degenerate homosexual aestheticism and the scene of pedagogy as a dangerous zone of homoerotic intrigue. "In the late nineteenth century, 'degenerate' was consistently code for perversion and shorthand for homosexual," writes Camilla Fojas, "and the classical pedagogical model meant being an aesthete or a decadent, where the rarified literary and aesthetic tastes borne by men of culture were passed on from man to boy."[20]

Certainly, *Rope* draws on such associations. It also registers their emotional and psychic costs. Hence the film's articulation of queer anguish specifically rooted in the lived experience of a self-conscious homo aestheticism within a larger homophobic culture. Brandon and Philip are Paterean and Wildean progeny. Richard Allen has linked Hitchcock to Walter Pater and Oscar Wilde and their late-nineteenth-century high aestheticism. It was through this aestheticism that homosexual culture, in an enshrinement of Hellenism (the perceived cultural superiority of ancient Greece), found expressive vent. Taking their cue from the eighteenth-century German art historian Winckelmann, who stressed the desexualized beauty of ancient Greek sculpture, the Pater-Wilde form of aestheticism "as a species of pure formalism detaches the cult of art for art's sake from any reference to human sexuality." This sensibility plays out in Hitchcock's work in the "distinction between aestheticism conceived as pure formal design and aestheticism considered as displaced articulation of sexual content."[21] In *Rope*, "the fact that Hitchcock cannot actually depict the protagonists as homosexuals, and more specifically, cannot depict the activity that defines them as homosexuals, leaves us seeking evidence of something we cannot prove."[22] The deployment of form here (the elaborate camera movements and the hidden cuts) emerges as a large, complex joke, linked to the perilous guessing game of the closet.

Allen makes the point that Hitchcock must endorse Rupert's moral position at the end of the film because it maintains the distinction between murder and high aestheticism that was crucial for Hitchcock.[23] While I do not agree that Hitchcock endorses Rupert's final speech, as I will discuss, I want to make a not entirely distinct point here. Perhaps surprisingly, queer anguish extends not only to the frightening and frightened young killers but also to Rupert. As I will show, Rupert's modus operandi throughout signals a massive defensiveness, laboring to prevent what Cuordileone calls the "wholesale loss of *self*" that threatened the mid-century male subject.[24]

Brandon and Philip believe that they are superior to the social order. But it is crucial to note, without exculpating them, this social order also imprisons and delimits them. While hideously destructive, their sense of superiority is, at least on some level, an expression of mourning and rage that is most likely related to their sexuality. Further, what they principally chafe against may be not only the overt homophobia but also the stifling silences around the issue in their culture. Eve Sedgwick argues that homosexuality has been a crucial node in an epistemological cultural network that regulates knowledge and determines who is or isn't "in the know," as we had occasion to discuss in chapter 2. The staging of the perverse dinner party thematizes homosexuality as a knowing game, a series of simultaneously unacknowledgeable and diffusely available intelligences.

The invisible/nearly visible body of the victim can be seen as a sign of the killers' own hidden yet increasingly visible homosexuality.

If the lovers/killers mete out punishment to the heterosexual male who has abandoned their queer circle, the murder is a counterassault on heterosexual society. In this regard, it is crucial that their vengeful violence extends not only to David Kentley but also to his quiet, reserved father, as well as his aunt, fiancée, and absent mother. Indeed, the young men submit the entire heterosexual gendered economy with its oedipal basis in the family and marriage to scornful critique. It is therefore telling that the lovers encase David's dead body within a *cassone*, an inlaid, ornate piece of furniture associated with the late Middle Ages, frequently given to brides as a wedding gift. Indeed, David Kentley was fond of telling a morbid folk tale, "The Mistletoe Bough," involving a *cassone*, as Brandon mentions and Mr. Kentley confirms. It is he who fills in the details of the folk tale (which actually does exist in English folklore and was collected in the early nineteenth century): A playful young woman mischievously hid herself in a *cassone* on her wedding day, never to be seen alive again; fifty years later, her wedding dress-clad skeleton was discovered within. That David was fond of it and that his father knows and recounts the tale hints at a darkness in them both, particularly surprising in Mr. Kentley's case given his adamant moral opposition to Rupert's and Brandon's rhetoric about superior beings who have the right to kill. Moreover, David's fondness for this folk tale obviously ironizes his own position in the chest, insinuating him as the ill-fated bride.

Brandon and Philip mount their most violent attack against oedipal normativity by making David's father partake in the meal of his own son. The murderous queer sons feed their normative brethren back to the father, evoking the Greek myth precedent of the House of Atreus.[25] The murder of David by his friends also evokes the fraternal rage incited by the biblical Joseph, whose brothers brutalize him and sell him off, presenting his garments, which they have soaked in animal blood, to their father Jacob in order to convince him that his favored child Joseph has been killed. In his association with feminizing dreams, heterosexual ambivalence (he recoils from the sexual advances of Potiphar's wife), and alienation from male group identity, Joseph is a historical queer figure. *Rope*, then, chiastically revises the biblical Joseph story, making the straight "brother" the victim, the queer males his vengeful aggressors. Poignantly, Mr. Kentley, as Hardwicke plays him, is a diminished, weary paterfamilias; we experience Rupert's chiding of him as insensitive and Brandon's intensification of this chiding as sadistic—a sadism metonymic of the larger one of the killers' entire plan.

Rope explores a theme that will be taken up by *Strangers on a Train, Psycho*, and later films such as William Friedkin's *Cruising* (1980): the blurring of normative and queer manhood. These films ransack the image repertoire of gay men in American culture, which is to say, the historically evolving arsenal of gay male stereotypes. Sam Loomis, the vacillating lover of the murdered Marion Crane in *Psycho*, appoints himself as the knowing, hostile "straight interlocutor" to the queer Norman Bates.[26] If *Psycho* provocatively collapses straight and queer masculinities, *Rope* has already done so. It has already

demonstrated that being the straight interlocutor who persecutes the homosexual—"he knows, he knows," as Philip desperately says of Rupert at the climax of the film—depends upon an undeniable intimacy, which is to say, complicity with that same dreaded sexual disposition.

If David Kentley is a closeted gay man—and as such, only a quieter, more success-ful heterosexual "passer" than the more obviously gay Brandon and Philip—Rupert Cadell represents not just a persecutorial heterosexual masculinity newly energized by the incipient Cold War, but also an understanding of closeted homosexuality as the deepest form of hypocrisy. When, at the climax, Rupert shrieks in a rage at Brandon and Philip over their heinous crime, he does not make too fine a point of what David represented for them: "He lived and loved in a way you never could!" Rupert's hypo-critical inability to take any responsibility for his own complicity in their crime is made especially apparent in his unfunny comic asides during dinner about the art of murder. (Complaining about long lines for the theater, he encourages "Cut a Throat Week." The grisly humor here bespeaks a desire to cut off the body from the very conduit of orality.) No sooner does he indulge in such morbid humor than he chastises Brandon for his harassment of David's father, visibly discomfited and then openly appalled by Brandon's spouting of mock-Nietzschean rhetoric about "superior beings" and his right to do as he wishes because he is one, including the right to dispatch any lesser being. Rupert's role in the crime his own messianic dictates inspired emerges as an allegory for closeted homosexuality and defensive denials of it. "There was something deep inside you that *let* you do this thing," he theorizes to Brandon, "just as there was something inside me that would never let me do it." The film depends entirely on this question of something "inside" men—or, paradoxically, not inside them at all, something they lack. It is little wonder that Rupert fires a gun out of the window at the climax. This theatrical gesture is a frantically public display of his own male potency, an attempt to display his lack of lack.

As Amy Lawrence observes in an excellent analysis, "The vehemence with which Stewart denounces Brandon and Philip indicates the importance of projecting the bloody guilt outward, his inquisitorial zeal necessitated by the fear that guilt lies within. . . . To save himself he must sell [Brandon and Philip] out." Lawrence helpfully links Stewart's star persona, particularly postwar, as a man capable of great reserves of feeling—even dangerous levels of emotionalism—to Hitchcock's use of him here, which ultimately results in Hitchcock's "unthinkable" suggestion that "James Stewart is a killer."[27]

It happens very quickly, but the murder of David at the start of the film provides one of the most explicit scenes of homoerotic exchange in classical Hollywood film (see figure 4.1). Feeling for a heartbeat in the now-dead body of David, Brandon and Philip massage his fleshy chest before putting him in the coffin-like *cassone*. The gloves the killers wear lend their perusal of David's body for any lingering signs of life a fetishistic kinkiness. The desired male body, seen only briefly at the start of the film, becomes the tantalizing meal

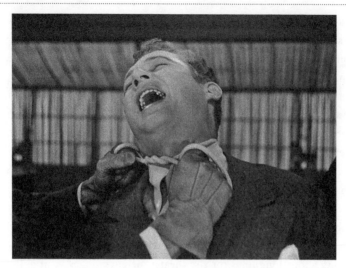

FIGURE 4.1 The murder of David Kentley at the start of *Rope*.

that can never be consumed, lying always out of reach. The miserable, tense dinner party parodies the collective wishes of the guests—to varying degrees of intensity and with different agendas—for joyful communion with David's body.

Rope offers a different form of male suspenseful mystery. The film suggests that it is normative American manhood that inspires, rather than embodies, cannibalistic appetites. This is not bell hooks's model of "eating the other," but quite the reverse.[28] If white male homosexuality is frequently depicted in homophobic discourse—but not only there—as a form of cannibalism, *Rope* takes this suggestion to its logical extreme, depicting its lover/killer pair as consumers of white manhood who are themselves white men, eaters of their own kind. I have noted that *Rope* echoes Melville's work *Billy Budd*, especially in its associations among white masculinity, homosexuality, and cannibalism. *Rope* also anticipates later works such as *Suddenly, Last Summer* (1959), Joseph L. Mankiewicz's most cinematically daring film, based on Tennessee Williams's play. This film similarly links homosexuality, class politics, and cannibalism (I will touch on it in the next chapter as well). Fascinatingly, overlaps also exist with a contemporaneous Tennessee Williams work that foregrounds homo cannibalism, his short story "Desire and the Black Masseur," first published in 1948.[29] *Rope* contributes to a queer genealogy of male bodies, racial and sexual panic, and the symbolic *and* literal threat of cannibalism. Brandon and Philip all but serve their murdered friend to their guests; the predatory gay poet Sebastian Venable is devoured by the street urchins of the Spanish town Cabeza de Lobo as his cousin, a beautiful woman who helped him "procure" the sexual quarries who now devour him, looks on in helpless horror.

One could argue that, if *Rope* places more emphasis on orality than anality as metaphorical of homosexuality, its homophobia simply takes a different form than critical treatments such as Miller's have suggested. Yet by establishing orality as its chief symbolic

preoccupation, and by linking *all* of the characters in the film to orality—to drinking, eating, speaking, *consuming*—the film suggests that its homo killers are not rogue outliers distinct from the normative social order but, instead, well integrated into it, considering the crucial importance of orality in Hitchcock's work generally. Given the recurring associations in his films among food, eating, sex, and violence, which reach a nauseating aesthetic height in *Frenzy*, the presence in *Rope* of a cohesive theme of orality and eating pertains less to queer sexuality specifically than to its function as the register through which sexuality can be explored and desires expressed, in this case, queer sexuality and desire.

Orality's relationship to the hierarchy of sexual stages being crucial, a regressive return to the "primitivism" of the oral stage provokes reactionary judgment, one that dovetails with the theorizations of homosexuality as a form of arrested development that infiltrated the Freudian 1950s. Freud's complex theoretical positions on homosexuality, as Henry Abelove has persuasively shown, were grotesquely misinterpreted and misapplied throughout this decade and beyond.[30] Rather than viewing it as regressively homophobic, *Rope* understands queer orality as a return to a state of polymorphous perversity before oedipal socialization and its attendant forces of repression and proper heterosexualization occurred.[31] Queer orality and queer fetishism—embodied by those gloved transgressively roving hands—signal a return to perversity that has implications for sexuality generally. Threatening to rock the stability of not only film text but also a defensive, apprehensive nation, this explosive perversity heralds both a larger sexual crisis and a potentially potent form of sexual liberation, albeit one ineluctably tinged with a tragic sense of the loss of possibilities of any kind.

As I have been discussing, Freud's theories of mourning (normal grief) and melancholia (interminable mourning), as well as the links among homosexuality, jealousy, and paranoia, are crucial to my interpretation of core themes in Hitchcock. I want to emphasize here as well the importance of his theory of incorporation. In *The Language of Psycho-Analysis*, Laplanche and Pontalis observe that "incorporation contains three meanings: it means to obtain pleasure by making the object penetrate oneself; it means to destroy this object; and it means, by keeping it within oneself, to appropriate the object's qualities. It is this last aspect that makes incorporation into the matrix of introjection and identification."[32] The invaluable work of Nicolas Abraham and Maria Torok further clarifies incorporation's relevance to Hitchcock and especially to *Rope*. In their essay "Mourning or Melancholia: Introjection *versus* Incorporation," they argue that

in order not to have to "swallow" a loss, we fantasize swallowing (or having swallowed) that which has been lost, as if it were some kind of thing. Two interrelated procedures constitute the magic of incorporation: *demetaphorization* (taking literally what is meant figuratively) and *objectivation* (pretending that the suffering is not an injury to the subject but instead a loss sustained by the love object). The "magical cure" by incorporation exempts the subject from the painful process of reorganization. When, in the form of imaginary or real nourishment, we ingest the

love-object we miss, this means that we refuse to mourn and that we shun the con-
sequences of mourning even though our psyche is fully bereaved. Incorporation is
the refusal to reclaim as our own the part of ourselves that we placed in what we
lost; incorporation is the refusal to acknowledge the full import of the loss, a loss
that, if recognized as such, would effectively transform us. In fine, incorporation is
the refusal to introject loss.[33]

Rope enacts the processes that Abraham and Torok outline: By killing David and stuff-
ing him into the chest, the killers *demetaphorize* David, making him the literal, physical
object around which the dinner party guests swirl. Their unwitting dance around his
body materializes their symbolic relation to him in life: his centrality to this group—
family, friends, fiancée, and mentor—his widespread appeal. And the killers *objectivate*
him, if we interpret their murder of the young, beloved man as an expression of their
own desires for him, shot through with envy and rage: envy because he represents the
heteronormative ideal; rage because the larger culture silences any expression of their
desires. If closeted homosexuality as a lived experience in homophobic society is a form
of social death, the killers murder David in their stead. In keeping with Abraham and
Torok, the murder expresses an inability to mourn. This inability to mourn is endemic
to queer experience, especially pre-Stonewall.[34] Making a meal of manhood, the killers
disacknowledge their own loss; moreover, they force those who also love the beloved
straight male object to partake in a parodic ritual of shared bereavement. ("Is it David's
birthday?" Kenneth asks, surprised by the offer of champagne. "More like the opposite,"
Brandon responds.) Brandon and Philip have invited those who have loved David to a
collective funeral, for him and for his killers. The meal is both a parody of the Christian
ritual of communion that emphasizes its suppressed associations with cannibalism (we
eat the body and blood of Christ, though they have been transubstantiated into bread
and wine) and an act of incorporation that suppresses knowledge of loss, grief, and the
now fully realized potential for savagery that the killers embody.

For D.A. Miller, the effect of Hitchcock's intensely self-conscious use of the cut in this
film is to obliterate the possibilities of homosexual desire. I argue, however, that the cut as
used here also lends itself to queer *evocation*. The cut that Miller reads as the interruption
and erasure of queer sex potentially functions as its sign. Hitchcock made this film dur-
ing the studio era, dominated by the Production Code, in which homosexuality, or "sex
perversion," could never be explicitly mentioned and in which even implicit signals were
suspect, as Robin Wood has shown.[35] (Wood is particularly eloquent in his treatment of
the cultural silences that made *Rope*'s articulation of its homosexual themes so difficult.)
As Arthur Laurents and Farley Granger both attest in their respective autobiographies,
Hitchcock was unruffled by the fact that Granger and Laurents were lovers during the
time the film was made. Nevertheless, homosexuality was never discussed by Hitchcock
or others on the set, referred to only as "It."[36] *Rope* finds numerous ways, however, of alle-
gorizing homosexuality within a culture of silence.

Given the centrality of the issue of the cut in Miller's essay, as well as the general critical fascination with the ten-minute take in *Rope*, it behooves us to pay close attention to the issue. When *Rope* was filmed, ten minutes was the maximum amount of time for a reel of film; Hitchcock attempted to make a film devoid of any obvious cuts. Robin Wood summarizes and clarifies common misunderstandings of the technical issues in the film. I quote Wood at length because he provides ample evidence that the very issue of the camouflaged cut—what sets *Rope* apart from Hitchcock's other films and lends it its particular identity as a film text—is itself often misunderstood and also mischaracterized:

> Repeatedly, one hears that *Rope* was shot entirely in ten-minute takes. As the film is approximately eighty minutes long, this entails the presumption that it consists of eight shots. Including the credit shot (roughly three minutes; it has to be included because it is clearly "within the diegesis," establishing the environment and culminating in the camera's pan to the left to show the closed curtains from behind which issues David Kentley's death-scream), there are eleven shots. Only three of these (Nos. 2, 6, and 9) are over nine minutes long; one (No. 10, culminating in the flinging open of the chest lid by Rupert Cadell/James Stewart) is under five minutes; the last is six. The remainder are all between seven and eight minutes.[37]

David Sterritt observes that "Bill Krohn and Donald Spoto are among the commentators who have misdescribed *Rope* as consisting of ten-minute takes. In fact the shots vary between four minutes thirty-seven seconds and ten minutes six seconds, and no two are the same length."[38] (While exceeding the scope of my discussion here, the contested relationship between Hitchcock and cinematic reality—as theorized by Bazin, Kracauer, and so forth—needs to be revisited. In particular, Bazin's antipathy toward Hitchcock for his lack of realism needs further analysis in light of the sheer self-consciousness with which Hitchcock presents his stylized, artifice-laden film worlds.[39] The anti-mimetic dimensions of Hitchcock's work are considered in chapter 7.)

It is telling that *Rope* was the first film that Hitchcock made for Transatlantic Pictures, the production company he and his erstwhile friend Sidney Bernstein created to evade "meddlesome producers and officious studios bosses," David O. Selznick in particular.[40] If we want to psychologize Hitchcock's interest in homosexual themes, *Rope* might be read as his "coming-out" film, his first film made in the United States as an independent director/producer.[41] Nevertheless, *Rope* was chosen to be made first because the film scheduled to inaugurate Transatlantic Pictures production, *Under Capricorn*, had to be delayed because of Ingrid Bergman's other commitments at the time. *Under Capricorn* was then made after *Rope* and released in 1949. Much like *Rope*, it is a difficult and self-consciously alienating film (Hitchcock's second in Technicolor) that also uses extended takes. *Rope* and *Under Capricorn* join other experimental films such as the single-set *Lifeboat*.

In the film's first four blackouts, Miller finds the articulation of *Rope*'s view of gay male sex as an anal fetish/phobia. The technique Hitchcock uses to mask the inevitable cut,

focusing on the dark expanse of a character's backside, invites one "to imagine that the camera's itinerary has been blocked, or what comes to the same thing, *would otherwise have continued*— ... from the cleft of the buttocks all the way to the perforation of the anus itself. ..." This maneuver prevents us from seeing "the orifice whose sexual use general opinion considers ... the least dispensable element in defining the true homosexual" and "the cut, for whose pure technicity a claim could hardly be sustained at so overwhelmingly hallucinatory a moment. ..." Hiding the cut, Hitchcock's technique infers the anus "*as what remains and reminds of a cut.*"[42] Miller's argument itself has a hallucinatory power. While compelling, it closes off the possibility that this transfixed moment of "pure technicity" might reveal directorial desire, a fascination with or even a longing for homosexual intimacy and sex.

As I see it, Hitchcock's cumbersome treatment of the cut in *Rope* contributes to his overall effort to create an atmosphere of entrapment and claustrophobia, an atmosphere directly related to the film's core themes. When the cuts do come in *Rope*, they are dramatically obvious *as cuts*; this film famous for its erasure of the cut actually enshrines this piece of film grammar. By making a movie that, far from suppressing the cut, makes its very appearance momentous, Hitchcock calls attention to and radically disrupts one of the cinema's crucial mythologies: that it represents reality. Hitchcock alerts us to the fact that film is *made*, something constructed out of random elements forced into a coherent alignment, a Frankenstein's monster of assembled parts. In terms of homosexuality, the shattering of the illusion that film represents reality is crucial: Far from seeing the story of these homo lovers or of their sexually charged murder of another young man, Hitchcock openly declares that we see—can *only* see—*parts* of this story, that the story has been, at all points, cut. *Rope* allegorizes the suppression of sexual content (homosexuality prominent within it) that characterizes the studio system—and continues to inform filmmaking practice; it does so by making the cinema's sleight-of-hand a very heavy one. (One thinks of bowdlerized films from the 1930s and '40s with gay source material—William Wyler's *These Three*, Billy Wilder's *The Lost Weekend* [1945], and Edward Dmytryk's *Crossfire* [1947].) The brazenly emphasized and visible cut in *Rope* challenges the viewer's sense of total mastery over the visual scene. It does so by exposing such a sense of mastery as entirely dependent on never *seeing* the cut, never noticing the sheer artificiality of film, immersing oneself so totally in the filmic experience that we never realize that we have been, at all times, manipulated and conditioned by technicians skilled in the arts of performance and masquerade. The lovers believe themselves to be similarly skilled, making them Hitchcock's stand-ins or enunciators. (*Vertigo* [1958] similarly thematizes the dynamics of duplicitous narratives.)

To return to an earlier point, critics such as Edelman, Miller, and, I would add, Linda Williams present us with a Hitchcock whose heartless technological manipulation of his audience, of which the filmmaker was quite proud, was his chief agenda.[43] If the sadistic-prankster aspect of Hitchcock's sensibility is undeniable, so is the pain in *Rope*, its frustration and increasing despair.[44] The focus on Hitchcock as a cunning master technician

(no dispute there) overlooks the sympathetic treatment that Hitchcock gives the lovers at certain points, especially Farley Granger's dark, troubled Philip, tremulously sensitive and physically beautiful, physically and emotionally similar to so many other Hitchcock males. When Mrs. Atwater holds the talented young pianist's hands in her own and proclaims, "Your hands will bring you great fame," Hitchcock pauses on the moment and Philip's reaction to her ironically devastating words. I believe that he does so to allow us to see how disturbed, how rueful, Philip looks, to take in the full gravity of what he and Brandon have done, to register the sheer waste of their lives as well as David's. Brandon has just arranged Philip's debut at Town Hall; Janet warmly congratulates him when she arrives. Why commit so destructive an act, the ultimate form of self-sabotage, as murder when one's life holds so much promise? In killing David, they kill themselves—murder as suicide pact. Philip appears to understand the gravity of their crime, hence his torment throughout the narrative; Brandon revels in his own sadism, yet the mask slips before the curtains close.

Rope offers an analysis of the codes and structures of queer desire, knowledge, and repudiation in a simultaneously restrictive and subversive era of homophobic control and homoerotic fascinations. As I have been arguing, it is significant that a woman plays a key role in this system of knowledge and disavowal, repression and incitement to know. As we noted in the introduction, both Tania Modleski (in her 2005 afterword to the second edition of *The Women Who Knew Too Much*) and Patricia White have valuably called our attention to the erasure of women's roles in the writings of prominent gay male critics such as Miller and Edelman. To echo White, while Miller is under no obligation to offer a feminist analysis of *Rope*, ignoring its female characters obscures its queer politics.

As noted, Janet Walker, so well played by Joan Chandler as acerbic yet vulnerable, is a very significant character who has been overlooked, especially in queer theory readings. Janet is passed around by the young men in the film in a manner that dovetails with the theories of triangulated desire and traffic in women that we have touched on in previous chapters. Janet exemplifies the crucial role that women play in the representation of male queerness in Hitchcock's American films especially. In them, male homosexual desire and intrigue are organized around the perspicuity of a woman, whose paranoid knowledge extends, parodies, and mirrors the disavowed knowledge the men possess about the complexities of their own desires (see figure 4.2). Janet is shown to be cognizant of the weirdness of her young hosts' behavior, and calls attention to this weirdness in a manner that suggests her knowledge of the various potentialities of what their behavior can signify. Rupert Cadell "solves" the homoerotic crime, but in many ways, he merely follows up on Janet's earlier suspicions.

Janet uses the male public-school term "chum" on more than one occasion. She also says to her ex-boyfriend Kenneth, regarding her sorrow over their breakup, "I just couldn't be the gay girl anymore." This line may be a covert signifier, like Cary Grant's in *Bringing Up Baby* ("I suddenly went gay all of a sudden!" his exasperated stooge explains while wearing Katharine Hepburn's frilly nightgown in Howard Hawks's definitive 1938 screwball

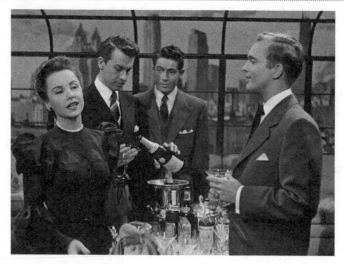

FIGURE 4.2 Janet Walker (Joan Chandler) threatens to penetrate the world of queer knowledge and intrigue.

comedy). Further linking Janet to the lovers, she says to Brandon at one point, "I could strangle you." Arthur Laurents simultaneously obscured the references to homosexuality in Hamilton's play and added strategic ones of his own. And he added the character of Janet, who, like *Vertigo*'s Midge (Barbara Bel Geddes), does not appear in the source text.

Janet and Midge both provide knowing, rational perspectives on and alternatives to their respective narratives' enclosed and murderous worlds of male/male intrigue. In *Vertigo*, the hero Scottie Ferguson falls in love with Madeleine, whom Scottie believes is the wife of the villain Gavin Elster, but who is actually a constructed image of femininity, a double of his wife played by another woman, Judy Barton, who has been trained by Elster. Midge, Scottie's best friend since their college days (they were engaged, and she broke it off, but still seems to be in love with him), attempts to puncture the allure of this female fantasy, albeit with middling results. In thrall to the enigmatic and seductive Madeleine, Scottie rejects the rational Midge after she shows him her parodic mockup of "Portrait of Carlotta." Midge substitutes her own wry, bespectacled face for that of Carlotta Valdes, Madeleine's suicidal female ancestor who appears to be haunting her. The artist Midge draws ads for women's undergarments. Janet, similarly, seems like a woman too intelligent for her own career; she jokes about her latest position at "an untidy publication called *Allure*," for which she writes a column on "the body beautiful." Similar to Midge, Janet had a romantic relationship with the protagonist—Brandon reveals that they were once an item. And like Midge, Janet takes a sardonic view of male emotionalism, laughing as Philip descends into hysterics at one point.

Rope's screenplay often has a double-edged, knowing significance. Arthur Laurents not only supplied the gay witticisms that Hitchcock wanted but also responses such as Brandon's "We all do strange things in our childhood" to Mrs. Atwater's "When I was

a girl I used to read quite a lot" (the look she gives him conveys a startled discomfiture). According to Laurents, the only worry Hitchcock expressed regarding the homosexuality angle was that audiences would perceive Mrs. Atwater as a lesbian, given the low voice of the actress playing her, Constance Collier. Though the film never makes its homosexual subject explicit, it is organized around "It." Moments such as the one in which Mrs. Atwater, Janet, and, especially, Rupert all discuss the Broadway musical that they can't name, the name being just on the tips of their tongues, as well as the name of the Ingrid Bergman film the women have seen, called "something, something" (which would appear to be Hitchcock's *Notorious* [1946]), and even the intensity of their panegyrics to Bergman, whom they call "divine," all add to the premonitory atmosphere of near explication. (Here the film echoes *Shadow of a Doubt*—the dinner table scene in which Charlie and her mother verge on articulating the name of the fateful waltz that is the basis of Uncle Charlie's murderous nickname the Merry Widow Killer—and anticipates the stutterer Norman Bates' faltering language in *Psycho*.)

Janet learns that the telephone is in the bedroom and, presumably, that there is only one. In Robin Wood's words, "Janet/Joan Chandler's response, 'How cozy,' can certainly be taken as the film's most loaded comment on the issue," the issue being the lovers' relationship. But *Rope*, Wood reminds us, was made in a homophobic era that policed any explicit acknowledgment of homosexuality. As he further points out, "later, however, we hear of a second bedroom (neither is ever shown)."[45] In any event, Janet seems to be in on the secrets that simmer beneath the film's socially polished surface. A triangulated or trafficked woman, Janet is circulated among a male group that almost entirely consists of men who may be said to be gay, closeted and otherwise, given the film's and the screenplay's repeated suggestions that the young men are all bound to each other and to Rupert by their homoerotic fixation on him.

As we've established, a system of sexual hegemony prevents the heterosexual females and the queer characters in Hitchcock films from joining forces. The class warfare that recurs in the films, often quite subtly, takes an equally subtle form in the interactions between the housekeeper Mrs. Wilson (another character invented by Laurents) and her strained, fussy employers. Played by Edith Evanson (later cast as Rita, the nearly deaf janitress who mops the floor in *Marnie* as the heroine tries to steal money from the Rutland office, her slipper suspensefully dangling from her purse and audibly plopping onto the floor, but unheard by the cleaning woman), Mrs. Wilson arrives shortly after David has been killed, carrying pâté and the other party goods she was sent to procure (presumably to get her out of the house). Mrs. Wilson informs them that she made a longer trip to the delicatessen that sells good pâté at a reasonable price because she refuses to misspend "our money," protecting her employers' funds as if her own. When Brandon decides to undo the table she has set and serve dinner on the *cassone* instead, Mrs. Wilson protests, adding that she thought her "table was quite lovely." She also reveals, with great affection on her part, that she used to work for Rupert. She begins to say that many have criticized him for being "peculiar, but I always think. . . ." The camera follows Brandon and Philip

into the living room, leaving the housekeeper off-screen in the dining room. But we nevertheless *hear* her saying, "You might let me finish." The indifferent young men treat her as irrelevant, disposable. But her connection to "Mr. Cadell," which they ignore, is significant: Like them, she shares past intimacies with him (they once had a glass of champagne together on her birthday, a line that Evanson delivers with a heartbreaking-though-offhand poignancy) and probably witnessed his galvanizing pedagogy. Mrs. Wilson initially appears to have a special bond with Philip, slyly commiserating with him about Brandon's bossiness and instructing him to eat, especially some of the pâté before everyone else devours it. She worries about Philip's health, that he's become too thin. But later, when she privately complains about the hosts' erratic behavior to Rupert, who mock-flirts with her in a friendly manner, Philip chastises her for "lecturing the guests" rather than serving them—for having forgotten her place.

Arthur Laurents has revealed, with misgivings, that everyone on the set treated Edith Evanson as if she were their own housekeeper, ordering her about, asking her to bring them water, and so forth.[46] *Rope* is more class-conscious than even its on-set atmosphere would suggest, attentive to the ways that a higher-class profile provided a social cover for gays and lesbians. Mr. Kentley remarks that he'd like to have Brandon and Philip over for dinner soon, treating them as a couple. Within their rarefied social world, the young men can *be* a couple. Their cavalier treatment of Mrs. Wilson—the silencing, literally, of her voice and Philip's severing of the emotional tie he shares with her—adds another dimension to the feminine/queer conflict. The lovers may suffer social opprobrium and potential ostracization, but this does not make them more aware of Mrs. Wilson's vulnerable social position in relation to them.[47]

Had original casting choices like Cary Grant or James Mason played the role of Rupert Cadell, no doubt the queerness of his character would have been much more vividly registered. (As it stands, direct references to both Grant and Mason and their considerable sexual appeal appear in the script: Janet and David's aunt swoon over them and Ingrid Bergman. Hitchcock also tried to get Montgomery Clift to play Philip. All too aware of the homo resonances of these roles and the potential for being outed, both Grant and Clift turned down the parts.) Having the hyper-all-American James Stewart in the role lessens the queer associations of the character, but at the same time, it is important to consider the insinuations of Rupert's homoerotic complicity, put into ironic relief by the very incongruity of Stewart's casting. His diabolical jokes about murder; his having been the person responsible for teaching Nietzschean philosophy to the boys; his having been present, as he reveals, when Philip "strangled a chicken," a euphemism for masturbation with cultural connotations of homosexual practice ("chickens," young men; "chicken hawks," older men who sexually prey upon them), all link him to the killers and the welter of associations that here signal homosexual identity. (The film implies, Robin Wood argues, that the lovers' sexual relationship is limited to masturbation.[48])

The character of Kenneth Lawrence merits some attention. Kenneth was Janet's boyfriend before she became involved with David, and David was his best friend. Now he

and David are no longer good friends, much to Janet's chagrin. Brandon takes particular delight in setting up a situation that forces Janet and Kenneth to interact again, much to their surprise, and quite awkwardly, as they await David. Sardonically ruminating on her erotic history, Brandon remarks to Janet, "After me, came Kenneth, then David. . . ." Their conversation highlights (though not the snide Brandon's intention) the constrictions placed on female sexuality in the period. As I argued in the previous chapters, a mutual lack of empathy is at the core of the feminine/queer conflict. If Brandon's sexuality makes him an outsider, surely Janet's premarital sexual experiences—if they do indeed exist beyond Brandon's hints and digs—makes her one as well, yet he cannot see her as an ally or a fellow victim of societal strictures. Instead, he aligns himself with the social order's scornful regard for the sexual woman, responding to her outrage at his taunting by mock-apologizing for his inability to keep track of her various lovers. That he was one of those lovers himself extends and complicates the feminine-versus-the-queer thematic and evokes the Kleinian theme of intimate violence. Their past intimacy, most likely a sexual one, makes Brandon and Janet's desire to wound and diminish the other—Brandon's sadistic aim, Janet's retaliation—all the more keen. There is no impulse to repair and restore the other, no attempt to establish parity and new intimacies.

It is worth mentioning, in this film obsessed with doubles, that Mrs. Atwater initially mistakes Kenneth for David. Both men resemble one another: They wear the same brown suit and have blonde hair and seem, compared to Brandon, Philip, and Rupert, fairly short. Mr. Kentley also makes note of resemblances between the two. An incipient sense of the gay clone emerges, one deepened by the casting choice of the slight and unmemorable Douglas Dick as Kenneth; he seems wan enough to *be* a clone.[49] David was a member of a circle that includes Brandon, Philip, Kenneth, and Rupert. It is strongly suggested that this circle was a homosexual one that David, through his relationship with and engagement to Janet, was attempting to escape.

One must, along these lines, wonder if Janet is somehow an honorary gay man. Certainly she is depicted as one of the boys, and included in their abusive games. Understandably vexed by these attacks, Janet says to Brandon, "I could strangle you," linking her to chickens and especially chicken hawks. The traffic in women is presented here as an economy exclusive to gay men, who bandy Janet about as a pliable beard. When the increasingly agitated Philip tells Janet that he never eats poultry, Janet's response is "How queer." In the climactic portion of the film, Rupert observes of Brandon, "You often pick words for sounds rather than meaning." Even though most audiences may not have been familiar with the term, some moviegoers would have picked up on the distinctive sound of terms like "queer."

Janet's line is decodable as a challenge to Philip. Perhaps she refers to an array of taboo sexual subjects that includes queer chicken for predatory hawks. One thinks ahead to *Psycho*'s stuffed birds, always read as metaphors for its victimized women; perhaps the sexuality of the predatory gay man, as well, animates these birds immortally poised for attack. As Amy Lawrence points out in her essay on *Rope*, a 1922 Department of Labor

manual used the term "queer" to refer to an effeminate male; it is precisely the fear of "unusually fine" effeminate men, such as Brandon and Philip, that enables Rupert not only to distance himself from them but to align himself with the retributive forces of their destruction.[50] Brandon reveals that, when both were at "Mother's house in Connecticut," he once witnessed Philip strangling *two* chickens one morning, which Philip apoplectically denies. As the lovers violently bicker about this matter in front of their dinner guests, effectively outing themselves as a pair whose relationship (whatever their guests perceive that relationship to be) often veers into angry conflicts, Janet laughs about the fuss they're making over dead chickens. Later, Rupert challenges Philip, saying that despite his protestations he did, indeed, strangle a chicken as Rupert watched; moreover, Rupert asks the pair if their fight is over because they seemed like they were "about to strangle each other next." These moments support the idea that Philip, verging on hysteria, attempts to deny something rooted in and characteristic of his nature and that everyone around him *knows*. Far from being the charismatic and domineering Brandon's pawn, Philip possesses a full capacity for violence, particularly one directed against the defenseless, as he himself appears to be in juxtaposition with Brandon. Moreover, despite the couple's cultivated air, a turbulent emotionalism keeps breaking out and disrupting their façade, even Brandon's.

If we venture beyond the limits of Miller's argument in "Anal *Rope*," we find a queer world that encompasses virtually everyone, including Mr. Kentley, who appears as dominated by his wife as Norman is by "Mother" and therefore feminized on some level; moreover, David is also dominated by his mother's incessant attentions. Like Mrs. Bates, Mrs. Kentley is an unseen but controlling, maddening presence, from whom Mr. Kentley has tried to free his son but has been unable to free himself. Brandon's references to "Mother," who lives in Connecticut and to whose house he frequently brings Philip— they are headed there, in fact, after the party—reinforce the idea of maternal figures as unseen but dominant, looming in their significance, an idea that reaches an apotheosis in *Psycho*. (Brandon's mother occupies a central place in the more private realm, out in the country and away from city scrutiny, that he and Philip can enjoy; indeed, it is her realm. At Mother's house, the pianist Philip will, under Brandon's supervision, practice six hours a day in preparation for the performance Brandon secured for him at the Town Hall.)

Of all of Rupert's former charges, David Kentley is the one who threatens to break away through marriage, a denial and rejection of the homosocial intimacy of the group's prep-school days. If David is a closeted gay man dominated by his mother in accord with clichéd Freudian paradigms, Brandon and Philip's murder of him is a desperate, horrifying form of outing. Their "ugly," as Rupert puts it, erotically charged murder of David forces him to acknowledge their shared sexual past and predilections while allowing the three to be physically intimate once more, however gruesome this intimacy. At once, their murder is a homoerotic tribute to Rupert and an act of fierce provocation, especially on Brandon's part. Brandon strives to out-Rupert Rupert; as he says to his former headmaster, "Philip and I have lived what you and I have talked."

Dared to do so by Brandon, Rupert flings open the chest and discovers, to his horror, David's body within it, incontrovertible evidence of Brandon and Philip's crime. After an initially devastated reaction, Rupert rails against the young men, morally denouncing them and vowing to "help" as society punishes them, Old Testament-style, with their own deaths. He manages to wrest the gun from Philip's hands, fling open the window, and fire the weapon into the night air. Robin Wood reads this moment as a moral liberation—the gunshots explode the miasmic deceit and violence of the atmosphere, and we identify with Rupert's attempts to restore justice. Moreover, it is Rupert's very complicity with the crime that makes his attempt to expose it all the more "powerful and ratifies the film's moral authority."[51] As noted, Richard Allen also makes a case that Rupert's actions reflect Hitchcock's allegiances. In my view, however, Rupert's reclamation of the gun, which replaces the circular, coiled, and yonic rope with a phallic emblem of masculine force, signifies his alignment with the social order and the law, a rebuke of his corrupt and shameful complicity with Brandon and Philip. The suggestion is that the phallus properly belongs to Rupert, cynosure of the social order, not the queer killers. His firing of the gun confirms his effort to renounce his former homoerotic ties and, possibly, sexual relationship with the killers. Wresting the gun away from the fumbling, hysterical Philip, Rupert reestablishes patriarchal, heterosexual gendered order while reentering it himself. At the same time, James Stewart's acting cannot be discounted here. He characteristically brings an increasingly desperate emotional urgency to the role and to the film—he registers the heartbreaking horror of David's death, his own fear of the killers, and the *weariness* of his fear (see figure 4.3). He thereby shares in the queer anguish he promulgates.

Emotional urgency is a significant dimension of Hitchcock films; it underscores the queer anguish in *Rope*. Philip unravels, his hysteria fueled by heavy drinking. Philip's

FIGURE 4.3 Brandon (John Dall) desperately asks Rupert (James Stewart) for recognition and perhaps empathy.

alcoholism, which Brandon explicitly calls "his condition," cannot be incidental to a film so concerned with the dark side of ingestion—it suggests an attempt to force-feed oneself disavowal. Brandon maintains a steady, jousting composure throughout, but at the end, even he cannot sustain this front. Failing to prevent Rupert from opening up the chest, Brandon says, "Go ahead and look. I hope you like what you see." As he utters these taunting-yet-desperate words, his voice almost audibly cracks from the strain. This line delivery is a telling rupture in John Dall's otherwise steadfastly arch, mordant tone, the moment when the mask slips.[52] Belying his imminent, gun-wielding virilization, Rupert, his face luridly lit by the flashing red and green streetlights outside the window as he stares down at David's corpse, can only pitifully say, "Oh, no."[53] Rupert may ultimately be in league with the law, but his pitiability here reflects his own queer anguish. Or, more to the point, he shares in Philip's unraveling, the inability to maintain the stoic male masquerade of which Brandon's antic gamesmanship is a variant.

I would argue that *Rope* is less a negative image of homosexuality than it is a film that explores homosexuals' negative images about their own identities. In this manner, it somberly prefigures the comic yet searing *The Boys in the Band* (William Friedkin, 1970), with a screenplay by Mart Crowley based on his 1968 Off Broadway hit play. Both *Rope* and *Boys* thematize a homosexual male subjectivity that understands itself chiefly through negative cultural images of homosexuality; moreover, both works feature the midpoint entrance of an ostensibly straight male character who may or may not have engaged in the homosexual practices he rails against, explicitly in *Boys* and implicitly in *Rope*. *The Boys in the Band* extends *Rope*'s analysis of ingestion as numbing; both works indicate links among alcoholism, homophobia, and the closet.[54] Early in the film, Brandon and Philip negotiate a tellingly large bottle of champagne, Philip eager to drink from it. Philip's excessive drinking throughout and clear intoxication by the end of the film make *Rope* one of the first American films to link closeted homosexuality to alcoholism (the expurgated content of *The Lost Weekend*). The film's analysis of orality facilitates this treatment.

On the verge of heterosexual marriage and escape from a miasmic queer subculture, David becomes a grotesque art exhibit, a self-portrait of the artist's own self-loathing that can be seen by only one museumgoer, the fellow connoisseur Rupert. (Both *Vertigo* and *Torn Curtain* will make the museum a metaphor for balked sexuality, homosexuality in the latter film's case.) He is the "David" of heterosexual male sexuality, literally rendered an object of desire. Brandon muses early on that the glass from which David drank whiskey should be saved as a "museum piece"; his dead body serves as such.

"Hitchcock," Richard Allen writes, "is not concerned to demonize homosexuality. His interest in these characters lies in staging the performance of a gentlemanliness beneath which the darkest secrets are harbored in a manner that renders them alluring and often sympathetic."[55] *Rope* clarifies the range of available types that can fall under the title "Hitchcock gentleman." Anything but gentle though certainly cultivated, Rupert is a new kind of monster, the educated American as moral hypocrite, and an anticipation of a more contemporary kind of menace, the "attack queer" who scores points by vehemently

impugning the morals of his or her fellow queers. The theme of queer anguish that runs throughout Hitchcock's films from *The Lodger* to *Marnie* (and perhaps beyond) manifests in *Rope* as the eradication of queer possibilities. This nullity lies in the double determination of Brandon and Philip's self-annihilation and murder, their self-annihilation *through* murder, and the social order's own intentions to annihilate them.

5

The Fairground of Desire

PARANOIA AND MASOCHISM IN *STRANGERS ON A TRAIN*

BUILDING ON OUR discussion of *Rope*, this chapter focuses on the closely related film *Strangers on a Train* (1951), and the interplay between homoerotic antagonism and the feminine-versus-the-queer dynamic. Here the heterosexual woman and the queer male contend with one another from positions of paranoia and masochism, respectively. That the woman's knowledge is paranoid does not make it inaccurate, only more vexed; that the queer male understands his position from a masochistic perspective throws light on his relations with his female rival and the male object of his desire.

In the introduction, I noted the feminist critique of Freud's theory of female paranoia in his 1915 essay "A Case of Paranoia Running Counter to the Psychoanalytic Theory of the Disease." For our purposes, the following points are most relevant. Freud's patient is a woman who has accused her lover of hiring people (who remain unseen) to photograph them when they make love in his apartment. The lawyer to whom the woman brings charges against her lover refers her to Freud. For "external reasons," her lover is unable to marry her, but encourages her to defy social convention and continue to enjoy sexual relations with him. As Jack Halberstam parses, "During their lovemaking the woman hears a 'kind of knock or a tick' which the man says comes from a little clock on his writing table. The woman, however, later connects the noise to two strangers she sees on the stairs outside carrying a box and she imagines she has been photographed. . . . [Later,] she reveals the presence of an older woman at work whom she suspects of having an affair with her lover. Freud now easily makes the case for a mother complex and female paranoia seems

to conform to the male paradigm." Locating the necessary component of homosexual desire in the woman's primal-scene fantasy of the mother, Freud is then, to his relief, able to link this woman's initially unclassifiable case to his theory of paranoia.[1]

I want to highlight an aspect of Freud's brief case history for our discussion of *Strangers on a Train*. Freud describes his female patient's experience of sudden fear while making love to the unavailable man. "In the midst of this idyllic scene she was suddenly frightened by a noise, a kind of knock or click." The woman comes to believe that the knocking/clicking sound emanates from a clock on the writing desk.

As she was leaving the house she had met two men on the staircase, who whispered something to each other when they saw her. One of the strangers was carrying something which was wrapped up and looked like a small box. She was much exercised over this meeting, and on her way home she had already put together the following notions: the box might easily have been a camera, and the man a photographer who had been hidden behind the curtain while she was in the room; the click had been the noise of the shutter; the photograph had been taken as soon as he saw her in a particularly compromising position which he wished to record. From that moment nothing could abate her suspicion of her lover.[2]

This portion of the case history parallels some of the most significant action in Hitchcock works and provides a template for the feminine versus the queer. Inevitably, one thinks of *Rear Window* and Lisa Freemont's relationship to the distant hero Jeff, an action photographer who mediates his personal interactions and conflicted relationship to his own desire through his technological apparatus and long, phallic telephoto lens; of Judy Barton's awareness that Scottie is watching her as she performs the role of Madeleine Elster in *Vertigo*; of Mitch Brenner in *The Birds* looking at the active woman Melanie Daniels through binoculars as she attempts to escape his gaze within the framework of screwball courtship.

Freud interprets the tick the woman hears as "a metaphoric series—camera, clock, clitoris," in Halberstam's parsing. By interpreting the tick in this manner, Freud manufactures a "technology of sex which produces femininity in a certain relation to discursive authority and then defines a particular sexuality for the female body."[3] Halberstam's Foucauldian analysis valuably calls our attention to the misogyny in Freud's interpretation, his complicity with both the lover, who writes to Freud to express his regret that his "beautiful and tender" relationship with the woman has been "destroyed by this 'unfortunate morbid idea,'" and the woman's lawyer, who consults Freud in the hopes that he can confirm that his client's accusations have a "pathological stamp." Freud's interpretation is not without value, however, especially for the concerns of the present study.

The woman's suspicion of her lover, the "unfortunate morbid idea," is at the center of key Hitchcock films in various ways, as in *The Lodger, The 39 Steps, Secret Agent, Sabotage* (1936), *Young and Innocent* (1937), *Rebecca, Mr. and Mrs. Smith* (1941), *Shadow*

of a Doubt, Spellbound, Notorious, The Paradine Case, Stage Fright, Dial M for Murder, The Wrong Man, Vertigo, Psycho, The Birds, Marnie, Torn Curtain, Topaz (1969), *Frenzy, Family Plot* (1976), and, most definitively, *Suspicion*, released right after *Rebecca*. The idea that the woman suspects her lover (or husband) of questionable behavior is one of the most consistent in the Hitchcock canon.

But there is another key Hitchcockian theme within this Freudian case history. "As she was leaving the house she had met two men on the staircase, who whispered something to each other when they saw her. One of the strangers was carrying something which was wrapped up and looked like a small box." While the trigger for the woman's paranoid fantasy was the ticking sound, what catalyzed the full development of the fantasy was the woman's encounter with two men walking in unison past her, who whisper something to each other when they see her. In other words, the men are unknown to the woman, but known to one another. Their private yet publicly displayed intimacy simultaneously excludes and includes her. There is even a Hitchcockian staircase, his expressionist motif par excellence, indicative of perilous psychological states in motion.

This pair of strangely intimate men may be talking about the sexual intercourse that *they* are about to have rather than about the woman, which is to say that something about their paired presence instigates her morbid fantasies. Let me make it clear that I do not endorse her lover's description of her fears as morbid, but want instead to make use of morbidity as a provocative category for the issues we are considering here, especially considering the Cold War-era commonplaces about homosexual morbidity that inform *Strangers*. The male couple exists at a discrete remove from both the woman and the heterosexual couple—which is to say, from female experience and the scene of heterosexual sexual intercourse, respectively. Yet they are incorporated into both through the fervent, uncomfortable power of the woman's paranoid apprehension. The men on the staircase exchange information about her, if we follow the woman's interpretation. In other words, just as she devises a paranoid scenario that includes them and from which she derives knowledge, they devise an equally paranoid one about her from which they derive knowledge. The woman and the male pair, then, mirror one another not only in their paranoid interpretation but also by being similarly distinct from the heterosexual male, left out in the cold—and free to claim the right to his sexual privileges while defining any impediment to them as "morbid." The male pair, by talking about the woman (if they are indeed really doing this), establish themselves as rivals. They represent the overall male sensibility that surrounds, even engulfs, the woman, whose recourse to paranoid interpretation reflects this entrapment and a resilient strategy against it. I posit that this scenario helps us to interpret the social implications of *Strangers*. Before discussing the feminine-versus-the-queer thematic in the film, I want to explore its homoeroticism or, as I termed it in the introduction, homoerotic antagonism. As Jonathan Goldberg has argued in his important monograph on *Strangers* as a "queer film classic," the film places emphases that distinguish it from Patricia Highsmith's novel and make it the queerer work. I would argue that it is also more emotionally charged than Highsmith's brilliantly taut novel.

In her essay "Paranoia and the Film System," Jacqueline Rose observes that the "woman is centered in the clinical manifestation of paranoia as position. Paranoia is characterized by a passive homosexual current, and hence a 'feminine' position in both man and woman.... For the woman it is the infantile image of the mother which lies behind the delusion of persecution even where the persecutor is apparently a male." Referring to Freud's case history of female paranoia, Rose writes, "the woman regressively identifies with the mother in order to free herself from the primary homosexual attachment; the mother is then released as voyeur and persecutor into the place where the child once was at the moment of the primal scene. Narcissism is referred here not only to the choice of object but also to the process of identification itself...."[4] While a crucial study, Rose's essay is impoverished by a lack of attention to lesbian desire and the full ramifications of homosexuality within Freud's theory of female paranoia. I will take up the issue of lesbian desire within a narcissistic/paranoid position in the next chapter; here I want to emphasize that the heterosexual woman's relationship to the queer male's mother is a significant dimension of the feminine/queer conflict, which is mediated through the figure I call the *queer mother*. Therefore, the heterosexual woman's relationships with the queer villain and with his mother are equally significant. *Psycho* enshrines and extends the moment when "the mother is ... released as voyeur and persecutor into the place where the child once was at the moment of the primal scene," particularly apparent in her invasive resistance to and domination over the scene of presumably heterosexual desire between Norman Bates and Marion Crane (one thoroughly complicated by Norman's queerness of course).

THE QUEER MOTHER

Hitchcock's frequently disturbing maternal figures are almost always tied to an overly close relationship to their sons, and very often the sons turn out to be the queer villains. Emma is a version of this in terms of her incestuously charged relationship with her brother Charles in *Shadow of a Doubt*, and we can add Mrs. Sebastian in *Notorious*, the villain's mother in *Strangers on a Train*, and Mrs. Bates in *Psycho* to the list. And though she is mother to the ostensibly heterosexual hero, Clara Thornhill (Jessie Royce Landis) in *North by Northwest* very much belongs in this group. The mother's relationship to the queer male is almost always incestuously charged and charged with violent potentiality. We see this explicitly rendered in the early morning tête-à-tête between Mrs. Sebastian and her son Alex in *Notorious* as both plot to eliminate his wife Alicia, who has been discovered to be an American spy. The decadence of these maternal figures links them to their sons, as does their gender ambiguity, conveyed in gestures such as Mrs. Sebastian's peerless, gangster-like, and crude lighting of a cigarette out of the side of her mouth when Alex first breaks the news of Alicia's identity to her, and in the phallic violence of knife-wielding Mrs. Bates's murder of Marion Crane. The queer mother relinquishes

and in some cases repudiates her own femininity to sustain her link to her nefarious son, whose own gendered identity is rendered suspect by his behavior, mores, and lack of heterosexual ardor.

Lee Edelman penetratingly discusses the Cold War-era cultural mythologies that linked the homosexual and his mother as menaces. He quotes from Ken Worthy's *The Homosexual Generation* thusly: "Kinsey has given us a brutal picture of the homosexual's mother, listing, a. her overpossessive love of him during his infancy and early childhood, and b. her underlying hatred of his wife, no matter how wise, devoted, and long-suffering the latter may be." [5] Edelman observes, in the context of *The Birds*, "This mass-market version of gay etiology might afford us some interpretive purchase on the film by allowing us at last to make sense of the ascot [that the male lead Mitch Brenner] wears beneath his sweater and letting us catch the full force of the drift when [Annie Hayworth, once his lover] wistfully muses out loud, 'Maybe there's never been anything between Mitch and any girl.' "[6] As I will discuss in the epilogue, Mitch's mother Lydia is another queer mother figure, locked into conflict with the heroine, albeit one that finds a moving resolution by the end, at least as I read the film. Lydia's penetrating stares at the heroine Melanie Daniels convey her fierce attachment to her son but also, perhaps, her envy of and even desire for Melanie. The queer mother both recognizes the heroine's beauty and appeal and repudiates them, covetously keeping the queer son to herself. While in many ways, this Hitchcockian schema accords all too comfortably with the Ken Worthy version of the Kinsey Report, there is nevertheless an urgency and even a plangency increasingly in evidence in his maternal portraits, no matter how dark. The sympathy that Hitchcock characteristically extends to the queer villain is extended to the queer mother as well. For example, at the climax of *Notorious*, as Devlin rescues the nearly catatonic Alicia from the Sebastian home as Alex's Nazi cronies sternly observe the proceedings, we feel for Mrs. Sebastian's peril and desperation as she urges her son, "Alex, talk to them, quick!" Despite her cold malevolence throughout the film, Mrs. Sebastian, Alicia's poisoner along with Alex, is suddenly a vulnerable, pitiable woman in need of our help.

Strangers on a Train (as *Notorious* did and *Psycho* will do) places the investigative, paranoid woman in a position of enmity against both the queer male and his mother that reinforces their mutual antagonism and estrangement while occluding their shared experience of submission to the reign of the heterosexual male, which is to say that an important aspect of the woman's paranoia in the Hitchcock text is its compensatory role as shield against knowledge of her own subject position within the gendered hierarchy and of the potential menace within the heterosexual relationship, as well as within the male protagonist's psychosexual identity. While the queer villain and his mother could be her allies, most often, due to sexual hegemony, they oppose her and she opposes them. Most often, the heroine's paranoid acuity is directed against queer intrigues, seductions, and illusions, thereby safeguarding herself, her male love object, and institutionalized heterosexuality from damaging scrutiny. Moreover, her fraught, repressed relationship

with her own rejected mother and/or the maternal imago returns in distorted form in her showdown with the monstrous mother of the queer villain.

Before turning to our analysis, it will be helpful to remind the reader of the movie's plot. Guy Haines (Farley Granger) is a tennis player trying to divorce his shrewish first wife Miriam (Kasey Rogers, billed here as Laura Elliott) so that he can marry a senator's daughter, Anne Morton (Ruth Roman). On a train from Washington, D.C., to his hometown Metcalf, Pennsylvania, where Miriam lives, Guy meets Bruno Anthony (Robert Walker), a wealthy psychopath. Guy is headed to Metcalf to finalize his divorce. Guy and Bruno share lunch in Bruno's private car. Unwittingly, Guy agrees to Bruno's fiendish plan to get away with murder—"I do your murder, you do mine—crisscross!" Bruno kills Miriam, who refuses to divorce Guy, and expects Guy to kill his father in return. With the police suspecting him of murder, and Bruno stalking him at every turn, Guy finally confronts Bruno at the same fairground where he killed Miriam and is now trying to frame Guy by depositing his lighter (found and kept by Bruno after Guy got off the train) at the scene. The two men climactically brawl on a merry-go-round spinning out of control; after the gigantic apparatus flies off its base, Bruno, crumpled and dying, continues to insist on Guy's guilt to the police. Just before he dies, however, his hand goes limp and reveals the lighter clutched therein, corroborating Guy's story that Bruno has been trying to frame him. Guy and Ann are now free to marry.

STRANGERS WITH APPETITES

In the previous chapter, we explored the links among orality, incorporation, loss, and homosexuality in *Rope*. *Strangers on a Train* extends these themes as it establishes the basis of its double protagonists' intimacy.[7] The film extends *Rope*'s analysis of the crucial importance of "orificiality," to use Kyla Wazana Tompkins's term, to questions of queerness.[8] Reading orificially allows us to "imagine a dialogic in which we—reader and text, self and other, animal and human—recognize our bodies as vulnerable to each other in ways that are terrible—that is, full of terror—and, at other times, politically productive."[9] Orality informs, as we have seen, the representation of male/male desire in works such as *Spellbound* and *Rope*, and we can find a similar preoccupation with these dynamics in *Strangers*, *Psycho*, and *Frenzy*, in which the levels of vulnerability and terror associated with orality—and queerness—reach a particularly acute level. At times, though, as it is in *Strangers*, *Dial M for Murder*, and *North by Northwest*, the linkage between queerness and the commensal is subtler, though no less charged. While *Strangers* has benefited from important critical readings by Robert J. Corber, Sabrina Barton, and Goldberg, especially, no one, to my understanding, has considered the significance of eating to the film's queer design.[10] My focus in this section will be on the initial scenes between the film's male leads.

The carefully textured early scenes between Guy and Bruno on the train are especially fine. Telling differences exist between the two known versions of the film, the release and the preview versions, which at one point were called the American and the British versions.[11] The preview version runs two minutes longer and includes additional dialogue between the men on the train. The release version cuts out several small details in the initial train scenes between Guy and Bruno; tropes of food and eating dominate these excised moments. They evoke images of the dandy and the gastronome, important figures in the genealogy of male homosexual cultural mythologies.[12]

In *Strangers*, food indicates homoerotic threat. Generally speaking, the gulfs between characters in Hitchcock are represented by food and eating—take, for example, the miserably unfinished and uneaten chicken dinner between the strained lovers in *Notorious*. The items in the lunch Guy and Bruno share reflect their inability to communicate clearly or coherently; more subtly, they underscore Bruno's queerness and Guy's gender normalcy, which will be steadily undermined. As their conversation on the train comes to an end, Bruno believes that Guy has agreed to collaborate with him on his murder scheme. "We *do* speak the same language, don't we!" exclaims Bruno (see figure 5.1). Humoring him, Guy responds as he leaves the train, "Sure, Bruno, we speak the same language," and the gears of fate are now locked into place. Speaking the same language is one of many surprisingly readable metaphors for homosexual contact, insinuated early on.

In a nod to a well-known practice in the rituals of cruising, the film commences with shots of the two men's respective shoe-clad feet as they approach the train. These shots, matched through parallel editing and highlighted by Dmitri Tiomkin's loping score, lends an air of adventure and momentousness to the men's incipient meeting. They establish

FIGURE 5.1 "We do speak the same language, don't we!" Bruno (Robert Walker) makes Guy (Farley Granger) an indecent proposal. Physical intimacy belies the psychological gulf between the men.

the men's distinct personalities at the level of their footwear: Guy's sensible, dark, rather nondescript shoes and Bruno's flashy, two-toned pair, a yin-and-yang black and white. The montage of shoes establishes Guy's nondescript everyman personality, Bruno's dandyish wealth and theatricality. Pointedly, Guy's shoe brushes against Bruno's, the gesture that instigates their discussion. Given Guy's seeming horror at Bruno's relentless pursuit of him, the fact that *Guy's* shoe brushes against Bruno's is crucial. They could be two men cruising each other in a bathroom, a ritual known as "tea-rooming" in the U.S. and "cottaging" in England, in which foot-tapping in a bathroom stall signals sexual interest; if so, Guy takes the lead, initiating contact.

Bruno orders "doubles" of scotch and water for himself and Guy. Guy initially says, "You'll have to drink both yourself." But when Bruno provocatively asks Guy about Miriam's cuckolding of him, Guy snaps at his interlocutor and suddenly decides to take him up on the offer of a drink ("Thanks, I think I will"). Their shared drink signals homosocial bonding and the disavowal of anxiety and anger. It also reinforces the sense of a growing physical intimacy, as Bruno, after having begun a conversation with Guy, gets up and sits right next to him, leading Guy, initially reading his paper, to speak with him face to face. Their physical intimacy is striking, as is Guy's push/pull attitude, palpably conveyed by Farley Granger, toward Bruno's undeniably vivid presence. Submitting to Bruno's will, Guy drinks the drink ordered for him, as if imbibing Bruno's threatening yet mesmerizing evil. Bruno then encourages Guy to have lunch with him in his compartment. Having already begun drinking with Bruno, Guy might be expected to acquiesce to lunch. But he anxiously says no, asking the overburdened waiter if the dining car has a free table. Informed that there will be a twenty-minute wait, Guy looks worried. "There now, you see, you'll *have* to have lunch with me!" beams Bruno. In one of the small but loaded moments cut from the release version, Bruno encourages Guy to order lunch and we hear the items each man orders.

Bruno orders lamb, French fries, and chocolate ice cream. He urges Guy to order. Guy finally asks for a hamburger and coffee—a sensible, sturdy, "manly" meal, especially in comparison to Bruno's more lavish one. After the meal is over and their murderous compact established (unwittingly on Guy's part), Bruno complains that his lamb was "overdone." Bruno's lunch is a variant of the signature French meal steak frites, and as such, it signifies a European aesthetic sensibility and acculturated taste. This note is later amplified by Bruno's conversation with the Darvilles, a French couple with whom he speaks fluent and raucous French. Guy's all-American hamburger is plebian and standard—nothing sexually suspect about this choice, which is precisely the point.

Guy's growing interest in Bruno is signaled by his indulgence of Bruno's personality. "I don't think you know what you want," Guy remarks, looking straight into Bruno's eyes; the nuances in Granger's delivery of the line are striking—he almost sounds like he is flirtatiously challenging Bruno. Hitchcock's consistent attraction/repulsion to homosexuality informs Guy's discomfited efforts to wrest himself free of Bruno's charms while in danger of succumbing to them. Altogether, Guy's demeanor conveys a sense of a man

attempting to overmaster his willingness to submit to homosexual seduction. Guy's reluctant order of a plain lunch defends against any inclusion in Bruno's more sophisticated-yet-decadent sensibility, underscored by his luxuriant dessert.

The preview version is significant for the emphasis it places on the waiter's servitude. A second waiter, not seen in the release version, takes the men's lunch order. Inordinately taxed, he carries a large tray on his head and must repeatedly stop, turn around, answer questions, and make his way back to the kitchen, only to be yanked back by Bruno's incessant questions. The wealthy Bruno has no qualms about directing these numerous inquiries to the beleaguered waiter, whereas the social-climbing-yet-genteel Guy almost deferentially beams in appreciation when he places his order.

It is not often that one considers race in the alabaster-white world of Hitchcock, but it is significant, to be sure, that the waiter is a man of color. Very subtly, the waiter's color and his stark separation from the entire spectacle of white privilege reinforce the idea of homosexuality—which the preview version links to the gustatory—as a privileged white man's disease. Such a view informs the writings of the Martinique-born Afro-French psychoanalytic theorist Frantz Fanon.[13] *Rope*, as we have seen, stages homoerotic desire as a perverse meal; *Strangers* makes similar associations. The relationship between the killers in *Rope* and their prep-school mentor, who shares in their corrupt fantasies of superiority yet exposes their crimes, is doubled by the Bruno/Guy relationship: If the killers make a meal of manhood in the earlier film, Bruno makes a meal *for* manhood, almost literally setting a place at the queer table for Guy.

Although a fuller discussion of this exceeds the present chapter, the issue of race and the erotics of whiteness in the Hitchcock oeuvre are well worth considering. *Vertigo*, Hitchcock's greatest work, will reformulate some of the motifs present in *Strangers*. Much like Guy, the protagonist of *Vertigo*, John "Scottie" Ferguson (James Stewart), is overmastered by another man's narrative. Tricked into believing that he is following Gavin Elster's wife Madeleine (Kim Novak), who appears to be devolving into madness, Scottie instead finds himself a patsy in Elster's plan to murder his actual wife, who is being impersonated by a woman trained by Elster, Judy Barton. The film's construction of an idealized white beauty in Madeleine, whose status as copy foregrounds artificiality, demands further consideration, especially the ways in which this eroticized and sculpted whiteness intersects with a plot about a female ancestor (Carlotta Valdes) that is charged with elements of nineteenth-century racialization on the one hand, and a profound gender ambiguity on the other. Interestingly, Scottie, at Elster's behest, first glimpses the surpassingly beautiful Madeleine when she is having dinner with her seeming husband; the meals between Scottie and Judy Barton at Ernie's, the same restaurant where he first saw Madeleine, are crucial to their relationship; and after Judy has been transformed, this time by Scottie, into Madeleine once more, she craves "a great big steak," an indication of the vitality Scottie snuffs out.

As Charlotte Chandler, drawing on personal conversations with the director, observes, "Food frequently appears in Hitchcock films, and even when it seems not to serve a

purpose, it helps define the characters." She quotes Hitchcock himself on food and the lunch between Bruno and Guy:

> "Preferences in food characterize people," Hitchcock said. "I have always given it careful consideration, so that my characters never eat out of character. Bruno orders with gusto and an interest in what he is going to eat—lamb chops, French fries, and chocolate ice cream. A very good choice for train food. And the chocolate ice cream is probably what he thought about first. Bruno is rather a child. He is also something of a hedonist. Guy, on the other hand, shows little interest in eating the lunch, apparently having given it no advance thought, in contrast to Bruno, and he merely orders what seems his routine choice, a hamburger and coffee."[14]

As Chandler also reports in her conversation with Farley Granger, who played Guy Haines, Hitchcock was well aware of the work's homosexual themes, even though Granger said that he and the director "never discussed any homoerotic attraction Walker's character had for me"; "he just wanted me to act kind of normal and not be aware of too much of an undercurrent." Granger adds that Hitchcock most likely *did* discuss such matters with Robert Walker, who played Bruno Anthony. "Of course, Hitchcock understood all of this," Granger noted in reference to the homoerotic "undercurrent," "and he knew what he could do, and what we could do."[15] Granger was, like so many of Hitchcock's males, dark-haired, handsome, tremulously sensitive, and gay/bisexual in real life. Hitchcock was well aware that Granger and Arthur Laurents, the screenwriter for *Rope*, were lovers at the time. Hitchcock's choice of Granger for the straight male lead was itself a deconstruction of that category, as was the casting of Robert Walker in the queer role.

The fact that Hitchcock found Bruno childlike and viewed his choice of lunch fare as revealing speaks volumes about the director's understanding of both queerness and food's metaphorical meanings. If Hitchcock, along with American psychiatry, understood homosexuality as a regressive return to earlier stages of development, he also saw Bruno as attractive, charming, and seductive—certainly much more so than the normative heterosexual couple Guy and Anne.[16] Psychotic murderousness becomes a metaphor for Bruno's queerness, his queerness an indication, in the film's Cold War context, of his psychosis. While Hitchcock is guilty of perpetuating stereotypes, he is clearly as seduced by Bruno's charms as Guy and the other characters are—more so.

WOMEN AND THE QUEER LABYRINTH

Tellingly, the two scenes that directly follow the men's initial meeting on the train involve their relationships with women: Guy meets with Miriam in the record store where she works to settle their divorce, and after this meeting goes disastrously awry, speaks to Anne on the phone; Bruno has a scene with his mother in the patrician Anthony family's

plush home. The latter establishes Bruno as the Freudian homosexual with an overly close attachment to his mother, at least insofar as American psychiatry's reactionary reception of Freud would have it; Guy's encounter with Miriam alerts us to his potentially homicidal rage.

The record store scene thoroughly portrays Miriam as the taunting, scheming seductress. Pregnant with another man's baby and mercilessly threatening to pass it off as Guy's own in Washington, Miriam is a mixture of iconic negative female roles, the film-noir femme fatale and the small-town tramp. Yet she also cannot be reduced to these roles. In the important sequence in which Bruno stalks and ultimately murders her at the fairground, we see much more of Miriam, her vitality and lust for life, which link her to Bruno and also to Barbara Morton, Anne's lively, caustic younger sister, played by the director's daughter Pat Hitchcock. Jonathan Goldberg has identified Barbara, invented for the movie, as its queerest character. "The voice of the anti-social, Barbara demonstrates how Hitchcock inhabits Highsmith's world and makes it his."[17] Both agreeing with and challenging this reading, Tania Modleski has discussed the significance of Pat Hitchcock's casting and also the feminist and queer implications of Miriam's pregnancy.[18]

Had the one scene between Guy and Miriam been her only appearance, the film's representation of her would be indefensibly misogynistic. Kasey Rogers is terrific as Miriam, but this scene establishes her as wholly amoral as she coldly threatens Guy. Like Daphne du Maurier's and Hitchcock's Rebecca, Miriam taunts her husband with the prospect of claiming her bastard child as his own, dashing his political and romantic hopes (no more Anne Morton or the Senate). Guy silenced Bruno's prodding on the train about Miriam's infidelity: "Skip it, Bruno. It's kinda painful for a man to discover he's been a chump" (and Guy's voice tellingly cracks on "Bruno"; when a voice cracks in Hitchcock, it is significant, as I have noted). Incensed at further exposure to her extramarital affairs and their results, Guy grabs and shakes Miriam, clearly a pointed parallel with Bruno's impending violence, and is stopped only by the elderly proprietor ("Break it up, folks, this isn't the place for a family quarrel"). In the next scene when he talks to Anne on the payphone about how angry he is with his uncooperative wife, Anne remarks, "But you sound so savage, Guy." Frustrated that the roar of an oncoming train distorts his words, he yells into the phone that he could strangle her to death, further paralleling the two men and their capacity to kill. Hitchcock clearly plays around here with the idea that Bruno commits the murder that Guy wishes he could. Anne's controlled-yet-suspicious affect links her immediately to the woman who *knows*, who can penetrate the veil of male mystery, a recurring figure in Hitchcock as we have seen. Anne will not be lost in the queer labyrinth but instead attempt to make her way through it on her own.

Bruno's stalking of Miriam, however, casts her in a remarkably different light that also has the effect of making us reinterpret her behavior in the record store. Bruno, now in Metcalf, sits on a park bench outside of his prey's house at night. Laughing, happily racing for the bus, and accompanied by two young men, Miriam is a force of nature, intoxicated by her own sensuality. Bruno also boards the bus and follows her and her companions to

the fairground. Once there, Bruno's behavior becomes quite odd for someone surreptitiously following someone he plans to murder. Always at a distance but in full view of Miriam, Bruno stands, staring at her and all but demanding that she stare back at him. A greedy sensualist, Miriam licks an ice cream cone and mentions her desire for a hot dog, all the while being observed by Bruno and returning his gaze as she licks and swallows the white ice cream. At one point, she holds two ice creams cones in her hand. The sexual symbolism could not be more blatant.

What are we to make of Bruno's popcorn eating, however? Miriam expresses interest in getting popcorn before she and the young men take the "Tunnel of Love" ride, but they talk her out of it as they hurry her onto one of the little boats, which they all ride together. Bruno, also going on the ride, does get a bag of popcorn, however. In expressionistic style, Hitchcock films the Tunnel of Love ride—more blatant sexual symbolism—as a series of shadow images, the silhouettes that the riders cast on the wall inside the tunnel. Bruno's looming shadow seems to engulf Miriam and the men's shadows at one point, and as it does, she utters a high-pitched scream, an indication of her glee. All the while, like a moviegoer watching the big screen, Bruno eats his popcorn. The Tunnel of Love ride is clearly meant to promote sexual contact between couples. Miriam and her two young men, in contrast to Bruno, symbolize heterosexual courtship (although, again, her interactions with them are remarkably non-sexualized, and the addition of another male to their playful get-together calls attention to the fact that the three do not form a couple), and she symbolizes the triangulated woman (the status she holds between Guy and Bruno as well). It's almost as if Bruno, eating his popcorn, watches the movie of heterosexuality, which he plots to undermine, projecting his own shadow upon it. It's also worth noting that Bruno and Miriam, in whatever limited fashion, cannot share a meal together—he eats popcorn on his own, and she doesn't get any even though she wanted some. If the early scenes between the men locate in food and commensal ritual a basis for intimacy, the lack of shared food between Bruno and Miriam suggests the opposite, the feminine/queer impasse.

The film both contrasts and pairs the queer and unattached man with the sexual woman who enjoys male companionship but is also not exactly attached to anyone, since it is not clear that she is in any kind of romantic or sexual relationship with her two male friends (in happy league with her, unlike the two men on the staircase in Freud's study of female paranoia). Indeed, given their antic, friendly rapport and camaraderie with her, it's just possible that they are in a relationship with each other and that Miriam is, like *Rope*'s Janet, their beard. Miriam could not be more energized by this role. But, clearly, Bruno's masculine poses arrest and stimulate her—she cannot take her eyes off him. A dandy like Uncle Charlie in *Shadow of a Doubt*, Bruno solicits the female sexual gaze.

Though she does pull her friends away to walk in the opposite direction as they eat their ice cream, Miriam's gesture bespeaks sexual gamesmanship. And her move is matched and answered by Bruno's sudden appearance by her side. Her male friends do not succeed in ringing the bell on the "Test Your Strength" game. She looks around, as if

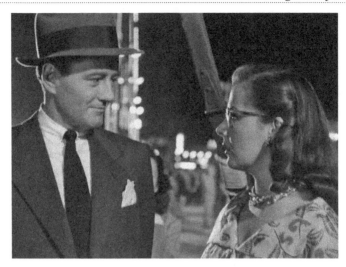

FIGURE 5.2 The queer villain and the promiscuous woman share a subversive vitality: Bruno and Miriam (Kasey Rogers).

hungering for male bravado, only to find Bruno standing right next to her, staring at her (see figure 5.2). Unlike her companions, Bruno scores big when he plays the game, shooting the ball right up to the top. His prowess confirmed, he presents himself to Miriam as a more resolutely masculine sexual prospect.

This adds further complexity to Bruno's enigmatic nature. Earlier, with his mother, he is louche and arch, a corruption of the cultured Wildean dandy: He sits around in a silk robe even though it's close to dinnertime; he inspects his freshly manicured nails, a service that his mother has just performed for him. Here he comes across as the kind of effeminate male who would be terrified of and threatened by his fairground persona. Later, when he tells Guy, in the expressionistic shadows behind a wrought-iron fence, about having dispatched Miriam, handing him her smashed and signature eyeglasses as proof, Bruno rolls his eyes, saying in campy fashion, "You must be tired, Guy. I know I am. I've sure had a *strenuous* evening."[19] Bruno's shifting gender affect signals him as the definition of queer—he oscillates between effeminacy and masculinist brio. Miriam doubles him in her wide range of affects: her taut, cold demeanor and eventual hysteria at the bookstore; her wild, lascivious comportment at the fairground. Far more than the stiff heteronormative couple Guy and Ann, Bruno and Miriam contain affectional and gendered multitudes.

Robin Wood describes the metaphorical meaning of this Hitchcockian mise-en-scène thusly:

The fairground and amusement park is a symbolic projection of Miriam's world; a world of disorder, the pursuit of fun and cheap glamour as the aim of life, of futility represented by the circular motion of merry-go-round and ferris wheel that receive

such strong visual emphasis in every shot. . . . Through Miriam, Hitchcock evokes a whole social milieu, smalltown life in all of its unimaginativeness and restriction.[20]

Wood reads Miriam as a spoiled child, linking her giggling as she runs (in a long shot) with her male friends to the bus to her sullen attitude in the bookstore. When her mother, sitting on the front porch, warns, "Now don't be out late," another element is added to the portrait. Her hot-dog craving and ice-cream-cone eating remind us that she is pregnant, Wood notes, as does her declaration that she has a craving, to which her friends jocularly retort, "Craving for what?"

> She turns, gazing around the fairground with her glasses, licking at her ice cream like a spoiled schoolgirl, looking at once childish and sensual, and her eyes fix on Bruno, watching her from a distance. . . . She is not pathetic in herself (she is never aware of needing anyone's compassion), but her situation—the narrow, circumscribed outlook, the total lack of awareness—is both pathetic and horrible. And what is being defined, ultimately, is the world from which Guy is struggling to escape. . . .[21]

Wood's reading is certainly perceptive, as always. But I believe that he misses out on a crucial component of the sequence. Here Miriam is pathetic only because she is a murder victim. In no other way does the film depict her as pathetic in this portion of the narrative. Her sexuality and pleasure flow freely and visibly for all, and especially Bruno, to see; this does not make her pitiable. Rather, it makes the snuffing out of her abundant, transgressive vitality all the more horrifying and agonizing a loss. (As will be the case with Judy Barton in *Vertigo*, also associated with gustatory desire—after her transformation back into Madeleine near the end, she tells Scottie that she wants "a great big steak.")

Retroactively, her affect here leads us back to the nasty confrontation she had with Guy and forces us to reinterpret it. Is it possible that her vindictiveness toward him stems from the fact that he could not give her pleasure of the kind she amply enjoys and craves here? Is it also possible that Guy exhibited a form of class-shaming behavior toward her that left her both wounded and vengeful? Without a doubt, Miriam is hopelessly inadequate for his political ambitions, the antithesis of the chiseled and poised Anne. In any event, I do not see any evidence for Miriam's behavior or affect here making her pathetic.

Both the sexual woman and the queer male exhibit—or are interpreted as exhibiting—childlike and therefore regressive behavior. As Valerie Rohy has shown, classical psychoanalysis framed homosexuality in just such a manner, as arrested development, a form of primitivism.[22] Readings that link homosexuality to orality, as Diana Fuss has discussed and we considered in the previous chapter, map onto these associations with primitivism. *Strangers on a Train* connects the sexual woman and the queer male through orality and sensual childlike appetites. As is harrowingly inevitable in both Hitchcock's oeuvre and my argument, the profound link between the woman and the queer man—and clearly, Miriam's sexuality, for all of its polymorphous-perverse sensuality, is marked as

heterosexual—can in no way result in intimacy or collaboration. The feminine-versus-the-queer pattern arises once more, connecting this film to *Shadow of a Doubt* but achieving an even deadlier intensity. Whereas the heroine of that film was an avenging angel (and not wholly by necessity), here the woman must mortally submit to the nefarious male's power. The killing of Miriam is without question among Hitchcock's most brutal sequences—far from diminishing its emotional impact, its heightened aestheticism (as we see the murder through the victim's glasses that have fallen to the ground) only calls attention to its brutality, which can only be conveyed through formal distancing, the visual equivalent of a silent scream. Despite our introduction to Miriam's character as amoral and despite the denigration she receives from Barbara later, Miriam's murder is represented as thoroughly reprehensible.

MALE MASOCHISM

Bruno's masculine display—his display of his own maleness—conveys the sense that he craves Miriam's recognition. Her fixation on him speaks to some longing perhaps for the sexual stimulation he provides (or promises/threatens). But what does his desire for her recognition tell us about him? Bruno's apparent narcissism conceals a non-narcissistic desire to be looked at, seen, and appreciated for what one is or hopes to be. For all of Bruno's preening—his loud lobster-patterned tie, "Bruno" tie-clip, flashy two-toned shoes—he needs to be looked at and appreciated: as a friend and possible lover by Guy, as a sexually significant male by Miriam as well as Guy.

If we follow Theodore Reik, we must interpret the seeming narcissist Bruno as a masochist instead. The Narcissus of Greek myth was enraptured by his own image and indifferent to his environment.

> How different is the impression the masochist makes on us! His displaying and showing himself have all the characteristics of wooing, of making himself noticeable. His behavior is just the counterpart to narcissistic behavior. It would be more correct to state that evidently the narcissism of these masochistic persons had been deeply disturbed as they make such frantic attempts to attract the attentions of others. Therefore masochism is never a sign of narcissism but an expression of its being damaged and of an attempt to restore it.[23]

Bruno's masochism speaks to another dimension of the critique of homophobic society in Hitchcock films such as *Rope* and *Strangers*: internalized homophobia. The paranoid forms of knowledge discussed in this chapter provide a structure for the battle between the heterosexual woman and the queer male (in these cases). Masochism, however, speaks to the emotional experience of living within a homophobic culture and is therefore related to the theme of queer anguish I elucidated in the previous chapter. Indeed,

in many ways, the truly narcissistic character here is Guy. Given that he does not appear to be narcissistic in the conventional sense, Guy can easily be taken as the regular guy his name signals, an average well-meaning Joe despite his evident class aspirations. Yet it is Guy's very complacency within the field of desire that hints at his narcissism as defined by Reik. It is Guy who has no need to look and be looked at. It is Guy who incites the queer and female sexual gaze (from Bruno; from Anne, Barbara, and Miriam, who zings him with frank erotic appraisal in the music store while plotting to reclaim him). Bruno provides a similar lure for the female sexual gaze, but he actively *solicits* it; Guy commands it without effort. (I am using the term "gaze" here as Laura Mulvey does in her work, as one person's active, direct, potent, and potentially injurious looking at another.) Guy's status as cynosure takes explicit form in the famous scene in which, as the spectators watching Guy perform at a practice tennis match turn their heads in each direction in sync with the plays, the camera zeroes in on Bruno's eerily smiling face (foreshadowing Norman Bates's at the climax of *Psycho*) as he stares straightforward at Guy, his head and body immobile. Yet Bruno is as transfixing a visual object within the crowd as he is transfixed by Guy's sexual spectacle, determined to impress upon the desirable athlete the power of his menacing gaze.

Kenneth Paradis addresses the significance of the relationship between masochism and paranoia for masculinity. "Both male masochism and paranoia involve the recasting of authority as a diffuse, hostile principle of antagonism circumscribing individual autonomy."

> The difference is that where the male masochist perversely (in Freud's sense of the term) *displays* [as Reik also contends] and even enjoys the sense of being treated unfairly by the world (he just wants to be *appreciated*, after all, is that so much to ask!) the paranoid disavows the agency that would censure if he sought its approbation, and instead arrogates its authority to himself, psychotically projecting an alternate reality.[24]

The masochist renounces power, reveling in his subjugation, protesting against the world's brutal mistreatment of him, yet always craving its love. The paranoid renounces love, and with it his emotional connections to others along with any feeling of accountability to authority.

Bruno is the masochist who longs to be the narcissist. He longs to be Guy, the man who commands and solicits the sexual gaze without actively seeking to be its object. Bruno's preening display connotes a longing to be looked at and desired. The desperation within his flamboyance indicates queer anguish. Miriam at the fairground, however, represents a distinct emotional and libidinal life. She is the figure of the desiring woman whom we have encountered in *Suspicion, Shadow of a Doubt, Spellbound*, and *Notorious*. Her gaze is active and phallic, if also tempered by compulsory femininity's recourse to coyness, elusiveness, retreat, inaccessibility, and other sexual strategies displayed in her behavior

toward the stalking Bruno. Miriam, much more successfully than Bruno, is the narcissist who enjoys and can withstand the sexual gaze without yielding to masochism. As Freud argued in his famous essay "On Narcissism" and as psychoanalytic feminist critics such as Sarah Kofman and Kaja Silverman have further theorized, narcissism affords women a surprising agency within the desiring field. [25] Miriam inhabits her narcissism with a freedom next to which Bruno's self-display pales.

Barbara Morton is presented as Miriam's double, both physically and temperamentally. The women are roughly the same height and build, and both wear glasses. While Barbara's attitude toward Miriam upon learning that she has been murdered is shockingly brusque—"She was a tramp!" Barbara retorts to her senator father's pieties—it is her very impolitic brusqueness that links her to Miriam along with her liveliness and intransigently unfeminine lack of sympathy. Nevertheless, Barbara will develop a palpable empathy for Miriam as victim when she feels, symbolically, Bruno's own hands around her throat.

Barbara, in her defiance of social niceties—"I think it would be wonderful to have a man love you so much he'd kill for you!" she announces to Anne and Guy, as if sensing her tense sister's misgivings and upending them—also doubles Bruno. In the Hitchcockian schema, however, it is Barbara who develops a conscience, through her apprehension of Bruno's threatening nature. When Anne introduces Barbara to Bruno after Guy's practice match, Bruno has been speaking animatedly to the Darvilles, making risqué jokes with them in French. But when he looks at Barbara, he is stricken, unable to speak. As he stares at her, he hears the music of the fairground; she definitely senses that something is wrong. The shot of Bruno holding up the cigarette lighter to Miriam's face is superimposed over the image of Barbara, making her appear as Miriam momentarily. She encounters him again in a later scene. When Bruno, incessantly hounding Guy, who refuses to kill Bruno's father as part of their "bargain," crashes a party at the senator's home, he entertains two older society women, Mrs. Cunningham and Mrs. Anderson, with a comic discussion of strategies for the perfect murder (a link to *Rope*'s Rupert Cadell and "Cut-a-Throat-Week"). "May I borrow your neck?" he says to the beaming, giggle-prone Mrs. Cunningham, who responds, "Well, if it's not for long!" Suddenly, Barbara appears, standing behind the woman being mock-strangled. His hands around the older woman's neck, Bruno stares intently into Barbara's face as she grows increasingly alarmed. Lost in his murderous reverie, Bruno comes close to killing Mrs. Cunningham, whose friend tries to free her from Bruno's grasp and calls for help; Bruno then collapses. Barbara, stricken, confides to Anne, "He was strangling her, but he was looking at me. Anne, he was strangling *me*!" Both Bruno and Barbara achieve an uncanny and frightening intimacy, one that stems from their shared complicity in Miriam's murder, much less pronounced on Barbara's side but a complicity nonetheless. Barbara develops a connection to Miriam, sharing in the horror of her murderous violation, whereas Bruno, incapable of empathy, descends deeper into madness. At the same time, there is the possibility that in discovering Miriam in Barbara, he looks into an accusatory mirror image and can see

his monstrous crime as such. With this damning exposure of his own monstrousness, he collapses, rejecting any knowledge that would destabilize his psychotic alternate reality.

THE FEMININE VERSUS THE QUEER IN *STRANGERS ON A TRAIN*

In her superb essay "Crisscross," Sabrina Barton discusses Bruno's and Miriam's roles as projections of Guy's own paranoia. She argues that *Strangers* "explores not the mystery of Miriam's murder but the mystery behind Guy's 'normal' subjectivity."[26] While Barton's analysis is invaluable, especially of Miriam's characterization and the deconstruction of Guy's seeming normalcy, my reading of *Strangers* places different emphases. To begin with, I do not read Bruno as a projection of Guy's fears but rather as the other and masochistic half of the film's double protagonist structure. I also believe that Hitchcock's decentering of the heterosexual male lead here, as elsewhere, allows for the other characters' struggles for narrative dominance to become more potent. Therefore, I want to explore the screen time given to a character only briefly mentioned by Barton, Anne Morton, who occupies the position of paranoid knowledge in the film as I interpret it.

In chapter 1, we discussed an allegorical rendering of the impasse between the heterosexual woman and the homosexual man in *North by Northwest*: Eve Kendall and Leonard talk to each other in separate phone booths at a distance from one another; once they emerge from the phone booths, they stand far apart, never making eye contact. I call this visual motif of feminine/queer estrangement the *thwarted gaze*.

Strangers foreshadows this moment when Anne ventures to the Anthony mansion and has encounters with the dotty and disturbing Mrs. Anthony and Bruno. Anne's interactions with the queer mother and her son double one another tellingly and prefigure themes in *Psycho* and *The Birds*. Mrs. Anthony displays a pathological indifference to human life that matches Bruno's: When Anne tells her that Bruno is responsible for Miriam's death, his mother shrugs it off, going on about how irresponsible her son can be, but also saying that he would never get involved with anything "so ridiculous as a murder." Their fruitless conversation recalls the theme of sororophobia we discussed in terms of *Spellbound* and deepens the sense of an unbridgeable impasse: If no bond exists between the heterosexual woman and the queer male, none exists between women either, and there is no chance to overcome cross purposes.

Jonathan Goldberg notes that Anne may have been motivated by the belief that, by working together, the two women "could solve the muddle in which the two men found themselves." If this is indeed her strategy, "the film locates the impossibility of this woman-to-woman solution precisely in the socializing of women that (within a patriarchy) makes them subordinate to men." Goldberg raises the possibility that both the abortive conversation between Anne and Bruno that follows and this scene of "impossible female bonding" are sadistic in nature and in a way that is directed against the two women.[27] He also raises the possibility, however, that "Hitchcock holds out (even as he

makes impossible) this alternative to the intense male bonding in the film." Goldberg correctly notes that no such scene occurs in Highsmith's novel and, less incontrovertibly, explains that this is so "because lesbian Highsmith has no sympathy for women ruined by patriarchy."[28]

To my mind, such scenes between women correspond to the feminine/queer conflict by extending it to include both women's positions and their respective positions of submission to male dominance. Anne represents the heterosexual couple and Guy just as she represents her own gender privilege as a white, upper-echelon heterosexual woman and upholder of patriarchal values; Mrs. Anthony, the queer mother in league with her son, represents their perverse union, a matriarchy of sorts in opposition to the father's rule, but only to a certain extent. Antagonistic though he may be toward his father, Bruno also relishes the chance to command and dominate women, including his mother—we see evidence for this in their first scene when he suddenly snaps at her for mentioning his father. As Marion Lorne plays Mrs. Anthony, she looks genuinely startled at Bruno's mercurial outburst. This moment recurs, its effect greatly intensified, in *Psycho* when Norman Bates snaps at Marion for suggesting that he put his mother in a facility of some kind ("You mean an institution—a madhouse? My mother there?"). The shift in tone is harrowing and conveys the real terror of the situation, as does the palpable unease in Marion's eyes as Norman, his eyes and manner as cold as a predatory bird's, berates her for her insensitivity.

Once Mrs. Anthony, in the most plastic manner possible, bids her visitor adieu (holding out her hand imperiously as she says, "Come see us again sometime"), Bruno appears and, with the sympathy of a crocodile, commiserates with Anne: "I'm afraid Mother wasn't much help, was she?" He proceeds to incriminate Guy for the murder, claiming only to be Guy's loyal friend who has been put in the terrible position of keeping his secret.

As Bruno and Anne speak, Hitchcock's blocking is highly significant, producing the thwarted gaze. Within the same shot, Bruno and Anne never make eye contact; she stares ahead as he (in his louche silk gown once again) stands behind the sofa she sits on. Indeed, even when he comes around to the other side of the sofa and stares down at her, she does not make eye contact with him; instead, we cut to a medium close-up of Anne averting her gaze from Bruno (see figure 5.3). The fact that they never make eye contact in the same shot—and that there is none of Hitchcock's frequently used formal device of shot/reverse shot to convey their doing so as they speak—allegorizes their impasse. Quite literally, each is unable to see the other; recognition, empathy, and connection remain utterly unimaginable; that they both fiercely love the same man only compounds the problem. In *Strangers* and *North by Northwest*, the inability to exchange a look on the part of the woman and the queer male speaks volumes about not only their interpersonal but also social estrangement. Even a shared high-class status does not facilitate Anne's attempts to reach Bruno and his mother. The lack of eye contact metaphorizes the inability to see the world from the other's position, a failure that is crucial to the

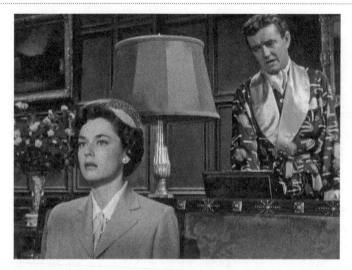

FIGURE 5.3 The thwarted gaze: Neither Bruno nor Anne Morton (Ruth Roman) can look at each other in the same shot.

political implications of the feminine-versus-the-queer thematic. When one minoritized subject has no ability to see the world as another does, and is furthermore incapable of even attempting to do so, there is no possibility whatsoever for unification or even a shared struggle; there is only further estrangement and defensive counterattack, hence the logic of sexual hegemony.

Responding to Jaqueline Rose's essay on female paranoia in the cinema, Elizabeth Cowie offers a very helpful reading for our purposes. As she parses Rose's argument, "the apparent plenitude of the cinematic look is always already broken in so far as the look is reversible and it is this potential reversibility, of looking and being looked at, which Rose defines as the paranoiac alienation of the ego, leading Rose to argue that 'paranoia could be said to be latent to the structure of cinematic specularity in itself, in that it represents the radical alterity of signification (the subject spoken from elsewhere).'" Extending Rose's findings to her reading of the film *Coma* (Michael Crichton, 1978), a medical thriller starring Genevieve Bujold, Cowie offers insights helpful to our discussion. Cowie notes that the status of *Coma*'s heroine Susan as a "place of narrative truth and knowledge has been undermined by earlier scenes emphasizing her paranoia"; at the same time, "the spectator has been given information not known to Susan which allows us to confirm that she should indeed be suspicious of the good intentions of those around her." And as members of the audience, "we have even more reason than she to be suspicious and our knowledge makes us anxious for her, indeed paranoid since our worst fears are not yet narratively justified."[29]

The feminine-versus-the-queer thematic establishes the woman as paranoid even though she has every reason to be, even though her suspicions are utterly justified, as they are here and in the other films mentioned. Hitchcock's female characters often find

themselves suspicious of the male—either the protagonist or a supporting character—and to depict this cinematically, Hitchcock frequently gives us discrete shots of the woman looking, of her eyes as she registers and negotiates her suspicions. I call this technique and motif in Hitchcock "thinking with the eye." We see this kind of shot in *Strangers* after Senator Morton announces to Guy that Miriam has been murdered. On Anne's line "She'd been strangled," the camera focuses on the averted position of her eyes, underscoring the muffled, restrained tones of her voice. We get a similar kind of depiction of Anne when, in a discrete shot, she is twice shown looking at Bruno with concern, first when he laughs uproariously at a risqué joke with the Darvilles, and then after he and Barbara have exchanged agonized looks. Such shots are rife in the later sections of *Notorious* once the heroine begins to suspect that her husband and his mother are poisoning her; indeed, Hitchcock films her growing suspicion, triggered by her alarm when someone else verges on sipping her coffee, as a series of covert peripheral glances on her part. In *Vertigo*, there is a similar shot of Scottie's best friend and former fiancée Midge (wonderfully played by Barbara Bel Geddes): When Scottie discusses something seemingly innocuous about himself in their first scene together in her apartment, Hitchcock cuts to a shot of her raised eyebrows, indicating her doubts about his self-presentation.

As I have argued elsewhere, Hitchcock's 1956 remake of his own 1934 *The Man Who Knew Too Much* foregrounds the woman's role as the penetrator of worlds of male intrigue, which can be interpreted as queer knowledge.[30] Jo McKenna's nearly immediate suspicion of the olive-skinned, seductive, and enigmatic Frenchman Louis Bernard when the McKenna family is on holiday in Morocco is a key instance of the feminine versus the queer. Jo's apprehension of Bernard's strangely intent preoccupation with her husband Ben allegorizes, I have argued, Cold War paranoia about homosexuals, believed to be easily seduced and especially vulnerable to blackmail, and hence ripe prospects for Soviet spies trying to get state secrets out of them. Jo's suspicion over Bernard's intentions conveys a larger one of the potential homoeroticism in male homosocial relations, a suspicion held and maintained by the heterosexual woman. A lesbian panic motif occurs here as well, one previously seen in *Rebecca* and *Stage Fright*. Jo's eerie encounters with the Englishwoman Mrs. Drayton, who turns out to be duplicitous, are marked by penetrating stares that provocatively suggest desire. Indeed, just as Louis Bernard appears to be cruising Ben right under Jo's nose, Mrs. Drayton seems to be cruising *her*, which Jo also suspiciously registers. Mrs. Drayton seems to be in a marriage of expediency for her political cause and, as it turns out, deeply opposes her husband's capacity for evil. Mr. Drayton decides that Hank, the McKennas' kidnapped son, must be killed after their plot to assassinate a European ambassador fails. If Mrs. Drayton is revealed to be a nefarious queer character, she is also treated with Hitchcock's customary sympathy for such characters. Her desolation as she waits with Hank, whom she wants to protect but cannot, for the return of her intent-on-murder husband, and her terror when the door smashes open—it turns out to be Ben, but assuming it is her husband, she screams—are palpable, making it impossible not to sympathize with her.

There is a different approach to generating sympathy for the nefarious queer in *Strangers*. We like and are drawn to Bruno, expertly played by Robert Walker, because he is charming, funny, and scabrous, able to cut through social niceties and express blunt truths. Horrifying as his murder of Miriam is, Bruno is *right* to suspect that Guy wishes she were dead. When Bruno emerges from the shadows as Guy and Anne stroll through a museum-like government building and forces Guy to talk with him privately, Bruno sizes up the well-dressed Anne at a distance and says to Guy, "A slight improvement over Miriam, eh, Guy?" His suggestive eye movements lewdly underscore his line. Bruno's eruptive laughter at his mother's painting also charms us. "That's the old boy—that's father!" Bruno heartily announces, his arm clutching his petite mother's shoulders, and there is a fast cut to an image that appears to be a tribute to German Expressionism, a desolate-eyed male figure swirling in a vortex of madness. "I was trying to paint Saint Francis," his mystified mother murmurs. And in the most Hitchcockian touch of all, we identify with Bruno when he drops Guy's lighter into a sewer grate, goes into a panic, and, as a crowd of onlookers (heavyset blue-collar men, a pointed contrast to the fulminating dandy) gawks, manages somehow to retrieve the lighter from the vile depths.

I believe that it is necessary to emphasize Hitchcock's sympathy for his queer personae because, without it, we would have before us an interminable array of homo/queer characters associated with morbidity, madness, and murder. Similarly, the sympathy and empathy for women in Hitchcock's films counterbalance the violence frequently directed toward them. While sympathy and empathy do not exculpate Hitchcock from charges of phobia, their presence does broaden and deepen the representations of gender and sexuality in the director's work. The internecine war between heterosexual women and queer characters in Hitchcock deepens matters further still. We are made to feel for the woman's suffering as we are made to delight in the depravities of the queer male in *Strangers*—depravities that are a direct assault against the stifling atmosphere of conformity embodied by Senator Morton (played by Leo G. Carroll, in quite a different turn from his more Bruno-like role in *Spellbound*) and his stiff reticence.

Barbara constantly sends up her father and his stuffy political stature; this further links her to Bruno. Guy, the object of desire, effectively wishes to become Senator Morton; this makes him less the hero than the target of a satirical attack, further decentering the hegemonic rule of the male protagonist. Ruth Roman's performance as Anne has often been criticized, and Anne, especially in her first appearance as she talks to Guy on the phone, seems as stiff, proper, and sexless as one would expect the senator's daughter to be. ("You sound so savage, Guy," she responds to him as he discusses his anger at Miriam, a line that makes Anne seem easily stunned by the slightest impropriety. While Guy's escalating violence is certainly worrisome, her affect, removed and placid, nevertheless primarily conveys a sense of patrician iciness.) Yet Anne grows into a more interesting and sympathetic character than she initially seems to be, and Roman's performance and screen presence, while not submitted to the swooning romanticism associated with Hitchcock's glorious blonde stars Grace Kelly and Kim Novak, have been undervalued. Indeed, there

is something refreshing in her non-objectified depiction; she seems like a poised and sensible woman. With her dark hair and eyes, she doubles Guy; a handsome woman, she complements the gender fluidity in Granger's screen presence. She is also able to piece together and penetrate the mystery even to the extent of initially believing Guy to be as murderous as Bruno. "How did you get him to do it?" she asks Guy after Bruno's collapse and Barbara's panic at the party. And when Anne's hopes of enlisting Mrs. Anthony's help are dashed and Bruno further mocks her, we feel for her loneliness and the futility of her efforts.

The scene in the museum-like building in which Bruno calls to Guy as he walks through the corridors with Anne is interesting. As Guy and Bruno furtively speak (Bruno complains, "You're spoiling everything—you're making me come out in the open"), Anne stares at the two men. Her growing suspicion marks her as paranoid even though she is obviously right to be suspicious. Here we get the customary shot/reverse shot technique that shows us Anne looking and just what she is looking at: Bruno's "Bruno" tie-clip.

Anne's paranoia about Guy informs her interactions with him from the moment she expresses alarm at his emotional state after his meeting with Miriam. Her paranoia leads her to deduce his involvement in Miriam's murder, but this does not diminish its paranoid character. When, from a solitary distance, she observes the two men speaking intimately, the scene resonates with the tensions in Freud's case study of female paranoia. Anne's suspicious scrutiny of Guy and Bruno's tête-à-tête recalls the moment when Freud's patient encounters the two men in private conversation on the staircase and suspects that they are in league with her lover's plot to ensure her mental torment. The parallels are her suspicious regard for the male couple and their catalyzing of her doubts about her lover Guy playing a bifurcated role.

Anne's paranoid suspicion is indistinguishable from her insightfulness as a reader. In the scene with the Darvilles in which Bruno erupts into transgressive laughter, there is a discrete shot of Anne observing Bruno, penetrating his facade of bonhomie. Once again, her eyes zero in on his tie-clip. One might say that a more conservative aspect of her perspicuity emerges here: The reticent Anne is discomfited by Bruno's flamboyance, established by his brazen self-display and absurdly egocentric tie-clip. It is significant that she introduces Barbara to Bruno, as if playing matchmaker. She shifts almost immediately from this mode, however, her suspicions of Bruno further intensified by his malevolent glare at Barbara.

Anne's role in the film exhibits a surprising agency. Her independent excursion to the Anthony home is a remarkable enlargement of the narrative focus on the two male protagonists. It also indicates the narrative possibilities opened up by Hitchcock's characteristic decentering of the narrative rule of the male protagonist, split between the figures of Guy and Bruno. Moreover, Anne's persona is marked by a palpable erotic hunger for Guy. When she and Guy are together onscreen for the first time, just after Miriam's murder has been announced (Guy of course already knows about it from Bruno), Anne says to him, "I wonder if you know how much I love you." Guy responds while kissing her

closely, "Brazen woman, I'm the one to say that." Robin Wood notes that this line is "an odd, endistancing, defensive kind of joke." He continues: "If the world from which Guy wishes to escape is defined for us by Miriam, then Anne—formal, rather hard, rather cold, in Ruth Roman's unsympathetic performance—defines the life to which he aspires: a life of imposed, slightly artificial orderliness."[31] There is more to appreciate in Anne and in Roman's performance than Wood's analysis allows, in my view, and I believe that we should take Anne seriously. Anne is a controlled woman nevertheless capable of great feeling; she expresses passionate, even overwhelming sexual desire for a beautiful, eminently desirable man; this links her to the Constance Petersen of *Spellbound* and also to the seemingly prim-yet-passionate wife of the defense lawyer in *The Paradine Case*, whose husband burns with desire for the fallen woman he represents in court (who in turn loves the valet who was most likely having a homosexual love affair with her murdered husband). The sentiments Anne expresses to Guy are most provocative: "Even more terrifying than the murder itself, Guy, was the awful thought that if you had anything to do with it we'd be separated—perhaps forever. I'd never see you again. I couldn't bear it."

Anne's ardent sexuality is no less constrained than Miriam's, even if Anne has far broader opportunities for social and personal exploration. "Brazen woman" is a joke perhaps, but an indication nevertheless of Guy's imposition of sexual decorum on a desiring woman. Once again, the queer male and the heterosexual woman share a balked, silenced sexuality that does not allow any possibilities for collaboration or empathy between them. That having been said, both Hitchcock's casting of Farley Granger, whom he knew to be homosexual, and Granger's own screen presence and interpretation of Guy lend the role a distinctive queerness. This opens up a distinct dimension of the feminine-versus-the-queer thematic: Anne fights against the queerness in the man she desires. And given the queerness of her own persona and, for that matter, of Barbara's as well, the woman also fights against the queerness in herself.

Yet one more dimension of the feminine versus the queer in the film is Bruno's relationship with his mother, who nearly matches him in psychotic indifference to human suffering. His mother, however, is also entrapped within the stifling patriarchal world of "The King," as Bruno derisively calls his father (unlike the Morton women, who seem comfortable with their father's reign). If Mrs. Anthony and Bruno embody the stereotypical overly close mother/son relationship that produces male homosexuality insofar as American psychiatry's crude application of Freudian theory would have it, there is nevertheless a poignant quality to the fact that these utterly isolated and nonconforming characters have one another as refuge and ally. Hitchcock's later works will make the mother a source of overwhelming dread, but here Mrs. Anthony occupies a liminal ground between morbidity and disarming weirdness. She too is a queer character, in league with her son against authority, and therefore another kind of paranoid.

Anne's paranoia in some ways leads her away from authority—she conspires to deflect the detectives from Guy as he escapes them to thwart Bruno's plot to frame him. Yet

she is also the embodiment of law, order, rationalism, and the father's Symbolic realm. Her campaign against Bruno is also a campaign against the decadence of his mother and his relationship to her. Class affiliations do not ensure any greater intimacy than analogous sexualities do here, as noted. *Strangers* reworks a similar structure in *Notorious*, in which the heroine is pitted against a queer male and his monstrous mother. Only in the dyad of queer male and mother can the feminine-versus-the-queer conflict be resolved and healed, and true affinity and intimacy, grounded in shared blood and bloodletting, achieved.

In contrast to the gulf between Anne and Bruno, Anne and Barbara do have a genuine bond. When the latter staggers away from her virtual strangling at the party, it is to Anne she turns for comfort. Both women resourcefully work together to distract the detectives assigned to tail Guy, prime suspect for Miriam's murder, as he races to the fairground after his tennis match to intercept Bruno, intending to incriminate Guy by dropping his lighter at the spot where Bruno killed Miriam. What unites Anne and Barbara is their ability to penetrate the veil of male mystery.

HOMOEROTIC ANTAGONISMS: INTIMATE VIOLENCE

In the introduction, I discussed homoerotic antagonism as a complement and counterbalance to the feminine-versus-the-queer dynamic. The fairground setting of *Strangers* provides a backdrop for the full articulation of both struggles and their intersection. I argue that Bruno's courtship of Guy—which is how I read his behavior—is an expression of the desire to tear apart and restore the other that, as we have discussed, is central to the work of Melanie Klein. In a Kleinian fashion, Hitchcock films enact a perpetual relay between aggressive and reparative impulses. Violent impulses in Hitchcock intersect with those toward love and longing, hence the concept that I have been developing throughout this book of intimate violence. It is significant that the men's relationship has its foundation in an anxiously shared meal, which symbolically brings them back to orality, the first stage in psychosexual development. It's as if the narrative transforms the men into infants in order to raise them as men. As men, each must confront, adapt to, marvel at, and war against the other's masculinity. Bruno's attitudes toward Guy reveal a reparative impulse that steadily gives way to an unremittingly aggressive one, but the longing within his behavior is palpable as well.

From the outset, Bruno expresses a fascination with Guy's qualities—"I admire people who do things," he remarks. It seems that Bruno reads Guy's fame—literally in the society page of the newspaper—as proof that he has achieved the recognition for which Bruno pines. Guy is therefore Bruno's ego ideal, the mirror reflection he longs to cast. Homoerotic desire has its basis here, as it does in Freudian theory, in narcissism. Indeed, Bruno's alienation from his father and intimacy with his mother, his negative Oedipus complex, seems to be the basis of his desire for Guy; he wishes, in Freudian fashion, to love

Guy as his mother loves him—in this case, neurotically and possessively.[32] Confirming the oedipal logic of their sexualities, the heterosexual Guy attempts to become the patriarch, the man he identifies with, Senator Morton, while putting the "brazen woman" in her place.

Although, as we have seen, Bruno's relationship to Miriam is highly significant, it is also one component within his larger preoccupation with Guy, and in this regard, I read his decision, his *need*, to eliminate Miriam as an expression of his desire to install himself in her place—to make *himself* the thorn in Guy's side, the obstruction to the fulfillment of Guy's desires. While this very need calls attention to the feminine-versus-the-queer dynamic, speaking as it does to Bruno's rivalrous identification with Miriam, it also calls attention to Bruno's desire to have Guy recognize him as a significant entity in his life, a metonym for the larger quest for recognition that drives the masochistic Bruno. If Guy can recognize Bruno even within his capacity as scourge and imp, making a mockery of Guy's ambitions and causing havoc in his life, that is at least acknowledgment in some form. Just as Brandon and Philip kill David Kentley to attract and secure Rupert Cadell's attention in *Rope*, so does Bruno kill to captivate Guy, to force Guy to look on him with the same riveted attention with which his admiring adversary looks upon his quarry.

Barbara's memorable line "I think it would be wonderful to have a man love you so much he'd kill for you!" applies fittingly to Bruno. To impress Guy with the seriousness of his intentions and desires, Bruno commits this heinous deed. But what are we to make of Guy's refusal to tell the police about Bruno's crime? Bruno calls out to Guy as he makes his way into his home the night of the murder, and Guy joins Bruno in the shadows behind a jail-bar-like fence; when the police show up (with news of the murder), Guy hides along with Bruno. "Now you've got me acting like a criminal," Guy says, but the image of the two men huddled in the shadows inevitably suggests, in its era, covert sexual relations between men under cover of darkness, with the threat of surveillance and exposure everywhere present (see figures 5.4, 5.5, and 5.6,).

Guy shifts rather swiftly into criminal panic, confirming his complicity in Bruno's stratagem and outsider status. And Guy's behavior toward Bruno bespeaks an equally reparative impulse. After Bruno has caused a scene and collapsed at the senator's party, Guy talks to him privately as he comes to on the couch. (A nod to the perversity of the entire setup, Senator Morton complains, "I thought he was a bit weird. . . . First thing you know, they'll be talking about orgies!") Standing up as Guy berates him, Bruno rather dreamily responds, "But Guy, I like you," to which Guy responds by punching Bruno in the face. (This action precisely mimics that of Melville's Billy Budd when his homosexual admirer and menacer Claggart falsely accuses him of mutiny, albeit with murderous results in Billy's case. Guy's fist does the talking, just as the stuttering, inarticulate Billy's does for him. Billy's stutter will reappear in Norman Bates's impaired utterances.) Yet as the scene ends and Bruno attempts to straighten his tie (which was loosened after his collapse), Guy takes over, redoing Bruno's tie for him. It's an amazingly intimate, tender gesture,

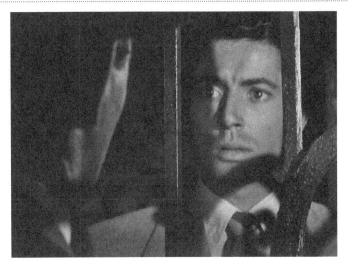

FIGURE 5.4 Guy hides along with Bruno: "Now you've got me acting like a criminal."

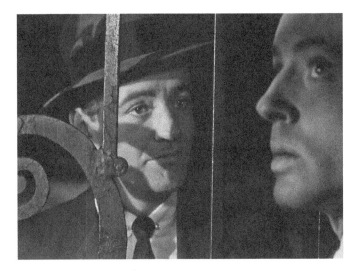

FIGURE 5.5 Bruno appeals to Guy as a co-conspirator.

one that underscores their tie, as it were, to one another. Guy symbolically restores Bruno to fitting coherence after having bloodied him.

Hitchcock deploys his most ingenious formal designs to convey Bruno's threat to Guy and his stable-yet-fragile world. The famous long shot of Bruno posed darkly against the Jefferson Memorial, an image that unsettles the agitated Guy, recalls the shot of the masked menacer holding the wheel, seen from a great height and at a distance, in *Spellbound*'s dream sequence. Both of these images aestheticize homoerotic threat.

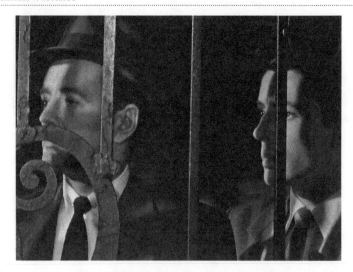

FIGURE 5.6 The noir lighting, shadows, and prison bar-like gate unite the men, another scene of connection and disconnection at once.

The climactic sequence set on the merry-go-round takes this aestheticized threat to the nth degree.

Robert J. Corber has argued that Hitchcock's homophobia comes through in these visual designs. His reading of *Strangers* helpfully reinserts the film into its Cold War context, alerting us to the intensity and the intricacy with which the U.S. government attempted to rout out the homosexual menace.[33] But his analysis implicates Hitchcock much more thoroughly in national attitudes at the time than I believe is justified; I see the director's stance as more resistant.

Robin Wood challenged, in the context of his rebuttals to critics who have found Hitchcock homophobic, the entire issue of Bruno's homosexuality, arguing that such readings depend on stereotypes.[34] Yet Patrick McGilligan and Robert L. Carringer have each demonstrated that Hitchcock sought to represent homosexuality onscreen through Bruno while critiquing Cold War homophobia. Hitchcock drafted the leftist writer Whitfield Cook to write a treatment of Highsmith's novel because "Cook knew how to code the signals from his circle of friends, and in his hands the film's Bruno became a dandy, a mama's boy who speaks French, and who professes ignorance of women."

The politically left-leaning Cook was . . . drafted by Hitchcock expressly because he was comfortable with sexually ambiguous characters. Cook used Guy to make the film a parable "quietly defiant of the Cold War hysteria sweeping America," in the words of the film scholar Robert L. Carringer. That hysteria was targeting homosexuals along with Communists as enemies of the state. . . . Carringer persuasively argues that the film was crucially shaped in part by these Cold War events. The very

blandness and decency of Guy, wrote Carringer, made the character a stand-in for victim of the antihomosexual climate.[35]

Wood maintains in *Hitchcock's Films Revisited* the position he held in the first edition of the book: "Hitchcock clearly has no interest whatsoever in the characters played by Farley Granger and Ruth Roman, and this lack is inevitably communicated to the audience; their relationship has no emotional weight, their aspirations no moral value. Everything gravitates toward Bruno as the film's magnetic center of attraction. . . . I find it difficult to decide exactly how much this has to do with Hitchcock's fascination with sexual/gender ambiguity and how much with the failure of the scenario to provide opportunities to develop an effective counterweight or counteridentification," such as Charlie in *Shadow of a Doubt*, the motley crew of *Lifeboat* united against the amoral Nazi Willy, and "James Stewart's horror and self-horror in *Rope*."[36] Given that I find Hitchcock's works centrally concerned with his "fascination with sexual/gender ambiguity," I am not in agreement with Wood here, especially about *Strangers*. Moreover, as I have been suggesting, the "counteridentification" figures in Hitchcock, Stewart's character in *Rope* in particular, are less than aptly described as such.

The chief sources of my disagreement with Wood flow from my view that Bruno was intentionally depicted as homosexual and also that Hitchcock does indeed maintain an interest in Granger's and Roman's characters, as I have demonstrated. Granger brings an extraordinarily touching gender fluidity to his "straight hero" role. The director, McGilligan observes, "had to accept an odd crisscross in the casting: a straight actor (Robert Walker) playing a homosexual, who comes on to a 'super-straight' (to borrow Robert L. Carringer's word) played by a homosexual actor (Granger)."[37] It is precisely this discordance (as well as superbly nuanced acting from both male leads) that lends their scenes an intriguing, disturbing frisson.

I would also add that a particularly interesting aspect of the film's depiction of Bruno is that the scenes that popularly establish him as a homosexual were written by the female screenwriter Czenzi Ormonde, who effectively wrote the script with another woman, Barbara Keon. Indeed, though the famous noir novelist Raymond Chandler is listed as the co-screenwriter, his contribution was jettisoned by Hitchcock, who found the drunken and belligerent Chandler impossible to work with. The true credit for the screenplay belonged to Alma Reville, Cook, Keon, Ormonde, "and—of course—Hitchcock," writes McGilligan. In particular, what appealed to Hitchcock about the functionary-turned-screenwriter Ormonde were the early scenes she wrote depicting Bruno's relationship with his mother and establishing his telling traits: "lounging in a silk robe," getting a manicure from his mother, and other "vices."[38]

To return to the issue of aestheticization, Hitchcock strikingly links both Bruno's murderous encounter with Miriam and his climactic confrontation with Guy, as we have noted, through the fairground setting. Just as Bruno rode the merry-go-round along with Miriam and her companions (as all sang "And the Band Played On"), so he does battle with

Guy on the merry-go-round. The climactic battle between men on the merry-go-round extends the symbolic insinuations of this figure. First the site of the frivolously exhilarating ride Bruno took along with Miriam, the merry-go-round emerges, in the climactic sequence, as a zone of chaos and death. Recalling the image of the leering court jester in the painting in *Blackmail*, the merry-go-round connotes the carnivalesque aspects of Hitchcock's sensibility, his awareness that merriment can swiftly transform into savagery. "Carnival," as Bakhtin argues, "is the place for working out, in a concretely sensuous, half-real and half-play-acted form, a new mode of interrelationships between individuals."[39] Yet Hitchcock does not pursue Bakhtin's utopian promises. There is not so much a new mode of interrelationships as there is a repetition of sexual masquerade and murderous showmanship: Guy performs the role of moral hero no less by rote than Miriam does that of coquette; in each fairground episode, Bruno seizes an opportunity to test his mettle publicly, as if declaring his masculinity a spectacle for all to judge and rate approvingly. Bruno competes alike with Miriam and Guy for gendered supremacy as he appeals to each for healing recognition, however profoundly inaccessible. Bizarrely and poignantly, he inserts himself within the failed heterosexual couple as its new, queer logic.

Orderly, synchronized, and then careening out of control, the merry-go-round, a metonym for the fairground and its open-ended possibilities for pleasure and mayhem, symbolizes desire itself and its potential descent into uncontrollable perversity. Bruno dies because his desire, like the merry-go-round, spins out of control. Hitchcock is at his most expressionistic here. He uses form (montage cutting and images) and symbolism (the shots of the various artificial merry-go-round horses, grinning as if in mockery of human struggle, their phallic hooves moving up and down and jabbing at the desperate riders; the ceaseless, anarchic revolutions of the out-of-control contraption) to convey the grandeur and terror of the conflict.

Jonathan Goldberg relevantly discusses Hitchcock's aesthetics in terms of the depiction of Miriam's murder:

> The bodies become indistinct in the distorting lens. As they fall, they lose recognizable shape. Bruno's hands, as many have noticed, look like the claw of the lobster that decorated the tie he wore in the opening scene on the train. Visually, he's becoming a cold-blooded crustacean, a sinthomosexual [Lee Edelman's term]. In the glasses, human bodies stop looking human; they become forms, inhuman shapes. The human is being perverted. . . . Aestheticization, in its distance from a recognizable representation of the human, brings out the non-human.[40]

Here, we can anticipate the arguments of the next two chapters of this book, which focus on the queer and gendered meanings of Hitchcock's aesthetics. Important valences exist among *Strangers'* aesthetics of sexual panic and *Psycho's* aesthetic conceptualization of a dark maternal force, which I call the death mother, on the one hand, and the formal depiction of the social world as hollow and artificial in *Marnie*, on the other.

In all of these films, the thematization of identity politics at their breaking point finds chief expression through an extreme manipulation of form. This pattern overwhelmingly applies to *Vertigo* as well. *Strangers* anticipates the extreme, formal self-consciousness and agonized sexuality in Hitchcock's films from the late 1950s to the mid-1960s.

The loss of distinction between the human and the nonhuman that Goldberg discusses dramatically informs the climactic portion of *Strangers*. The antic, life-in-death furor of the artificial horses—uncannily animated and mobile yet lifeless—underscores as it mocks the futility and the wild excessiveness of the men's struggle. (We will see a similar motif, with real horses, in *Marnie*.) As the men grapple with one another, they threaten the lives of all the unfortunate people, including several children, stuck on the ride along with them. Pursuing Guy, whom they believe to be the killer, as Guy pursues Bruno who is attempting to frame him, the police accidentally shoot the mechanic in charge of the merry-go-round; as he falls to his death, his body lands on the control lever, sending the ride hurtling into maximum velocity. The futility of this mock epic brawl, with Guy trying to get back his lighter and Bruno punching and kicking him, achieves a harrowing level of totality never too far from perverse laughter, yet also not reducible to this mocking stance. The environmental and human costs of this climax have not been extensively discussed in criticism but are well worth noting. An old man bravely crawls on the ground beneath the crazily whirling merry-go-round in order to turn off the ride. The old man finally succeeds, turning the lever in the opposite direction. As the huge merry-go-round flies off its axis and crashes to the ground, bodies and props careen through the air; smoke, rubble, and thunderous mayhem fill the screen. It is impossible to imagine this outcome without a significant loss of life and bodily injury. The film, however, focuses only on Bruno, lying crumpled beneath sheared-off metal rods and dying.

Heath A. Diehl observes of distinctions between Hitchcock's and Highsmith's narratives:

> The conclusion of this film is even more unsettling given how significantly it differs from the source novel's conclusion. Highsmith's novel much more explicitly reinforces Cold War ideologies regarding the Queer Other through the public revelation of Guy's "crime" and his subsequent institutionalization—a metaphor of containment that renders Queerness silent. . . . Hitchcock's conclusion is cloaked in ambiguity—if not moral, then narratological and ideological.[41]

I'm not sure why Diehl puts crime in scare quotes because Guy does kill Bruno's father in the novel, and critics such as Wood have read Hitchcock's decision not to make Guy a murderer as a serious failing. That Guy's guilt is exposed by the end of the novel (the drunken Bruno dies earlier by falling off a sailboat) certainly distinguishes it from Hitchcock's vision. Of the film's ending, Diehl aptly observes, "Spectators are invited to question the kind of closure engendered by the re-inscription of an ideology built on 'normality,' the kind of social order engendered by the exclusion of Otherness." This is

Hitchcock's characteristic maneuver, to be sure, but in *Strangers*, this maneuver reaches, like his aesthetics, a breaking point. The carnage and wreckage so utterly exceed the problem being literally wrestled over as to make the problem itself—the men's struggle, the question of guilt or innocence—an amoral concern.

Most strikingly, in Bruno's final moments, the police chief, detectives, and workers at the amusement park watch as he and Guy speak. Bruno's words, as delivered by Walker, have an insinuating softness, as if he were speaking to an errant lover he has tried and failed to protect. The inability of men to connect, their essential antagonism, has a homoerotic quality to the end. It is important that Guy not be a murderer so that we have a male protagonist who does not sink into the sameness that Bruno holds out as hope and promise, which is to say that Bruno's appeal to Guy is for Guy to emulate him, to be on his level and indistinguishably complicit in murder. Guy, however, does not need to copy and reflect Bruno; as the true narcissist, Guy preserves his image to the end, while Bruno pursues the fantasy of inhabiting Guy's narcissism even unto death.

Writing in a different context, Peter Coviello observes of the logic of homophobia that "[t]o be heterosexual in such a scheme is not to desire every person of the opposite sex, but, categorically, *no one* of the same sex—to be capable of an attachment to persons of the same sex that is scrupulously free of desire. The clarity of hetero- and homosexual identities, that is, requires the notion of a quality of attachment *purged of desire*, utterly free of contamination by sex."[42] Clearly, Guy feels drawn to the unusual Bruno; the flickers of fascination on his face in their scenes on the train tell us as much. In his last reference to Bruno, Guy remarks with more awe than scorn: "Bruno Anthony—a very clever fellow." The film, however, cannot imagine an attraction between the men that could be explored, much less realized. This is largely the result of the censorship of the Hollywood system and the mores of its era, but there is something else as well. It lies in the fear of engulfment that the homosexual seducer, with the powers of illusion at his disposal, poses to the straight male quarry. In order to preserve his identity, Guy must renounce and ultimately obliterate Bruno.

6

The Death Mother in *Psycho*

HITCHCOCK, FEMININITY, AND QUEER DESIRE

IN HITCHCOCK'S *PSYCHO* (1960), the heterosexual male protagonist is an after-thought, an ancillary presence, and the feminine/queer conflict receives its most sus-tained and surpassingly violent treatment. Bruno's murder of Miriam in *Strangers on a Train* foreshadowed this violent turn; *Psycho* goes even further, fusing provocation and formal concerns. The film depicts the feminine/queer conflict with a new acuity. First, it treats the relationship between Marion Crane and Norman Bates with far greater empa-thy than Robert Bloch's novel does (Mary, as she is called in the novel, regards Norman with impatience and even contempt), as we outlined in chapter 1. This empathy makes the murder of Marion Crane even more horrific. Second, the feminine/queer relation-ship is doubled and extended in the second half of the film through the introduction of a second significant female character, Marion's sister Lila Crane. Her narrative arc, as she investigates the fate of her missing sister, is strikingly contrasted against Norman's. The possibility that Lila herself is lesbian/queer adds a riveting tension to her charac-terization. Third, and most crucial of all, the formal plan of the film forces us to con-sider the relevance of a new figure to the feminine/queer conflict. I call this figure the *death mother*, an entity located in the plot of the film but chiefly the result of its aesthetic design. In the previous chapter, I delineated several aspects of Hitchcock's recurring figure of the *queer mother*. The character of Mrs. Bates, or "Mother," corresponds to this type while also deviating from it. As I will show, however, though clearly interrelated,

the queer mother is distinct from the death mother. Indeed, the death mother is distinct from all of Hitchcock's mothers, existing in a realm that is hers alone.

Psycho is an endlessly fascinating work; it is also a highly politically ambiguous and ambivalent work. There is much to appreciate in the film's mordant-yet-anguished treatment of gendered and sexual subjectivity, yet also much to give one pause, particularly the shocking violence against the heroine at its core. *Psycho* offers a harrowing portrait, rooted in empathy for the socially silenced, of an essential American estrangement, and that it can be read this way makes the film politically valuable. Hitchcock's proleptic critique of the antisocial thesis gives *Psycho* its enduring force as a nightmarish vision of American society, which is to say that Hitchcock refuses the antisocial position, as *Psycho* clarifies in its portrait of cultural nullity centered in a profound and pervasive social disconnection. The endless quest for financial gain, the fantasy that monetary gain leads to personal autonomy in defiance of the social order, is here tied, as it will be in *Marnie*, to gender and sexual normativity.

Although my chapter on *Marnie* is informed by Marxian theory, that is not my focus here, however germane it might be to *Psycho*, which at least initially revolves around the question of woman's relationship to capital (a topic central in *Marnie*). *Psycho*'s cultural critique, though valuable, is indistinguishable from a suspect gender politics located in the film's spellbinding aesthetics, from a misogynistic framework that presents the forces of entropy as a devouring, death-breeding maternal menace, the figural death mother. Given this figure's ties to the death drive, the death mother inevitably leads us to the antisocial thesis in queer theory and its focus on the queer death drive, as elaborated with particular care in the work of Lee Edelman. Before proceeding to our analysis of the film and elucidation of the death mother concept, I want to take a moment to locate my argument within the antisocial debate.

DEBATING THE DEATH DRIVE

As we discussed in the introduction, the antisocial thesis has been extensively debated in queer theory and is chiefly associated with the work of Edelman and Leo Bersani; the challenges to it from scholars such as Jack Halberstam have attempted to enlarge, rather than refute, the thesis. My own position is that, despite the provocative brilliance and use value of Edelman's and Bersani's work, the antisocial thesis is a vexing and questionable approach to the consideration of queer sexuality in culture as well as experiential life. Arguing for the potentially positive political uses of certain works and artists, I want to make the case that Hitchcock's cinema is, or at least can be, resistant to dominant structures that determine and organize gender and sexuality in our culture. Clearly, as we have outlined, his provocations can be as politically suspect as they are incisive; what I am arguing for is that they do have a value nevertheless. From the antisocial perspective, such a position, I assume, will be seen as support for (and indoctrination by) the status

quo and its unflagging, inherent allegiance to reproductive futurity and heteronormativity, the main elements, as Edelman theorizes, of the social order's constitutive ideology. Without dismissing this potential critique, I forge ahead.

One of the chief hallmarks of Edelman's argument is his contention that queers should embody the death drive.

> This, I suggest, is the ethical burden to which queerness must accede in a social order intent on misrecognizing its own investment in morbidity, fetishization, and repetition: to inhabit the place of meaninglessness associated with the *sinthome*; to figure an unregenerate, and unregenerating, sexuality whose singular insistence on jouissance, rejecting every constraint imposed by sentimental futurism, exposes aesthetic culture—the culture of forms and their reproduction, the culture of Imaginary lures—as always already a "culture of death" intent on abjecting the force of a death drive that shatters the tomb we call life.

In terms of Hitchcock, I can think of no better shorthand description for the death mother he constructs than that provided by Edelman in his description of the death drive's "immortality" as "a persistent negation that offers assurance of nothing at all: neither identity, nor survival, nor any promise of a future."[1]

Edelman's position is strikingly provocative and highly charged. For all of my admiration for its rhetorical power, however, I believe that we should resist it. One of the many problems posed by this proposition, a queer call to arms, is that the death drive, as Luce Irigaray has theorized, is also the *patriarchal death drive*.[2] As such, it is inextricable from the forces of masculinist dominance that have traditionally subjugated female and queer subjects. Edelman asks the queer subject to hold a grotesque mirror up to society so that it can glimpse the "culture of death" that it polemically and at times murderously assigns to and associates with queerness. But to follow Edelman's dictates to uphold the queer death drive—its grotesque, parodic mirror—is also on some level to adopt the death drive's logic as one's own. To accede to the view that representation is always already complicit in the social order's pernicious fantasies and therefore that one must perpetually defend against its "lures" is to deny oneself any critical agency. I am opposed to this view of aesthetics at least insofar as it fails to distinguish more resistant texts from retrograde and reactionary ones.

Psycho is an irreducibly difficult work, its reactionary aspects inextricable from its radicalism. The death mother is a paranoid fantasy of an all-powerful maternal presence that will render art impossible; but it is also a concept that, beyond its crucial basis in formal preoccupations, emerges from the delicate and deadly interplay of competing sexual identities and struggles for recognition and expression. The battle to the death that ensues between Norman Bates and Lila Crane, synthesizing sexual hegemony, is made possible by this phobic apprehension of the death-centered power of the maternal. *Psycho* critiques the antisocial position, but does so by demonizing the maternal as the

embodiment of this negative stance. This is the chief difficulty the film poses on a political level. At the same time, it is precisely the maternal metaphor that allows the film to critique the social order's investments in controlling female sexuality and silencing queer sexuality, to explore the competing desires of those trying to imagine a life beyond heteronormative standards.

"MRS. BATES?"

Psycho famously kills off its main character Marion Crane halfway through the picture, when she has stopped off at the Bates Motel, run by Norman Bates (see figure 6.1). Marion stole $40,000 from her boss's client in hopes of freeing her lover Sam Loomis from his debts, which he claims prevented their marriage; she is murdered in the shower right after deciding to go back to Phoenix, Arizona, and return the money. Ostensibly, Marion is killed by Norman's pathologically jealous and possessive mother. When Lila Crane, Marion's sister, faces off against Norman dressed up as Mrs. Bates at the climax, the film stages a confrontation that will be endlessly replayed in the genre of the slasher/horror film, *Psycho*'s most obvious cinematic legacy.[3] While Lila does not defeat the monster, she survives, and her investigative actions and resourcefulness lead to a resolution of the murder mystery at the film's core.

Lila's confrontation with Norman and Mrs. Bates at once is crucial to a recurring pattern in Hitchcock. The heterosexual woman's conflict with the queer male extends and is doubled by her equally fraught relationship with his mother (*Notorious*) or a fruitless attempt to forge an alliance with her (*Strangers on a Train*). *Psycho* extends these earlier versions of the conflict into a particularly acute analysis of the impasse between the heterosexual woman, the queer male, and the queer mother. As we considered in our analysis of *Strangers*, the only resolution of the feminine/queer conflict in Hitchcock is this relationship between the queer male and his mother. *Psycho* considers new possibilities: the

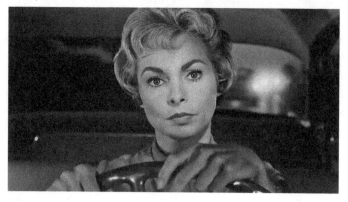

FIGURE 6.1 Marion Crane (Janet Leigh), in search of love and freedom, driving toward death.

relationship of the queer male to the queer woman and the queer woman's relationship to him and to the queer mother—and the death mother's relationship to all subjects.

I draw a distinction between the character of Mrs. Bates, or "Mother," and the death mother concept. Never seen until the climax yet everywhere present, Mother's absent/present persona evokes the dead but omnipresent titular woman in *Rebecca*. A spectral presence given the illusion of life, Mother nevertheless becomes a literal, material form by the end of the film once her preserved corpse is discovered in the basement of the Bates house. In contrast, the death mother is *an effect produced by the film text as a whole*.[4]

The death mother is a maternal figure associated with death, offering threat, not nurture, terror, not love. More crucially, the death mother emerges as a synthesis, an emblem, of a world of death, akin to what the psychoanalytic theorist André Green calls "the maternal necropolis." The domain of the death mother exceeds all human efforts to escape it. It is tied to culture, nature, gender roles, and sexuality, but ultimately exceeds these specific associations. As I will show, the death mother is primarily tied to the aesthetic, to formal experimentation that flows out of or expresses a particular concentration of phobic conflicts and preoccupations. The death mother emerges as the female face of the death drive, a relentless force that wants nothing more than to vanquish living beings and render them monuments to her ineluctable triumph. If, as Irigaray theorizes, the death drive emanates from the patriarchal system, *Psycho* locates this relentless force in a figural maternal power.

The death mother is the dark side of the realm that Juliet Mitchell calls "the Law of the Mother."[5] At the same time, "she" is a disruption, a deformation, a tearing open of the text and a maddening goad to aesthetic experimentation. The death mother figures this very desire to manipulate and innovate a work of art's formal design. This aesthetic ecstasy inextricably meshes with a misogynistic understanding of female power as a form that must be challenged, outmatched, even as it goads the artist to heightened creative production.

Hitchcock's use of the cinematic techniques of superimposition and dissolve in the final shots of *Psycho* elucidate the effects of the death mother. Gathering intensity and definition over the course of the film, the figure of the death mother now at last comes into focus. Norman Bates, having been revealed as the impersonator of his dead mother, whom he murdered, sits in a prison holding cell, but it is Mother's words in a voiceover that we hear as the camera steadily bores into his face. The image of Mother's face, a skull with an eerie grin, is superimposed, almost subliminally, on Norman's, and then this Mother skull/Norman face blurs, through the use of a dissolve, into a shot of a car being dragged out of a swamp by a metal chain. Life and death fused, a cesspool and a mechanistic monster, the death mother blurs male, female, and technological/industrial signifiers and exceeds them.

As we discussed in the previous chapter, a motif of life-in-deathness recurs in Hitchcock's work, as evinced by the artificial horses on the merry-go-round in *Strangers on a Train*. The lifeless-yet-malevolently-grinning-and-stampeding horses

ironize the characters' frenzied struggle. *Marnie* reinforces these associations, as we will discuss in the next chapter. Mother's associations with life-in-deathness in *Psycho* animate the death mother. Her corpse positioned at her bedroom window leads others to believe that she sits there watching; turned to a bare wall in the basement, she resembles a moviegoer in front of a screen. In the famous shower murder sequence, filmed as a montage, in which "Mother kills the girl," Mother and the death mother intersect. A dark, shadowy, but visible form looming above the woman in the shower, Mother kills Marion Crane (see figure 6.2). That we never see the knife actually piercing the body during the murder, a detail noted in every analysis of *Psycho*, alerts us to the absence/presence motif that heralds the death mother. The quasi-material form of Marion's assassin anticipates the skull-faced materiality of the corpse at the climax. Mother "belongs" to these material indications of her presence; the death mother, however, emerges from the stylistic effects that animate and give her remnants the semblance of life, such as the play of light (its source in a wildly swinging light bulb) on Mother's skull face at the climax and the uncannily shrieking effect of Bernard Herrmann's violins.

The montage shower murder sequence signifies, as it enacts, the inherently violent nature of film, an assemblage of images ripped apart and spliced together. The montage murder contributes to the death mother allegory of film form as a system of disassemblage and dissolution.[6] As Hitchcock's films developed, so too did the formalization of his consistent concerns with gender and sexuality, which his maternal themes reflect. Mother remains tethered to the diegetic; the death mother absorbs the diegetic and takes it to a higher level of difficulty, distance, disturbance, and fragmentation in form. Yet the death mother cannot be reduced to formal concerns even as the concept emanates from them. Irreducibly, the psychosexual basis for these formal concerns determines the shape they assume of a dark maternal presence, as I will elucidate.

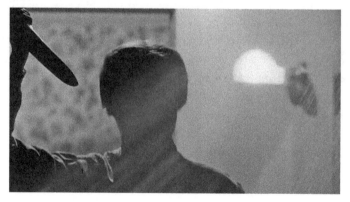

FIGURE 6.2 The quasi-material form of Marion's assassin anticipates the skull-faced materiality of the corpse at the climax.

I develop the concept of the death mother from the writings of Freud, Nietzsche, the psychoanalyst André Green, and from feminist psychoanalytic theory: Barbara Creed, in her reworking of Julia Kristeva's theory of abjection, and Diane Jonte-Pace, in her analysis of Freud's work.

For Kristeva, the mother must be repressed in order for the subject to emerge, and for these reasons, the mother is "abject," associated with bodily waste and the ability to evoke disgust.[7] Expanding on Kristeva, Creed argues that the primary fear at the core of the horror film genre is that the subject will be re-engulfed by the terrifying figure of the archaic mother, as in such films as *The Exorcist* (William Friedkin, 1973), *Carrie* (Brian De Palma, 1976), and *Alien* (Ridley Scott, 1979) and its sequels. This dread-inducing archaic mother is "present in all horror films as the blackness of extinction—death."[8] To take Hitchcock films as an example, we can see that a panic over strong maternal figures does indeed characterize them. Yet they are also informed by an equally urgent desire for *return* to the mother.[9]

One of Freud's central explorations of the death mother occurs in his 1913 essay "The Theme of the Three Caskets" and its consideration of the significance of narratives in which a man must make a choice among three options in pursuit of the "right" woman, such as Shakespeare's play *The Merchant of Venice.* In another example, Freud argues that at the end of Shakespeare's *King Lear,* when Lear walks onto the stage carrying the dead body of his daughter Cordelia, it is really she who carries Lear. She is "the Death-goddess who, like the Valkyrie in German mythology, carries the dead hero from the battlefield" and teaches him to "make friends" with death. "We might argue," Freud observes, "that what is represented here are the three inevitable relations that a man has with a woman—the woman who bears him, the woman who is his mate and the woman who destroys him . . . the Mother Earth who receives him once more . . . the silent Goddess of Death, [who] will take him into her arms."[10] As Diane Jonte-Pace observes, the suppressed figure of the mother in Freud manifests itself in fantasies of mothers as "instructors in death."[11]

As Nietzsche writes in reference to Sophocles' tragedy *Oedipus the King,* the only way that nature, represented in monstrous feminine form as the Sphinx who forces men to answer her riddles, can be subjugated is through "victorious resistance to her, i.e., by some unnatural event." The man who solves the Sphinx's riddles "must also destroy the most sacred orders of nature." Only Oedipus—in flight from the prophecy revealed to him by the oracle at Delphi that he will one day kill his father and marry his mother—manages to do so, hence the acts of murdering his father and marrying his mother. "Wisdom, the myth seems to whisper to us, and Dionysiac wisdom in particular, is an unnatural abomination; whoever plunges nature into the abyss of destruction by what he knows must in turn experience the dissolution of nature in his own person."[12]

Oedipus the King, of crucial importance to Freud and classical psychoanalysis, is highly relevant to *Psycho.* Incestuous desire, while never named as such, suffuses the

backstory of Norman's relationship to his mother, whom he killed along with her lover while claiming that *she* had poisoned them both. Norman's murder of his mother is identified by the psychiatrist (played by Simon Oakland) in his long explanatory speech as a prior trauma; his murder of others, young women in particular, is a particularly hideous form of repetition compulsion in which he kills the mother again and again. (It could be argued, however, that if the repetition compulsion started with matricide, this killing was an attempt to solve an *earlier* conflict rather than what caused the conflict.)

Nietzsche's reading of *Oedipus* enlarges our understanding of *Psycho*: Both works thematize the unnatural act whereby nature is subjugated, the precarious pursuit of knowledge, and nature's revenge on those who solve her riddles. Norman's incestuously charged murder of his mother is analogous to Oedipus's solving of the Sphinx's riddle, the unnatural act through which secret knowledge of the mother is obtained. (*The Oresteia*, Aeschylus's trilogy of tragedies, is also relevant. A son kills his mother and must then answer for his crimes, albeit in a manner that exonerates him and leads to the establishment of patriarchal law.) This knowledge is tied to sex (Mrs. Bates and her illicit lover were found dead "in bed," whispers the sheriff's wife, shaking her head) and to possession, a kind of subjugation, of the mother's body after death, and with it possession of her personality, however wildly distorted, within Norman's own. While Oedipus effectively kills the Sphinx, this female monster kills with merciless rapacity herself; similarly, Mrs. Bates appears to kill with remorseless abandon. Much of the film involves an investigation brought about by the "unnatural" act of female crime. Marion's theft of the money sets the plot in motion, which can be described as a pursuit of knowledge haplessly attempted by men (the private investigator Arbogast who gets murdered, Sam who finds out nothing; both are duped by the apparition of "Mother" in the window). This pursuit of knowledge can only be successfully achieved by a woman. Exemplary of this pursuit, Lila Crane, searching for her sister, investigates the Bates house, which leads her to solve the crime and discover Mother. But her success comes at the terrible cost of discovering that her sister truly is dead.

André Green's theory of the dead mother is particularly affecting. The dead mother allows the child to develop a way of both preserving and mourning the mysteriously vacant and detached—in a word, dead—mother who had once been affectionate and loving toward the child. Green found a recurring motif in the accounts of his various analysands, who often reported back to him feelings of "emptiness," ". . . the sentiment of emptiness, so characteristic of depression, which is always the result of a narcissistic wound experienced at the level of the ego."[13] He theorized that this profound and pervasive emptiness—a "blank mourning"—related to some kind of deep, intense childhood experience with a depressed mother who emotionally withdrew from the child.

The mother's blank mourning induces blank mourning in the infant, burying a part of his ego in the maternal necropolis. To nourish the dead mother amounts, then,

to maintaining the earliest love for the primordial object under the seal of secrecy, enshrouded by the primary repression of an ill-accomplished separation of the two partners of primitive fusion.[14]

In the "primitive fusion" of the child's and the mother's bodies, the child experiences its mother's body as continuous with its own. The separation that must occur between these bodies is traumatic for both. But when the mother becomes depressed or detached, an alien to the child, this separation becomes doubly traumatic, a double death. The child preserves a sense of the maternal imago within its own psychic structure, but the mother preserved within the child is a figure of mysterious detachment and inaccessibility, emotionally killed off. It is this emotionally deadened mother—the dead mother—who continues to live within the wounded, bereft subject, feeding the subject's ultimately overwhelming sense of emptiness well into adult life. As Green elaborates, the dead mother complex can last into adulthood, an intransigent melancholic state (and therefore not a state of mourning) with no clear terminus point. It does not simply end at some point in adulthood, but can only be eradicated through psychoanalytic treatment. The death mother, as I am theorizing the concept, is distinct from Green's dead mother. We might argue that Hitchcock's death mother is the *spatialization* of that force as Green described it. Therefore, the death mother is not tied to individual psychology in real persons or fictional characters. Rather, it emerges from the intersection between conflicts over gender and sexuality and formal concerns.

One of the difficulties in reading a film like *Psycho* through a largely abstract concept such as the death mother (even as we acknowledge its basis in fearful longing) is the potential loss of attention to the film's investments in gender, sex, desire, and the body and its punitive attitude toward female sexuality. Indeed, nothing could be more punitive, it would appear, than the hideous murder of Marion Crane. Without exculpating Hitchcock for his misogyny or his homophobia, I want to show that if they are indeed present here, so is a committed investment in exploring the psychosexual foundations of female and queer negotiations of the strictures of the social order, with the death mother a controlling metaphor for these tensions.

STRANGERS: SONS AND MOTHERS

In the previous chapter, I began to lay out my theory of the queer mother. I want to elaborate on the queer male's sexuality within his relationships to maternal figures. Hitchcock's queer villains most often command his sympathy, and this holds especially true for Norman Bates, played with extraordinary delicacy—and ferocity—by Anthony Perkins. Like so many of Hitchcock's leading men, Perkins was tall, thin, dark-haired, physically beautiful, and a gay man forced to contend with homophobia.[15] Perkins represents the apotheosis of a type in Hitchcock's work that I call the tremulous brunet.

As I demonstrated in chapter 1, the cinematic Norman Bates could not be more distinct from Robert Bloch's conceptualization.

The mother/son relationships in Hitchcock often connote the son's homosexuality/queerness; even the relationship between Roger O. Thornhill and his mother (played by an actress close in age to Cary Grant, Jessie Royce Landis) has such overtones. (Thornhill, twice divorced, still lives with his mother; he regularly plays bridge and attends the theater with her, and she expects him to keep his dinner appointment at home even as he flees assassins.) All of the films in which a queer-inflected mother/son relationship are central—*Notorious, Strangers on a Train*, and *Psycho*—pit the heroine against not only the son but also the mother. In *Strangers*, the woman appeals to the mother for help with her diabolical son and is rebuffed; in *Notorious* and *Psycho*, the woman's conflict with both the mother and the son escalates into murderous violence. (*Psycho* obviously muddies the waters in this respect, since Mother does not actually exist.) *Notorious* is especially relevant, containing a scene in which Alex Sebastian, the homosexual villain (as he is typed) and his cold, evil mother—both Nazis attempting to restore the party in Rio de Janiero, Brazil—argue behind closed doors, an early indication of the "voice without a body" theorized by Michel Chion.[16]

The woman's conflict with the mother is an important variation of the feminine-versus-the-queer pattern, especially given that the queer mother is so complicit in her son's diabolism. Unlike *Notorious* and *Strangers*, however, the mother in *Psycho* does not exculpate her son for his crimes—quite the reverse. She is closer to being his adversary than his advocate, even as she adversarially counters the heterosexual woman. If, as David Thomson argues, the audience is primed to believe that Norman Bates will gallantly rescue Marion Crane from her predicaments—including her unsatisfying relationship with her vacillating lover Sam Loomis—Mrs. Bates opposes the match with more ferocity than even the fierce Mrs. Sebastian does her son's marriage to Alicia Huberman. As is so frequently the case in Hitchcock, food and the commensal are the rhetoric of internecine warfare. Mrs. Bates fulminates, "She won't appease her ugly appetites with my food, or my son!" And we recall that it is Mrs. Sebastian's idea to poison Alicia, her everyday cup of coffee her undoing. Norman oddly munches on candy corn, an activity that Hitchcock emphasizes through a disorientingly tilted shot of Norman chewing it as he speaks with the private detective Arbogast. We see Norman's jaw muscles working, the strange angle making him look nonhuman. His corn-eating links him to the literal birds (stuffed and staring) and the symbolically female birds (women in British slang) of the film. (That he eats *candy* corn insinuates that he is a man impersonating a woman, a fake "bird.") His corn-eating also links him to the popcorn-eating Bruno Anthony and the dinner-serving homosexual killers of *Rope*, orality consistently signifying the regression associated with male homosexuality.[17]

Given that the queer mothers of both films, associated with phallic violence, so thoroughly evoke the mother's role in Freud's theory of male homosexuality—she provides the model for his desire, and he wants to love another male "as his mother loved

him"—it seems equally likely that each mother's intense opposition to heterosexual eros is a defensive countermeasure against deeper knowledge of the son's homosexuality. Such a paranoid stance—and Hitchcock's queer mother is another version of the paranoid woman—drives the plot of a crucial work released only a year before *Psycho*, the 1959 film adaptation of Tennessee Williams's play *Suddenly, Last Summer*, directed by Joseph L. Mankiewicz from a screenplay by Gore Vidal (Williams was listed as the co-screenwriter).[18] Both *Suddenly* and *Psycho* pit a deeply sympathetic young woman against a homosexual male and his fearsome mother, and both involve intense aesthetic experimentation (the sustained cinematic evocation of the dead Mrs. Bates's presence; in *Suddenly*, the heroine Catherine's narration of her cousin Sebastian Venable's grotesque cannibalistic murder, which cinematically involves the superimposition of Catherine's face in the present over the flashback scenes of her narrative and also involves a similar absence/presence motif in the depiction of Sebastian as a fleeting, white-suited presence whose face we can never see; the name Sebastian, for what it is worth, links this film to *Notorious*).

Marion Crane, as she waits for Norman to prepare the dinner he offered her ("Just sandwiches and milk—I don't set a fancy table, but the kitchen's awful homey!"), overhears the cacophony of a true lovers' quarrel: Norman and his mother arguing over whether or not she is allowed inside the Bates home. As Marion, alarmed at this violent rhetoric, peers out of her window, she sees the looming and terrible Bates house, with its glowing eye-like windows, as she listens to the venomous conversation caused by her presence. The death mother concept gains articulation in such moments: It is the house she sees, not the human beings having the conversation. A metonym for the bickering mother and son and their entire anguished struggle, the house seems strangely alive. Similarly, when Lila Crane, in the famous forward-tracking shot, ascends the hill and makes her way to the Bates house near the climax, the house seems to be looking at her, beckoning her in. The death mother charges the inanimate with seeming life.

In a horrifying sequence, Marion Crane is murdered in the shower by Mother. Hitchcock's endlessly studied technique for the representation of the murder and its immediate aftermath adds immeasurably to the death mother paradigm. When, from Marion's POV, we look up at the showerhead spewing water, it uncannily appears to be looking back at us. The barely visible but undeniably present figure of Mother (a dark outline, a hairnet-covered head, a face in which only the eyes are briefly visible, a robed body) indicates Mother's material presence. The death mother emerges through abstraction and formal distance and the trope of life-in-deathness. Therefore, the images of the knife appearing to pierce but never actually penetrating Marion's nude body articulate the death mother, as does the choice to film the murder through the distancing technique of the montage. As Marion, dying, falls to the ground, the vertiginous shot of the darkened water spiraling into the drain that appears to come from Marion's lifeless eyeball reinforces the death mother motif at the level of camera movement. Uninhabited by the living—Mother has left, Marion is dead—the scene nevertheless seems animated by a

presence, as if the force that directs the water and then causes the camera to emerge from the dead woman's eye has a momentum and agency of its own.

The murder of Marion Crane represents the height of both the feminine-versus-the-queer conflict and Hitchcock's aesthetic rendering of it. Mrs. Sebastian, Mrs. Anthony, and Mother's shriveled, pitiful corpse are all-too-human presences, but the death mother is quite distinct, an abstracted and infinitely more potent force. The shot of the bloodied water swiftly swallowed up by the drain registers the terrible loss of Marion's life, but it also connotes a larger sense of entropy, a vast wastefulness, in American culture. As Donald Spoto writes, "*Psycho* postulates that the American dream can easily become a nightmare, and that all its facile components can play us false."[19] What is crucial here, as I have noted, is that this entropy is framed through a terrifying maternal metaphor.

IN THE BEDROOM: LILA, MOTHER, AND LESBIAN DESIRE

The feminine-versus-the-queer thematic, seemingly brought to a head with Marion Crane's murder, is revisited within the narrative almost immediately through the introduction of Lila Crane. The scenes in which Lila investigates the Bates house, hoping to solve the mystery of her sister's whereabouts, are a narrative of her psychosexual development, from a phase of childhood sexuality in which mother was the chief sexual object, to a scene of symbolic matrimony (Sam saving her from gender confusion, from cross-dressed Norman, and from the family in his rescue of her in the cellar). Lila is born anew in Mother's room, goes through a mirror stage of sorts there, and enters childhood (Norman's bedroom). She then descends into the adult world of knowledge to discover Mother's corpse in the basement. The trajectory concludes with Sam's rescue of her, which transforms an enterprising and sexually ambiguous female character into a more conventional one. The film finds several means of disrupting this conventionalization, however, even though it is helpful to keep Lila's symbolic development in mind. One such way is to eschew any possibility for romantic or sexual connection between Sam and Lila. (Lila is an early version of the horror movie-heroine that Carol Clover called the "Final Girl." Unlike the stock horror film type of the woman who screams for help and is rescued, the Final Girl alone survives the horror bloodbath and kills or escapes the monster. Even though rescued by Sam, Lila, whose autonomy diminishes Sam's importance, hews more closely to Clover's figure in her resourcefulness and defiance of the man's paternalistic authority.)

Alexander Doty reads Lila as "a brash, heroic dyke" who must meet her mirror image in the distorted queer image of transvestic Norman. Donned in Mother's attire, wielding the knife, Norman is ultimately disabled by Sam, who bursts in to save the heroine. Resourceful and heroic though she is, even Lila cannot escape the "queer apocalypse" of *Psycho*'s end.[20] Doty interprets the infamous psychiatrist's speech at the end of the film as a corrective to both Norman's and Lila's suspect gender performances.[21]

I am grateful to Doty for establishing Norman as a queer character (non-normative in gender and sexual terms that are not necessarily indicative of homosexuality). At the same time, Norman is clearly a figure of the homosexual, in particular, the homosexual male tyrannized by a dominant mother, the definitive image of the Americanized Freudian views of the period that crudely distorted Freud's far more complex thought. Doty treats the usually overlooked Lila with welcome care, and his reading of her as a lesbian character is particularly suggestive. Nevertheless, the conservatism suggested within the Lila character, which links her to Mrs. Bates/Mother, demands scrutiny. When the psychiatrist Dr. Richman explains (in his thoroughly heterosexist way) to Lila that Marion was killed because Norman "was touched by her, aroused by her, he wanted her," which led to Mother's jealous retribution, the close-up of Lila's face doesn't register concern as much as it does subdued alarm at impropriety. The links between Lila and Mrs. Bates connote Freud's repressive hypothesis, embodied by the Victorian era. As Robin Wood astutely put it in his 1960 essay on the film, Mother's room evinces this hypothesis: "the Victorian décor, crammed with invention, intensifies the atmosphere of sexual repression . . . one can almost smell it."[22]

Lila is represented in suggestively ambiguous ways, both as the upholder of the law and a character with queer possibilities. Her first meeting with Marion's lover and would-be fiancé Sam is telling. She enters his hardware store in single-minded pursuit of her sister, interrupting him as he is writing a letter to Marion. (The shot of Sam writing the letter echoes the earlier one of Marion, seated at a desk in her motel room, adding and subtracting $40,000 right before she is murdered; this shot is juxtaposed against a separate one of Norman seated at his kitchen table, alone and pensive.) The letter that Sam is writing seems to be a conciliatory one to his now-dead lover: "Dear Right-as-Always Marion." Symbolically, the forceful Lila halts the course of heterosexual romantic love, as figured by Sam's interrupted love letter (an echo, perhaps, of Judy Barton's tearing up the letter she has written in *Vertigo* and Melanie Daniels doing the same in *The Birds*).

Tough, forthright, and determined, Lila takes decisive action, in contrast to pensive Sam. When the private detective Arbogast (Martin Balsam) fails to get back in touch with Lila, waiting for him in the hardware shop, she threatens to go to the Bates place herself. Sam, finally roused to action, insists on going alone, telling her to wait in case Arbogast shows up. As Sam leaves, Hitchcock gives us a shot of Lila framed with an array of rakes above her head. Through the use of chiaroscuro lighting, Lila's face is darkened within the shot. As she stands, singular within the frame, the nighttime breeze, a link with the natural world, eerily blows through her hair and across her stiff features. The raised rakes resemble scythes, linking Lila to knife-wielding Mother. This shot evokes the death mother by emphasizing Lila's still, iconic presence. The lighting and the physical placement of Vera Miles in the shot and the funereal tone of Bernard Herrmann's eerie music transform Lila's image into a frieze, a cinematic sculpture in shadow, to which the nighttime breeze gives a semblance of life. Later, when Sam returns, Lila runs to the door and toward the camera, and when she stops moving, Hitchcock freezes the image of her

before us. Lila's face is not just darkened *but completely obscured*, which deepens her associations with death and literalizes "the blackness of extinction" noted by Barbara Creed.

Unable to locate Arbogast even after Sam has gone to the Bates Motel to look for him, Sam and Lila wake up Sheriff Al Chambers (John McIntire) and his wife (Lurene Tuttle). The worried pair tells the skeptical sheriff about Marion's case; Lila insists that Arbogast found out something from Mrs. Bates and was going to tell them about it but, as Lila puts it, he "was stopped." Sheriff Chambers then reveals that "Norman Bates' mother has been dead and buried" for quite some time. At Lila's pressing that Mrs. Bates must still be alive, the sheriff gooses the audience with the line, "If Norman Bates' mother is alive, then who's that woman buried out in Greenlawn Cemetery?" Hitchcock closes the otherwise nondescript scene with an image of Lila's taut, expressionless face (see figure 6.3). This concluding image sharply contrasts with Lila's affect within this scene of impatience and irritation, for which she apologizes (and which Miles adeptly conveys). On the line "then who's that woman buried out in Greenlawn Cemetery," the film cuts to the resolutely still close-up of Lila. Her stone-like face could be that of Athena on a medallion, blank and remote.[23] The iconicity of the woman is the logic of the death mother, tied to form.

Secretly exploring the Bates house, Lila performs the role of investigator, which links her to Charlie in *Shadow of a Doubt*, Constance in *Spellbound*, Alicia in *Notorious*, Eve Gill in *Stage Fright*, and Jo McKenna in *The Man Who Knew Too Much*. In contrast to the scene of Arbogast investigating the house, Lila's investigation inspires Hitchcock's sustained cinematic interest. Hitchcock contrasts her exploration of the house with the increasingly tense discussion between Sam and Norman in which the men, standing on opposite sides of the screen, visually and physically double each other.[24] This doubling, which evinces the influence of German Expressionism on Hitchcock's aesthetic, emphasizes how closely the tall, dark-haired, pale-skinned men resemble each other, which adds to the menacing homoerotic undertones. Thus doubled, Norman and Sam provide an allegory for the correspondences and complicities between a psychotic, queer

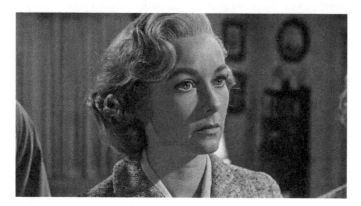

FIGURE 6.3 Lila Crane (Vera Miles) in close-up: harbinger of the death mother.

masculinity and a normative heteromasculinity; that this doubling parallels Lila's exploration of the house and specifically Mother's domain is crucial to a reading of the queer dynamics of the sequence. The homoerotic and homophobic tensions in the dialogue between Norman and Sam mirror the standoff—or merger—between Lila and Mother and deepen the antagonism and complicity between Lila and Norman. They too are doubled as queer personae.

As she cautiously yet boldly enters Mother's bedroom, Lila first observes, through a POV shot to her left, an immaculate, ornate sink, with a completely pristine bar of soap. This image evokes both Mrs. Bates and the death mother, Mother's obsession with hygiene (resonant of her obsession with "disgusting things" she will not discuss "because they disgust me") and the trope of life-in-deathness (in that everything seems at once actively in use yet completely untouched). Lila then opens the door of a wardrobe, its contents a row of strangely identical dresses. We see what appears to be either a fur coat or stole, recalling Mrs. Danvers's erotic exhibition of Rebecca's furs to the tremulously frightened second Mrs. de Winter.

Then, in the most cinematically fascinating moment here, Lila sees Mother's vanity table. Above it looms a mirror that captures the image of a standing mirror opposite it. From Lila's point of view, we see a bronze sculpture of a woman's hands, which Hitchcock zooms in on. This startling shot evokes nostalgia for Victorian maternal femininity, but it also makes the clearest association between Mother and murder: If Mother had hands like those, she really could have murdered all those girls. Moreover, the clasping bronze hands suggest Mother's inescapable grip on Norman.[25]

Lila moves toward the vanity table and, in the mirror, she spies an image—or series of images—of herself. This sight leads her to gasp in alarm, as if she has seen another woman, perhaps Mother. (Inevitably, one thinks of Charlotte Perkins Gilman's nightmarish feminist classic "The Yellow Wallpaper," an 1892 short story about a woman's mental unraveling hastened by her belief that she sees living female forms within the wallpaper.) As Lila swings around to look at this other woman, she sees only her own reflection in the standing mirror, which also captures the reflected images of her in the vanity mirror. Lila sees endless reflections of her own reflection within two different mirror images, paired versions of the *mise en abîme* (literally, "placed into an abyss"). Lila as physical person becomes only one in a series of distinct Lilas: In the vanity mirror's farthest end, one Lila swings around to look at her darkened, backward-facing other, while in the standing mirror, her reflection looks directly at her from a much more lifelike standing position, one that is roughly commensurate with her physical height. The harrowing impression is that Lila herself has been captured within the mirror image. The film brilliantly intensifies this effect through the soundtrack: Lila's respiratory response, her alarm ceding to relief at discovering no one else there but herself, reverberates throughout. But there is more life-in-deathness: The image of Lila in the standing mirror appears to breathe first and the real Lila second. As we know from *Spellbound*, it is far more terrifying to discover a mirror without an image.

If we recall Freud's theory of female paranoia, we will remember his own gasp of relief at being able to discover the homosexual motive for the woman's paranoia in a maternal presence within the scene of heterosexual conflict. The homosexual panic fundamental to Freud's theories of paranoia in the 1911 Schreber case and the 1915 study of female paranoia finds a complement here in Lila's apprehension of a female figure lurking everywhere in this maternal space, one that threatens to leap out and destroy her. She encounters her mirror reflection, her double, incorporating her into the narcissistic paradigm of Freud's theory of male homosexuality. (Classical psychoanalysis held that the female homosexual was not narcissistic enough, as Freud proposed in his 1920 case study "The Psychogenesis of a Case of Homosexuality in a Woman."[26]) Certainly, Lila is framed as a paranoid character, even if she turns out to be utterly right (recall Elizabeth Cowie's reading). Lila continues the tradition of the paranoid woman rooting out the suspenseful mystery of male sexuality, which impinges on queer masculinity in *Rope*, *Strangers on a Train*, and *Psycho* most directly.

In seeking Mother, Lila has (it would appear) sought and found herself. The sequence links Lila to Mother but also to the death mother. Reified as a series, the image of Lila conveys the sense of her transformation from living character to mass-produced object, a copy of her copy, endlessly reproduced versions of her once-living self. The maternal aspect of this sequence is overdetermined by the central mystery of Mother/Mrs. Bates. One way to think through this overdetermination is to consider that nothing generative, in a biological/reproductive sense, is occurring here, only the Benjamin-like work of mechanical reproduction, embedded within and embodied by the cinematic apparatus itself. The death mother emerges through the parodic suggestion that the repetition of Lila's images is a kind of maternal reproductivity, as if Lila were giving birth, could only give birth, to her image in an endless loop. (This idea more than any other confirms Doty's hunch about the character's sexuality, which the film regards as unregenerative.) The parody empties the mother/child bond of any emotional or even simply mammalian resonance, but the suggestion that this bond exists in the lifeless gulf of the mirror, uncannily animated with semblances of Lila, gives the death mother vitality.

Lila notices the indentation left on the bed from Mother, and runs her hand over the spot. The palpable erotic undertones of her tactile inspection remind us of Mrs. Danvers's fetishization of dead Rebecca's possessions and ghostly presence. William Rothman argues that the "depression" of Mother's body in the bed "is a poetic image of solitude and absence, of sexuality denied."[27] I argue that this is simultaneously an image of sexuality denied and an enticement to sexual desire, an emblem of Mother's sexuality that lures Lila's own. Lila's physical contact with the hollow suggests a desire to touch the maternal body without coming in contact with it, a kind of psychic/spiritual lesbianism that cauterizes the infection of same-sex desire through non-corporeality. (*Vertigo* suggested as much in its depiction of a maternal female ancestor haunting a woman in the present.) Male homoeroticism is conveyed through the doubling of the physically similar faces and bodies of Norman and Sam, reinforced by those of the actors; female homoeroticism is

conveyed through symbolic suggestion, the narcissistic encounter between a woman and her own image and her encounter with a dead woman's still-palpable presence.

OTHER VOICES, OTHER ROOMS: LILA AND NORMAN

Next, Lila investigates Norman's childhood room, a scene even more extraneous to the plot, yet one that crystallizes the feminine/queer conflict. As Lila investigates the room, we see everything from her perspective (typically Hitchcockian shots of her looking at objects and of the objects themselves).

Lila's investigation of Norman's room, doubling the one of Mother's, both provides her with evidence of Norman's lonely life, devoted to nostalgia, and represents the limits of empathy. She observes Norman's artifacts, an aching *mise en scène* of childhood objects. The quiet feeling in Lila's eyes, movingly conveyed by Vera Miles, suggests the attitude with which Lila observes this room and what it suggests about its former (or present?) occupant. Her gasp of fear in Mother's bedroom humanized her and prepared us to believe that she may be looking at Norman's room with sympathy and even empathy. She inhabits his past, his present, and his very mind. In having unparalleled access to Norman's life, Lila shares in the queer abjection that unites them both. But, as holds true throughout Hitchcock's body of work, there can be no collaboration or sustained empathy between them, no merger of even queer souls.

Meanwhile, the situation between the men grows more heated: Sam taunts Norman about his having killed Marion in order to get the stolen money (which sounds ludicrous) and about Mother. The men struggle; Norman hits Sam on the head with a heavy object and knocks him out. Norman then races into the house to look for Lila. Eluding him, she descends into the chthonic recesses of the fruit cellar. Mrs. Bates sits facing the wall with her back to Lila. Seeing the elderly woman, Lila walks up to her saying, "Mrs. Bates?" Tapping the seated figure on the shoulder, Lila confronts the mummified corpse of Mother, whose body swings around to reveal a grinning skull face, hideously animated by a swinging light bulb that Lila has hit with her hand in alarm and by Bernard Herrmann's shrieking violins.

Suddenly, Norman, in drag as Mother and wielding a knife, races toward Lila. The line "I'm Norma Bates!" thunders forth on the soundtrack, but it does so non-diegetically, competing with Herrmann's thunderous score yet emerging from no visible source. This aural effect is the definitive example of the disembodied voice theorized by Michel Chion. Mrs. Bates's voice provides an aural metaphor for Norman's attempt to inhabit—to repeat—the identity of the mother he murdered. As Lacan noted in his revisionist treatment of Freud's theory of repetition compulsion, "Repetition is fundamentally the insistence of speech."[28] Preserving and ventriloquizing Mother's voice, Norman perpetuates the fantasy that his mother's chief agenda in life was to mock and parody him. Norma Bates's voice issues forth from the domain of the death mother, corresponding to

the action of the film text but never located within the diegesis. The mystery of the voice's source forces the viewer to inspect the aesthetic design for answers. The fissured voices in Hitchcock's work—voices that break under duress, indicative of queer anguish—find their definitive expression in Norman's stutter in his scenes with Marion and especially Arbogast. His most forceful expression of personal identity ("I'm Norma Bates!") never comes from his own mouth; he can only ventriloquize the dominant persona's self-proclamation.[29]

Norman and Lila can confront and unmask each other only in a sphere of sexual masquerade and maniacal violence. Lila expresses sympathy for Norman at the end of Robert Bloch's novel, but Hitchcock's adaptation offers a distinct vision. No sympathetic connection can exist between the woman, even the lesbian and/or queer woman, and the queer male (or, in the case of *Rebecca*'s Mrs. Danvers, the queer woman). The feminine-versus-the-queer thematic in Hitchcock comes to an especially hopeless impasse in *Psycho*.

However accurate her suspicions, Lila is the model of the female paranoid. In her crucial study of lesbian desire *The Practice of Love*, Teresa de Lauretis discusses Freud's 1915 case study "A Case of Paranoia Running Counter to the Psycho-Analytic Theory of the Disease." She notes that Freud assumes, rather than attempts to offer any empirical evidence for, his female patient's homosexuality, making an even less persuasive case for this contention than he had in his "Dora" case. "However . . .," de Lauretis adds, "this text introduces the notion of primal fantasies (*Urphantasien*), which is indeed of the utmost relevance to my study of fantasy in lesbian sexual structuring and self-representation." Primal fantasies—the child's unconscious witnessing of the primal scene—are highly relevant to any analysis of Hitchcock's work.[30] As I posited in chapter 1, Hitchcock's cinema is an arena in which the spectators similarly regress to the position of witnesses to an endless primal scene. Lila's experience of Mother's bedroom inevitably returns her to origins and the primal scene; one remembers the scandalized-yet-prurient tone of the Sherriff's wife, noting that Norman found his mother and her lover dead . . . "in bed." Her investigation of Norman's room reinforces the sense of a return to origins and a childlike state. If Lila negotiates her own same-sex desire in her investigation of Mother's bedroom and confronts her queerness as reflected in Norman, these negotiations cede to an inevitable submission to the death mother's power over representation and subjectivity. The matrix of desire—queer, heterosexual, and otherwise—cedes to the overarching presence of a maternal power that obliterates all agency, desire, and life.

THE DEATH MOTHER'S WORLD

After the psychiatrist's explanation scene, we proceed to the coda, the scene of Norman sitting in his cell, wearing a blanket that suggests burial garments, and speaking in a voiceover in Mother's voice. The coda replaces the psychiatrist's diagnosis—his authoritarian and jejune musings—with a metaphysical nightmare, Norman's Mother's skull face

blurring into an image of Marion's car being pulled out of the swamp by a chain. Robin Wood argued in 1960 that this shot restores us to Marion and to "psychological liberty." Hitchcock shows us the worst crimes of which humanity is capable yet cathartically frees us by the end.[31] But the final image is a culminating statement of fear and despair, as I read it. The death mother contains all in her inescapable embrace.

In *Psycho*, a woman (Marion) must be annihilated so that her dominance over narrative cedes to a male (Norman). This is the argument that Barbara Klinger makes in her essay "The Institutionalization of Female Sexuality" in response to Raymond Bellour's influential essay "Psychosis, Neurosis, Perversion."[32] Bellour argues that *Psycho* exemplifies both classical Hollywood's insistence on narrative closure and Hitchcock's prevalent oedipal structures: The end must answer the beginning, which in this case means containing the unruly threat of unlicensed female sexuality that half-clad Marion poses in the first scene, when we voyeuristically perceive her illicit lunchtime sexual tryst in a hotel room with Sam. The film transforms her feminine illness of "neurosis" into Norman's male malady of "psychosis," thus providing masculine closure to an initially feminine narrative through scopic schemes of voyeurism.[33] Klinger concurs with Bellour that the film strives to contain Marion, but argues that it does so within the institutionalized systems of the family and the law that contain Mother as well.

I argue that the death mother defies both Bellour's and Klinger's readings of female containment; the death mother exceeds specific gender coding while indicating a total dominance by a maternal force. To return to the final images, the car being pulled out of the swamp is a maternal metaphor, the car a womb, the dead woman in its trunk a grisly fetus, the attached metal chain an umbilical cord. Yet, in an almost a stereoscopic effect, the chain appears to jut from the screen, a phallic image. The maternal car and its phallic chain evoke Freud's theory of the phallic mother. In the child's fantasy, the pre-oedipal mother is all-powerful; possessing a penis, she transcends castration.[34] As we have noted, Freud linked the figures of mother, wife, and death, and symbolized death as a mother come to take her errant child home; the *death mother*, however, uses signifiers of the maternal to connote death.

Throughout the film, phallic women pursue their desires and move the narrative forward. In his impersonation of Mother, Norman specifically imitates her phallic femininity. Yet phallic femininity cedes to the petrifying force of the death mother. A fully realized phallic femininity leads not to liberating agency but to union with the death drive, grotesquely literalized by the car that contains Marion's murdered body. Scratching and clawing and never budging an inch, those in the death mother's domain are always already-dead forms. The death mother emerges from life-in-deathness, images of which abound in the final moments. As the car is being dragged from the swamp, it uncannily resembles a face, the headlights a pair of eyes, the grillwork a kind of leering smile. The car recalls the image of the mother as skull-faced corpse, a movement from the vestiges of a once-living woman to an apparatus that represents machine-tooled nonlife. The swamp, with its obvious feminine associations, oozes and sputters as if a living being. The black

wet earth covering the car links the image to the dark Bates house at night and its weird window eyes. These dead objects seethe with the semblance of life. Uncannily animate, the objects in the death mother's grasp never have a life of their own, and this applies in the end to the human characters on the screen, gradually indistinguishable from the stuffed birds mounted on the walls.[35]

Ultimately, the death mother suggests a great deal about the dread of the mother in culture and the misogynistic dimensions of this dread. Perhaps as resonantly, it reveals, as a fantasy but also an aesthetic preoccupation and achievement, the profound and utterly troubling link between the dread of maternal power and art-making. As happens frequently in Hitchcock but never more intensely than it does here, an impetus toward identification with the victimized and the silenced competes against the phobic object and defensive strategies designed to conceal and contain it. In this case, the phobic object is the mother with the power to bring death to art.

7

Marnie's Queer Resilience

REFLECTING A NEW maturity in Hitchcock's treatment of gender and sexuality, *Marnie* (1964) is one of the cinema's richest explorations of what I call *queer resilience*: a continuous level of self-reliance and fortitude within structures of stifling social conformity that emphasize visible manifestations of gender and sexual normativity. As Judith Butler writes, "masculine and feminine are not dispositions, as Freud sometimes argues, but indeed accomplishments, ones which emerge in tandem with the achievement of heterosexuality."[1] Being properly male or female and being manifestly heterosexual, an achievement most commonly confirmed by marriage, are treated as mysterious and overwhelming demands in *Marnie*. *Psycho* remains Hitchcock's bleakest film; the bleakness in *Marnie*, however pervasive and palpable, is counterbalanced by a faltering attempt to discover meaning and agency. *Marnie* subjects *Psycho* to a feminist critique, enlarging and humanizing the maternal themes of Hitchcock's work and considering a much fuller range of implications for the heroine's attempt to secure an independent future.

The social order, as *Marnie* envisions it, not only depends on but also promulgates constriction, loneliness, and an inexorable descent into violation and violence, the most intimate violence occurring within the closest bonds (mother/child, the married couple). The forms of intimate violence that Hitchcock's films frequently depict find a newly politicized urgency in *Marnie*. The character Marnie's queer resilience can be described as her constant effort to stay alive and derive some form of pleasure and satisfaction from doing so in a culture that negates, through its focused and specific demands, the heroine's

very means of existing.[2] My effort in this chapter will be to demonstrate the ways in which *Marnie* not only thematically but also formally explores its concerns with gender, class, and social isolation. Both the feminine-versus-the-queer thematic and its complement (the mother/adult child relationship) that have been our central focus in this book powerfully inform *Marnie*.

LESBIAN DESIRE AND THE INVIOLATE WOMAN

In the previous chapter, we considered the implications of Lila Crane's lesbian sexuality for the feminine/queer conflict, usually occurring between the heterosexual heroine and a queer male. We considered similar possibilities in *Shadow of a Doubt*. *Marnie* is, along with *Rebecca*, the Hitchcock film that all but explicates the presence of lesbian sexuality, and the film has been importantly explored by critics such as Robert J. Corber and Lucretia Knapp in terms of this question.

Lesbian desire haunts the Hitchcock oeuvre. Foregrounded in *Rebecca*, it informs many significant Hitchcock works ranging from *Suspicion* to *Stage Fright* to *The Man Who Knew Too Much* (1956). Lesbian desire is an important concern in the feminine/queer conflict, as evinced by the Lila Crane/Norman Bates doubling in *Psycho*. In *The Birds*, the romance between Melanie Daniels (Tippi Hedren in her first film role) and Mitch Brenner (Rod Taylor) takes center stage, but Melanie's relationships with the other women in the film—especially the schoolteacher Annie Hayworth (Suzanne Pleshette) and Lydia Brenner (Jessica Tandy), Mitch's mother—are equally significant and, as I elaborate in the epilogue, suggest the presence of lesbian desire. Jack Halberstam's essay on the film addresses the question of desire between women, which is not considered by Jacqueline Rose or Lee Edelman in their notable essays on *The Birds*.[3]

In *Cold War Femme*, Corber breaks new ground in his ongoing study of homophobia in the 1950s and '60s Cold War era. As elaborated by Jess Stearn in his bestselling book *The Grapevine: A Report on the Secret World of the Lesbian* (1965), which Corber frames as a central work for his subject, the view that most lesbians looked and acted just like other, conventionally straight women began to reshape and influence societal understandings of—and panicked attempts to control—lesbianism. The lesbian could no longer be typed as the "butch," nor could she simply be diagnosed through the longstanding sexological model that linked sexual and gender nonconformity. The "femme" of Corber's book was newly perplexing and threatening precisely because she so easily blended in with other women and straight society. Indeed, unsuspecting men often married femmes, only to discover their secret, troubled natures later. *Marnie* features a blonde femme whose desire is ultimately "realigned" with normative heterosexuality in its institutionalized forms, especially marriage.

Marnie expresses a profound ambivalence toward heterosexual marriage, especially pronounced at its conclusion. Marnie Edgar (Tippi Hedren) steals from the powerful

bankers she works for in order to keep herself and her mother in comfort and free of the need for male companionship. When she steals from Philadelphia aristocrat Mark Rutland (Sean Connery), he forces her to marry him rather than turning her over to the police. At the end of the film, Mark forces Marnie to confront both her strangely distant and unaffectionate mother and the childhood trauma at the root of her opposition to normative heterosexual relations. As Marnie, enlightened but shattered, and Mark leave Mrs. Edgar's Baltimore home at the end of the film, Marnie, aware that her criminal past is catching up to her, says to Mark, "I don't want to go to jail, Mark—I'd rather go with you."

In my view, Marnie's words reflect Hitchcock's career-spanning ambivalence toward heterosexual relations. For Corber, films like *Marnie* "ratify" and "validate," "indirectly" or otherwise, Cold War homophobia by leaving open the possibility that Marnie may be a lesbian, which, far from diminishing, her very femininity (femme-ininity, that is), supports it. "Because there is no way to know whether Mark has succeeded in displacing her mother as the object of her desire, Marnie's femininity may still mask a lesbian identity."[4] Corber's work once again provides important contexts for understanding the intricacies of Cold War era homophobia. In my view, however, *Marnie* is a resistant text—specifically because it resists any clear definition of its heroine's sexuality. The more troubling implication of the film is that Marnie's sexuality may not be organized around object choice at all, as I will show.

In her 1993 *Cinema Journal* essay, Lucretia Knapp interprets *Marnie* as a specifically lesbian film. She focuses on its female relationships, most notably that between Marnie and Lil Mainwaring (Diana Baker), Mark's sister-in-law (his dead first wife's sister). As Lil eyes the new girl Marnie in Mark's office, she suggestively remarks to him, "Who's the dish?" Knapp also discusses Marnie's relationship with Susan Clabon, the warm, kind, and smiling fellow secretary at Rutland's (played by Mariette Hartley). Knapp offered one of the first challenges to Raymond Bellour's exclusively heterosexual and heterosexualizing treatments of Hitchcock texts as narratives of the male protagonist's oedipal development.

Although I agree that Marnie is not a heterosexual character and fully concur with Knapp that a lesbian presence is palpable within the text, I do not read Marnie as a lesbian character. As I will show, Marnie's sexuality eschews alignments with either heterosexuality or homosexuality. Without diminishing the lesbian specificity of Knapp's reading, I want to make a broader case for Marnie as a queer character, one whose sexuality is open-ended and does not conform to one sexual mode. At the same time, I suggest that similarities exist between Marnie's personality and that of the sexually inviolate males of nineteenth-century American literature.[5] The chief link between Marnie and these earlier figures, as I will discuss, is an onanistic sexuality.

Knapp's discussion of the relationship between Marnie and Lil emphasizes Lil's role as Marnie's "protector, comforter, and sympathizer."[6] Fascinatingly, in the source material for Hitchcock's film, Winston Graham's *Marnie*, an English novel first published

in 1961, Lil is a gay man named Terry Holbrook, frequently described as "bitchy." As Donald Spoto rather oddly puts it, an excess of "sexual specialism" in the adaptation led to the decision to replace Terry, a gay man "who turns Marnie over to the police because of his jealousy of her relationship with Mark," with Lil.[7] *Marnie*, as Walter Raubicheck and Walter Srebnick discuss, underwent "one of the most complex collaborations in Hitchcock's career," involving *Psycho*'s screenwriter Joseph Stefano, the novelist Evan Hunter (who wrote the screenplay for *The Birds*), and Jay Presson Allen, who wrote the final script. The director approved of the elimination of Terry, the addition of Lil, and the expansion of Mark's role, which involved the removal of the psychiatrist Dr. Roman, to whom Mark sends Marnie in the novel, and the incorporation of his role into Mark's relationship with her (Mark eagerly plays amateur psychiatrist, trying to heal Marnie of her sexual frigidity).[8]

Lil is a deliciously polymorphously perverse character, especially as wittily played by the dark-haired, tartly poised Baker. Drawing on Knapp's reading, I would argue that *Lil* is the lesbian presence in this text in that she appears aroused by Marnie and her sexual possibilities; indeed, her erotic interest is expressed fairly directly. At the same time, Lil also seems sexually drawn to and invested in her brother-in-law Mark and his inaccessible handsomeness. In this regard, Lil is also a queer character, her sexual tastes wide-ranging and her commitments to sexual normativity far from apparent.

But, while Lil does come to Marnie's aid when her beloved horse Forio is grievously injured and offers Marnie comfort as she lies in bed after her nightmare, she is primarily a "negative" character, a wicked dark lady to Marnie's vulnerable fair lady, vengefully inviting Strutt, a businessman whom Marnie swindled, to the post-wedding party that Mark throws for Marnie and that is supposed to be Marnie's big social "coming out." (This archetypal fair lady/dark lady split also informs a contemporaneous film that is explicit in its lesbian themes, William Wyler's *The Children's Hour* [1961]. It should also be noted that Marnie herself embodies the dark lady/fair lady split in her hair's changing colors through dyes and wigs.)[9] In this manner, Lil is linked to the malevolent Mrs. Danvers in *Rebecca*—a film that directly relates to *Marnie*—who successfully tricks the heroine into dressing up in the same dress (worn by a female de Winter ancestor whose portrait imposingly hangs in the hallway) that Rebecca (secretly hated by Maxim de Winter) wore for the masquerade ball.

Lil's sexual threat, in that her sexuality seems overt, links her to one of the primary images of female homosexuality of the period, "the stereotype that lesbians are 'oversexed' and 'obsessed' with straight women."[10] Marnie is the antithetical stereotype, the desexualized woman, assumed to be lesbian because of her lack of sexual heat. Lil represents a version of lesbian desire that is quite different from Mrs. Danvers's in *Rebecca*. Mrs. Danvers is presented as simultaneously desexualized but ravenous with desire for the dead Rebecca (as Judith Anderson plays her, Mrs. Danvers is at once impassive and seething). Mrs. Danvers opposes not only the heroine but the heterosexual couple. The heroine's proper gender decorum is crucial here. Maxim de Winter's first wife Rebecca was brazenly

self-assured, provocative, and sexually omnivorous; the second Mrs. de Winter appeals to Maxim because she is more timid (though eventually forthright). Mrs. Danvers realizes that Maxim's love for his second wife signifies his hatred for his first. Her pyrrhic act of vengeance (she dies in her own flames) is an act of defiance and devotion: She burns down the patriarchal house to thwart the heterosexual couple, the heroine especially, though the couple and the heterosexual order survive; she sets the house and herself ablaze to unite in death with Rebecca and carry out her destructive wishes.

In contrast to the hard, cold Mrs. Danvers, Lil is a sexual and sexualized presence, always depicted as fashionable and sensually alive. Moreover, she seems just as sexually interested in her brother-in-law Mark as she is in Marnie. Indeed, her desire for Marnie, "the dish," is inextricable from her determination to thwart and impoverish her, which may indicate her jealousy that Marnie has been able to possess Mark in marriage, never suspecting that Marnie would gladly relinquish this prize to her rival. Lil is in league with the patriarchal order, telling Mark, "I'm a good fighter. . . . I have absolutely no scruples. I'd lie to the police or anything." She aligns herself with Mark, his money and power, against Marnie.

The feminine-versus-the-queer pattern undergoes some intriguing shifts here. Though the queer presence in *Marnie*, in many ways, Lil polices against Marnie's queerness and attempts to thwart Marnie because of her feminine desirability (which Marnie uses expediently but also attempts to keep at bay). Their interaction evinces the theme of sororophobia that we discussed in chapter 3 and represents a reworking of the relationship, in both visual and emotional terms, between the dark-haired Annie Hayworth and the blonde Melanie Daniels in *The Birds*, whose relationship begins tensely and competitively but deepens into friendship, however briefly shared. Valences between Lil and Marnie include their criminality—Lil's declaration of her willingness to do anything whatsoever for Mark confirm her potential as a law-breaker. Both women may be said to be at heart on the side of paranoia. If female paranoia is, as I have been suggesting, the increasingly dominant female attitude in Hitchcock's works, Marnie's paranoid distrust of males and sex (paranoia once again being another way of saying "correct" or "justified") and Lil's paranoid distrust of Marnie evince the continued development of this stance.

Undeniably, an erotic frisson exists between Marnie and Lil. To overemphasize the emotional, nurturing links between these female characters, however, is to blunt the forcefulness of the film's social critique. Like the nineteenth-century inviolate male, Marnie is as constitutionally opposed to same-gender friendships as she is to normative heterosexual relations. Both friendship and heterosexuality are *social obligations*—markers of the properly socialized and, indeed, the human—even as they are social possibilities.[11] Marnie is a poignant, affecting, sympathetic character precisely because of her aloneness and her despair. She attempts to create a separate, singular reality in which she will be able to fend off the demands of friendship and marriage, the most heightened forms of the social order's demands for conformity. If true friendship is largely unthinkable in this film—though there are some tender buds of a developing relationship between

Marnie and Susan Clabon—heterosexual relations are a source and site of pain, violation, betrayal, and violence.

Friendless Marnie has neither a mate nor really a mother.[12] Recalling the thieving Marion Crane, Marnie chiefly evokes mother-venerating but motherless Norman Bates. Yet it is also true that—*before* her marriage—she is depicted as very much a *less* abject figure than Norman. While her criminality constricts her life to the point of unlivability, it also gives her for a time precisely the freedom for unfeigned self-pleasure and self-society she craves above everything else except the relationship with her mother, which she does just about anything to maintain.

Marnie's mother Mrs. Bernice Edgar (Louise Latham) is one of Hitchcock's most complexly drawn characters. As will be revealed, the mother's own conflicted feelings, as well as the memory of sexual trauma that she shares with her own child, block her from expressing her love for and to her daughter. She much more demonstrably and effortlessly bestows her affections on the neighbor's daughter, the blonde girl Jessie, whom she babysits. The heroine's relationship with her mother is the locus of the theme of isolation, a never-ending source of anger and, as William Rothman puts it, the "unbearable sadness" of the film.[13]

Hitchcock's depictions of cold, remote mothers take on both a new intensity and a new depth in *Marnie*. The near inability of the heroine to get her mother's love metonymically represents her entire relationship to the social. The film frequently and palpably conveys her loneliness, most affectingly in the shots of Marnie isolated even when in contact with, or at least in physical proximity to, others: when, as business shuts down for the day, she hides in the bathroom stall at Rutland's, preparing to steal the money from the safe, as the chatter of the cheerfully loquacious office workers gradually dies down; when Mark, as they stand together inside the stables on his estate, makes suggestive noises to her about their apparently burgeoning romance. In each of these shots, especially the latter, Marnie's expression conveys a deep sense of apartness from what is happening around her.

Clearly, Marnie struggles with questions of self-worth even as she exudes personal resources for coping with an inhospitable world shown to be as barren, at its heart, as her own spirit is much of the time. Marnie constructs a shadow world of artifice, a world in which immoral deeds procure transitory and ambiguous pleasures: Stolen money transforms into gifts to appease an emotionally remote mother; rides on a horse bought with the same illicit funds are made to function as a means of liberation. What is especially curious and unsettling here, however, is that the "real" world of the film is depicted as no less artificial.[14] The vast Rutland building where Marnie works for the scion behind the name, Mark Rutland, is a modernist monstrosity. Visually depicted by a painting, the immense building seems almost entirely isolated, existing in a stylized realm all of its own. Mark's mansion, in which he installs Marnie as his wife, is presided over by a man he calls "Father" (Alan Napier) who has no more intimate connection to him than, say, a fellow businessman might. Irreality and the lack of intimacy in human relationships

suggest a blank, denatured world, yet perhaps this world is simply the social order laid bare and unvarnished before us. But intimacy, fraught with potential menace, provides no better alternative.

THE CRIME OF ONAN: SEX AND ISOLATION IN MODERN URBAN LIFE

Marnie seems to mean it when she says to her mother, "We don't need men, Mama. We can do very well ourselves, you and me" (see figure 7.1). The alternative mother/daughter world Marnie attempts to maintain provides a break from social reality. But it is shown to be a deeply frustrating aspect of the heroine's life that leaves her bereft. What links Marnie to the inviolate male and female figures of the nineteenth century is her simultaneous rejection of heterosexual desire and friendship. Like the hard, isolated, and stoic manhood, to wax Lawrentian, of the earlier period, Marnie would rather go it alone.

In *Vertigo*, the theme of aloneness even within friendship significantly emerges in the scene between the hero Scottie (James Stewart) and his friend Midge (Barbara Bel Geddes). Both Scottie and Midge are presented as sophisticated dwellers of the modern urban world and friends with a deep, sustained, and loving bond—though there are depths of ambivalence within this bond. They are friends without benefits. That they are curiously adrift and isolated from each other is a suggestion made even in their first scene together, which is suffused with warmth and wit. In *Rear Window, Vertigo, Psycho*, and *Marnie*, sexualities and socialities are trapped within the deadening gears of modernity, tied to isolation-making urban life. This ennui borders on despair; moreover, it is heightened by the social demand to *have* a functional sexuality in the first place.

Marnie's exploration of onanistic selfhood as a response to conformist social pressures has a precedent in *Vertigo*. Both Scottie and Midge seem to have sexualities that are largely expressed in solitude. I detect two possible coded references to onanism, or

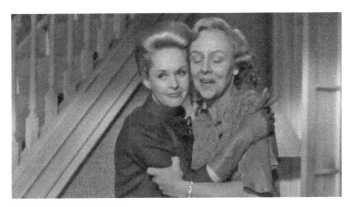

FIGURE 7.1 Marnie (Tippi Hedren) tries to create an alternative world for herself and her mother (Louise Latham) alone.

masturbation, in their first conversation, which occurs after the detective Scottie, who suffers from vertigo, has had the near-fatal experience of hanging from a rooftop during a chase, a mishap that has left him wearing a corset: When Scottie is discussing the removal of his corset, he announces that he'll be able to scratch himself like everybody else. He and Midge have an exchange about the bra and the aircraft engineer who designed it.

SCOTTIE: Kind of a hobby. A do-it-yourself type of thing. . . . Hey, Midge, how's your love life?
MIDGE: There's following a train of thought!
SCOTTIE: Well? . . .
MIDGE: Normal.

On first hearing, the "train of thought" here appears to refer to the bra, perched on a stand, that Midge is drawing for an advertisement (which Scottie doesn't recognize as such: "What's this doohickey?" Midge responds, "You know about those things, you're a big boy now."). Note that this scene is structured partly around two pieces of women's underclothing, one worn by a man, the other worn by no one. The bra is an item of clothing that accentuates a woman's attractiveness to men especially when, as this one does, it works like a cantilever bridge and leaves no straps visible to betray the workings of the feminine mystique to the masculine gaze. As such, it naturally suggests Midge's love life to Scottie, as his question about it reveals, even though for her, it is simply an object she is being paid to draw. I think, however, the more immediate connection to the "do-it-yourself type thing" should also be understood as part of the train of thought here. Beneath the radar of the Hollywood censors, this scene may subtly imply that both Scottie and Midge serve as their own instruments of sexual gratification. The theme of modernity, sexuality, urban life, and entrapment—the private traps, as Norman Bates puts it—narrows down to a lonely, isolated woman's negotiation of the vast, barren, and exhaustingly demanding social world in *Marnie*. Onanism emerges as a viable form of sexual expression—perhaps the only one that is a personal expression—in such an environment.[15]

Onanism provides an alternative to sexual and social relationships, depicted as alien experiences and compulsory social demands at once here. Indeed, the onanistic informs many Hitchcock films—one thinks of L.B. Jeffries (Stewart again) in *Rear Window*, his leg stiffly extended in a cast, and his frantic attempts to scratch an itch and audible sigh of relief afterward; Norman Bates's peep-show-like viewing of Marion Crane in *Psycho*. (Gus Van Sant's 1998 remake of *Psycho* depicts Norman actually masturbating while peeping on Marion, assigning his character a much more explicit heterosexual sexuality.) Onanism emerges in *Marnie* as an alternative form of sexuality that resists the sexual demands of the social order—a do-it-yourself kind of thing.[16] The onanism motif makes the attempted robbery of Mark's own safe erotically charged—a scene between Marnie and an imposing object rather than another person. Hitchcock films Marnie's inspection

of the safe as a feverish, illicit sexual encounter marked by her knowing looks as she fondles it with fetishistic gloved hands.[17]

The chief sexual register of the film, onanism is a "powerful form of sexuality," as Eve Kosofsky Sedgwick puts it, that runs "fully athwart the precious and embattled sexual identities whose meanings and outlines we always insist on thinking we know."[18] As such, it is a queer sexual mode. The theme of onanistic sexuality that, to my knowledge, has not entered into critical debates over the film, undergoes a grueling culmination in the fox-hunt sequence. This sequence links Marnie's isolated sexuality to the larger issue of class. For all of the danger and panic that inhere in her stealing and series of fake identities, her overall fake life, Marnie is, for the most part, fairly comfortable in the alternative existence she carves out for herself, and her isolate pleasure is depicted in an increasingly erotic register.

While it would be absurd to champion this life of stealing and lying, failing to see how indicative it is of her deep despair, the extent to which she seems to enjoy herself—when on her own—is equally significant. The shot of her raising her blonde head from the sink as she rinses out black hair dye, which concludes the opening section of the film; the smile on her face as she does so, amplified by the "Marnie theme" in Bernard Herrmann's score; the shots of her riding Forio, blonde hair blowing in the breeze as she smiles rapturously, an effect again enhanced by the triumphalism of Herrmann's score here (and, as I will show, Forio, while a possible motif of bestiality, is a metaphor for onanistic desire on Marnie's part); even the shot of her arriving in Philadelphia, where Rutland's publishing company is located, quietly smiling as she surveys her new surroundings. Such moments convey her sense of possibilities that await her and a kind of pleasurable *inhabiting* of her own life. Indeed, it is contact with others, including her mother and little Jessie, that muddles things for meticulous Marnie.

MOTHER MADE REAL

In the previous chapter, we discussed the formal elaboration in *Psycho* of a concept that I call the death mother. In one shot of Marnie's mother going down the stairs in silhouette, her descent punctuated by the echoing footsteps of a bad dream, we are back in the *Psycho* territory of the maternal uncanny; but by the end of the film, the mother is all too pitiably and recognizably a lonely and defeated human figure. *Marnie* contains a great deal of formal stylization, but its depiction of the mother largely eschews this approach. *The Birds*, extending key motifs in *Psycho*, constructs the death mother in the figure of the titular menace, tied to nature but connoting violence, death, and anti-life.[19] (The birds are, on so many levels, also the queer side of the feminine/queer conflict, as I will discuss in the epilogue.) *The Birds* heralds the start of a notable attempt in Hitchcock's films to treat the mother as a flawed, complex, and irreducibly human person in the wake of *Psycho*'s demonization of the maternal. The affection and tenderness between Melanie Daniels,

the initially brittle and ultimately compassionate and courageous heroine, and Lydia Brenner at the end of the film suggest a reconciliatory healing of the mother/daughter rift. Lydia expresses hostility toward Melanie that is rooted in Lydia's fears that her son Mitch's attraction to Melanie will take him away from her. By the end of the film, when Melanie, wounded and dazed, seeks Lydia's affection, the older woman returns it.

Certainly, Marnie's persistent efforts to connect—pace E.M. Forster, connection seems nearly impossible in this film's world—with her mother indicate her longing for maternal intimacy. One of the most moving scenes in the film is also one of the briefest: Marnie, in her first day as mistress of Rutland house, phones her mother, a conversation that scheming Lil overhears and uses against Marnie. Marnie calls Bernice to reconnect with her as well as to reassure her that she is alright. Her mother remains the only person in Marnie's life to whom she can turn even if the increasingly chaotic details of her life cannot be shared. It is never clear that she would like or even needs intimate bonds beyond those she ardently pursues with her mother. As becomes evident almost immediately, encounters with her mother, far from a respite from her masquerade, routinely trigger Marnie's anger and sorrow, as the early scene with the overturned pecans in Mrs. Edgar's kitchen evinces. This scene is emblematic of the impasse and the potential violence within this chilly-yet-intimate relationship, a recurring motif in the film being, as it is in Hitchcock generally, that violence erupts within our closest affiliations. Marnie is presented as desperately in need of the talking cure, even Mark's amateur-psychiatrist version of it. Yet here, Marnie articulates her sorrow and frustration to her mother as she prepares Jessie's pecan pie, eloquently asking, "Why don't you love me, Mama? I've always wondered why you don't. You never give me one part of the love you give Jessie." Marnie also asks her mother why she always pulls away from her. When Marnie puts her hand on her mother's own, Mrs. Edgar withdraws it as if it's been bitten by a snake. Their exchange leads to angry accusations from Marnie ("Why do you always pull away from me? What's wrong with me?"). Mrs. Edgar slaps her, knocking down the bowl of pecans, when the accusations pierce too deeply.

The mother/daughter relationship is the basis of *all* social interactions in the film, including those that are sexually charged, the template for the tender/terrible relationship between Marnie and Mark and for the attraction/repulsion relationship between Marnie and Lil. The antithetical poles of desire as established within the film are the onanistic and the properly heterosexual. Queer/lesbian forms of desire emerge primarily, in my view, within Marnie's anguished bond with her mother and her icy bond with hot-blooded Lil. We have had several occasions to discuss the relationship between the mother and the villain—which is to say, the queer mother and her son. Hitchcock's films, beginning with *Rebecca* but especially from *Vertigo* to *Marnie*, emphasize the mother/daughter relationship in a variety of ways. This relationship, biological or symbolic, is hardly distinct from queer issues, as we have seen. But on another level, it is also an alternative to the feminine/queer conflict, though it is an analogous structure in that it too proceeds from Hitchcock's customary decentering of male rule.

I can think of no major character in a Hitchcock film who is as deeply *bereft* as Marnie, not even Norman Bates; he can possess the mother in his own mind at least, even if this possession clearly brings him grief and inspires murderous violence. One almost gets the sense that, and this is merely to echo the heroine herself, Marnie would be content were she and her mother the only people in the world. The mother who will not give the gift of love is still the *only* mother one has. The theme of *compensatory consolation* emerges in the considerable pleasure Marnie derives from buying and presenting her mother with expensive gifts and from having them received and enjoyed by her, at least to a limited extent. Palpably conflicted when she receives them, smiling but also admonishing her daughter for spending so much, Mrs. Edgar seems to have a sixth sense that these gifts have been illicitly procured (her suspicions move in the direction of believing that Marnie has whored herself out; she doesn't perceive the extent to which Marnie has made Bernice's attitudes toward men and heterosexual relations her own). Money serves as both a conduit to and barrier against love and affection, in every sense the economy of desire in this film, as it is in the first half of *Psycho*.[20]

CLASS AND THE ANTISOCIAL: *MARNIE* AND QUEER THEORY

Marnie is about the unbearable sadness of being in capitalism. In a manner uncannily coeval with some of the major questions in contemporary queer theory, we might argue that *Marnie* offers, on the one hand, a critique of queer desire within capitalism and that, on the other hand, the film pursues an antisocial thesis, as its heroine wonders to what extent relationships are possible and even desirable.

The former has emerged as a major locus of queer theory analysis, evinced by a 2012 issue of *GLQ*, "Queer Studies and the Crises of Capitalism."[21] In an essay of particular relevance to the present inquiry, Meg Wesling returns to the theory of "value" in Marx as well as Hannah Arendt in terms of gender, sexuality, and even desire as forms of "necessary labor." As Wesling puts it, "To think the production of gender as a form of labor (the repetitive, compulsory performance of the body to produce its own gendered 'self' as an object that appears independent of that repetitive creation and 'natural' in the world) is to begin to have a way to think about the costs of such labor and to question the forms of value it accrues." Drawing on Matthew Tinkcom's *Working Like a Homosexual*, Wesling argues that "the question of value reminds us of the imbricatedness of sexual desire and gender identity with material practices of production, accumulation, and exploitation, and helps us to resist the temptation to see queerness as necessarily resistant to or outside of such practices." [22] Indeed, we too frequently make the error of believing that queer desire might be able to "extricate" us from the exploitations of capitalism. I would add that we do this as if, somehow, queer desire was inherently and necessarily opposed to capitalism and its benefits, pleasures, and, in a word, values.[23]

Queer resilience, as a theory, is inescapably vulnerable to the critique that Wesling puts forth. From the perspective she establishes and from the perspective of Louis Althusser's theory of ideological state apparatuses, we might well understand that Marnie's forms of subverting and even gaining pleasure from the system can only reify and support it.[24] Her manipulations, subversions, personal exploitations, and reimaginings of the social order pose challenges to it that are built into its very logic: The social order anticipates and finds ways of re-assimilating all challenges to it.

What I take to be of importance in contemporary Marxian work is its illumination of the capitalism-bound and capitalism-supporting achievements of normative gender and sexual identity. (Jasbir Puar has made a similar argument about the contemporary United States and its mass-market exportation of a pro-queer capitalist ethos.[25]) A proper class analysis of *Marnie* would far exceed the scope of this chapter. What I want to make the case for—and this is both to agree with and to dissent from Wesling's insightful reading—is that *resilience*, while it may very well be classifiable as a mode of resistance that capitalism anticipates and assimilates, is also not a necessary or (necessarily) predictable *response* to capitalism. This is to say that, however deep and intricate an understanding of capitalist subjectivity we develop, we must also be able to recognize what are, on personal, collective, and social levels, acts of heroism. My view of Marnie is that she is heroic precisely in her refusal to die and in her attempt to go on being, to echo D.W. Winnicott.[26] Wesling's essay reminds us that capitalism expects proper fulfillment of sex and gender roles. Marnie must successfully perform these roles even if she does not authentically inhabit them—or, if she inhabits them in a manner that does not accord, perhaps even thwarts, "the system." (Inevitably, one thinks again of why Hitchcock might have identified with his heroine—he was, after all, a director equally ill-fitted for following the system of the classical Hollywood studio, producer, style, etc. As an obese and unconventional-looking man working in the realm of spectacular physical beauty throughout most of his adult life, he may have felt a similar level of estrangement—and a desire for recourse to personal pleasures.)

We have had several occasions to discuss the antisocial turn in queer theory.[27] My chief reason for dissenting from the antisocial thesis is the image of homosexuality as unremittingly negative at its core. This negativity is then recuperated as a positive political counter-defense against homophobia. This is not, in any way, to make a demand for "positive images" of homosexuality. Rather, it is to protest against the propping up of negative images of homosexuality as somehow inherently or manifestly subversive, politically daring, and far more authentically "queer" responses.

To bring these concerns back to Hitchcock: If we see *Marnie* as a queer film and its heroine as a queer character, what Hitchcock contributes to our understanding of queer antirelationality is that an inability or unwillingness to form, or simply a sustained ambivalence toward, social relations may be indicative of a larger refusal of (or simply bewilderment in the face of or indifference to) the demands of heterosexual and gendered normalcy. In other words, Marnie's avoidance of social relations may be an avoidance of the compulsory

demands of the sexual marketplace, the demands that are made everywhere vividly apparent. The cataloguing of these demands commences with the angry, flustered, and then strangely detailed monologue given by Marnie's former boss Sidney Strutt (Martin Gabel), as he lists Marnie's attractive physical attributes to Rutland and a detective. Ironizing his gruff, exhaustive account of Marnie's attributes, his current secretary, with a memorably mordant expression, reminds him that he never actually asked for Marnie's references. Further items in the catalogue include Lil Mainwaring's initial appraisal of Marnie and, most important of all, Rutland's fascination with the woman he will trap into marriage.

The dialogue in the scene at the racetrack between Marnie and Mark comes close to explicating the antisocial theme. On what seems like an informal first date, Mark has taken her to the racetrack because she likes horses. "What do you believe in?" he asks. "Nothing," Marnie responds, qualifying it by adding, "Horses, maybe," but also adding that she does not like people. Responding to Marnie's observation, Mark wryly adds his own misanthropic observations, but clearly on a more comedic level far removed from Marnie's overwhelming despair and alienation when the question of human contact arises. (Mark will become much more sensitive to Marnie over the course of the film, in a way that deepens, though in no way exculpates, his character.)

Marnie may be chiefly motivated, pace Mary Ann Doane, by the desire *not* to desire at all.[28] If the human social realm disappoints, with whom can Marnie achieve true intimacy? Not her mother, that much is clear. Horses, maybe. The questions regarding intimacy, relationships, humanness, sexuality in its compulsory as well as personally motivated forms, and queer desire intersect with the larger question of class—and in Hitchcock's work, the question of aesthetics.

"ARE YOU STILL IN THE MOOD FOR KILLING?" CLASS, AESTHETICS, AND THE FOX-HUNTING SEQUENCE

The recent turn to questions of class in queer theory helpfully enlarges our understanding of *Marnie's* exploration of such convergences. The definitive reading of *Marnie* as a film about the trauma of class differences is Michele Piso's essay "Mark's Marnie." As she eloquently argues, in this film, "the world of capital dominates and chills the erotic and creative aspects of life."[29] Piso focuses our attention on the discarded, abandoned Mrs. Edgar at the end of the film, and interprets the expressionistic trope of red color that suffuses the screen as a symbolic rendering of the "blood of the terrified and violated body, the blood of women, of murder and rape . . . the red of suffering."[30] Lucretia Knapp reads "the blood that washes over Marnie's eyes" as maternal blood, "horrifically fetishized."[31] The scarlet suffusions of the film link it to another supreme American text about mothers, daughters, the criminal woman, and morally suspect masculinity, Nathaniel Hawthorne's *The Scarlet Letter* (1850). The sexual trauma that links Marnie and her mother—the violation of both—deepens the resonances of the fox-hunt scene,

as I will show. If the film is about the trauma of class on the one hand, and about female sexuality on the other—both onanistic and lesbian, the basis of which here is the mother/daughter bond—this sequence brilliantly foregrounds these themes and submits them to a critique on a formal as well as analytical level.[32] Form is crucial to the film's analysis of gendered and sexual relations in capitalism.

The fox-hunt sequence is a bravura reinterpretation of the rabbit-and-bird-hunting passage in Jean Renoir's *The Rules of the Game* (1939), another film about the intersection of class strictures and desire. In the fox hunt and its aftermath, *Marnie* depicts society as a life-in-death, in which cruel merriment animates the participants' involvement and gives the performance of social relations their vitality. Clad in their posh hunting clothes, which blur the lines of gender difference by conforming all to a masculine model, the aristocrats on their horses chase, along with their aptly named hounds, a lone fox to its death. Marnie and the other riders following the hunt wear black coats. The uniformity of their appearances lends the riders of the hunt a clone-like sameness. At the same time, the fox hunt is depicted as absurdly grandiose, with phalanxes of predators pursuing so small a prey.

This microcosmic social satire is made more resonant still by what it implies about the English Hitchcock's late reencounter with one of his own culture's most famous social rituals, albeit transplanted to an American setting here, and the class discourse that is inextricable from it. The social satire allegorizes Marnie's relationship to Mark's moneyed world, over which, as his wife, she is expected comfortably to preside (another link to *Rebecca*). Rear projection, initially denigrated in critical assessments of *Marnie* upon its release, is an exquisitely apposite means of rendering the fox-hunting aristocrats' simultaneous motion and encasement in nullity.[33] In process shots against a rear-projected background, the riders bob up and down in side views on their horses. The riders twitch with life while being utterly disconnected *from* life—vitality, true movement—a stasis conveyed by the artificiality of the cinematic techniques Hitchcock employs. We are reminded of life-in-deathness—the lifeless yet antic merry-go-round horses in *Strangers on a Train*, and the death mother in *Psycho*.[34] While *Marnie* humanizes *Psycho*'s demonic mother figures, the trope of life-in-deathness, which evinces the influence of Edgar Allan Poe, is no less significant in the later film.[35]

Marnie is shown to be one of the riders, encased in life-in-deathness; the crucial maneuver will be to jolt her out of this stasis and into movement, even as this seeming movement is depicted as artificially constructed. The social order in *Marnie* is always already deadening and dead, but the violent urges and persistent fantasies of its actors give it an uncanny vitality, as the cartoonish shots of the riders bobbing up and down suggest. Rear projection as Hitchcock deploys it (in the first depiction of Marnie riding Forio and in the fox hunt) functions as an allegory of entrapment that overrides fantasies of escape and movement; rear projection reifies stasis as the mode of existence.

Paradoxically, however, it is Marnie's very *trauma* that gives her some semblance of actual feeling and freedom. This is perhaps the most provocative claim that I make in this

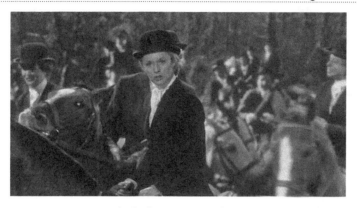

FIGURE 7.2 Marnie at the fox hunt: Trauma galvanizes queer resilience.

chapter, so I want to be very precise about what I mean. Distressed as she watches the fox being torn to bits by the dogs while the callous aristocrats chortle at the mayhem, Marnie scans her fellow riders in horror (see figure 7.2). Suddenly, she notices a huntsman dressed in his "pinks," as the traditional red coats worn by huntsmen are called. Seen from Marnie's POV, the red coat is a blinding blaze of the color that triggers her traumatic flashbacks. As one of the expressionistic red suffusions that signal Marnie's "seizures," as Lucretia Knapp puts it, engulfs the screen, an effect heightened by Bernard Herrmann's dramatic musical motif, Marnie suddenly has the energy to escape the scene of carnage, class warfare, and exhibitionistic cruelty.[36] The sight of the color red provokes her painful, maddening seizure, but it also provides the jolt of recognition that frees her from her social and cultural imprisonment within the hunt, depicted as a ritualistic bloodletting on literal and symbolic levels. Her seizure allows her to take immediate, furious flight from the scene of savagery. Riding on Forio, she wrenches herself away from the other riders and the hunt. I believe that this scene embodies the major subject of Hitchcock's film. Trauma, isolation, and loneliness, horrific though they are, are also defining elements of the social outcast's resourcefulness. Marnie's connection to her own constitutive, core pain allows her to escape from the collective banalization of cruelty and violence—if only for a moment.

Herein lies the cinematic expression of queer resilience. Queer resilience is an ambiguous and ambivalent concept, one with positive and negative manifestations. Marnie's resilience emerges from her empathetic connection to the violated animal. Like the fox, Marnie is pursued and hunted by the demands of the social order; and if the fox hunt is class ritual par excellence, valences exist between it and Marnie's violations. The tea service scene, while no blood is shed, is in its own way another kind of hunt—a rooting-out of class undesirables.

Marnie, I argue, is experiencing shame. Shame has direct relevance to queer experience. Drawing on the work of Silvan Tompkins, Eve Kosofsky Sedgwick writes:

One of the strange features of shame, but perhaps also the one that offers the most conceptual leverage for political projects, is the way bad treatment of someone else,

bad treatment *by* someone else, someone else's embarrassment, stigma, debility, bad smell, or strange behavior, seemingly having nothing to do with me, can so readily flood me—assuming I'm a shame-prone person—with this sensation whose very suffusiveness seems to delineate my precise, individual outlines in the most isolating way possible.[37]

Marnie feels ashamed of the social class of which she is now a member—their grotesque display of indifference to and mockery of suffering—while also feeling tremendous levels of shame herself. The hard outlines of individual identity melt away in the "suffusive" flood of empathetic shame. Marnie's connection to her own constitutive pain allows her to feel for the violated animal and briefly escape from the collective banalization of cruelty and violence. If shame is part of queer resilience, we can understand the positive and negative affects that mutually define the concept. The shame Marnie feels comes very close to ruining, even to extinguishing (as in the suicide attempt after sex with Mark), her life; this shame is also precisely what allows her to escape a scene of psychological and physical torment and finally to articulate a moral sensibility. As she later challenges Lil, "Are you still in the mood for killing?"

The artificiality of rear-projection and process shots serves complex purposes throughout the film, especially in the hunting sequence, deriving new meanings from its use here. As Marnie takes flight on Forio, there is a decisive combination of techniques, a blending of the real and the artificial. Location footage of a woman riding her horse across vast outdoor vistas is combined with shots of Hedren astride a horse in the studio as manufactured wind blows through her increasingly unkempt blonde hair and a rear-projected background of shifting, mobile outdoor scenes rolls behind and around her. The montage sequence of Marnie riding evokes and fuses the three major influences on Hitchcock's aesthetics, Soviet montage, German Expressionism, and Surrealism.[38]

George Tomasini's editing and Robert Burks's austere, autumnal cinematography contribute vitally to the meanings made manifest here. The editing creates a sexual momentousness, a movement from premonitory anticipations of release to the final climactic devastation of Forio's crash against the second embankment.[39] The scattershot editing of the bodies falling—Marnie's and the horse's—on the ground further conveys the sense that this would-be orgasmic release has become a confusion of pain and panic. Marnie's control of the situation sputters, along with the images, wildly and incoherently out of control. But at the same time, Burks's austere colors convey an overall sense of somber detachment from the proceedings, of nature itself as life-in-death. It is in this austere rendering of the natural setting that the sequence's expressionistic dimensions come through most forcefully.

Adding an ambiance of perversity, Marnie's horse can be read as a tipping of the hat to the great cinema surrealist Luis Buñuel, whom Hitchcock admired, and his frequent and perverse horse and animal imagery. The film explores the varieties of sexual

possibility, ranging from lesbian desire (Lil and Marnie, Marnie and her mother), to fetishism (Marnie's purse, her gloved hands), to lesbian fetishism (the fur coat that Marnie gives Mrs. Edgar, who seems visibly pleased by it, evoking the shot of the most clearly lesbian character in the Hitchcock canon, Mrs. Danvers [Judith Anderson] holding up Rebecca's lustrous fur to the second Mrs. De Winter's trembling face). If bestiality is an unmistakable sexual register here ("Oh, Forio, if you want to bite somebody, bite me"), onanism is the more pronounced one, I would argue, with horse-riding as a figure for Marnie's aforementioned do-it-yourself sexuality. One could argue that Hitchcock explores the emotional undercurrents beneath sexual perversity, the motivations and the sheer need behind Marnie's relationship with her horse, no mere gallant steed here but a stand-in for sexuality itself. The montage effect of rapidly shifting views of Marnie riding and of what she sees before her (landscapes; embankments to be leaped over, the first one successfully, the second one a fatal disaster for Forio), accentuated by a gathering aural momentum—the diegetic one of the horse's furiously pounding hooves, the non-diegetic one of Herrmann's hammeringly intense score, building in this passage to a climax all its own—contribute greatly to the sequence's metaphorical meanings and value as an allegory for sexual intercourse.[40]

REVISITING THE PRIMAL SCENE

During the free association game with Marnie, Mark poses the question "Sex?" In turn, it raises a series of questions: what to do about it, how to achieve it, how to resolve it, and how to acquire heterosexual sexual legitimacy. All of the film's attendant questions regarding self, solitude, authenticity, relationships, the animal versus the human, and the moral depend on this central question. I want to turn now to the question of rape that has loomed, and continues to do so, over the film since its initial production. One way to think about this aspect of the film is that it addresses the feminine-versus-the-queer dynamic—Marnie must relinquish her queerness for a properly feminine identity. The film depicts the harrowing costs of this demand.

Mark Rutland, as played by the '60s sex symbol Sean Connery, the epitome of hairy-chested hunkiness and the first actor to play English superspy James Bond in a movie, is a difficult character to make sense of, a flawed and suffering human character who is also a masculinist brute and rapist. I believe that we cannot shy away from this word and its implications. Mark is worthy, like Marnie, Mrs. Edgar, and others, of sympathy, which only makes his crime more agonizing and infuriating to contemplate. A moneyed scion of patriarchal power, Mark wields white male heterosexual privilege. Though he can be introspective, quiet, and gentle, these are not his only modes. He avidly boasts to Marnie, whom he forces into marriage, about having trapped and "caught something really wild this time!" His entire plan to blackmail her into marriage is as cruel as it is woefully misguided.

Mark is, in some ways, a poignantly drawn male character who adopts and identifies with the female subject position. His question "Sex?" is not articulated, as Connery compellingly plays him, in a knowing, leading manner, but rather in a shy, almost abashed way, the word uttered as if from a position of essential bewilderment. Nevertheless, I believe that Robin Wood missteps in exculpating Mark to the extent that he does in his revised analysis of *Marnie*. Raising the question "Does Mark save Marnie?" Wood replies that yes, he does—but more importantly, she saves herself.[41] Wood exculpates Mark by arguing that, while Marnie knows that she is being raped, Mark does not know that he is raping her. Another crucial critic of Hitchcock, William Rothman, also takes great pains to free Mark from charges of rape. One of the most perplexing trends in criticism of this film is the effort to exonerate Mark from charges of rape in the shipboard scene in which he forces Marnie, now his wife, to submit to him sexually.

My reading of the scene is that it is unbearable not only because of Marnie's deep suffering, but also because Mark knows precisely what he is doing and does it anyway; he rapes her *even though he has intense sympathy for her*. Unlike Wood, I do not find much salvation at the end of *Marnie*, though its surface text does appear to follow the therapeutic-cure model of films like Hitchcock's *Spellbound* (1945) (which, like *Marnie*, disrupts the model) and *The Three Faces of Eve* (Nunnally Johnson, 1957). It is for this reason that I disagree with Robert J. Corber that the film ends with the reconstitution of the heterosexual couple. If Marnie gains a "local" knowledge about her own backstory, she is nevertheless trapped within the social order's resolute commitment to the heterosexualization of all its subjects, and the film allows us to see precisely this.

In order to understand the total significance of the rape scene, it is important to work through the full implications of the flashback scene at the end of the film, which reveals the roots of Marnie's psychosexual crisis. Mrs. Edgar, it is revealed, was a prostitute; one night, she took a young male client, a sailor (the handsome, idiosyncratic young Bruce Dern), into the bedroom and put the child Marnie to sleep on a sofa. Marnie's conflation of sex and money (the latter a defense against the former in her case) would seem to have its roots in this transaction. Marnie begins crying, and the sailor walks out of the bedroom and over to the child to find out why (a sudden thunderstorm the obvious cause).

Tapping on the wall to trigger Marnie's hallucinatory revisiting of her childhood trauma at the climax of the film, Mark mimics the actions of the sailors when they tapped on the door of the prostitute mother's window to signal their interest. Mark successfully inserts himself into Marnie's unconscious life. Like Verena Tarrant's exploitative huckster father in Henry James's 1886 novel *The Bostonians*, Mark "starts" the woman so that she can speak: in Verena's case, the stirring language of feminist reform that she expertly ventriloquizes; in Marnie's case, the "truth" of her sexual case history. (Mark also resembles Basil Ransom, the conservative Southern male who rescues Verena from feminist activism and the lesbian Olive Chancellor.) While the therapeutic model that Wood steadfastly adheres to insists on this truth *as* truth and as liberating, the film treats the revelation scene with ambivalence. Perhaps the deepest indication of this attitude lies in

the irony of intransigent Marnie's ultimate submission to social conformance, signified in her submission to the law ("I want to clear it all up") and her marriage to Mark ("I don't want to go to jail, Mark—I'd rather stay with you.").

The climactic portion of the film reveals that its ambivalence is chiefly directed toward institutionalized heterosexuality. We are trained from infancy to recognize sexual difference as embodied by the parental/oedipal couple and also to recognize that sexual intercourse lies at the heart of coupling. Though the child Marnie is older than the infant in Freud's classical paradigms, it is still the child Marnie that we see, complementary to the child in Freudian theories of childhood sexual development. It is significant that Marnie is a female child. While Freud's elaborations, however vexing, on the female Oedipus complex are well worth considering, for my purposes, I am going to consider Marnie as the child of Freudian theory and consider the implications of making this child female within the larger thematic structures of the film.[42]

To recall Piso's analysis, red in the film is the color of female victimization. The scene of violence, both physical and sexual, in the flashback, provides the explanatory basis for Marnie's seizures and general traumatization; this more than confirms Piso's reading. Marnie is specifically cast as the witness to the scene of adult sexual relations, evoking Freud's theory of the primal scene, which we discussed in chapters 1 and 6. Hitchcock brilliantly opens the flashback with a fisheye-lens view that eerily foreshortens the bodily forms of the actors. The fisheye-lens effect emphasizes—and visually renders—the inherently distorted qualities of memory. The original definition of the primal scene, as Freud elaborates on in the case history "From the History of an Infantile Neurosis" (1918 [1914]), more commonly known as "The Wolf-Man," involved a vision, imagined or literal, of one's parents having sex with each other.[43] What the child Marnie witnessed and recalls is not, strictly or technically speaking, a primal scene, but instead functions as a kind of collage of elements from Freud's theory. Chiefly, the mother's able-bodied sexuality is put on display—a striking contrast to her adamant opposition to sex in the present and her physical impairments (she has a bad leg and walks with a cane).

Critics have debated over whether or not the sailor is endangering—i.e., molesting or about to molest—Marnie; Robin Wood claimed to find no evidence of molestation. There is a shot, however, that raises this possibility: The sailor buries his face in the little girl's neck, a gesture that seems to exceed the desire merely to comfort her. Moreover, she protests against his "smell," confirming the physical closeness of their contact. Clearly, Marnie is upset by his ministrations, even if her emotional state chiefly signifies her frustration that *he* is there and not her mother. And it is her discomfort that provokes Mrs. Edgar's protective wrath. In the confused violence that ensues, the sailor falls on Mrs. Edgar, specifically on her leg, causing the injury that will leave her disabled. Amid the mother's shrieks, the sailor's cries, and the flailing bodies, the child Marnie stands screaming.[44] The child becomes the mother, the mother the child: Mrs. Edgar, initially protecting her daughter, begs Marnie for help. And Marnie responds, battering the sailor with an iron poker. In killing the sailor, Marnie is simultaneously protecting her mother

and destroying her own innocence. In a lurid effect, Hitchcock focuses on the spreading splotch of red blood on the sailor's white shirt, which intensifies, as well as abstract shots of his bloodied face.

In *Marnie*, sex is a commodity one pays for—its transactional nature links both the sailor and Mark, whose wealth allows him to buy and physically take possession of Marnie. Mark deliberately triggers Marnie's memories by tapping on the wall, just as the sailor did to signal his interest in sex with the prostitute Bernice. Tellingly, Marnie's mother wildly beats at Mark as Marnie regains memory of the traumatic event, mimicking the way she beat at the sailor to get him away from her child. (The difference here, however, is a crucial one: beating the sailor was a protective gesture, an effort to shield her child; beating Mark is an indirect attempt to silence Marnie, whose memories flow from Mark's efforts, however questionable.) Sexuality is itself so elusive and problematic a prospect for the heroine that the scene of the sexual is inextricable from the violent; this is an underlying attitude throughout Hitchcock's work. Sexuality is an expression of violence as well as desire and tenderness; hence the Freudian nature of Hitchcock's cinema. Marnie's experience of the social order, her strategies for making use of it and keeping it at bay, proceed from the basis of a profound resistance to the sexual violence at the heart of the social order, rendering all of its prettifying masquerades suspect and alienating.

Marnie is Hitchcock's most direct and emphatic statement on the maddening and menacing effects of the heterosexism of our culture.[45] The view of heterosexuality as inherently natural and an unquestionably positive and desirable goal emerges from what Lauren Berlant has called the sexualization of all desire in our culture, which institutionalizes heterosexuality as a binding social narrative to which all subjects must conform.[46] Hitchcock's body of work contains images of loving, tender encounters and possibilities between men and women. But the terror and violence that are the recurring preoccupations of his cinema deeply qualify these other modes.

Various forms of resistance, many criminal, all illusory—but somehow no less heroic and moving for being that—to institutionalized sexual normativity are explored in *Marnie*. I have attempted to evoke these forms of resistance throughout the chapter—onanistic, lesbian, fetishistic, and queer forms of sexuality that threaten to topple the reign of phallic monism. But let me add—and this allows me to turn, at last, to the shipboard rape scene—that the most daring element in the film's deconstruction of heterosexism is its analysis of the ways in which heterosexual male desire is also distorted and disfigured by this system.

THE RAPE SCENE

Deborah Thomas rightly argues in her essay "Self-Possession and Dispossession in Hitchcock's *Marnie*" that it is unfair and insupportable to think of Mark as a completely negative character on the one hand, and that the film becomes far richer if we consider

the implications of Marnie's problems for numerous characters in the film, including Mark, whose own family history is problematic and worthy of our sympathy on the other hand. Nevertheless, I believe that a disquieting critical trend to read the ship scene as indicative of just about anything *other* than rape needs to be addressed. To fail to see this scene as an act of supreme violation is to miss out on why Hitchcock fought to keep it in the film. And a proper understanding of Mark as a sympathetic as well as morally dubious character need not be jettisoned in order to understand the scene's meanings—indeed, it is essential for understanding them.

During the Hitchcock Centennial Conference held at NYU in 1999, questions over the issue of rape were frequently posed to the screenwriter Jay Presson Allen by commentators such as Robin Wood and Slavoj Žižek. Allen was hired to replace the previous screenwriter Evan Hunter (who quit working on *Marnie* because he protested against this controversial scene). One exchange, between Allen and Robin Wood, is particularly relevant and has been discussed by Tania Modleski.[47] When asked about this scene, Allen concurred with Wood's assessment that while Marnie knows that she is being raped, Mark does not know that he is raping her.

> ROBIN WOOD: Can I also, at risk of pushing this too much, go back to the so-called rape scene once more? I've always been bothered by the simple description of that as a rape. I think it's more ambiguous, the way Hitchcock shoots it and perhaps the way you wrote it. . . . Now, the way I read it, Marnie knows that she is being raped but Mark does not know he is raping her.
> JAY PRESSON ALLEN: You're absolutely right.[48]

Earlier in the Q&A, Allen noted that she found Evan Hunter's objections to the scene "psychologically a little naïve" and further explained that "[t]here's a vast audience of women out there who fantasize about the idea of rape, as has been proved over and over and over again."[49] Later, she cited *Gone with the Wind* (Victor Fleming, 1939) as an example of a film that contains a rape that no one ever complains about: "Clark Gable raped Scarlett. I've never heard anybody complain about that."[50] One of the audience members, the film scholar Susan White, made the point that "Scarlett liked the rape and Marnie didn't," which, to my mind, sums up just about every difference between the films' approaches to female sexuality. (This is not, to be clear, a negative judgment on *Gone with the Wind*, which, for all of its ideological failings, is most interesting as a study in narcissistic female sexuality. *Gone with the Wind* is about the famished intensity of its heroine's desire; *Marnie* is about the attempt to defer desire, perhaps indefinitely.)

As Allen's own responses suggest, longstanding controversies exist about what constitutes rape. While I personally find Allen's comments about women's rape fantasies bewildering in this context—the specific context of *Marnie* and its meanings—they indicate the difficulties of sorting out the sexual politics of the era in which the film was made and released, an era that held views about marital rape distinct from those generally held

today.[51] While historical work on legal and social views of marital sexuality and marital rape in the 1960s would no doubt enlarge the understanding we have about *Marnie*, I believe that the text itself, closely analyzed, tells us what we need to know about the film's own stance regarding the scene, which reverberates in all of the action that narratively follows, up until the very last shot of the film.

The ship scene is a study in intimate violence. It is the ultimate love-scene-filmed-as-murder-scene in the Hitchcock canon, before *Frenzy*, that is, which hideously literalized that reading. Hitchcock makes it clear that Mark knows full well that he is not only violating Marnie, he is raping her. The first definition in the *Oxford Dictionary* of rape is:

> Noun: the crime, typically committed by a man, of forcing another person to have sexual intercourse with the offender against their will.[52]

I see no way in which to read the scene other than as a representation of this act so defined. In my view, if we do not understand Mark's psychological awareness, and the awareness of the filmmaker as well, we fail to understand everything that the film stands for and everything it has to offer us as a critique of gendered and sexual roles and relations in capitalism. Indeed, Mark's blackmailing of Marnie into marriage could be taken as a symbolic form of rape, harkening back to ancient times:

> Literary: the abduction of a woman, especially for the purpose of having sexual intercourse with her: *the Rape of the Sabine Women.*

The OED's reference to the early Romans' abduction of the Sabine women, the Sabines being a neighboring society that did not want to permit marriage with their Roman rivals, points to slippages between the meanings of rape and abduction. The Sabine women were kidnapped and forced to marry their abductors, which necessarily includes rape in the sexual sense. In many ways, Mark abducts Marnie, cutting her off from all she knows. Certainly, he imprisons her, installing himself as jailer, warden, counselor, and sexually starved cellmate. In a way, the analogy of prison rape is appropriate here. If we view this marriage as a prison, rape is its apparently inevitable outcome.

In raping Marnie, Mark is betraying all of his own principles. His actions proceed from the basis of his physical and emotional desires to possess Marnie sexually, even though he knows full well—intellectually and (given his Hitchcock-like ambivalent identification with the suffering woman) emotionally as well—that she will experience sexual intercourse with him as an unbearable violation. It is precisely because he continues to force her to submit to him sexually *despite* his intimate knowledge of her revulsion toward the sex act and his genuine feelings of tenderness for her, feelings he expresses physically in the moment when he places his own robe around her naked body, that the scene is so devastating—and absolutely crucial to the film and to Hitchcock's body of work.

Before Mark forces Marnie to submit to him sexually, Marnie, almost like a cornered animal, defensively, angrily, and also pitiably demands that Mark never "touch her" ("I cannot stand to be *handled*"). Then there are montage scenes of the couple in different locations, times, and outfits. Each time, they have distinct kinds of conversations that range from the social (Marnie asking, "I assumed I would be a society wife?") to the often-discussed one in which Mark's zoological fascinations take the form of a monologue about a Kenyan flower that is actually composed of hundreds of insects. The distinct views of the couple visually signify the film's central preoccupation with sexual difference. We are given, or taken on, a brief tour of the varieties of male/female interaction—standing at the prow of the ship (casual), having an elegant meal for which they are elegantly attired (formal)—all of which are, in effect, a put-on, with many other feelings bubbling beneath the surface. These scenes begin a lengthy deconstruction of marriage, treated as the ultimate form of social theater. This will become explicit, as the scene on the couple's first morning back from their honeymoon evinces. As Marnie walks Mark to the door (and even here she seems to be led), Mark, with an ironic tone that does not undercut the political pointedness of the exchange, instructs Marnie about how to behave as a proper wife, including giving her husband a public peck on the cheek as he departs. The scene ends with Marnie telling Mark that she doesn't have any money, reinforcing her childlike helplessness and the political understanding of marriage as a social institution in which the wife depends on the husband for subsistence. *Marnie* is the fulfillment of Hitchcock's films of this period in which the figure of the "wife" is submitted to consistent analysis, clearly a theme with relevance to the Cold War-era redomestication of femininity.[53]

The scene of marital rape commences with a discussion (laced with irony and anger) that begins, as many momentous discussions frequently do, with a quotidian dilemma. Marnie asks Mark if he would mind if she shuts the door to the bedroom because the light in the sitting room, where Mark is reading a book called *Animals of the Seashore*, bothers her. In a facetious tone, Mark responds that "we couldn't possibly have anything bothering Marnie, now, could we?" Marnie, not missing his sarcasm, counters with another question: "How long?" To her question about the duration of their dreadful honeymoon, he responds with continued facetiousness, why would anyone want these "halcyon" days to end? Interestingly, this scene comes right after the dinner conversation about the Kenyan flower, implying Mark's attempt to stimulate her interest in him as well as the botanical subject. Marnie slams the door, and it is at this point that Mark angrily throws his book down, gets up, opens the door to the bedroom, and confronts Marnie. In response, she adamantly tells him that she wants to go to bed. Mark responds, "I *also* want to go to bed, Marnie," and his sexual meaning becomes clear, because it is at this point that Marnie looks deeply alarmed and cries out, "*No!*" As we will learn, she cried out in the same way as a child seeing her mother being hurt by the sailor. Mark yanks off her robe and she stands naked before him. There is a pause, and then he approaches her.

The intimate violence of the film (the moment when Mrs. Edgar slaps Marnie during their fight; Marnie's betrayals of her employers and her trusting, potential friend Susan

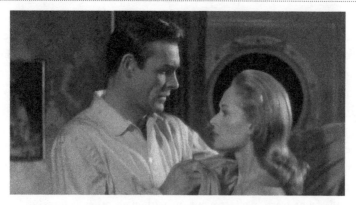

FIGURE 7.3 Mark (Sean Connery) covers Marnie with his own robe, a pro-prietary and revealing gesture.

Clabon) comes to the fore here. After Mark has exposed Marnie, he then, with exquisite gentleness, puts his own robe around her shoulders (see figure 7.3). I explored connec-tions between Hitchcock and Milton in chapter 1, and they are also relevant here: One thinks of the line in *Paradise Lost* that Milton uses to describe the shame of the newly fallen, naked Adam as he dons clothing for the first time: "he covered, but his robe/ Uncovered more" (9: 1058–59). What the gesture of the robe uncovers is the truth about Mark's character.

I believe that the tenderness of this gesture has led some critics to believe that rape is not occurring here. But the tenderness Mark demonstrates toward Marnie is not only inextricable from but demonstrative of his desire to possess her. Indeed, it indicates he believes that he *does* possess her. This clarifies the validity of Michelle Piso's analysis of the film as a critique of the dehumanizing effects of capitalism. "*Marnie* is as much about a man's inability to free himself from the constraining ideology of his wealth, from the authority and certainty it confers, as it is about a woman's refusal to submit to that ideol-ogy," Piso writes.[54] "So accustomed is he to owning, so synonymous is his sexuality with social power, that he assumes he can possess Marnie too, violate her, break her down, and then build her back up (in his image, his language, in the image of the 'normal' female) in much the same way that he built the Rutland business. In the most literal and terrible way, Marnie is Mark's."[55] Mark does not pick up Marnie's robe and put it back on her; he puts *his* robe on Marnie's body. To have put her robe back on her would have been to acknowledge his wrongdoing and attempt to atone for this invasive action. Placing his robe on her signifies his belief that she is his possession. It is this same attitude that informs the climactic section of the film, in which Mark taps into and draws out Marnie's repressed memories, as if he had a right to them.

The implicit menace within a gesture of seeming generosity and tenderness is a key facet of *Marnie* and Hitchcock's films as a whole. It is precisely the people we love the most (Mrs. Edgar) and people who love us the most (Mark; the undemonstrative, secretly

loving Mrs. Edgar) who can be our keenest violators. The tenderness that Mark expresses, in the end, may have much more to do with his own desires than with his desire to "bring Marnie out" sexually, to show her that she can experience genital contact in a loving fashion and find it pleasurable and emotionally satisfying, hopefully both.

There is an extraordinary over-the-shoulder (Mark's shoulder) shot of Marnie as Mark forces her down onto the bed. Its uncanny gliding effect recalls Miriam Haines's slow, steady descent into the grass as Bruno Anthony murders her in *Strangers on a Train*. Marnie's expression—as conveyed through Tippi Hedren's remarkably nuanced, varied, resonant performance, responsive to every contour of Marnie's emotional life—is frozen, fixed.[56] Disassociation has been linked to childhood sexual abuse and other traumatic experiences. Marnie's blankness conveys life-in-deathness, the floating away of her consciousness as she submits to Mark's power. (This dissociation will be formally expressed again in the detached, high-angle shots of a zombie-like Marnie making her way to Mark's safe after she shoots Forio; the theme of life-in-death, the ultimate dissociative state, again emerges here, as the inspection of the inanimate safe activates Marnie's coolly erotic desires.)

Perhaps even more fascinating, however, is the close-up that we get of *Mark's* face. Now, as we see him from Marnie's point of view, his face looks expressionistically stylized: darkly lit, brooding. His strangely sly and decisive near grin recalls Norman Bates's death-head's grin at the end of *Psycho*. One also remembers the introduction to Cary Grant's character Devlin in *Notorious* (1946), shown to us from the back, a seated dark, faceless figure, and then shown to us from a distorted funhouse angle as he brings the sleeping Alicia Huberman a reviving drink. Hitchcock's denatured depiction of heterosexual screen masculinity reaches its apotheosis here, as Mark takes on a carnal and menacing but also eerie air. I would propose that, in this film obsessed with the infinite variety of feminine appearances and styles, masculinity, in a remarkably compressed fashion, undergoes a series of shifts and assumes a variety of styles as well. Mark shifts from intellectual companion, to angry husband threatening violence, to Gothic ravisher.[57] Tania Modleski notes that "however crude Hitchcock's intentions might have been in describing what he wanted to be shown in the rape scene" (here Modleski refers to Hitchcock's rather coarsely described directions to Evan Hunter about the scene), "the end result is to make us question the authority of the film's supposed hero and to elicit the feminist interpreter's sympathy for its trapped and caged heroine."[58] I want to add that this scene enlists both my feminist and my queer sympathies and identifications.

Perhaps the most telling moment in the entire sequence, a tour de force of pure cinema, is the one in which Hitchcock's camera puts us in Marnie's subject position, not only emotionally but physically. When Mark says "I *also* want to go to bed, Marnie," the camera, which had previously held a two-shot image of Mark standing on the left, with Marnie on the right (a visual representation of the emotional impasse between them rendered in spatial terms), now swings around so that we are facing Mark—so that *we* are now Marnie.

The canted, low angle—an unusual touch—from which we look up as Mark kisses Marnie recalls the scene in Mark's office during the thunderstorm when he first kissed her. There the perspective of the canted angle made the kiss between man and woman seem truly alien—lovers do not passionately kiss from *this* angle. A scene that foregrounds ancient civilizations (the pre-Columbian art of Mark's dead wife) and the zoological now renders the erotic contact between man and woman as an almost clinical study in mating ritual. We see Mark's lips drag over the inert expanse of Marnie's face, and even glimpse the adhesive effect of lips on lips, and see lips pull away from lips as well. If we compare this scene to the famous scene of Cary Grant and Ingrid Bergman kissing for an endless duration in a long take in *Notorious*—itself a film that deconstructs the couple—we can see a remarkable difference in tone. The scene in *Notorious* borders on perversity in its sustained erotic intensity; in *Marnie*, however, the kissing scenes convey the awkwardness and strangeness of the mismatched pair, however much palpable yearning on Mark's part undergirds it (see figures 7.4, 7.5, and 7.6,).

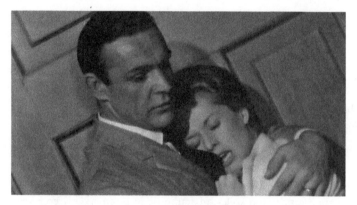

FIGURE 7.4 Marnie, terrified by the thunderstorm, in Mark's office.

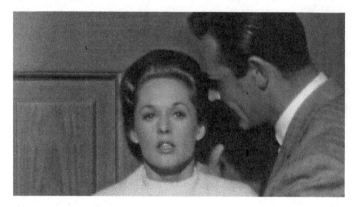

FIGURE 7.5 Marnie, having begged Mark to "stop the colors," assumes an attitude of blankness, as she will also do on the ship.

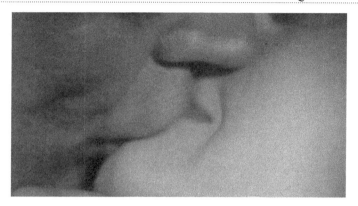

FIGURE 7.6 The scene of heterosexual desire rendered as alienation effect.

I would argue that the class critique here is at its most implicit and most resonant. Because of his wealth, Mark believes that he can possess Marnie. He believes that he can trap her as if she were an animal and get her to "trust" him, just as he did the jaguarondi Sophie, the South American cat whose framed photograph he proudly displays in his office. (In response to Marnie's glance at the photograph, Mark says, "That's Sophie . . . I, uh, trained her." Marnie asks, "Oh, and what did you train her to do?" He responds, "To trust me. That is a great deal . . . for a jaguarondi.") His wealth gives him, as *Vertigo* similarly envisions, the "power and the freedom" to trap Marnie into sexuality and, later in the film, into discourse, as she is forced, along with her mother, to speak the truth of their unspeakable violation. That Mark is himself a vulnerable, empathetic character only deepens the poignancy and horror of this narrative.

Paradoxically, Marnie expresses her queer resilience by attempting to drown herself, transforming the symbol of helpless femininity maddened by male cruelty (Ophelia's suicide by drowning, alluded to in *Vertigo* as well) into a form of desperate female agency. Her retort when Mark rescues her and asks her why she did not simply throw herself into the ocean ("The point was to kill myself, not feed the damn fish") conveys a dark wit. Marnie's mordant take on her predicament evinces her resilience. Mark, I would argue, as the upholder of patriarchal power, is also its victim. In some ways, he wills himself into the role of Marnie's rapist, convincing himself that he is only doing so for her benefit. Moreover, his own bruised ego demands reassurance. What he says jokingly in one scene ("Is this your way of telling me that you do not find me attractive?") becomes real need and demand expressed through physical and emotional violence in a subsequent scene. What is not willingly given to us, we take, sometimes with unforgivable violence. Hitchcock, in this pivotal sequence—pivotal in *Marnie* and in his entire body of work—conveys with astonishing power the complexities and pathos of how Marnie is endlessly victimized, by the social order and by those who uphold it, such as Mark, perpetrators who are, at least in Mark's instance, themselves at odds, though only to a certain extent, with a system that favors some but truly liberates or humanizes no one.

Other than *Vertigo, Marnie* is, perhaps, Hitchcock's most complex film. One runs roughshod over its fillips, its small telling moments and nuances, in attempting to theorize one's way through it. *Marnie* presents a view of the world, the American world at least, as fundamentally disordered, but no less ferociously devoted to order for being that. The praeterite, the powerless, must helplessly acquiesce to those in power. In turn, those in power may have good intentions but inevitably fall back on that power and its privileges to get what they demand.[59] Compulsory heterosexuality imprisons (Marnie) and impels (Mark), fundamentally distorting all relations, including those of the heterosexually oriented. Marnie's Mark (the man who understands Marnie and her violation and life-long vulnerability) struggles forever against money's Mark (the Mark who wields power and crushes those without it, such as Mrs. Edgar, left truly bereft by the end). The question is not, then, does Mark save Marnie, but what can possibly save this culture?

Perhaps the most resonant message in *Marnie* is the idea that, if it does not subsume one, trauma (memory, recurring pain, a feeling of being overpowered or seized by these) can be the foundation for a continued and perhaps even ethical life. By saying this, I in no way mean to contribute a "positive" reading of *Marnie*, film or character. But *Marnie*, in my view, is Hitchcock's own reparative reading of his body of work, particularly attuned to the fixation on penetrating the woman's mystery and the violence against women at the forefront of his cinema. Here there is little swooning sexualization of the woman, and the violence has its profoundest impact. If queer resilience has any resilience at all as a concept, it will be for its ability to illuminate both the positive and negative aspects of experience, both the dubious and more heroic aspects of survival in an often unimaginable world.

Epilogue

MELANIE'S *BIRDS*: DECONSTRUCTING THE HEROINE

THE FEMININE-VERSUS-THE-QUEER THEMATIC sometimes involves two female characters, but most often, my focus in this book has been on conflicts between a heterosexual woman and a homosexual/queer man in Hitchcock's oeuvre. Uncannily, this cinematic relationship mirrors the tense standoff between feminists and gay male critics within the subfield of Hitchcock studies, which is one of the reasons (though only one) that I have been especially attentive to it. I have also argued that the woman's relationship to queer male sexuality is one of paranoia (which is not to suggest that paranoia does not also inform homoerotic antagonism or heterosexual relations). One of my chief efforts has been to offer an alternative to Lee Edelman's theory of the queer death drive. Although it is a critical work of great importance that offers numerous incisive and provocatively energizing readings, *No Future* leaves the queer subject in an impossible position, which may be the point, unable to move forward in any way politically except by embracing the positions of nullity and death.

My reparative reading of Hitchcock has attempted to make the case that his body of work gives us, in however distorted, strained, or agonized a manner, a glimpse into the kinds of social struggles that have dominated women's history and queer history in the twentieth century and, in so doing, suggest, even if only implicitly, ways in which a shared social struggle might be possible, a collaborative project distinct from the enmity and disconnection so often foregrounded in Hitchcock's films. At the same time, the desire for connection and recognition in them is palpable, sometimes overwhelmingly so.

With these concerns in mind, I want to turn to a sequence in *The Birds* that speaks to the thematic focus of this book. It is neither one of the scenes in which children are attacked nor is it the climactic one in which Melanie Daniels is attacked in the attic, though I will address the latter.[1] It is the sequence that begins in the Tides Restaurant after the attack on the schoolchildren, involves Melanie's conversation with an amateur ornithologist, the elderly Mrs. Bundy (Ethel Griffies), develops into a full-scale attack by the birds in which a man accidentally sets himself and his car on fire, and ends with Melanie being hysterically shouted at by a woman in the diner (Doreen Lang), a mother with two children: "Why are they doing this? Why are they doing this? They said when you got here, the whole thing started. Who are you? What are you? Where did you come from? I think you're the cause of all this. I think you're evil—*evil!*"

The feminine-versus-the-queer thematic is very much present in *The Birds*. Melanie fully embodies the Hitchcock feminine ideal, a cool, carnal blonde in a long fox-fur coat and matching two-piece green ensemble.[2] The birds convey the idea of queerness in abstracted form, being neither human nor gay but also not in any way "natural," animals with a collective consciousness that behave in a manner utterly unlike that of normal birds—to begin with, they act as one. I roughly follow Edelman's lead in seeing the birds as queer, though he problematizes as much as promulgates this reading: "my point is not to equate the birds with homosexuality nor to suggest that they be understood as 'meaning' same-sex desire. Neither is Hitchcock's film, as I read it, an allegory of gay coming-out. Insofar as the birds bear the burden of sinthomosexuality, which aims to dissociate heteronormativity from its own implication in the drive, it would, in fact, be more accurate to say that the meaning of homosexuality is determined by what the film represents in *them*: the violent undoing of meaning, the loss of identity and coherence, the unnatural access to jouissance, which finds their perfect expression in the slogan devised by Hitchcock himself for the movie's promotion, '*The Birds* is coming.' "[3] In that the birds represent the drive toward meaningless and antisociality that Edelman, following Lacan, terms sinthomosexuality, they suggest the very position that Edelman calls on queers to occupy vis-à-vis the heteronormative social order.

While the birds are a queer threat to Melanie and every other human, the image of queerness in the film is far from limited to the titular menaces. Several of the film's human characters connote queerness—Annie Hayworth, the isolated schoolteacher still ostensibly pining for the romantic male lead Mitch Brenner, maintaining a vigil to her unrealizable heterosexual relationship; Lydia Brenner, Mitch's mother, prone to penetrating stares at Melanie; Mitch himself, a bachelor lawyer who lives in San Francisco and seems to retreat from heterosexual romance as much as he pursues it; and Melanie herself. Perhaps the character who most explicitly signals queerness is Mrs. Bundy, a "butchly tailored and tweedy bird-lover."[4] Mrs. Bundy recalls the popular image of the mannish female intellectual embodied by Gertrude Stein (see figure E.1). She is, along with Mrs. Danvers in *Rebecca* and the Sapphic couple in *Suspicion*, one of Hitchcock's explicitly lesbian-typed personae.

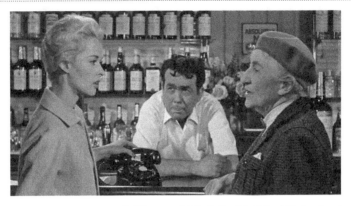

FIGURE E.1 A tense standoff between Melanie Daniels (Tippi Hedren) and
Mrs. Bundy (Ethel Griffies).

In Susan Lurie's well-known reading, Melanie's characterization challenges the male
viewer with the proposition that woman is not castrated, but instead a force to be
reckoned with and a site of plenitude, which triggers the patriarchal cinema's defen-
sive strategies to render the woman a castrated and therefore less threatening figure.[5]
Melanie's beauty, poise, class status (aristocratic), hyperfemininity, and also active,
phallic desire, as evinced by her self-manned boat trip across the water to leave Mitch's
sister the present of the lovebirds (an obvious gambit for his sexual attentions), make
her an arresting presence for the camera and the narrative; Hitchcock both delights
in her persona and attempts to cut her down to human size. Misogyny undeniably
inheres in the portrayal of Melanie, especially in the climactic portion of the film: The
attack on Melanie by the birds in the attic is conceptualized in a manner that evokes
a classical rape (which itself evokes the framed paintings of this genre in *Psycho*).
Nevertheless, Melanie is also one of Hitchcock's richest female characters, someone
who develops into an authentic personhood over the course of the narrative. In this
manner, she recalls the heroine Iris Henderson (Margaret Lockwood) of *The Lady
Vanishes*, initially associated with wealth and vapidity but who develops maturity,
empathy, courage, and depth.

Melanie's characterization has remained highly controversial. Tania Modleski takes
both Edelman and Susan Smith to task for their failure to address the violence of
Melanie's treatment at the climax and her resulting catatonic state.[6] The suspect sexual
politics admitted, Melanie's acceptance and embrace, literal and symbolic, by Lydia after
Melanie has suffered a horrible bird attack are a moving anticipation of the similar strug-
gles, more finely etched, in *Marnie*. And as I will also note, the climax has relevance for
the feminine-versus-the-queer conflict that enlarges, though admittedly does not resolve,
the pressing question of misogyny.

Mrs. Bundy is Lydia's double (as an older woman who regards Melanie with suspicion
and even derision), as well as Annie Hayworth's (as a solitary female character despite

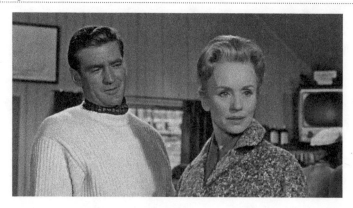

FIGURE E.2 Mitch Brenner (Rod Taylor) is no match for his formidable mother Lydia (Jessica Tandy), whose gaze commands the film.

the "Mrs." title). She also doubles Melanie herself in offering an antithetical but equally adamant account of the significance of the birds. Melanie unflinchingly explains why they attacked the schoolchildren: "To kill them"; Mrs. Bundy scoffs at the idea that birds could want or have the capacity to attack humans. In taking a skeptical view of the beautiful woman, the queer Mrs. Bundy performs a role and takes a stance that recall Mrs. Danvers's attitude toward the second Mrs. de Winter and Mrs. Sebastian's toward Alicia Huberman. Camille Paglia has argued that *The Birds* is Hitchcock's meditation on woman's sexual glamour.[7] What is most interesting about Hitchcock's admittedly obsessive construction of female beauty is its ultimately neurotic character, one that results in a quizzical rather than a lascivious attitude.

The woman's beauty dazzles; it also goads others into sadistic action. The male lead Mitch Brenner immediately spots Melanie in the bird shop at the start of the film. His sexual interest in her leads him to trick her into humiliating herself. (At his faux-naïve address to her as the proprietress, she takes the bait and proceeds to direct him around the shop; he easily exposes her knowledge of the various birds on display as limited and fraudulent while demonstrating his own as superior.) Similarly, his mother Lydia immediately registers Melanie's beauty and proceeds to snub and scorn her (see figures E.2 and E.3). Annie's initial attitude toward Melanie is suspicious, and Mrs. Bundy takes a caustic attitude toward the beautiful blonde woman right away. Perhaps the chief indication of this skeptical attitude is the version of the feminine/queer conflict presented in miniature at the film's start. Melanie attempts to leave the gift of lovebirds outside of Mitch's apartment (she gets his address from one of her contacts at her father's newspaper). Walking down the hallway to his apartment as she carries the birdcage, Melanie encounters his male neighbor, an imposing tall, business-suit-attired, balding, and bespectacled man with an odd smirk (identified in the cast list as "Mitch's City Neighbor" played by Richard Deacon, who specialized in pompous roles and was best known for his work on the sitcom "The Dick Van

FIGURE E.3 "A gull hit me, Mrs. Brenner," explains Melanie. The heroine's beauty causes a disturbance.

Dyke Show").[8] The neighbor informs Melanie that Mitch is away for the weekend at the family home in Bodega Bay. After giving Melanie instructions about how to get there and apologizing for not being able to look after the birds himself given his own plans, the male neighbor looks down oddly at Melanie as he remarks, in an insincere manner, "I'm awfully sorry." His manner conveys the attitude of a gay man looking derisively at a woman who isn't as compelling as she believes herself to be—an uncomfortable suggestion, to say the least.

While there is a misogyny here and even a homophobic aspect (the crudely conventional belief that gay men dislike women and are cattily competitive with them), I think that something powerful is nevertheless being thematized in such moments. The woman's beauty signifies less about her own considerable, affecting charms than it does about the overarching social and cultural heterosexism that is so heavily invested in advancing the spectacle of woman's beauty and sexual desirability as an obvious, inevitably valued commodity. Hitchcock's refusal of heterosexual presumption begins with his deconstructive attitude toward the woman's glamorous beauty (compare the introduction of Grace Kelly's Lisa Freemont in *Rear Window*). Dazzlingly beautiful though she is, she descends upon the sleeping hero Jeff (James Stewart) like the shadow of death, engulfing him when she kisses him in slow motion, her exquisitely made-up face seen in a huge, disorienting close-up. Some may view this sequence as typically misogynistic, reflective of Jeff's own fears that Lisa is smothering him. In my view, while misogyny may be present here, the larger goal is to disorient the viewer, to make the most conventional of moments—the heterosexual couple kissing—strange and denatured.

The woman's beauty leaves her non-committed audience, especially the queer mother, cold. One thinks of a variation on the latter, the stern and hidebound Mrs. Peniston, and her response to the heroine's beauty in Edith Wharton's famous 1905 novel *The House of Mirth*. Chastising her enterprising niece Lily Bart for her extravagant and indecorous behavior, Mrs. Peniston looks on Lily, whose beauty is frequently noted and even

described as poignant, without the awe the heroine is accustomed to seeing registered in her male admirers' eyes:

> [Lily] raised the troubling loveliness of her face to Mrs. Peniston, vainly hoping that a sight so moving to the other sex might not be without effect upon her own. But the effect produced was that of making Mrs. Peniston shrink back apprehensively. "Really, Lily, you are old enough to manage your own affairs. . . ."[9]

Lily manipulatively uses her own beauty to get a favorable response from the rigorous older woman, yet Mrs. Peniston takes a clinical view of her niece's "troubling loveliness" and even "shrinks" from it. The key detail is that Mrs. Peniston's view of Lily is entirely distinct from those of her heterosexual male suitors—an attitude of distance and skepticism that lays not just Lily (our sympathetic-if-maddening heroine) but the whole machinery of heterosexual courtship bare.

Mrs. Danvers's manipulation of the second Mrs. de Winter hinges upon humiliating her in terms of her appearance. Tricking the heroine into wearing the same outfit—of a female de Winter ancestor whose portrait hangs imposingly in the hallway—to the masquerade ball that Rebecca wore, Mrs. Danvers reminds her, once she has been publicly shamed for her error, that she can never hold a candle to Rebecca and her sumptuous beauty, even as she replicates its form. Similarly, Mrs. Sebastian, upon meeting Alicia for the first time, immediately compliments her on her beauty (which the casting of Ingrid Bergman amply corroborates) and just as quickly casts suspicion on her for not having testified at her Nazi-sympathizer father's trial. Alicia quickly responds that he insisted that she not testify; Hitchcock cuts to a close-up of Mrs. Sebastian responding, just as swiftly and with deadening coldness, "I wonder why." The effect is to reduce the spectacle of female beauty to smithereens—Alicia's beauty has no impact on the older woman's disdainful attitude.

This deconstructive attitude to the heroine's beauty—a prerequisite of the Hitchcock heroine to be sure—evinces the ambivalence toward her and her role in narrative that informs Hitchcock's body of work. As the woman's role so frequently involves penetrating the mystery of queer sexuality, this ambivalence is perhaps a reflection of the sympathy for queerness exhibited in the Hitchcock text. Yet, as we have seen, the Hitchcock text also exhibits sympathy for the woman, often exceeding what is directed toward the queer figure and very often the male lead. As Tania Modleski pointed out, *Rebecca* was a crucial, shaping film for Hitchcock, establishing the emotional template of profound identification with the heroine. (Modleski has written a definitive treatment of the film as exemplary of the female Oedipus complex.)[10] The general emotional atmosphere in Hitchcock films is generally one of contested difficulty that springs from the irresolvability of the feminine/queer conflict, a split demand on our identificatory allegiances. *Psycho* is representative of this difficulty: We identify with Marion Crane; we are with her every step of the way on her frenzied journey, yet we are also made to feel intensely for Norman Bates, as well as to

fear for him, which also lends an air of ambiguity to another identification figure, Lila Crane, and her investigation of Norman's house.[11]

Of Mrs. Danvers's trick on and general power over the second Mrs. de Winter, Modleski writes, "Mrs. Danvers's gaze continually places the heroine in a sort of hypnotic trance . . . it becomes clear that Mrs. Danvers is really willing her to *substitute her body for the body of Rebecca*" (emphasis original). When the heroine, tricked into wearing Rebecca's female ancestor's costume and publicly shamed, confronts Mrs. Danvers, the housekeeper turns the tables on her. She nearly succeeds in getting the heroine to kill herself by jumping off the balcony in Rebecca's bedroom. ("Why don't you . . . why don't you? Don't be afraid.") The spectator is "forced to undergo an experience analogous to that of the heroine: both she and we are made to experience a kind of annihilation of the self, of individual identity, through a merger with another woman."[12] In agreement with this reading of Hitchcock's identification technique, I would add that we are also put in the position of Mrs. Danvers, made to feel her desire to dominate and her hostility toward the heroine, a most uncomfortable sensation, especially given how deeply sympathetic the heroine is, due in large part to Joan Fontaine's sensitive performance. This dual identification with the heroine and her queer oppressor contrasts but also dovetails with our dual identification with the queer villain and his straight male rival—as is made strikingly apparent in Hitchcock's crosscutting between Bruno Anthony, trying to retrieve Guy Haines's lighter from the sewer drain, and Guy, attempting to win the tennis game so that he can get to the fairground before Bruno can incriminate him with the lighter.

Hitchcock's deconstruction of the heroine has been illuminated by Laura Mulvey. While she once established *Vertigo* as the ur-example of cinematic voyeurism, a reflection, rather than a critique, of the male's sadistic desire to investigate and penetrate the woman's mystery, Mulvey's current treatment of Hitchcock strikes quite a distinct note.[13] Given how heavily invested Hitchcock's portraits of femininity have been in their idealization of the woman's blondeness, it is worth considering his estrangement-making construction of female beauty within this context. Part of Hitchcock's supreme mastery of the film medium and a key aspect of his genius is "to capture visually these strange, almost perverse gender relations that would have had so much interest for Freud," notes Mulvey, adding that "over the years I've become convinced that Hitchcock is not a misogynist."

> He uses cinema to reflect on, even analyze, the way certain alluring, fascinating female iconographies encapsulated particularly by the blonde have a particular symbiosis with the male protagonist's sexual anxieties as well as their desires. . . . Two closely linked attributes [are] peculiar to the Hitchcock blonde: None of those qualities of naturalness or innocence associated with other types of cinematic blondeness. She is essentially cosmetic and artificial. Blondeness is denaturalized and connotes the constructed appearance of highly stylized femininity. And this perfection fuses, of course, with the particular aura of Hollywood stardom, but there's something more to it. And this leads me to the second point. This extra

perfection, polish, and poise that Hitchcock invents in his blonde star's appearance and performance creates a surface, a sense of an exterior, a masquerade, that conceals. So behind the masquerade of perfection—the masquerade of perfection hints that behind it lies a secret. The performance of beauty fuses with the performance of deception. This narrative trope [is] most fully realized in *Vertigo* [and also present] in *North by Northwest*, *The Birds*, and *Marnie*. . . . His blonde heroines are unlike the enigmatic and ultimately deadly femme fatale . . . from the perspective of the audience, for us watching the film . . . the feelings, and particularly their ambivalence about male domination, that of the male protagonist and the male domination of society more generally, are made explicit. And Hitchcock always out of this, out of this insight into the psychology of the heroine, engages the audience sympathetically with her situation.[14]

To build on Mulvey's insights for queer purposes, it is a crucial dimension of Hitchcock's refusal of heterosexual presumption that we can see the woman's sexual masquerade as such, that we are encouraged to see its foundation in illusion even as we—straight or queer—fall hopelessly under the heroine's beguiling spell. The woman's artifice metonymically alerts us to the general artifice of the heterosexual romance plot at the center of conventional narrative film. There is a queerness within the heightened stylization that is inextricable from its effort to beguile. That certain characters can see through the mystery aligns them with a queer skepticism toward the heterosexist illusion, which is not to suggest that the cinematic artifice of both heterosexual romance and female sexual glamour, especially in the Hitchcock oeuvre, fail to retain their considerable allure.

Though Mrs. Bundy is not a sexualized character, her queerness is an undeniable aspect of her screen presence; therefore, her confrontation with Melanie has an importance for the feminine/queer dynamic. Unimpressed by Melanie in any way, Mrs. Bundy unswervingly maintains, in the face of Melanie's documentary evidence of the bird attacks, her simultaneous belief in the impossibility that the birds could be inflicting harm on others and in the awesome power that the pulling together of avian resources would represent. In response to Melanie's contention that the attacking birds consist of several different species working together, Mrs. Bundy exclaims, "The very concept is unimaginable. Why, if that happened, we wouldn't have a chance! How could we possibly hope to fight them?" Mrs. Bundy also demonstrates her loyalty to the birds, in opposition to the heroine: "Birds are not aggressive creatures, Miss. They bring beauty into the world. It is mankind, rather, who insists upon making it difficult for life to exist on this planet." Melanie, for Mrs. Bundy, is mankind itself: crude, arrogant, hostile, limited, and repugnant.

The concept that I have been developing throughout this book of sexual hegemony achieves a rather startling expansion in *The Birds*. The titular creatures as a collective force consist of crows, blackbirds, finches, gulls, and so forth. Hitchcock's films, in tracking the cold war among gender and sexual minorities, darkly track the effects of hegemony. In hegemonic societies, power is hierarchically consolidated, with those most embodying its vaunted qualities given the most privileged positions while the rest are left scrambling

for the crumbs. Hegemony disciplines *all* bodies precisely through its threat to unsettle those "at the top" if they fail to adhere to its mandates—thus making them anything but secure—and punishing marginalized others. The birds, however, represent a range of oppressed groups—if we see such an allegory in them—uniting to defeat their shared enemies, human beings such as the chicken-eating, fur-wearing animal oppressors on display here. As Jack Halberstam observes,

> The birds, in this film, very literally represent the power that could potentially be released by the spectacle of different species of women (or different classes or races) flocking together. If they did that, Mrs. Bundy warns, "we wouldn't have a chance." The "we" in this sentence obviously stands for "human" but the distinction between human and bird insistently breaks down through the film as birds become aggressive and humans become defensive. The narrative of romance, humanism and family values that underwrites both the story of Mitch, Melanie, and Lydia and also the story of the people of Bodega Bay (closing ranks against outsiders) is under severe attack here from the narrative of a unified and intentional attack from above by harpies whose intent seems clearly to break down the structures of heterosexual desire and replace them with a female homosexuality.[15]

The accusatory outcry directed at Melanie by the woman in the diner, portrayed as a concerned mother, evinces the upsetting theme of sororophobia once more. Less often noted, however, is the mutual exchange, of sorts, between Melanie and Mrs. Bundy after the terrible bird attack outside the Tides Restaurant, incontrovertible proof of the menace posed by the birds. Melanie looks into the crowd of faces—all of whom are women, and several of whom are older women, suggesting a punitive maternal chorus—staring at her with accusatory looks. It is from within this sea of scorn that the accusatory mother rises up and confronts Melanie: "They say that you're the cause of all of this. I think you're evil—*evil*!" At this hysterical and frightening outburst, which Mitch regards with notably silent concern, Melanie slaps the woman across the face, which has the effect of silencing her.

Peering into the crowd of female accusers, Melanie—whose POV we share—looks at Mrs. Bundy. But Mrs. Bundy lies low with her back to us in an abashed position. Her bodily movements (a slight tilt of the head quickly retracted) suggest that she knows she is being looked at—as if she knows that Melanie is asking for her input—yet, significantly, she does not turn around to look at Melanie and we never see her face. I have tracked this scopophobic impasse, which I call the thwarted gaze, the inability of either the heterosexual woman or the queer character to look at one another, in *Strangers on a Train* and *North by Northwest*.[16] *The Birds* offers the most poignant depiction of this mutual blinding—an inability to acknowledge the other's presence, to offer recognition, much less the ability to imagine the other's experience or desires (see figure E.4).

There are surprising and welcome grace notes in the film of the bonds possible between women: Melanie and Annie, though rivals for Mitch, discover a genuine rapport,

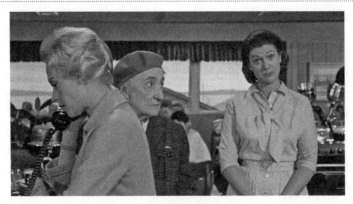

FIGURE E.4 Sexual hegemony exemplified by the mutually alienated gaze of the women in the film.

Annie encouraging Melanie to pursue Mitch despite the jealous Lydia's disapproval; Melanie's love for Cathy Brenner (the extraordinary young Veronica Cartwright), Mitch's adolescent sister, and Cathy's for both Melanie and Annie, who heroically sacrifices her own life to save Cathy's during a bird attack; and, most movingly, the final reconciliation scene between Melanie and Lydia (which some commentators have seen as part of a pernicious wiping-out of Melanie's agency, given that Melanie is largely speechless and physically wounded at the end).

The feminine-versus-the-queer dynamic would seem to be generative of its typical emotional nullity in the rapport, or lack thereof, between Melanie and Mrs. Bundy. But if, as Halberstam and to a qualified extent Edelman argue, we see the birds as the embodiment of queer desire, their seeming attack on Melanie in the attic may not be an attack at all but rather a call to arms. As Halberstam puts it, "the birds will batter and bomb the house until it gives way and relinquishes the domestic female."[17] While I am very mindful of the misogyny at work in the scene of Melanie's bombardment by the birds—which literalizes the symbolic deconstruction of the heroine, whose body and clothing are mercilessly pecked away at by the unceasing creatures—I am also struck by the dreamlike surrender that it represents, an effect heightened by Hitchcock's languorous focus on the sounds of the birds' flapping wings and his decision not to include the sounds of their terrifying, inhuman screaming.

As Hitchcock described his decision-making to Truffaut,

... when Melanie is locked up in the attic with the murderous birds, we inserted the natural sounds of wings, but we stylized them so as to create greater intensity. We wanted to get a menacing wave of vibration rather than a single level. There was a variation of the noise, an assimilation of the unequal noise of the wings. Of course, I took the dramatic license of not having the birds scream at all.[18]

It's almost as if the birds are attempting to claim Melanie for themselves, attempting to bring her into the queer fold at last. But Hitchcock himself saw the matter differently, less as an appeal to solidarity and more as enclosure. "It was a strange, artificial sound, which in the language of the birds might be saying, 'We're not ready to attack you yet, but we're getting ready.'" For Hitchcock, the manipulation of the aural emissions of the birds was the attempt to get at "its equivalent in dialogue. What I wanted to get in that attack is as if the birds were telling Melanie, 'Now, we've got you where we want you. Here we come. We don't have to scream in triumph or in anger. This is going to be a silent murder.'"[19] Hitchcock's cinema, as I see it, is an archive of silent murders, the social order's endless tendency to crush the nonconforming and hide the evidence of its crimes, and the inability for those crushed to recognize their grievous kinship.

Notes

INTRODUCTION

1. See Halberstam, "Reading Counterclockwise: Paranoid Gothic or Gothic Paranoia," *Skin Shows: Gothic Horror and the Technology of Monsters* (Durham, NC: Duke University Press, 2000), 107–137; Rose, "Paranoia and the Film System," *Screen* (1976) 17 (4): 85–104, republished in *Feminism and Film Theory*, ed. Constance Penley (New York: Routledge, 1988), 57–68.

2. Mulvey, "Visual Pleasure and Narrative Cinema," *Screen* 16 (3): 6–18; republished in *Visual and Other Pleasures*, 2nd ed., Language, Discourse, Society (Houndmills, Basingstoke, Hampshire, UK; New York: Palgrave Macmillan, 2009), 14–27.

3. Modleski, *The Women Who Knew Too Much: Hitchcock and Feminist Theory*, 3rd ed. (New York: Routledge, 2016 [1988]).

4. See White, "Problems of Knowledge in Feminist Film Theory," *Alfred Hitchcock: Centenary Essays*, eds. Richard Allen and S. Ichii-Gonzales (London: BFI, 1999), 278–298; Paula Marantz Cohen, *Alfred Hitchcock: The Legacy of Victorianism* (Lexington, KY: University of Kentucky Press, 1995); Keane, "A Closer Look at Scopophilia: Mulvey, Hitchcock, and *Vertigo*," *A Hitchcock Reader*, eds. Marshall Deutelbaum and Leland Poague (Ames, IA: Iowa University Press, 1986), 231–248; Piso, "Mark's Marnie," *A Hitchcock Reader*, eds. Deutelbaum and Poague, 280–294; Jacobowitz, "Hitchcock and Feminist Criticism: From *Rebecca* to *Marnie*, *A Companion to Alfred Hitchcock*, eds. Thomas M. Leitch and Leland A. Poague (Chichester, West Sussex, UK; Malden, MA: Wiley-Blackwell, 2011), 452–472; Mulvey, The British Film Institute's "Birds Eye View" lecture series, March 8, 2010, accessed on 3/3/16 at http://www.bfi.org.uk/live/video/310.

5. For his review of the 1951 *Strangers on a Train*, see Farber, "Films," *Nation* (July 8, 1951): 77–78; Hepworth, "Hitchcock's Homophobia," *Out in Culture: Gay, Lesbian, and Queer Essays on Popular Culture*, eds. Corey K. Creekmur and Alexander Doty (Durham, NC: Duke

University Press, 1995), 186–197; Russo, *The Celluloid Closet: Homosexuality in the Movies*, rev. (New York: Harper & Row, 1987); Miller, "Anal *Rope*," *Inside/Out: Lesbian Theories, Gay Theories*, ed. Diana Fuss (New York: Routledge, 1991), 119–141.

6. See Wood, *Hitchcock's Films Revisited* (New York: Columbia University Press, 2002 [1989]); Doty, "How Queer is My *Psycho*," *Flaming Classics: Queering the Film Canon* (New York: Routledge, 2000), 155–189; "Queer Hitchcock," *A Companion to Alfred Hitchcock*, eds. Thomas Leitch and Leland Pogue (Malden, MA: Wiley-Blackwell, 2011), 473–489; White, "Hitchcock and hom(m)osexuality," *Hitchcock: Past and Future*, eds. Richard Allen and S. Ishii-Gonzalès (London: Routledge, 2004), 211–229; Knapp, "The Queer Voice in *Marnie*," *Cinema Journal* 32.4 (Summer 1993): 6–23; republished in *A Hitchcock Reader*, eds. Marshall Deutelbaum and Leland Pogue (Malden, MA: Wiley-Blackwell, 2009), 295–311.

7. See Miller, "Anal *Rope*"; Edelman, *No Future: Queer Theory and the Death Drive* (Durham, NC: Duke University Press, 2004); "*Rear Window*'s Glasshole," *Out Takes: Essays on Queer Theory and Film*, ed. Ellis Hanson (Durham, NC: Duke University Press, 1999), 72–97; Goldberg, *Strangers on a Train: A Queer Film Classic* (Vancouver, CA: Arsenal Pulp Press, 2012).

8. See Thomas Elsässer, "The Dandy in Hitchcock," *The Persistence of Hollywood* (New York: Routledge, 2012), 175–182; Richard Allen, *Hitchcock's Romantic Irony* (New York: Columbia University Press, 2007).

9. Modleski, "Afterword to the 2005 Edition: Resurrection of a Hitchcock Daughter," *The Women Who Knew Too Much* (2016), 123–152.

10. White's analysis of Hitchcock's *Rebecca*, a crucial reading, takes critics such as Modleski and Mary Ann Doane to task for failing to include an analysis of lesbian desire, not just the character of Mrs. Danvers but also that of the ghostly Rebecca. See the chapter "Female Spectator, Lesbian Specter" in Patricia White, *Uninvited: Classical Hollywood Cinema and Lesbian Representability* (Bloomington, IN: Indiana University Press, 1999), 61–93. For a painstaking response to White's criticisms, see Modleski, "Resurrection of a Hitchcock Daughter (2005)," *The Women Who Knew Too Much*, 123–152.

11. Robert J. Corber, *In the Name of National Security: Hitchcock, Homophobia, and the Political Construction of Gender in Postwar America* (Durham, NC: Duke University Press, 1993), 72.

12. Corber, *Cold War Femme: Lesbianism, National Identity and Hollywood* (Durham, NC: Duke University Press, 2011).

13. Goldberg, *Strangers on a Train*, 104.

14. Robin Wood's 1965 *Hitchcock's Films* remains one of the finest books written on the director. The book grew out of Wood's 1960 essay on *Psycho*, which was published by *Cahiers du Cinema* after being rejected by *Sight and Sound*. Influenced at Cambridge by the famous critics F.R. Leavis and A.P. Rossitter, Wood was the one of the first critics to champion *Vertigo* (calling it one of the four or five greatest works of the cinema), likening it to Shakespeare and Keats's poetry; he called *Psycho* "one of the key works of our age," likening it to *Macbeth* and arguing that it evokes the horrors of the Holocaust (Wood, *Hitchcock's Films Revisited*, 150). Wood published his self-revisionist *Hitchcock's Films Revisited* (New York: Columbia University Press) in 1989; in 2002, he published yet another version that now included a new preface of some length and a new chapter on *Marnie* (1964) entitled "Does Mark Save Marnie?" During the 1970s, Wood divorced his wife and came out as a gay man, and the new material in *Revisited* 1989 reflected his immersion in Marxism, feminism, and a psychoanalytic theory inflected by these critical perspectives. *Revisited* (2002) goes into considerable detail about the anguish of the closet.

15. "Farber didn't much like *Strangers on a Train*, and one of the things he didn't like was 'the travestied homosexuality of the murderer' (78). Farber, that is, not only saw Bruno as gay; he also deplored the terms under which such recognition was fostered: neurosis or psychosis, the young man 'spoiled' by his mother, the homosexual as killer." See Goldberg, *Strangers on a Train*, 54; Farber quoted from Farber, "Films," *Nation* (July 8, 1951): 77–78.

16. *Out in Culture*, eds. Creekmur and Doty, includes Hepworth's essay "Hitchcock's Homophobia," Robin Wood's response to Hepworth, and Hepworth's rebuttal to Wood. Hepworth initially offers some insightful readings, but his incendiary argument seems more germane to societal homophobia than to Hitchcock's oeuvre.

17. Rohmer and Chabrol were critics for the French film magazine *Les Cahiers du Cinema* who would go on to become leading directors of the French New Wave, as would several other *Cahier* writers—Jacques Rivette, Jean-Luc Godard, and François Truffaut, who would produce his own influential book on Hitchcock, a series of interviews called *Hitchcock/Truffaut* (first released in 1967, then in revised form in 1985). Discussing one important early Hitchcock film, Rohmer and Chabrol made their view of homosexuality clear:

> In *Murder!* the homosexual kills when unmasked. Unlike the protagonists of *Rope*, or Bruno Anthony (Robert Walker) in *Strangers on a Train*, he considers himself abnormal and is aware that his vice is a defect. But he is also incapable of loving, and he is interested only in escaping the consequences of his crime. When Hitchcock gets around to probing the problem of homosexuality in the two other films, we will become aware that his condemnation of homosexuality is justly based on the impossibility of true homosexual love: since this love is only an imitation, it is condemned to nonreciprocity. Diana [the wrongfully imprisoned heroine of *Murder!*] loves the homosexual, since she allows herself to be convicted in his stead, but the homosexual doesn't love her, since he permits her to do so.

Rohmer and Chabrol's own biases and their aim to impose a strictly theological framework on Hitchcock's films come through much more clearly here than the director's own much more ambivalent attitudes. Rohmer and Chabrol, *Hitchcock: The First Forty-Four Films* (Plainview, TX: Ungar Film Library, 1979), 27–28.

18. Goldberg, *Strangers on a Train: A Queer Film Classic*, 72.

19. Ibid, 17.

20. Barton, "'Crisscross': Paranoia and Projection in *Strangers on a Train*," *Out in Culture*, eds. Creekmur and Doty, 216–238; cited at 226.

21. For Cavell and Rothman, the woman is helpmeet to the man, who brings her into an enhanced awareness of her own value as such. Both critics have considerable insights to offer even if their paradigms are quite arguable. See especially Rothman, *Must We Kill the Thing We Love?: Emersonian Perfectionism and the Films of Alfred Hitchcock* (New York: Columbia University Press, 2014); Cavell, *Cavell on Film* (Albany, NY: State University of New York Press, 2005). My essay "You Can Put That in the Past Tense: Heterosexual Ambivalence and *Torn Curtain*," *Hitchcock Annual*, Vol: 19 (2014), 36–81, critiques the conservative sexual politics of reading Hitchcock in terms of the comedy of remarriage.

22. Brill, *The Hitchcock Romance: Love and Irony in Hitchcock's Films* (Princeton, NJ: Princeton University Press, 1988).

23. When Brill does discuss these issues, he does so in archetypal terms, describing the villain's henchman in *North by Northwest* as "Leonard as dragon." While Brill wants to make sure that we do not see "Leonard's uncertain sexuality, and that of other evil figures in Hitchcock's work," as evidence of his "prudery," he is equally certain that "true heterosexual love between well-matched partners approaches divine grace in many of Hitchcock's films. Deviance is therefore generally demonic; and it is artistically consistent that Hitchcock's villains often show signs of sexual perversity." Brill, *The Hitchcock Romance*, 9–10.

24. Modleski, "Resurrection of a Hitchcock Daughter (2005)," *The Women Who Knew Too Much*. Modleski does not discuss Robin Wood, a gay critic of whom she had been critical in the past, especially his attempt to "save Hitchcock for feminism," but who exhibited a tremendous amount of interest in feminist issues. For a discussion between Modleski and me on this and related subjects, especially the relationship between feminism and queer theory, see "Interview with David Greven," *The Women Who Knew Too Much* (2016), 169–182.

25. Modleski, "Resurrection," 151.

26. Ibid., 141–142.

27. White, "Hitchcock and hom(m)osexuality," in *Hitchcock: Past and Future*, eds. Richard Allen and S. Ishii-Gonzalès (London: Routledge, 2004), 215–217.

28. For numerous examples of the usefulness of reparative approaches, see Cvetkovich, *Depression: A Public Feeling* (Durham, NC: Duke University Press, 2012).

29. See Halberstam, "The Anti-Social Turn in Queer Studies" (2008), *Graduate Journal of Social Science* 5 (2): 140–156.

30. Bersani calls this masochistic desire for self-dissolution "self-shattering *jouissance*." *Jouissance* is a pleasure extreme enough that it threatens to kill the subject. Bersani argues that the passive partner (or bottom) in homosexual sex, in thrall to the dominant partner, is seeking to annihilate the self. See chapter 3, "The Gay Daddy," in Bersani, *Homos* (Cambridge, MA: Harvard University Press, 1995).

31. See Bersani, *Homos*; Jean Genet, *Funeral Rites*, trans. Bernard Frechtman (New York: Grove/Atlantic, 1988); Edelman, *No Future*.

32. José Esteban Muñoz, *Cruising Utopia: The Then and There of Queer Futurity* (New York: New York University Press, 2009).

33. Muñoz, *Cruising Utopia*, 15.

34. Halberstam, "The Anti-Social Turn," 152.

35. Cited by Edelman (81) from Spoto, *The Dark Side of Genius: The Life of Alfred Hitchcock* (Boston: Little, Brown, and Co., 1983), 440.

36. Edelman, *No Future*, 81.

37. Ibid., 78.

38. I am particularly indebted to Bersani's *The Freudian Body: Psychoanalysis and Art* (New York: Columbia University Press, 1986).

39. To reiterate, while I find much to admire in Rothman's latest Hitchcock study, I do not accept his thesis of an Emersonian Hitchcock. Hitchcock's commitment to exposing the fragility of existence, rather than an idea of perfectibility, seems especially at odds with Emersonian optimism and his model of human perfectibility.

40. Melanie Klein and Joan Riviere, *Love, Hate, and Reparation* (New York: Norton, 1964); cited passage at 61. The two parts of this book are based on public lectures given in Westminster, UK, in 1936.

41. Lacan, in response to Klein's depiction of the inner world, remarked: "Look at this witch's cauldron ... at the bottom of which stir, in a global imaginary world ..., the container of the mother's body, all the primordial phantasies present from the beginning and tending to structure themselves in a drama which seems prefigured." Quoted in *The Klein-Lacan Dialogues*, eds. Bernard Burgoyne and Mary Sullivan (New York: Other Press, 1997), 189.

42. Klein, *Love*, 61.

43. In terms of dissent from Sedgwick's argument, see, e.g., Paul Morrison, *The Explanation for Everything: Essays on Sexual Subjectivity, Sexual Cultures* (New York: New York University Press, 2001), 143–145.

44. Eve Kosofsky Sedgwick, "Paranoid Reading and Reparative Reading; or, You're So Paranoid, You Probably Think This Introduction Is about You," in *Novel Gazing: Queer Readings in Fiction*, ed. Eve Kosofsky Sedgwick (Durham, NC: Duke University Press, 1997), 1–37; cited at 8. Sedgwick refers to Klein's *Envy and Gratitude* (London: Tavistock, 1957).

45. Sedgwick, "Paranoid Reading," 7.

46. Ibid., 24, 27–28.

47. Sánchez-Pardo, *Cultures of the Death Drive: Melanie Klein and Modernist Melancholia* (Durham, NC: Duke University Press, 2003), 157.

48. Butler, "Melancholy Gender/Refused Identification," *The Psychic Life of Power: Theories in Subjection* (Stanford, CA: Stanford University Press, 1997), 132–150; cited passage at 135.

49. See Sedgwick, "Toward the Gothic Terrorism and Homosexual Panic," *Between Men: English Literature and Male Homosocial Desire* (New York: Columbia University Press, 1985), 83–97.

50. Sedgwick explicitly challenges queer theorists such as D.A. Miller for pursuing a politics of paranoia at the expense of other kinds of engagements. "Writing in 1988—that is, after two full terms of Reaganism in the United States—D.A. Miller proposes to follow Foucault in demystifying the 'intensive and continuous pastoral care that liberal society proposes to take of each and every one of its charges' (viii). As if! I'm a lot less worried about being pathologized by my shrink than about my vanishing mental health coverage. . . ." Sedgwick, "Paranoid Reading," 19–20. Miller quoted from *The Novel and the Police* (Berkeley, CA: University of California Press, 1988).

51. While Sedgwick characteristically distances herself from both Freud and Lacan in favor of Klein and other, less tautological psychoanalytic approaches, Paul Morrison, in his critique of her argument, focuses on the pernicious Freudianism within reparative criticism: "[W]e have every reason to remain paranoid about paranoia, or about still-powerful cultural narratives of trace-and-expose, particularly of the Freudian variety, which can expose only one thing," homosexuality, which, in Morrison's titular phrase, is the "explanation for everything." Morrison's central example of "trace-and-expose" is the quest to discover the hidden homosexual logic of German fascism, an idea that resonates in Hitchcock works such as *Rope*. Morrison, *The Explanation for Everything*, 145.

52. All Freud quotations are taken from *The Standard Edition of the Complete Psychological Works of Sigmund Freud*, trans. James Strachey, in collaboration with Anna Freud, assisted by Alix Strachey and Alan Tyson, 24 Vols. (London: Hogarth Press and the Institute of Psychoanalysis, 1993 [1953–1974]). Freud analyzed Schreber's autobiography but never met Schreber himself. See "Psycho-Analytic Notes on an Autobiographical Account of a Case of Paranoia (Dementia Paranoides)" (1911), *Standard Edition*, 12: 1–79. See also Jean-Michel Quinodoz, *Reading Freud: A Chronological Exploration of Freud's Writings* (New York: Routledge, 2013), 101.

53. Freud, "A Case of Paranoia" (1911), *Standard Edition*, 12: 43.

54. Guy Hocquenghem, *Homosexual Desire* (Durham, NC: Duke University Press, 1993 [1972]), 56.

55. Ibid., 61.

56. See chapter 1, "Cruising, Hysteria, Knowledge: *The Man Who Knew Too Much* (1956)," in Greven, *Psycho-Sexual: Male Desire in Hitchcock, De Palma, Scorsese, and Friedkin*, 1st ed. (Austin, TX: University of Texas, 2013).

57. Freud, "Some Neurotic Mechanisms," *Standard Edition*, 18: 223.

58. McCallum, *Object Lessons: How to Do Things with Fetishism* (Albany, NY: State University of New York Press, 1999), 111.

59. See Freud, "Mourning and Melancholia" (1917), *Standard Edition*, 14: 239–258. Freud's 1917 essay has proven to be deeply influential for queer theory. For crucial readings of this essay along these lines, see Judith Butler, "Melancholy Gender/Refused Identification," *The Psychic Life of Power: Theories in Subjection* (Stanford, CA: Stanford University Press, 1997), 132–150; José Esteban Muñoz, "Photographies of Mourning: Melancholia and Ambivalence in Van Der Zee, Mapplethorpe, and *Looking for Langston*," *Race and the Subject of Masculinities*, eds. Michael Uebel and Harry Stecopoulos (Durham, NC: Duke University Press, 1997), 337–358; Douglas Crimp, *Melancholia and Moralism: Essays on AIDS and Queer Politics* (Cambridge, MA: MIT Press, 2002); David L. Eng and David Kazanjian, *Loss: The Politics of Mourning* (Berkeley, CA: University of California Press, 2003). For discussions of the queer implications of Freud's essay for antebellum American literature, see chapter 4 in David Greven, *Gender Protest and Same-Sex Desire in Antebellum American Literature: Margaret Fuller, Edgar Allan Poe, Nathaniel Hawthorne, and Herman Melville* (Farnham, Surrey, UK: Ashgate, 2014).

60. Butler, *Gender Trouble: Feminism and the Subversion of Identity* (New York: Routledge, 1990), 64.

61. Butler, "Melancholy Gender/Refused Identification," *The Psychic Life of Power*, 133.

62. Love, *Feeling Backward*, 2.

63. Jagose, *Queer Theory* (Carlton, Victoria, AU: Melbourne University Press, 1996), 3. Presciently, Jagose observed that the analytic framework, while primarily associated with lesbian and gay matters, also included "topics such as cross-dressing, hermaphroditism, gender ambiguity and gender-corrective surgery" (3).

64. Ibid, 98.

65. Freeman, *Time Binds: Queer Temporalities, Queer Histories* (Durham, NC: Duke University Press, 2010), xiii.

66. Doty, *Flaming Classics*, 157.

67. Doty, *Making Things Perfectly Queer: Interpreting Mass Culture*, 1st ed. (Minneapolis, MN: University of Minnesota Press, 1993), 3.

68. *Downhill*'s action begins at an exclusive boys' boarding school and focuses on the close friendship between two young men, Roddy (Novello) and Tim. Both men court a waitress named Mabel; when she becomes pregnant, she goes to the headmaster of the boarding school and falsely accuses Roddy of being the father. Tim is actually the father, but Roddy takes the blame for his friend, suffers expulsion, marries a manipulative and corrupt woman, and takes the titular path to self-destruction. Though he is reunited with his family and his honor is restored in the end, Roddy's dissolution links this role to the role of the Lodger. Roddy's emotional beatings leave him

fragile, bereft, and depleted. In the play *Down Hill*, Novello's female fans swooned when Roddy washed his hairy legs with soap and water onstage after a rugby match; Hitchcock filmed Novello from the waist up, which was risqué in its own way.

69. Paul Duncan, *Alfred Hitchcock: Architect of Anxiety, 1899–1980* (Köln, DE: Taschen, 2003), 46.

70. Allen, *Hitchcock's Romantic Irony*, 101.

71. Donald Spoto, *The Art of Alfred Hitchcock: Fifty Years of His Motion Pictures* (Garden City, NY: Doubleday, 1976), 49–50. In his revised 1992 version of this book, Spoto strangely removed all references to homosexuality. His 1976 take on the film is much sharper and sounder, in my view.

72. The montage that concludes the film pointedly takes a quizzical view of what has been won. Images of unstoppable, anonymous armies marching through the desert and of newspaper headlines boldly proclaiming British victory join a non-realist, stylized shot of Ashenden and Elsa's beaming faces, the couple happily united and far away from the international intrigue they have rejected. Hitchcock routinely eschewed specific political situations and explanations in his spy thrillers, but the lack of contextualization is especially striking here. Rather than comfortably celebrating either British military victory or the successful unity of the heterosexual couple, the concluding montage ironizes both. The implication is that the couple has been achieved *through* the infernal power of war machines, at any cost.

73. In his fine book on Hitchcock's English films, Charles Barr gives disappointingly short shrift to the importance of *Secret Agent*. He impugns Hitchcock for having Caypor's dog howl mysteriously when he is murdered, which he calls "the most portentously silly sequence Hitchcock ever made." See Barr, *English Hitchcock* (Moffat, UK: Cameron & Hollis, 1999), 165. The dog's howl is a non-realist but emotionally authentic means of conveying the horror of Caypor's senseless murder, amplified by the General's giggling indifference to the revelation that Caypor was not the German agent. Barr also pays little attention to the sexual themes so crucial to the film. Though he does not address the latter, Raymond Durgnat offers an astute assessment of the film within its English context in *The Strange Case of Alfred Hitchcock: Or, the Plain Man's Hitchcock* (Cambridge, MA: MIT Press, 1978), 131–137.

CHAPTER 1

1. Doty, "Queer Hitchcock," *A Companion to Alfred Hitchcock*, eds. Thomas Leitch and Leland Poague (Malden, MA: Wiley-Blackwell, 2011), 473–489; cited at 477.

2. Wood, "The Murderous Gays," *Hitchcock's Films Revisited* (New York: Columbia University Press, 2002 [1989]), 348, emphasis in original.

3. Diane Richardson argues that "the tension within and between feminist and queer theory can be understood as a pull between the disciplinary and enabling effects of gender and sexual categories." In queer theory texts such as those by Judith Butler, "the focus is primarily on the disciplinary effects of discourse. . . . For some feminists this highlights one of the limitations of queer theory, its reluctance to recognize that identity categories can provide both a space for political action as well as frameworks by which we become intelligible to ourselves and others." Richardson, "Bordering Theory," *Intersections between Feminist and Queer Theory*, eds. Diane Richardson, Janice McLaughlin, and Mark E. Casey, (Basingstoke, UK; New York: Palgrave Macmillan, 2006), 19–37; cited at 22–23.

4. In this film, the innocent heroine sacrificially takes the fall for the murder committed by the man she loves. As most critics have concluded, this film uses the murderer Handel Fane's shame over his mixed-raced heritage as a metaphor for homosexuality. There is an extraordinary sequence during a trapeze act in which ghostly images of the falsely accused woman, Diana Baring (Norah Baring), and the man trying to prove her innocence, the juror Sir John Menier (Herbert Marshall, who would go on to be a dependable support to Bette Davis), besiege Fane's consciousness and, apparently, conscience, since he suicidally plummets to his death. These images, paired expressionistic close-ups of man and woman, represent a psychic heterosexual normativity that the queer murderer can neither resist nor ignore.

5. For his analysis of *The Birds*, see Edelman, "No Future," *No Future: Queer Theory and the Death Drive* (2004), 111–154.

6. Modleski, "Resurrection of a Hitchcock Daughter (2005)," *The Women Who Knew Too Much: Hitchcock and Feminist Theory* (New York: Routledge, 2016 [1988]), 123–152.

7. Spoto, *The Art of Alfred Hitchcock: Fifty Years of His Motion Pictures*, 2nd ed., completely rev. and updated (New York: Doubleday, 1992), 281.

8. Thomson, *A Biographical Dictionary of Film: Third Edition* (New York: Knopf, 1994), 581.

9. Doty argues on behalf of not only Norman's queerness but also Marion Crane's sister Lila, who investigates the Bates house in the climax. Doty, *Flaming Classics: Queering the Film Canon* (New York: Routledge, 2000), 188.

10. Bloch, *Psycho* (New York: Overlook Press, 2010 [1959]), 29.

11. Ibid, 15.

12. Ibid, 35.

13. Ibid, 35.

14. Edelman, *No Future*, 78–81.

15. One critic writing about such matters who does consider the significance of Eve Kendall is Steven Cohan. See his book *Masked Men: Masculinity and the Movies in the Fifties* (Bloomington, IN: Indiana University Press, 1997), 12–15. Cohan pays particular attention to the race politics of the Hitchcock blonde.

16. As Paul Morrison, from a steadfastly Foucauldian perspective, observes, "traditional narrative is both heterosexual and heterosexualizing." Morrison, *The Explanation for Everything: Essays on Sexual Subjectivity* (New York: New York University Press, 2001), 72. Hitchcock's films, one might argue, merge a Foucauldian suspicion of structures of power with Freudian schemas.

17. Wexman, *Creating the Couple: Love, Marriage, and Hollywood Performance* (Princeton, NJ: Princeton University Press, 1993), 16.

18. Cavell, "*North by Northwest*," *Cavell on Film*, ed. William Rothman (New York: State University of New York Press, 2005), 41–58; cited passages at 49, 57. Cavell's essay was originally published as "*North by Northwest*," *Critical Inquiry*, Vol. 7, No. 4 (Summer 1981), 761–776.

19. Kael, *Hooked* (New York: Dutton, 1989), 228.

20. Britton, "Cary Grant: Comedy and Male Desire," *Britton on Film: The Complete Film Criticism of Andrew Britton*, ed. Barry Keith Grant (Detroit, MI: Wayne State University Press, 2009), 3–23; quoted passage at 23.

21. Sidney Gottlieb, "Hitchcock on Truffaut," *Film Quarterly*, Vol. 66, No. 4 (Summer 2013), 10–22; cited passages at 18–19. Transcribing portions of the interview that were not included in the published form, Gottlieb has enlarged our understanding of Hitchcock's self-representation

during his famous interviews with Truffaut. These newly available transcripts illuminate Hitchcock's at times controversial relationships with actresses, especially Tippi Hedren, who publicly denounced Hitchcock's onset treatment of her, particularly during the filming of *The Birds*.

22. As Truffaut put it, "in Hitchcock's cinema, which is definitely more sexual than sensual, to make love and to die are one and the same." See Truffaut, Alfred Hitchcock, and Helen G. Scott, *Truffaut/Hitchcock* (New York: Simon & Schuster, 1985), 346.

23. Millington, "Hitchcock and American Character: The Comedy of Self-Construction in *North by Northwest*," *Hitchcock's America*, eds. Jonathan Freedman and Richard H. Millington (New York: Oxford University Press, 1999), 135–154; quoted passage at 142.

24. As Landau observes of his performance, "I chose to play Leonard as a gay character. It was quite a big risk in cinema at the time. My logic was simply that he wanted to get rid of Eva Marie Saint with such a vengeance, so it made sense for him to be in love with his boss, Vandamm, played by James Mason. Every one of my friends thought I was crazy, but Hitchcock liked it. A good director makes a playground and allows you to play." Tim Burrows, "Martin Landau: 'I chose to play Leonard as gay': Martin Landau remembers filming Alfred Hitchcock's *North by Northwest* in 1958," *Telegraph*, 3/03/2016, http://www.telegraph.co.uk/culture/film/starsandstories/9601547/Martin-Landau-I-chose-to-play-Leonard-as-gay.html.

25. Bellour, *The Analysis of Film*, ed. Constance Penley (Bloomington, IN: Indiana University Press, 2001).

26. "Some Neurotic Mechanisms in Jealousy, Paranoia and Homosexuality" (1922), *Standard Edition*, 18: 221–232.

27. For an analysis of this era's institutionalized homophobic tactics, see David K. Johnson, *The Lavender Scare: The Cold War Persecution of Gays and Lesbians in the Federal Government* (Chicago: University of Chicago Press, 2004).

28. Cohen, *Hitchcock's Cryptonymies: Vol. 1. Secret Agents* (Minneapolis, MN: University of Minnesota Press, 2005), 187.

29. Edelman, *No Future*, 82–83.

30. For a sustained analysis of Hitchcock's Catholic themes beyond Chabrol and Rohmer, see Richard A. Blake, *Afterimage: The Indelible Catholic Imagination of Six American Filmmakers* (Chicago: Loyola University Press, 2000).

31. Cavell, *North by Northwest*, 57.

32. Christopher Morris reads the Christian significance of Hitchcock's "hanging" figures through both James Frazer and Michel Foucault. As Michael Walker parses: "In their very different ways, both of these writers agree on a religious reading of such figures, Frazer stressing death and resurrection, Foucault focusing on the state's use of the potent imagery of the Christian crucifixion to infuse fear through such rituals as public hanging." Morris reads the figures as representative of an "undecidability" that signifies no religious or political meaning; Walker disagrees, arguing along Frazerian lines that hanging motifs reflect Hitchcock's Christian themes, here death and rebirth. See Walker, *Hitchcock's Motifs* (Amsterdam: Amsterdam University Press, 2005), 203; Morris, *The Hanging Figure: On Suspense and the Films of Alfred Hitchcock* (Westport, CT: Praeger, 2002), 55 (Morris quoted in Walker).

33. Boss, *Empress and Handmaid: On Nature and Gender in the Cult of the Virgin Mary* (London: Cassell, 2000), 141.

34. John Milton, *Paradise Lost*, ed. Alastair Fowler, 2nd ed., Longman Annotated English Poets (London; New York: Longman, 1998).

35. "Suture" typically refers, in film studies, to the various methods whereby the viewer is "stitched" into the narrative, particularly in the editing technique of shot/reverse shot (one dear to Hitchcock) that hides any discrepancies between what the viewer believes she is able to see and what is actually visible in the world of the film. For the standard account of suture in film studies, see chapter 5 of Kaja Silverman's *The Subject of Semiotics* (New York: Oxford University Press, 1983).

36. Edelman, *No Future*, 109.

37. Cf. the outcry over the apparent homophobia of Jonathan Demme's 1991 film version of Thomas Harris's novel *The Silence of the Lambs*. In the intensive critical debates that followed, little to no attention was paid to the identification gay male viewers may have felt for the heroine Clarice Starling, played by Jodie Foster. Critics repeatedly associated the gay male spectator with the serial killer Jame Gumb (Ted Levine), who kills women and strips off their skin in order to fashion a grisly "woman suit." I discuss the ethics of cross-gender identification in the context of Demme's film in the last chapter of *Representations of Femininity in American Genre Cinema: The Woman's Film, Film Noir, and Modern Horror* (New York: Palgrave Macmillan, 2011).

38. See Joan Riviere's essay "Womanliness as a Masquerade," in *Formations of Fantasy*, eds. Victor Burgin, James Donald, and Cora Kaplan (London: Methuen, 1986), 35–44. The article was first published in *International Journal of Psychoanalysis*, Vol. 10 (1929): 303–313.

39. Mulvey's seminal 1975 essay for the journal *Screen*, "Visual Pleasure and Narrative Cinema," argued that conventional Hollywood cinema is organized around the male gaze that sexually objectifies the woman while devising strategies (voyeurism and fetishism) for warding off the threat of castration that she poses to the male screen protagonist. In her follow-up essay "Afterthoughts on 'Visual Pleasure and Narrative Cinema,'" Mulvey theorizes the relationship the female spectator maintains to the conventional film text as masochistic and transvestic. See Mulvey, "Afterthoughts on 'Visual Pleasure and Narrative Cinema' inspired by King Vidor's *Duel in the Sun* (1946)," *Framework*, Summer 1981; reprinted in *Visual and Other Pleasures*, 2nd ed. (Houndmills, Basingstoke, Hampshire, UK; New York: Palgrave Macmillan, 2009), 31–40.

40. Berenstein, *Attack of the Leading Ladies: Gender, Sexuality, and Spectatorship in Classic Horror Cinema* (New York: Columbia University Press, 1996), 47.

41. James Naremore, North by Northwest: *Alfred Hitchcock, Director*, Vol. 20 (New Brunswick, NJ: Rutgers University Press, 1993), 182.

42. Scholars such as Angelo Restivo and Edelman both discuss the queer ethics of Hitchcock's efforts to achieve the effects of "de-realization" in his later films like *North by Northwest* and the musical score-free *The Birds* (on which Bernard Herrmann, who wrote the scores to some of Hitchcock's greatest films, was nevertheless the sound consultant). As Restivo, writing in response to Edelman's theorization of queer negativity, observes:

> The change in Hitchcock's use of sound—at least in the period from *Vertigo* to *The Birds*—has indeed been noted by Elizabeth Weis, who characterizes the effects of Hitchcock's sound aesthetic in this period as an attempt to move "beyond the subjectivity" of the earlier films, using the soundtrack to break apart the system of spectatorial positioning constructed through point-of-view shots, which then allows the sound to seize the viewer more viscerally. This impulse in the sound aesthetic has, I would argue,

a correlative in the structure of the images, a kind of de-realization that occurs as figure and ground, or surface and depth, begin to become difficult to distinguish—as in, for example, the Mount Rushmore sequence of *North by Northwest*, where the ground has become literally a "figure," or in the suffusions of red on the surface of the screen in *Marnie*.

See Restivo, "The Silence of *The Birds*: Sound Aesthetics and Public Space in Later Hitchcock," in *Hitchcock: Past and Future*, eds. Richard Allen and S. Ishii-Gonzáles (New York: Routledge, 2004), 164–178; cited passage at 166. Restivo quotes Weis from her *The Silent Scream: Alfred Hitchcock's Sound Track* (Rutherford, NJ: Fairleigh Dickinson University Press, 1982), ch. 8.

43. The effect recalls that of Japanese martial arts films shown in the United States, their translated dialogue hopelessly out of sync with the original soundtrack.

44. Freud, "From the History of an Infantile Neurosis" (1918b), *Standard Edition*, 17: 1–122; cited at 33.

45. Freud, "Infantile Neurosis," *Standard Edition*, 17: 36.

46. Edelman, *Homographesis: Essays in Gay Literary and Cultural Theory* (New York: Routledge, 1994), 175. Edelman quotes from J. Laplanche and J.B. Pontsalis, *The Language of Psychoanalysis*, trans. Donald Nicholson-Smith (London: Hogarth Press, 1983), 112.

47. Pauline Kael, "The Man from Dream City," *New Yorker*, July 14, 1975: 40–68.

48. Nancy Nelson and Cary Grant, *Evenings with Cary Grant: Recollections in His Own Words and by Those Who Knew Him Best* (New York: W. Morrow, 1991), 219.

49. Robert J. Corber provides a nuanced critique of these oedipalizing paradigms in Bellour's and Mulvey's work in his *In the Name of National Security: Hitchcock, Homophobia, and the Political Construction of Gender in Postwar America* (Durham, NC: Duke University Press, 1993).

50. One of the key texts in which Freud expands upon his theory of identification is "The Ego and the Id" (1923), *Standard Edition*, 19: 3–69.

51. Straayer, *Deviant Eyes, Deviant Bodies* (New York: Columbia University Press, 1996).

52. See, e.g., Richard Dyer, "Gays in Film," *Jump Cut: A Review of Contemporary Media*, No. 18, August 1978: 15–16; Dyer, *The Matter of Images: Essays on Representation* (New York: Routledge, 1993); Alexander Doty, *Flaming Creatures* and *Making Things Perfectly Queer: Interpreting Mass Culture* (Minneapolis, MN: University of Minnesota Press, 1993); Thomas Waugh, *Hard to Imagine: Gay Male Eroticism in Photography and Film from Their Beginnings to Stonewall* (New York: Columbia University Press, 1996); Brett Farmer, *Spectacular Passions: Cinema, Fantasy, Gay Male Spectatorships* (Durham, NC: Duke University Press, 2000); Michael DeAngelis, *Gay Fandom and Crossover Stardom: James Dean, Mel Gibson, and Keanu Reeves* (Durham, NC: Duke University Press, 2001).

53. McCann, *Cary Grant: A Class Apart* (New York: Columbia University Press, 1996), 120–121.

54. Donald Spoto, *The Dark Side of Genius: The Life of Alfred Hitchcock* (New York: Da Capo Press, 1999 [1983]), 86.

55. McCann, *Cary Grant*, 190.

56. Britton, "Cary Grant," 5. The extent to which the woman, in her desires and her potential for aggression, is complicit in her own exploitation is an uncomfortable, not easily resolved question in the Hitchcock film. Certainly, Lina and Johnnie in *Suspicion* and Alicia and Devlin in *Notorious* play sadomasochistic games *with* one another, and each heroine nearly perishes at the film's climax as a result of these games.

57. Orr, *Hitchcock and Twentieth-Century Cinema* (New York: Wallflower, 2005), 36.

58. "Grant's acting creates the attractiveness of male femininity and of the relationships enabled by it." Britton, "Cary Grant," 23.

CHAPTER 2

1. *Shadow of a Doubt* is the sixth of Hitchcock's American films, on occasion called his favorite film by the director and notable for his close collaboration with the playwright Thornton Wilder, best known for the 1938 *Our Town*, who wrote the original screenplay. Credited as well for the final screenplay were Sally Benson (a *New Yorker* short-story writer and playwright brought in to work on the family dialogue, especially the children's) and Hitchcock's wife and career-long collaborator Alma Reville. The screenplay was based on an original story by Gordon McDonell, reworking a real-life murder case. Patricia Collinge, who plays Emma Newton in the film, wrote some additional dialogue. Hitchcock himself made contributions and worked closely with Wilder, who was irritated by the changes made to his script, which he discovered when seeing the film for the first time. See Penelope Niven, *Thornton Wilder: A Life*, 1st ed. (New York: Harper, 2012), 537.

That this was Hitchcock's favorite film is a postulation maintained into the present by such figures as Patricia Hitchcock O'Connell, the director's daughter; see her interview in *Beyond Doubt: The Making of Hitchcock's Favorite Film*, dir. Laurent Bouzereau (Universal Studios Home Video, 2000), DVD Extra. Yet Hitchcock also corrected this impression during his interviews with Francois Truffaut, first published in 1967: "I wouldn't say that *Shadow of a Doubt* is my favorite picture; if I've given that impression, it's probably because I feel that here is something that our friends, the plausibles and logicians, cannot complain about." See François Truffaut, Alfred Hitchcock, and Helen G. Scott, *Hitchcock*, rev. (New York: Simon & Schuster, 1985), 151.

2. Thornton Wilder's own sexuality may have influenced his screenplay for *Shadow*. "A case can be made that Wilder was bisexual in his emotional affinities, celibate by choice or circumstance more often than not, and private about his sexual relationships. . . . Wilder's private writings suggest sexual constraint, repression, sublimation, and, at times, self-imposed celibacy, but he did not leave definitive answers." Niven, *Thornton Wilder*, 438.

3. Truffaut, *Hitchcock*, 153.

4. Moreover, to view Emma as an anomaly is to ignore the depth of Hitchcock's sustained maternal portraits in *The Birds* and *Marnie* and also the surprising poignancy of his more "perverse" mother figures like Mrs. Sebastian in *Notorious* (associated with fascism) and Bruno Anthony's mother in *Strangers on a Train* (who exhibits an amoral indifference to the murder of a woman, linking her to the killer Bruno). When considered within the larger pattern of maternal representation in Hitchcock films, Emma reflects an ongoing directorial preoccupation.

5. *Rope*, at least in certain moments, depicts straight woman/gay male affinities; in *Rebecca*, no such affinities exist between the Sapphic Mrs. Danvers and the heroine, menaced not only by Danvers but also by the memory of "Danny's" too-close intimacy with the sexually voracious Rebecca. A similar impasse occurs in *Stage Fright*, in which the heroine Eve Gill (Jane Wyman), attempting to clear her boyfriend Jonathan Cooper (Richard Todd) of murder charges, pretends to be the assistant to the witty and carnal stage performer Charlotte Inwood (Marlene Dietrich). Jonathan claims that Inwood is framing him for the murder of her husband, which he further claims she committed. Eve believes that she has exposed Inwood as the actual killer, but Jonathan, it turns out, truly is a murderer. Eve's exposure of Inwood's involvement in the murder reveals the

heroine's affiliation with authoritarian forces. After Inwood offers her a gift of money, Eve tricks the older woman into confessing her role in the crime as the detectives hidden in the theater listen in; Eve literally puts Inwood into their hands. Yet Eve is herself betrayed and menaced by Jonathan, who comes close to killing her. Eve's greater endangerment at the hands of the man she has tried to help parallels and exceeds her punitive treatment of Inwood.

6. Raymond Williams, *Marxism and Literature* (Oxford, UK: Oxford University Press, 1977), 109–110.

7. "A lived hegemony is always a process. It is not, except analytically, a system or a structure. It is a realized complex of experiences, relationships, and activities, with specific and changing pressures and limits. . . . Moreover. . . . it does not just passively exist as a form of dominance. It has continually to be renewed, recreated, defended, and modified. It is also continuously resisted, limited, altered, challenged by pressures not at all its own. . . . The reality of cultural process must then always include the efforts of and contributions of those who are in one way or another outside or at the edge of the terms of the specific hegemony." Williams, *Marxism and Literature*, 112–113.

8. Ernesto Laclau and Chantal Mouffe, *Hegemony & Socialist Strategy: Towards a Radical Democratic Politics* (London; New York: Verso, 1985), 134.

9. Ibid., 161.

10. Ibid.

11. Hitchcock's films demonstrate the impact of this pervasive capitalist pattern in human relationships. Money lust motivates and facilitates not only sexual desire but also efforts to control and injure others in his body of work, as it does in film noir and crime fiction; prime examples include *Dial "M" for Murder, Rear Window, To Catch a Thief, Vertigo, Psycho*, and *Marnie*. The director's engagements with economic matters would be a worthwhile project that far exceeds this book's scope.

12. Wood, "Ideology, Genre, Auteur (1976)," *Hitchcock's Films Revisited*, rev. (New York: Columbia University Press, 2002), 300.

13. Wood, *Hitchcock's Films Revisited*, 337.

14. Wood often made strong cases for works that were maligned for their stereotypical or apparently offensive nature, such as William Friedkin's film *Cruising* (1980), in which Al Pacino's straight undercover NYC detective infiltrates the gay SM leather underworld, posing as one of their own to investigate a string of murders targeting gay men. See the chapter on *Cruising* in Wood, *Hollywood from Vietnam to Reagan—and beyond*, expanded and rev. ed. (New York: Columbia University Press, 2003).

15. Leo Bersani, *Is the Rectum a Grave?: And Other Essays* (Chicago; London: University of Chicago Press, 2010), 10, 14–15. "Is the Rectum a Grave?" was originally published in *October* 43 (Winter 1987): 197–222.

16. Thomas Elsässer, "The Dandy in Hitchcock," *Alfred Hitchcock: Centenary Essays*, eds. Richard Allen and S. Ishii-Gonzales (London: British Film Institute, 1999), 3–13.

17. Allen, *Hitchcock's Romantic Irony*, 65.

18. Ibid., 111.

19. For a relevant discussion of the incest/homosexuality metaphor in the contemporaneous works of Tennessee Williams and Gabriel Garcia Lorca, see José I. Badenes, "Triangular Transgressions: Tennessee Williams' *The Purification's* Debt to Gabriel Garcia Lorca's *Blood*

Wedding," *Old Stories, New Readings: The Transforming Power of American Drama*, eds. Mir López-Rodríguez, Inmaculada Pineda-Hernández, and Alfonso Ceballos Muñoz (Newcastle upon Tyne, UK: Cambridge Scholars Publishing, 2015), 101–114.

20. Allen, *Hitchcock's Romantic Irony*, 128. Allen commendably discusses the series of female dandies and rogues in Hitchcock, such as Marlene Dietrich's stage performer in *Stage Fright* and even the masquerade-donning Marnie.

21. Margaret Sönser Breen, *Narratives of Queer Desire: Deserts of the Heart* (New York: Palgrave Macmillan, 2009), 161.

22. Katherine V. Snyder, *Bachelors, Manhood, and the Novel, 1850–1925* (New York: Cambridge University Press, 1999), 211. For discussions of the queer bachelor in Victorian through twentieth-century fiction, see Barry McCrea, *In the Company of Strangers: Family and Narrative in Dickens, Conan Doyle, Joyce, and Proust* (New York: Columbia University Press, 2011), esp. 60–65.

23. John D'Emilio, *Sexual Politics, Sexual Communities: The Making of a Homosexual Minority in the United States, 1940–1970*, 2nd ed. (Chicago: University of Chicago Press, 1998), 52.

24. Ibid.

25. Craig M. Loftin, *Masked Voices: Gay Men and Lesbians in Cold War America* (Albany, NY: State University of New York Press, 2012), 9. Loftin refers to these Kinsey works: *Sexual Behavior in the Human Male* (Philadelphia, W.B. Saunders, 1948); *Sexual Behavior in the Human Female* (Philadelphia: W.B. Saunders, 1953). See also Robert Corber's books *Cold War Femme: Lesbianism, National Identity, and Hollywood Cinema* (Durham, NC: Duke University Press, 2011); *Homosexuality in Cold War America: Resistance and the Crisis of Masculinity* (Durham, NC: Duke University Press, 1997).

26. Loftin, *Masked Voices*, 10–11.

27. See Heather Love's essay considering the overreliance on thick description in post-war sociology and the relevance of Erving Goffman's microanalysis "Close Reading and Thin Description," *Public Culture* (2013) 25: 401–434. In his 1959 *The Presentation of Self in Everyday Life*, Goffman used the metaphors of theater and drama to offer his theory known as "the drama-turgical model of social life." See Goffman, *The Presentation of Self in Everyday Life* (Garden City, NY: Doubleday, 1959).

28. Julia Erhart, "Laura Mulvey meets Catherine Tramell meets the She-man: counter-history, reclamation, and incongruity in lesbian, gay, and queer film and media criticism," *A Companion to Film Theory*, eds. Toby Miller and Robert Stam (Malden, MA: Blackwell, 2004); cited at 175.

29. Ibid.

30. Richard Barrios, *Screened out: Playing Gay in Hollywood from Edison to Stonewall* (New York: Routledge, 2003), 201.

31. Hitchcock's, Wilder's, and Cotten's efforts to make Uncle Charlie an attractive figure eerily parallel the media's fascination with killers whose homosexuality seemed incommensurate with their conventionally masculine demeanors, such as Wayne Lonergan. In October of 1943 (*Shadow* premiered in January of that year), a man named Wayne Lonergan was arrested for murder.

> Lonergan, described by *Time* magazine as a "handsome, six-foot, crop-headed Royal Canadian Air Force aircraftman," had brutally murdered his American socialite wife. The details were lurid even by tabloid standards: Lonergan had been "kept" by an older gay man all the time he was married to the beautiful Patricia Burton [and had even had

an affair with her father].... The homosexual-as-psychotic murderer was one thread of the fabric of Depression-era social mythology [one recalls the infamous Leopold and Loeb murder case in 1924 Chicago that inspired *Rope*]. The queer killer might be many things, in this scenario, even married with a child, but he wasn't supposed to be dashingly good-looking and athletically muscular. The Lonergan case seemed to fuel the wish to see gay men as crafty and dangerous, even as it further challenged stereotypes about weak homosexuals—and stirred the interest of young men combing the books and magazines of the day for any mention of the topic.

John Loughery, *The Other Side of Silence: Men's Lives and Gay Identities: A Twentieth Century History*, 1st ed. (New York: H. Holt, 1998), 153–154.

32. Barrios, *Screened Out*, 10.

33. Snyder, *Bachelors, Manhood, and the Novel*, 17.

34. Doty, "Queer Hitchcock," *A Companion to Alfred Hitchcock*, eds. Thomas Leitch and Leland Poague (Malden, MA: Wiley-Blackwell, 2011), 473–489; cited at 478.

35. Doty, "How Queer is My *Psycho*," *Flaming Classics: Queering the Film Canon* (New York: Routledge, 2000), 155–189; quoted material at 180. As I argue in my chapter on the death mother, Doty's reading of Lila Crane, who investigates her sister's disappearance and solves the mystery of her murder, as a lesbian raises many provocative and vexing questions.

36. Eve Kosofsky Sedgwick, *Epistemology of the Closet* (Berkeley, CA: University of California Press, 1990), 1.

37. Ibid., 11.

38. See the chapter on *Shadow of a Doubt* in William Rothman, *Hitchcock: The Murderous Gaze*, 2nd ed. (Albany, NY: State University of New York Press, 2012), 181–254.

39. For the standard reading of *Rebecca* as a lesbian text, see the chapter "Female Spectator, Lesbian Specter" in Patricia White, *Uninvited: Classical Hollywood Cinema and Lesbian Representability* (Bloomington, IN: Indiana University Press, 1999), 61–93.

40. Fodder for another discussion: Mrs. Danvers acknowledges the natural world as a presence beyond even Rebecca's power and omnipresent reach: "It wasn't a man, it wasn't a woman who beat her—it was the sea."

41. Halberstam, *Skin Shows: Gothic Horror and the Technology of Monsters* (Durham, NC: Duke University Press, 2000), 64–66.

42. Niven, *Thornton Wilder*, 632.

43. Sedgwick, "Some Binarisms: *Billy Budd*: After the Homosexual," *Epistemology of the Closet*, 91–130; specific reference to Claggart as "a homosexual in this text" at 92. Melville's novella, famously homoerotic, offers in its titular figure a young sailor whose outward physical beauty exudes the essence of his moral beauty, specifically his lack of knowledge of evil. The satanic Claggart, the master-at-arms who envies Billy intensely enough to frame him for mutiny, may be said to perform an elaborate initiation rite, forcing Billy to confront evil in the form of Claggart's own false accusations. Famously, Billy, who stutters when anxious, cannot speak in this moment, cannot articulate his own innocence—he can only use his fist, and he does so, striking Claggart dead on the spot. "Struck by an angel of God—but the angel must hang!" surmises the authority figure present at the scene, Captain Vere. Herman Melville et al., *Billy Budd, Sailor (an inside Narrative) Reading Text and Genetic Text* (Chicago: University of Chicago Press, 1962), 101.

44. The narrator of *Billy Budd* describes the handsome, innocent, yet morally undeveloped young blond sailor as "little more than an upright barbarian, much such perhaps as Adam presumably might have been ere the urbane Serpent wriggled himself into his company." Melville, *Billy Budd*, 51.

45. See chapter 4, "The Woman Who Was Known Too Much," in Tania Modleski's study *The Women Who Knew Too Much: Hitchcock and Feminist Theory*, 3rd ed. (New York: Routledge, 2016), 55–68.

46. As Hitchcock said to Truffaut, "He is destroyed in the end, isn't he? The niece accidentally kills her uncle." Truffaut, *Hitchcock*, 153.

47. For a discussion of the female Fury in classical Hollywood films, related to but also distinct from the femme fatale in that her role is to punish men for their crimes against women, see chapters 2 and 5 in David Greven, *Representations of Femininity in American Genre Cinema: The Woman's Film, Film Noir, and Modern Horror*, 1st ed. (New York: Palgrave Macmillan, 2011).

48. Recent critics have explored connections between Hitchcock, the Englishman who moved to America, and Henry James, the American who moved to England. James's tale "The Beast in the Jungle" (1903) is another interesting precedent for *Shadow of a Doubt*. The tale's protagonist John Marcher feels that he has spent his life waiting for some *thing* to happen, an event that will define his life. A strangely recessive female character, May Bartram, a woman Marcher has met again after several years, decides—for reasons left ambiguous—to keep watch for this event with Marcher. Unlike May Bartram, Charlie's effort is not to wait out the event that will befall her dark intimate—for Charles, such an event would be his exposure, capture, and/or next murder—but to oust him from her home.

49. Rothman, *Murderous Gaze*, 230.

50. Fascinatingly, this theme had autobiographical resonance for Thornton Wilder, who was born prematurely and a twin; his identical twin brother was stillborn, however. Wilder was haunted by the knowledge of his dead twin, and the idea of a double being part of one's life became an obsession for the author. Martin Blank, "Wilder, Hitchcock, and *Shadow of a Doubt*," eds. Martin Blank, Dalma Hunyadi Brunauer, and David Garrett Izzo, *Thornton Wilder: New Essays* (West Cornwall, CT: Locust Hill Press, 1999), 409–417; quoted passage at 413. Blank also notes here that the idea of an accident, related to the child Charlie's skull fracture and possibly to his development of a murderous personality, was also a theme that ran throughout Wilder's work (414). Further indicating his involvement in the filmmaking process, Wilder recommended that Teresa Wright, the understudy for the lead role of the Broadway production of *Our Town*, be cast as Charlie.

51. In her famous essay "Woman and the Masquerade," Joan Riviere argues that, given the construction of femininity in culture, women must impersonate femaleness; being female is mimicry, a masquerade. See Riviere, "Womanliness as a Masquerade" (first published in *The International Journal of Psychoanalysis* 10 [1929]: 303–313). In *Femmes Fatales*, Mary Ann Doane notes that "masquerade is not theorized by Riviere as a joyful or affirmative play but as an anxiety-ridden compensatory gesture, as a position which is potentially disturbing, uncomfortable, and inconsistent, as well as psychically painful for the woman." See Doane, *Femmes Fatales: Feminism, Film Theory, Psychoanalysis* (New York: Routledge, 1991), 38.

52. William Rothman, *Must We Kill the Thing We Love?: Emersonian Perfectionism and the Films of Alfred Hitchcock* (New York: Columbia University Press, 2014).

53. Truffaut, *Hitchcock*, 153.

54. Emma embodies positively and negatively what Lauren Berlant describes as "woman's culture," "a capitalist, culture industry phenomenon dating from the nineteenth century in the United States that promotes a core form of gendered personhood for women; its diverse texts are linked by the claim that women identify with each other as women despite the myriad economic, social, and political forces that create differences and antagonisms among them. What links women across these fractures is the identification of women with the pleasures and burdens of reproducing everyday life in the family, which in the United States, since the end of the nineteenth century and the beginning of the twentieth, has meant, among other things, being charged with managing dynamics of affective and emotional intimacy." Berlant, *The Female Complaint: The Unfinished Business of Sentimentality in American Culture* (Durham, NC: Duke University Press, 2008), 170. Emma's indifference to or inability to hear the misogyny in Charles's rhetoric about the "useless" widows indicates something of the fissures involved here, at the very least a deep-seated anxiety in her negotiation of her roles as mother, wife, and sister. Given that Emma—unwittingly—"procures" Charles's next would-be victim, Mrs. Potter, we can add "friend" to this list of challenging roles.

55. Lee Edelman, *No Future: Queer Theory and the Death Drive* (Durham, NC: Duke University Press, 2004).

56. For an important analysis, especially in feminist terms, of the distinction between nostalgia and memory, see Gayle Greene, "Feminist Fiction and the Uses of Memory," *Signs* 16, 2 (Winter 1991): 290–321. Greene discusses "memory work" as a creative recovery of the past, but sees nostalgia as an antifeminist maneuver, a culturally sanctioned form of forgetting historically associated with women, the custodians of family histories in the forms of diaries, journals, scrapbooks, and so forth. Emma's preservation of Charles's photograph seems to occupy a difficult middle ground then between memory and nostalgia—for if it enshrines Charles in the latter, it is also representative of her own memory of trauma that she and her mother shared during Charles's transformative accident. That Emma asks Charlie to find the picture and bring it to Charles seems to me significant as well—Emma passes the female family historian role down to her daughter.

57. For a discussion of the implications of Charles's childhood head injury, see Mary Ann O'Farrell, "Bump: Concussive Knowledge in James and Hitchcock," in *The Men Who Knew Too Much: Henry James and Alfred Hitchcock*, eds. Susan M. Griffin and Alan Nadel, 73–84. "Uncle Charlie's concussion [skull fracture], the film suggests, has made him who he is, and who he is is someone who thinks he knows something that you don't know" (78). O'Farrell links the theme of knowledge to the (hetero)sexual relation and the Freudian primal scene, also reading the "Merry Widow Waltz" motif of the dancing couples in these terms.

58. Steven Bruhm, "The Counterfeit Child," *ESC: English Studies in Canada*, Vol. 38, Issue 3–4, Sept./Dec. 2012, 25–44; quoted passage at 43.

59. Ibid., 29.

60. The image of Charles lying in the boardinghouse bed at the start of the film is preceded by an image of male children playing a game on the street below; this is certainly relevant. Their homosocial camaraderie excludes both the adult Charles and, most likely, would have excluded his quiet, solitary child self. Roger (Charles Bates), the youngest of the three Newton children, barely figures in the film as a presence at all, though there is a significant close-up of him on Emma's line to the telephone operator regarding her brother's visit: "My younger brother. The baby. Yes, of

course, a little spoiled. Families always spoil the youngest." (Hitchcock himself was the youngest child and second son of three children.) When Charles gives the family presents, he gives Roger a gun and Ann a stuffed animal, to her obvious discomfort (and Joe a watch, Emma a fur and the photographs of their parents, and Charlie the engagement ring). Charles reinforces strict gender roles in his choice of gifts, despite what would appear to be his own gender nonconformity as a child and even more clearly as an adult.

61. For a discussion of the gendered family dynamics of this film, see Elsie B. Michie, "Unveiling Maternal Desires: Hitchcock and American Domesticity," eds. Jonathan Freedman and Richard H. Millington, *Hitchcock's America* (New York: Oxford University Press, 1999), 29–54. James Mclaughlin grants Hitchcock a critical disposition toward normativity, embodied in the repressive and repetitive patterns of the family, and views his films as essentially disciplinary. See his essay "All in the Family: Hitchcock's *Shadow of a Doubt*," *A Hitchcock Reader*, 2nd ed., eds. Marshall Deutelbaum and Leland Poague (Chichester, UK; Malden, MA: Wiley-Blackwell, 2009), 145–155.

62. As contributors along with Tania Modleski and Susan White to the Hitchcock panel on feminism, queer theory, and the director's films that I organized for the 2014 Society for Cinema and Media Studies (SCMS) conference in Seattle, Lee Edelman and Joseph Litvak gave a paper, "Something Strange About *Strangers*: 'L'histoire du croque-mort,'" *croque-mort* being French for undertaker/mortician. Their title refers to the moment in *Strangers on a Train* when, to the question, "Es-que tu connais l'histoire du croque-mort?" Bruno Anthony erupts into laughter and responds, "Oui, je le connais!" Here is an excerpt from their description of the paper for the panel proposal: "When Bruno Anthony finally comes out of the shadows and encounters Guy Haines in public, Guy sees him sitting with Ann Morton and a French couple, the Darvilles. In the course of the conversation, Bruno speaks fluent French with the Darvilles and erupts into a boisterous laugh over a line not included in the screenplay and not translated in the film: 'Es-que tu connais l'histoire du croque-mort?' This paper will recover 'l'histoire du croque-mort,' establishing its place in the sexual and gendered economy of the film and locating its relation to Hitchcock's biting humor—a humor that centers, as so often in his work, on the animating power of sexual perversity in the context of a (literally) deadening socio-sexual norm."

63. For an elaboration on the cultural meanings of Bruno's French, indicative of Hitchcock's own tangles with censorship and his ability to speak multiple languages, metaphorically as well as literally, see James M. Vest, *Hitchcock and France: The Forging of an Auteur* (Westport, CT: Praeger, 2003), 26–28.

64. "In *Shadow of a Doubt* it is above all sexuality that cracks apart the family façade. As far as the Hays code permitted, a double incest theme runs through the film: Uncle Charlie and Emmy, Uncle Charlie and Young Charlie." Wood argues that Hitchcock must convey this theme through images rather than "verbally explicit" references. But the scene with the "loaded cane" dialogue goes beyond the "suppressed verbal play" that Wood argues "certain of the images depend on" to express the incest and other risqué themes. Robin Wood, *Hitchcock's Films Revisited*, rev. (New York: Columbia University Press, 2002), 300. Wood discusses the film in the chapter "Ideology, Genre, Auteur," 288–302, which was originally published in 1976.

65. Wilder, *Shadow of a Doubt*, in *Thornton Wilder: Collected Plays & Writings on Theater*, ed. J.D. McClatchy (New York: Library of America, 2007), 731–820; quoted material at 780. Hitchcock's role as adapter and collaborator on screenplays and the question of adaptation generally have emerged as key elements in contemporary scholarship on the director. See, e.g., R. Barton Palmer and David Boyd, *Hitchcock at the Source: The Auteur as Adaptor* (Albany, NY: State University of New York Press, 2011). For a specific analysis of Hitchcock's indebtedness to Wilder's realism, see Donna Kornhaber, "Hitchcock's Diegetic Imagination: Thornton Wilder, *Shadow of a Doubt*, and Hitchcock's Mise-en-Scène," *CLUES: A Journal of Detection*, Vol. 31, No. 1 (Spring 2013), 67–78.

66. Irresistibly, one recalls a key moment from Shakespeare's tragedy *Macbeth* (believed to have been written between 1599 and 1606). Speaking of his prophetic encounter with the three weird sisters, Macbeth laments that the witches gave him only "a fruitless crown" and "a barren scepter," signifying his inability to father the sons who would take his crown; the vision is so humiliating that even these symbols of infertility are "wrench'd with an unlineal hand [from him]/No son of mine succeeding" (*Macbeth* 3.1.60–64).

67. I must dispute the meticulous William Rothman's reading of this scene. First, it is Emma, not Charles, who responds, "His loaded everything!" Second, I would argue that the shot of Joe's expression may indicate his frustration at being left out of the conversation, as well as meant to display his "embarrassed face." Rothman finds the line "His loaded everything!" "shocking" coming from Charles's mouth, and that it adds to the entire mocking "charade" of his behavior at the dinner table. But since the line comes from Emma and not Charles, it is even more shocking, signifying a sexual appetite utterly unsatisfied by her muffled, wan husband. (The shot of Joe during the exchange suggests that he's got his own frustrations.) As I suggest in the main text, the whole obscurely in-joke exchange actually seems to be a way of making a risqué sexual joke that both addresses the suspect nature of Charles's sexuality and dances around the scary subject entirely. See Rothman, *Murderous Gaze*, 224.

68. Bouzereau, *Beyond Doubt: The Making of Hitchcock's Favorite Film*. See also Patrick McGilligan, *Alfred Hitchcock: A Life in Darkness and Light*, 1st ed. (New York: Regan Books, 2003), 311.

69. Murray Pomerance, *Alfred Hitchcock's America* (Cambridge, UK: Polity, 2013), 56.

70. This earlier scene is significant for both its depiction of Charles's transgressive, anarchic energy as he makes a mockery of the sententious atmosphere of the bank (mortifying Joe and making Charlie borderline angry in her discomfort at her uncle's behavior) and Mrs. Potter's sexually forward demeanor when meeting Charles. One might almost say that she too readily conforms to his image of widows when, in apparent jest, she gaily and flirtatiously remarks, "There's one good thing in being a widow, isn't there? You don't have to ask your husband for money!" If we take Mrs. Potter as representative of the type that Charles despises, what he seems to hate is the older woman's vitality, economic power, agency, and unselfconscious pleasure in her own capacities. The Merry Widow and the dark dandy double one another in their transgressive tweaking of the moralism of the social order, but this dandy is also a misogynistic killer. Charles cannot recognize his similarities to the woman who will most likely be his next victim, while she is utterly dazzled by his charm. Charles *does* recognize, however, that Charlie's gender nonconformity, tenacity, and potential for violence closely mirror his own. This recognition does not protect Charlie from her uncle's contempt or his murderous wrath. With disdain, he calls her "the clever little girl who

[thinks she] knows something" and proceeds to try to kill the thing he loves repeatedly, however unsuccessfully each time.

71. For a discussion on the positive valuation of femininity's associations with the domestic sphere, particularly the kitchen, and the nineteenth-century ideology of woman's domestic role, see chapter 5, "Sentimental Power: *Uncle Tom's Cabin* and the Politics of Literary History" in Jane P. Tompkins, *Sensational Designs: The Cultural Work of American Fiction, 1790–1860* (New York: Oxford University Press, 1985), 122–146. Tompkins argues that Stowe advocates a new-world order of mothers in which power resides in the maternal, domestic space of the kitchen; *Shadow* can only be said to parody such an order.

72. Collinge's tremulous acting style is on vivid display in William Wyler's superb 1941 film adaptation of Lillian Hellman's *The Little Foxes*, a melodrama set in the post-Reconstruction Era South, in which Teresa Wright plays Alexandra, the daughter of Bette Davis's icy, power-seeking Regina Giddens, and Collinge plays her alcoholic, abused sister-in-law "Birdie" Hubbard. Collinge's performance in this film is wrenching, especially when she confesses to her niece-in-law Alexandra that she loves her more than her petty, mean-spirited son Leo (Dan Duryea), a confession that Birdie's abusive husband responds to by striking her.

73. Pomerance, *Alfred Hitchcock's America*, 53.

74. The asexual, fussy Herb, who always wanders in around dinner time to discuss the perfect murder with Charlie's father, is another potentially queer figure in that he seems as alienated from heterosexuality and the family as possible. "They're literary critics," Emma describes them to Charles after noting Herb's consistent timing, a detail that links both, perhaps, to Thornton Wilder and his literary art. Herb also, like many queer male personae in Hitchcock, has an overly close maternal relationship. "How's your mother, Herb?" asks Joe. "Oh, uh, just middling," Herb responds about the mother he cares for well into his adulthood. It should be noted that Charlie more or less directs her rage at her uncle's behavior at Herb, when she explodes at both him and her father for their murder-minded post-prandial conversation. This revealed hostility marks the scene in which Herb rescues Charlie from the garage as an ameliorative moment. Boasting, rather poignantly, of having been at the right place at the right time to save Charlie ("Lucky thing!"), Herb is met with the heroine's smiling approbation at last. "I'm glad you happened to be going by, Herb," Charlie responds. It's a small, fleeting moment, but it establishes that Charlie does not broadly oppose nonnormative males. Also interesting to consider, any sustained interaction between Herb and Charles is unthinkable.

75. "The Hitchcocks' notes had hinted at an incestuous relationship between the niece and her uncle—'her being attracted to him'—creating tension between the mother and daughter. Now, in Hitchcock's work with Wilder, safer 'twinship' motifs emerged—like the doppelgangers of German expressionism." McGilligan, *Hitchcock*, 310.

76. In a semiotic study of narrative, Denis Jonnes observes that "the moment of sexual initiation, whether in or out of marriage, is one charged with significance for both men and women, and marks for both sexes (however variously the cultural significance attached to each) a fundamental transformation of position within the sexual-familial-generational system. Indicative of something more than simply a coming-of-age, achievement of maturity, or successful completion of an act of transfer or exchange, it raises at the most fundamental level the question of procreative capability: the power to parent. Thus, it points to a new cluster of relations and sequences" related to the new possibilities of "mate and parent roles." Denis Jonnes, *The Matrix of Narrative: Family*

Systems and the Semiotics of Story (Berlin; New York: Mouton de Gruyter, 1990), 165. Charles's murders of women not only substitute for but provide the grimmest possible defense against actual genital contact with them; Charlie's desire to kill her uncle substitutes for and defends against heterosexual desire. If, as Denis Jonnes argues, both female and male sexual initiation is a crucial trope for narrative, in *Shadow*, initiation itself emerges as a figure of impossible desire, of sexual *un*fulfilment. The incestuous themes of the film reinforce this sense of impasse and impossibility.

77. In the 1940s, most "young American women were still oriented toward heterosexual monogamy and marriage." While the war did inspire a quest for new sexual freedoms, "the sexual freedoms of the 1940s, like the sexual revolution of the 1960s, was not as radical as its name. For most young women, marriage retained its primacy." Andrea S. Walsh, *Women's Film and Female Experience, 1940–1950* (New York: Praeger, 1984), 66.

78. Lillian Faderman, *Odd Girls and Twilight Lovers: A History of Lesbian Life in Twentieth-Century America* (New York: Columbia University Press, 1991 [paperback ed., 2012]), 121.

79. Mitchell, *Siblings*, 205.

80. McGilligan, *Hitchcock*, 318.

81. Greven, *Representations of Femininity in American Genre Cinema*, 164. I discuss *Shadow* here in comparison to *The Silence of the Lambs* in terms of gay male spectatorship and its uneasy, yet still meaningful, identification with the screen heroine in films in which the villain is typed as gay/queer/trans/sexually non-normative.

82. Juliet Mitchell, *Siblings: Sex and Violence* (Cambridge, UK;Malden, MA: Polity Press, 2003), 215. Mitchell argues that sibling relationships have been simultaneously disavowed within and central to psychoanalytic theory.

83. Ibid., 213.

CHAPTER 3

1. I am reworking Richard Allen's concept of suspenseful mystery for queer purposes. "In suspenseful mystery, something more is at stake than merely curiosity about the answer to a question; rather, what is posed in the narrative is a hidden danger that we at once fear and desire to reveal and confront." See Allen, *Hitchcock's Romantic Irony* (New York: Columbia University Press, 2007), 43.

2. Ibid., 11.

3. "*Spellbound* is a disaster," contends Pauline Kael, a "confection whipped up by jaded chefs." Kael, *5001 Nights at the Movies* (New York: Macmillan, 1991), 701. A notable exception to such denigrations is Lesley Brill's fine analysis of the film in chapter 6 of *The Hitchcock Romance: Love and Irony in Hitchcock's Films* (Princeton, NJ: Princeton University Press, 1988).

4. Andrew Britton, "Alfred Hitchcock's *Spellbound*: Text and Countertext (1986)," in *Britton on Film: The Complete Film Criticism of Andrew Britton* (Detroit, MI: Wayne State University Press, 2009), 193. I call this assessment surprising only in terms of the essay itself, since Britton's concluding statement about the film's aesthetic inadequacies falls within general critical estimations of it. Nevertheless, Britton's verdict rests uneasily alongside his general and customarily illuminating commentary, which elucidates the film's depth and complexity. Britton's conventional reading of Constance's sexuality as impaired before she meets Ballantyne and the lack of any attention to any queer potentialities are especially problematic.

5. Kael, *5001 Nights*, 701.

6. Doane, *The Desire to Desire: The Woman's Film of the 1940s* (Bloomington, IN: Indiana University Press, 1987), 46.

7. E. Ann Kaplan, *Trauma Culture: The Politics of Terror and Loss in Media and Literature* (New Brunswick, NJ: Rutgers University Press, 2005), 83–85.

8. "The fault, dear Brutus, is not in our stars,/But in ourselves, that we are underlings" (I.2.140–141). Andrew Britton points out that the film's opening quote from an early scene in Shakespeare's tragedy *Julius Caesar* has little to do with psychological disorder. Instead, it is one of Cassius's lines in which he attempts to convince Brutus to join the assassination plot against Caesar for his "ambition." *Julius Caesar* is one of the most homosocially oriented of Shakespeare's plays, as it is about the effects of the murder of a powerful leader by a group of driven but lesser men.

9. David Jarrett, "The Fall of the House of Clennam: Gothic Conventions in *Little Dorrit*," in *Gothic: Nineteenth-century Gothic: At Home with the Vampire*, eds. Fred Botting and Dale Townshend (New York: Taylor & Francis, 2004), 89–96; quoted passage at 89.

10. Leonard J. Leff, *Hitchcock and Selznick: The Rich and Strange Collaboration of Alfred Hitchcock and David O. Selznick in Hollywood*, 1st ed. (New York: Weidenfeld & Nicolson, 1987), 117.

11. Ibid., 123.

12. William MacAdams, *Ben Hecht: The Man behind the Legend* (New York: Scribner, 1990), 238.

13. Frances Beeding, *Spellbound* [*The House of Dr. Edwardes*] (Cleveland, OH: World Publishing Co., 1945 [1927]), 192.

14. "Some Neurotic Mechanisms in Jealousy, Paranoia and Homosexuality," *Standard Edition*, 18: 221–232.

15. Freud studied Schreber's autobiography; he never met him. See "Psycho-Analytic Notes on an Autobiographical Account of a Case of Paranoia (Dementia Paranoides)" (1911), *Standard Edition*, 12: 1–79. See also Jean-Michel Quinodoz, *Reading Freud: A Chronological Exploration of Freud's Writings* (New York: Routledge, 2013), 101.

16. Her effort is not to "take Freud's analysis on faith, but examine its grounds and workings." See Eve Kosofsky Sedgwick, *Between Men: English Literature and Male Homosocial Desire* (New York: Columbia University Press, 1985), 91–92.

17. Patrick Brantlinger, *The Reading Lesson: The Threat of Mass Literacy in Nineteenth Century British Fiction* (Bloomington, IN: Indiana University Press, 1998), 40.

18. To take the woman's film par excellence, *Now, Voyager* (Irving Rapper, 1942), as an example, the physically unattractive Charlotte Vale (Bette Davis), a shut-in within the Boston mansion presided over by her wealthy mother, transforms through the powers of psychiatric care into a "healthy" woman, and not only finds potential love with Jerry Durrance (Paul Henreid) but also becomes physically active and adventurous, playing tennis with Jerry's daughter Tina (Janis Wilson) and eventually taking her on camping trips.

19. Hitchcock's response to Truffaut's question, "Are you satisfied with *Rebecca*?" is characteristic (and Truffaut's question also seems leading): "Well, it's not a Hitchcock picture; it's a novelette, really. The story is old-fashioned; there was a whole school of feminine literature at the period, and though I'm not against it, the fact is that the story is lacking in humor." Truffaut, *Hitchcock*, 127.

20. "*Vertigo* tells us more about the impasse of the woman's being a symptom of man than most 'woman's films.'" Žižek, *Looking Awry: An Introduction to Jacques Lacan through Popular Culture* (Cambridge, MA: MIT Press, 1991), 33. Tania Modleski critiques this Žižekian line of argument as misogynistic in her new afterword, "Resurrection of a Hitchcock Daughter (2005)" to her *The Women Who Knew Too Much: Hitchcock and Feminist Theory*, 3rd ed. (New York: Routledge, 2016 [1988]), 134.

21. See Modleski's chapter on *Rebecca* in *The Women Who Knew Too Much*; White, "Hitchcock and hom(m)osexuality," in *Hitchcock: Past and Future*, eds. Richard Allen and S. Ishii-Gonzalès (London: Routledge, 2004), 211–229. White discusses both *Rebecca* and *Stage Fright* in the context of lesbian sexuality.

22. Robert Lang argues that female melodrama places a woman's "desire at the heart of the story." Lang, *American Film Melodrama: Griffith, Vidor, Minnelli* (Princeton, NJ: Princeton University Press, 1989), 49.

23. Doane, *The Desire to Desire*, 43.

24. According to Ben Hecht in one of his autobiographies, "The star for whom you were writing fell ill or refused to play in the movie for reasons that stood your hair on end. ('I won't do this movie,' said Ingrid Bergman of *Spellbound*, 'because I don't believe the love story. The heroine is an intellectual woman, and an intellectual woman simply can't fall in love so deeply.' She played the part very convincingly.)" Hecht, *Child of the Century* (New York: Simon and Schuster, 1954), 481.

25. That his patient Dora (whose real name was Ida Bauer), seeking help for her hysteria, feels disgust when she *should* be feeling sexual arousal appears to discomfit Freud. A *healthy* girl would be sexually excited if an older man made a pass at her. "I should without question consider a person hysterical," asseverates Freud, "in whom an occasion for sexual excitement elicited feelings that were preponderantly or exclusively unpleasurable." Freud, "Fragment of an Analysis of a Case of Hysteria," *Standard Edition*, 7: 1–122; cited passage at 28.

26. Judith Roof, *A Lure of Knowledge: Lesbian Sexuality and Theory* (New York: Columbia University Press, 1991), 5, 52.

27. See Michie, *Sororophobia: Differences among Women in Literature and Culture* (New York: Oxford University Press, 1992).

28. Britton, "*Spellbound*," *Britton on Film*, 179.

29. Robin Wood, *Hitchcock's Films Revisited*, rev. (New York: Columbia University Press, 2002), 311–312.

30. "Based like Horney's opposite theories on notions of biology and reality, Deutsch's account has become redolent with normative morality. Libido has become biological: 'as a zone of active energy the clitoris lacks the abundant energy of the penis; even in the most intense masturbatory activity it cannot arrogate to itself such a measure of libido as does the latter organ.'" Mitchell argues that the "distasteful psychologizing to which Deutsch is prone" is produced by the "underlying biologism" of her theories. Juliet Mitchell and Sangay K. Mishra, *Psychoanalysis and Feminism: A Radical Reassessment of Freudian Psychoanalysis*, rev. ed. (New York: Basic Books, 2000), 127. Mitchell quotes from Deutsch, "The Psychology of Women in Relation to the Functions of Reproduction," originally published in 1925 in the *International Journal of Psycho-analysis*, reprinted in *The Psycho-Analytic Reader; an Anthology of Essential Papers with Critical Introductions*, ed. Robert Fliess, The International Psycho-Analytical Library, No. 38 (London: Hogarth Press, 1950), 165–179; cited passage at 168.

31. Ian, *Remembering the Phallic Mother: Psychoanalysis, Modernism, and the Fetish* (Ithaca, NY: Cornell University Press, 1993).

32. Freud, "Femininity," *Standard Edition*, 22: 112.

33. Ibid., 112.

34. Ibid., 114–115.

35. Ardrey, Robert. *The Territorial Imperative, A Personal Inquiry Into the Animal Origins of Property & Nations* (New York: Atheneum, 1966).

36. Freud, "Femininity," *Standard Edition*, 22: 116.

37. What I believe Freud, seen in the most reparative light, is questioning here is why society would perpetually create a subject position and a subjectivity that was as troubled, troubling, and riddling as femininity? This isn't so much "What does a woman want?" as it is "What do *we* want from the feminine?" What does the creation of the feminine as such say *about* us?

38. Freud, "Femininity," *Standard Edition*, 22: 116.

39. Ibid., 117.

40. Ibid., 118.

41. Ibid., 126.

42. Mulvey, "Visual Pleasure and Narrative Cinema" (1975), *Visual and Other Pleasures*, 2nd ed. (Houndmills, Basingstoke, Hampshire, UK; New York: Palgrave Macmillan, 2009), 14–27; cited at 20.

43. For an incisive critique of Mulvey that develops the crucial concept of repressed homosexual voyeurism, see Steve Neale, "Masculinity as Spectacle: Reflections on Men and Mainstream Cinema," in *The Sexual Subject: A Screen Reader in Sexuality*, Screen Editorial Collective (London; New York: Routledge, 1992), 277–287; cited at 281.

44. Constance's stand anticipates contemporary neuroscience and actively opposes Freud, who placed great stock in the literary renderings of human experiences that she scoffs at.

45. Hecht's screenplay is collected in *Best Film Plays—1945*, eds. John Gassner and Dudley Nichols (New York: Crown Publishers, 1946), 57–114; quoted passage at 68–69.

46. Philippa Kelly, "Surpassing Glass: Shakespeare's Mirrors," originally published in *Early Modern Literary Studies* 8.1 (May 2002): 2.1–32, at http://extra.shu.ac.uk/emls/08-1/kellglas.htm.

47. See Greven, *Ghost Faces: Hollywood and Post-Millennial Masculinity* (New York: State University of New York Press, 2015).

48. As Samuels continues:

> Desperately attempting to avoid any confrontation with its own lack, the ego projects it "into the place of the Other," then using "this nothingness, or what Lacan called the 'object' (a), as a cause of its own desire or anxiety. In our current civilization and social structure, this dialectic between the Imaginary state of consciousness and the projected object of nothingness is most often played out in gendered and racial terms."

See Robert Samuels, *Hitchcock's Bi-Textuality: Lacan, Feminisms, and Queer Theory* (Albany, NY: State University of New York Press, 1998), 10.

49. Desired by both females and males, the beautiful Narcissus cruelly rejects his suitors of each sex, mocking "Hill-nymphs and water-nymphs and many a man." Ovid, *The Metamorphoses*, ed. A.D. Melville (New York: Oxford University Press, 1998), 3: 401.

50. Jacques Lacan, "The Mirror Stage as Formative of the Function of the *I* as Revealed in Psychoanalytic Experience," in *Ecrits: A Selection*, trans. Alan Sheridan (New York: Norton, 1977), 1–7. Lacan, in his theory of the mirror stage, argues that the formation of the ego occurs through the child's contemplation of his own image, the basis for the Imaginary, the passage from the pre-linguistic world of the mother and, along with the Symbolic and the Real, one of the three Lacanian "orders" of existence. The Symbolic is associated with language, law, rationality, and is therefore the order of the father; the Real is the unrepresentable. A crucial dimension of the child's encounter with the mirror stage is the mother's role. She stands behind the child, encouraging his self-identification with the image. One might say that *Spellbound* stages a secondary mirror stage in which maternal Constance plays this encouraging role for a tentative male in the process of becoming his own image.

51. Sándor Ferenczi diagnosed "spectrophobia" as "the dread of catching sight of one's own face in a mirror." Ferenczi, *Further Contributions to the Theory and Technique of Psycho-Analysis* (London: Hogarth Press, 1950 [1926]), 365.

52. Hecht, *Spellbound* screenplay, 73.

53. Blankness, as I will discuss in the chapter on *Marnie*, is associated with the heroine's dissociative states brought on by psychic distress. There are also moments of blankness associated with masculinity in Hitchcock's work, such as the inscrutable expression on Norman Bates's face after he has stopped staring at Marion Crane through the peephole behind a framed painting (which depicts the story of Susannah and the Elders, a scene of biblical peeping) and put the picture back on the wall. *Vertigo*, I argue, links this blankness to the film's idealization of racial whiteness. Both registers are present in *Spellbound*: Ballantyne's distress, which takes the form of an affectless self-perception, evokes Marnie's, while the film's obsessive trope of "white" arguably demands a race-based interpretation.

54. White, "A Surface Collaboration: Hitchcock and Performance," in *A Companion to Alfred Hitchcock*, eds. Thomas M. Leitch and Leland A. Poague (Chichester, West Sussex, UK; Malden, MA: Wiley-Blackwell, 2011), 181–198; cited passage at 189.

55. In my view, Peck gives a very affecting, beautifully nuanced performance. I am bewildered by the usual critical denigration of his performance.

56. See Greven, "Engorged with Desire: The Films of Alfred Hitchcock and the Gendered Politics of Eating," in *Reel Food: Essays on Food and Film*, ed. Anne Bower (New York: Routledge, 2004), 297–310.

57. Richard Allen, in his elaboration of the concept of romantic irony in Hitchcock's work, which takes the form of linking one thing to its opposite, such as human sexuality and perversity, ties the director's work to the artistic practices of Romanticism. As Chris Beyers observes, the male poets of Romanticism placed an emphasis on "the problem of understanding women as embodiments of their own ideas," one compounded by "the fact that they [had] trouble coming to grips with themselves. Byron generally depicts the self in the Hegelian state of becoming. In *Childe Harold's Pilgrimage*, the speaker asks, 'What am I?' only to answer his own question with one word: 'Nothing.' Yet this stance is not nihilistic since it anticipates the existential idea that the self and meaning must be created through action." Beyer, "Byron," in *Edgar Allan Poe in Context*, ed. Kevin J. Hayes (New York: Cambridge University Press, 2013), 251–259; cited passage at 256. *Spellbound* thusly revises traditional patterns of gendered fantasy. While Ballantyne typifies the idea of a male "nothing"-ness, his entire characterization can be read as the embodiment of Constance's shifting ideas about him.

58. Hauntingly beautiful, this sequence is nevertheless much shorter than the filmmakers intended it to be, the studio having radically shortened it, much to Ingrid Bergman's chagrin, although exactly how long the original sequence was and precisely what was cut remain contested, as reported in Spoto, *The Dark Side of Genius*, 277. Patrick McGilligan notes that "[l]ater interviews with Bergman have given rise to the idea that the dreams were originally 'a wonderful twenty-minute sequence that really belongs in a museum'—that Selznick hacked the Hitchcock-Dalí vision to bits. This is pure myth. . . . On-screen, the dreams totaled slightly under three minutes." While the dream sequence was supposed to be longer by at least forty or fifty seconds, it was never supposed to be the length Bergman later described it as being. "The only one of the vignettes to be dropped entirely was that of Bergman as a statue," reported James Bigwood. "The dreams may not have been hacked to bits, but Selznick fought them from the beginning." After the sequence was curtailed, "the director blamed Selznick, but he blamed the surrealist equally. The famed artist was 'really a kook,' Hitchcock told Charles Higham years later, whose notions were too bizarre for Hollywood." McGilligan, *Alfred Hitchcock: A Life in Darkness and Light*, 1st ed. (New York: Regan Books, 2003), 363–364.

59. Britton, "*Spellbound*," 187.

60. Ibid., 187.

61. Ibid., 187–188.

62. See Cavell's essay on *North by Northwest*.

63. Thomas Doherty introduces this term in his essay "Genre, Gender, and the *Aliens* Trilogy," in *The Dread of Difference: Gender and the Horror Film*, ed. Barry Keith Grant (Austin, TX: Texas University Press, 1996), 181–199; cited at 196. Of course, the wheel's tip could also be interpreted as the clitoris.

64. Simon Bronner notes, "In supernatural tales, a wheel associated with a natural circle shape (or anus) causes the thief to return the stolen goods." He gives an example of a story that emphasizes the anality of a farmer who determines who stole his purse filled with coins by rubbing balsam on the tail of a donkey—the posterior of an animal also called an "ass"—and commanding his men to rub the donkey's tail, telling them that the donkey will bray when the culprit rubs its tail. The farmer then smells the hands of the various male suspects and assumes that the one without the balsam smell on his hands must be the culprit because he never rubbed the donkey's tail. Bronner, *Explaining Traditions: Folk Behavior in Modern Culture* (Lexington, KY: University Press of Kentucky, 2011), 342.

65. Eve Kosofsky Sedgwick's famous theory of triangulated desire has its basis in Gayle Rubin's theory of the "traffic in women" and René Girard's theory of the importance of male rivalry in literary narrative. See Girard, *Deceit, Desire, and the Novel: Self and Other in Literary Structure* (Baltimore, MD: Johns Hopkins University Press, 1961); Gayle Rubin, "The Traffic in Women: Notes on the 'Political Economy' of Sex," in *Toward an Anthropology of Women*, ed. Rayna R. Reiter (New York: Monthly Review Press, 1975), 157–210; Sedgwick, "Gender Asymmetry and Erotic Triangles," in *Between Men*, 21–27.

66. Hyde, "The Moral Universe of *Spellbound*," in *A Hitchcock Reader*, eds. Marshall Deutelbaum and Leland Poague (Malden, MA: Wiley-Blackwell, 2009), 156–163; cited passage at 163, n.3; Wood quoted in Hyde, *Hitchcock's Films* (New York: A.S. Barnes, 1977), 44.

67. Britton, "*Spellbound*," 198.

68. Ibid., 188.

69. Knapp, "The Queer Voice in *Marnie*," in *A Hitchcock Reader*, eds. Marshall Deutelbaum and Leland Poague (Malden, MA: Wiley-Blackwell, 2009), 295–311; cited at 299.

70. Several suggestive moments code Alex as homosexual. Of both Devlin and Prescott, the CIA chief (Louis Calhern), Alex remarks, "He's very good-looking" and "Quite a handsome fellow." The most explicit bit of typing is his *Psycho*-like, too-close connection to his all-controlling virago mother.

71. As Doty writes, "Of course, not everyone finds Hitchcock's take on heterosexuality all that progressive or radical. For all of the elements of heteronormative exposé and critique in *Vertigo*, for example, there are aspects of the film that invite us to share Scottie's patriarchal romantic reverie." I would argue that this shared oneiric fascination is precisely the point and the power of the film—how easily seduced and mesmerized we are by not only the fantasy of ideal beauty and femininity but also by Scottie's own misogynistic fantasy. See Doty, "Queer Hitchcock," 483–484.

CHAPTER 4

1. When Miller published this essay, the AIDS crisis was still raging in the United States; no effective treatment for it was available; homophobia was at its height; and George Bush had taken office, extending his predecessor Ronald Reagan's reign. The intense suspicion of structures of power in Miller's essay and its palpable, though rhetorically contained, anger were rational, plausible responses to the infuriating national indifference to mass gay suffering, to say nothing of the openly derogatory public statements against gays and lesbians that marked the era. Nevertheless, I believe that Miller's essay says more about the grotesquely pervasive homophobia of its own moment than it does about Hitchcock's film.

2. "*Rear Window*'s Glasshole," *Out Takes: Essays on Queer Theory and Film*, ed. Ellis Hanson (Durham, NC: Duke University Press, 1999), 72–97.

3. Though the politics of anality are not his focus here, Miller writes decisively in a footnote:

Viewed as a sexual preference, male homosexuality is obviously a marginal phenomenon in Hitchcock's largely hetero-themed oeuvre; but it becomes considerably more suggestive when understood (as it is at every level of culture) as an insistence on the eroticized anus. Start counting up the many objects in the film that go from a retentive, integral state to an expulsive, ruptured, or sullied one: the firmly closed chest that ejects the rope; the "good crystal" that cracks in Philip's hand; the clean/encrusted candles, the neat/messy apartment, the piled/scattered books, the binding/slackening rope. . . . Hitchcock violates his usual proctophobic perfectionism so repeatedly here that it seems little more than the ruse of an anal *jouissance*.

Miller, "Hitchcock's Understyle: A Too-Close View of *Rope*," *Representations*, Vol. 121, No. 1 (Winter 2013): 1–30; cited at 29, n.14.

4. A vexing conflation: Criticism reinforces the associations between gay male sexuality and the anus that are rife in popular culture at its most homophobic. While criticism, especially queer theory, generally aims to be anti-homophobic, there are some disturbing overlaps here of which I encourage us to be mindful.

5. Fuss, "Oral Incorporations: *The Silence of the Lambs*," *Identification Papers* (New York: Routledge, 1996), 83–107.

6. I challenge the conventional wisdom that *The Silence of the Lambs* is homophobic and discuss its thematization of orality in chapter 3 of my book *Manhood in Hollywood from Bush to Bush* (Austin, TX: University of Texas Press, 2009).

7. Freud first wrote this study in 1905 and returned to it several times; he added the idea of the successive stages in 1915, and added the phallic stage in 1923, which includes the boy's discovery of the penis and the girl's of the clitoris. The genital stage occurs at puberty; the period between the phallic and genital is marked by "latency," when the child first begins school and sexual impulses are sublimated in favor of cultural achievement. Beatriz Markman Reubins, *Pioneers of Child Psychoanalysis: Influential Theories and Practices in Healthy Child Development* (London: Karnac Books, 2014), 21, provides a helpful analysis of these developments in Freud's thought.

8. See Freud, "Three Essays on the Theory of Sexuality," *Standard Edition*, 7: 198.

9. Links between cannibalism and homosexuality, literal and symbolic, inform key works of classic American literature (such as Poe's novel *The Narrative of Arthur Gordon Pym of Nantucket* [1838] and Melville's novels *Typee* [1846] and *White*-Jacket [1850]). The significance of this cannibalism/homosexuality trope in American literature has been explored by scholars such as Caleb Crain. As Crain observes in his essay "Lovers of Human Flesh," before the emergence of modern sexual taxonomies, cannibalism functioned on several metaphorical levels, one of which was homoerotic desire. He cites Théodore Géricault's 1819 painting *Le Radeau de la Méduse* (*The Raft of the Medusa*), which depicts men adrift at sea who have resorted to cannibalism, as an example. Crain discusses the ways in which Melville treats the ship as a setting rife with abuses of power—such as sodomitical rape. See Crain, "Lovers of Human Flesh: Homosexuality and Cannibalism in Melville's Novels," *American Literature* 66, No. 1 (1994): 25–53.

10. The blond, buff, Christ-like, and ostentatiously innocent young sailor Billy Budd is persecuted by the satanic, scheming Claggart, who, from envy and a desire that he cannot acknowledge or articulate, falsely accuses Billy of murder; the inarticulate Billy kills Claggart on the spot, punching him in the face rather than explaining that he is innocent. Hanged for having killed, Billy nevertheless salutes Captain Vere, who ordered his execution, before he dies. This execution scene parodies the crucifixion: The sailors who gather around his pristine corpse, feasting on this sacrificial lamb, love him but do nothing to protest his sentencing.

11. For his discussions of enunciation and directorial stand-ins for Hitchcock in films such as *Marnie*, see Raymond Bellour, *The Analysis of Film*, ed. Constance Penley (Bloomington, IN: Indiana University Press, 2000), 219, 236.

12. For an elaboration of these aspects of *Rope*, see David Sterritt, "The Diabolical Imagination: Hitchcock, Bakhtin, and the Carnivalization of Cinema," eds. Sidney Gottlieb and Christopher Brookhouse, in *Framing Hitchcock: Selected Essays from the Hitchcock Annual* (Detroit, MI: Wayne State University Press, 2002), 93–112, specifically 98–100.

13. As noted in the previous chapter, Craig Loftin in his historical research on gay and lesbian history argues that the mask, not the closet, was the figure for hidden homosexuality at mid-century. Nevertheless, the *cassone* retains a metaphorical suggestiveness as an enclosed space in which a man's murdered and desired body is hidden along with his killers' true motives.

14. Joseph Litvak, *Strange Gourmets: Sophistication, Theory, and the Novel* (Durham, NC: Duke University Press, 1997), 12.

15. Kael, *Taking It All In* (New York: Henry Holt & Co., 1984), 335.

16. "[H]omophobia both models itself on and disguises itself as a less contestably democratic-seeming anti-snobbery. But even 'liberal' discourses have adopted this procedure, modifying it only by further confusing snobbery with intellectuality itself." See Litvak, *Strange Gourmets*, 136.

17. Cuordileone, *Manhood and American Political Culture in the Cold War* (New York: Routledge, 2005), 136.

18. Donald Spoto, *The Dark Side of Genius: The Life of Alfred Hitchcock*, centennial ed. (New York: Da Capo Press, 1999), 86, 341.

19. For excellent analyses of the reception history of such associations, see Andrew Hewitt, *Political Inversions: Homosexuality, Fascism, & the Modernist Imaginary* (Stanford, CA: Stanford University Press, 1996); Laura Catherine Frost, *Sex Drives: Fantasies of Fascism in Literary Modernism* (Ithaca, NY: Cornell University Press, 2002). It is highly interesting that in 1945, Hitchcock and Sidney Bernstein, who would be his co-producer in the short-lived production company Transatlantic Pictures, attempted to make an eighty-minute documentary on Nazi concentration camps. The film, *German Concentration Camps Factual Survey*, was left unfinished. The footage that was created, which includes scenes from Dachau, Buchenwald, Belsen, and other Nazi concentration camps, was eventually shown on television in the U.S. and U.K. as *Memory of the Camps* (1985). The project was supervised by the British Ministry of Information and the American Office of War Information. A 2014 documentary film directed by Andre Singer, *Night Will Fall* chronicles the making of the 1945 British government documentary.

20. Camilla Fojas, *Cosmopolitanism in the Americas* (West Lafayette, IN: Purdue University Press, 2005), 120.

21. Allen, *Hitchcock's Romantic Irony* (New York: Columbia University Press, 2007), 120.

22. Ibid., 144.

23. In Allen's words, "Rupert's final speech in which he berates Brandon for distorting the meaning of his words, in his actions, has been criticized for its moralizing tone, but it does serve to restore the crucial distinction between the murderer (who acts on his impulses) and the aesthete in whom 'perversity' is contained, and hence it is surely a speech that commands the allegiance of Hitchcock himself." Allen, *Hitchcock's Romantic Irony*, 145.

24. Cuordileone, *Manhood and American Political Culture in the Cold War*, 136.

25. Tantalus, a son of Zeus, kills his son Pelops and feeds him to the gods; most abstain from the grisly meal, but a distracted Demeter eats Pelops's shoulder. The gods restore Pelops (replacing his shoulder with ivory) but they punish Tantalus by sending him to the underworld, where he is forever tantalized, in the experience he gives a name to, by luscious food and drink he can see but never consume. Another classical intertext for *Rope* that we might consider is the Platonic dialogue *The Symposium*, translated in 1818 by the Romantic poet Percy Bysshe Shelley as *The Banquet*. This dialogue about love, especially how the love of the beautiful leads to spiritual contemplation, has its narrative basis in a party thrown in the home of a male couple. A beautiful young man, the soldier/politician Alcibiades, arrives at the party drunk and declares his love for his older male mentor Socrates.

26. For an extended discussion of this dynamic, see chapter 2 of Greven, *Psycho-Sexual*.

27. Lawrence, "American Shame: *Rope*, James Stewart, and the Postwar Crisis in American Masculinity," in *Hitchcock's America*, eds. Jonathan Freedman and Richard Millington (New York: Oxford University Press, 1999), 55–76; cited passages at 71.

28. hooks, "Eating the Other: Desire and Resistance," in *Black Looks: Race and Representation* (Boston: South End Press, 1992), 21–39. hooks investigates the tendency for white culture to engage in fantasies of devouring the nonwhite. Her findings have been amplified by Kyla Wazana Tompkins in her *Racial Indigestion: Eating Bodies in the 19th Century* (New York: New York University Press, 2012).

29. This story was published in Williams's *One Arm: And Other Stories*, 1st ed. (New York: New Directions, 1948).

30. Abelove, "Freud, Male Homosexuality, and the Americans," *Dissent* 33 (Winter 1986): 59–69.

31. My reading of Freud here has been influenced by Jonathan Dollimore and his brilliant analysis of the centrality of perversity to Freud's work. See his *Sexual Dissidence: Augustine to Wilde, Freud to Foucault* (New York: Oxford University Press, 1991).

32. Jean Laplanche and J.B. Pontalis, *The Language of Psycho-Analysis* (New York: Norton, 1974), 212.

33. Nicolas Abraham and Maria Torok, "Mourning or Melancholia: Introjection *versus* Incorporation," in *The Shell and the Kernel: Renewals of Psychoanalysis*, ed. and trans. Nicholas T. Rand (Chicago: University of Chicago Press, 1994), 125–138; cited passage at 126–127.

34. "How . . . is it possible to mourn a lost loved object when the bond between subject and object lacks an adequate signifier? Is it possible to mourn a bond which cannot be named, which is subject to psychic censorship? . . . Is the homosexual freed from or isolated from the homophobia which characterizes her culture?" Hugh Stevens raises these important questions in the context of a queer reading of the work of Henry James. See Stevens, *Henry James and Sexuality* (New York: Cambridge University Press, 1998), 155.

35. Wood, *Hitchcock's Films Revisited*, rev. (New York: Columbia University Press, 2002), 350–351.

36. Arthur Laurents, *Original Story by: A Memoir of Broadway and Hollywood* (New York: Knopf, 2000), 127; Farley Granger, *Include Me Out: My Life from Goldwyn to Broadway*, 1st ed. (New York: St. Martin's Press, 2007), 67–71. See also *Rope Unleashed* (Laurent Bouzereau, 2000), a small feature on the *Rope* DVD (Universal, 2000).

37. Wood, *Hitchcock's Films Revisited*, 349–350.

38. David Sterritt, "Morbid Psychologies and So Forth: The Fine Art of *Rope*," in *Hitchcock at the Source: The Auteur as Adaptor*, eds. R. Barton Palmer and David Boyd (Albany, NY: State University of New York Press, 2011), 159–172; cited passage at 171, n.3.

39. See the several essays on Hitchcock, originally published in the journal *Cahiers du cinema* in the 1950s, collected in André Bazin, *The Cinema of Cruelty: From Buñuel to Hitchcock* (New York: Seaver Books, 1982), 101–180.

40. Sterritt, "Morbid Psychologies," 161.

41. Hitchcock characteristically deflates any such readings. As he remarked to Truffaut, "I undertook *Rope* as a stunt; that's the only way I can describe it. I really don't know how I came to indulge in it." François Truffaut, Alfred Hitchcock, and Helen G. Scott, *Hitchcock*, rev. (New York: Simon & Schuster, 1985), 179. Although the plot synopsis Truffaut provides makes reference to the killers as "two young homosexuals," he does not discuss the topic of homosexuality here with Hitchcock, nor does the interviewee bring it up.

42. Miller, "Anal *Rope*" (1990). *Inside/Out: Lesbian Theories, Gay Theories*, ed. Diana Fuss (New York: Routledge, 1991), 119–141; cited passage at 134, emphasis original.

43. See, e.g., Linda Williams's essay "Discipline and Fun: *Psycho* and Postmodern Cinema," in *Reinventing Film Studies*, eds. Linda Williams and Christine Gledhill (New York: Oxford University Press, 2000), 351–378. Williams provides a helpful overview of Hitchcock's manipulation of his audience's experiences, on a corporeal level, while watching the film, but leaves her analysis of the film at that level of somatic goosing. Miller's 2013 essay on *Rope* largely eschews the fierce analysis, valuable even if one disputes it, of the film's sexual politics he had earlier offered.

44. The purported "coldness" of Hitchcock's technique is well worth reexamining in broader terms. In *Original Story*, Arthur Laurents, who wrote the screenplay adaptation for *Rope* based on Patrick Hamilton's play and the actor/writer Hume Cronyn's story treatment, reveals what was, in his view, Hitchcock's "true obsession": the camera. Essentially, Laurents writes, Hitchcock "was a voyeur; *Rear Window* could have been his epitaph. He was consumed with his camera and the infinite possibilities in intricate maneuvers: how differently he was going to use it this time; what tricky, difficult shot he was going to pull off." Laurents criticizes Hitchcock for being so concerned with camerawork that, at times, it "got in the way of the story." This was Laurents's opinion of what happened with *Rope*. Laurents, *Original Story*, 124–125.

45. Wood, *Hitchcock's Films Revisited*, 351.

46. See Laurents's interview in "*Rope* Unleashed."

47. One cannot help but recall Mrs. Danvers in *Rebecca*, and see Mrs. Wilson as the antithesis of such a malevolent presence. Yet, as solicitous and warm to her employers as Mrs. Danvers is rigid and cold toward the second Mrs. de Winter, Mrs. Wilson has no greater chance of receiving emotional or social recognition from them. Moreover, if she bonds with the men in the film, she does not do so with the other women. While she encourages Philip to eat, especially the pâté, she specifically advises Janet to "go easy" on the pâté—"calories." The tenderness she displays in her treatment of Philip contrasts with her more ambiguous attitude toward Janet.

48. Wood discusses the moment after Brandon and Philip have killed David and Brandon tries to open a bottle of champagne to celebrate; Philip must help him with it and opens the bottle himself. This imagery, "heavily coded," reveals what the lovers "do" sexually: "self-masturbation rather than intercourse. The action vividly suggests the inherent shame and frustration that characterize the relationship—a kind of socially imposed impotence." Wood, *Hitchcock's Films Revisited*, 353.

49. While being interviewed in "*Rope* Unleashed," Arthur Laurents groused about Hitchcock's decision to show us David Kentley being killed and put in the chest. He felt that the director diminished a considerable amount of the suspense that could have been generated had we never been sure until the end if a dead body really was hidden there. For one thing, Hitchcock is almost never interested in whodunit mechanics. For another, I believe it was crucial to Hitchcock that he show us David physically, so that we could register his all-American, blond, everyday appearance.

50. Lawrence, "American Shame," 72–73.

51. Wood, *Hitchcock's Films Revisited*, 356–357.

52. In *Spellbound*, the voice of the nymphomaniac and possibly lesbian character of Mary Carmichael similarly cracks at one point. And like Norman Bates, Brandon stutters, in his case when he's excited, as Rupert observes earlier. The stutter is the clearest link between Hitchcock's sexually ambiguous males and Melville's Billy Budd, whose stutter is central to his character.

53. Judy Barton (Kim Novak) despairingly utters the same phrase ("Oh, no") in *Vertigo* when Scottie (James Stewart again) evinces his utter disregard for her as a person. Striving to remake

her as the dead, blonde Madeleine, he tells the brunette to change the color of her hair: "Please Judy, it can't matter to you." Moreover, *Rope* anticipates the flashing red and green lights and their obvious stop/go symbolism in *Vertigo*, an expressionistic visual aesthetic that connotes the barren, noirish emptiness of the nighttime city. As I will elaborate in chapter 7, Hitchcock associates the urban realm with disconnection and isolation.

54. One of the most welcome developments in queer film criticism of the present is the renewed attention to this film, unjustly benighted by its unfair reputation as homophobic. See the essay collection edited by Matt Bell, *The Boys in the Band: Flashpoints of Cinema, History, and Queer Politics* (Detroit: Wayne State University Press, 2016). The latter is also true about Friedkin's disturbing but brilliant *Cruising* (1980), in which Al Pacino's undercover New York City cop infiltrates the underground gay SM leather scene.

55. Allen, *Hitchcock's Romantic Irony*, 128.

CHAPTER 5

1. Halberstam, "Reading Counterclockwise: Paranoid Gothic or Gothic Paranoia," in *Skin Shows: Gothic Horror and the Technology of Monsters* (Durham, NC: Duke University Press, 2000), 121–122.

2. Freud, "A Case of Paranoia Running Counter to the Psychoanalytic Theory of the Disease," *Standard Edition*, 14: 261–272; cited at 264–265.

3. Halberstam, *Skin Shows: Gothic Horror and the Technology of Monsters* (Durham, NC: Duke University Press, 2000), 122.

4. Rose, "Paranoia and the Film System," in *Feminism and Film Theory*, ed. Constance Penley (New York: Routledge, 1988), 141–158; cited at 156–157.

5. Edelman, *No Future*, 147–149; Edelman cites Ken Worthy, *The Homosexual Generation* (New York: L.S. Publications, 1965), 44. Worthy refers to two books on human sexual behavior written by Alfred Kinsey: *Sexual Behavior in the Human Male* (1948) and *Sexual Behavior in the Human Female* (1953).

6. Edelman, *No Future*, 149.

7. I discuss the concept of the double protagonist film in chapter 4 of my book *Manhood in Hollywood from Bush to Bush* (Austin, TX: University of Texas Press, 2009). I locate *Strangers* as a template for narratives in the period between the late 1980s and early 2000s in which two males are locked in a struggle for narrative dominance, one male typed as narcissistic, the other masochistic, which has implications for the representation of masculinity in a period informed by an unprecedented queer visibility.

8. In her *Racial Indigestion*, Tompkins focuses on eating as a process—ritual, event, an established break with the flow of daily action—rather than the fetishization of foodstuffs. See Tompkins, *Racial Indigestion: Eating Bodies in the 19th Century* (New York: New York University Press, 2012), 2.

9. Ibid., 2–3.

10. Robert J. Corber, *In the Name of National Security: Hitchcock, Homophobia, and the Political Construction of Gender in Postwar America* (Durham, NC: Duke University Press, 1993); Sabrina Barton, "'Crisscross': Paranoia and Projection in *Strangers on a Train*," in *Out in Culture: Gay, Lesbian, and Queer Essays on Popular Culture*, eds. Corey K. Creekmur and Alexander Doty

(Durham, NC: Duke University Press, 1995), 216–238; Jonathan Goldberg, *Strangers on a Train, A Queer Film Classic* (Vancouver, CA: Arsenal Pulp Press, 2012).

11. A 1992 article by Bill Desowitz accounted for the two different versions of *Strangers* this way: Hitchcock had had a series of flops before *Strangers on a Train* came out. Rare for this director known for his precise vision and storyboarded exactitude, Hitchcock tinkered with the film right up until its release date, creating slightly different versions for the U.S. and British markets. The U.S. version has shorter dialogue between Bruno and Guy in their first conversation on the train but includes a final scene known as the "minister tag," in which Guy, on a train with Anne Morton and presumably on his way to marital bliss, is asked by a minister, "Aren't you Guy Haines?" Guy almost answers but then decides against it, moving with Anne away from the minister, which can be read as a bad omen of future marital discord, especially given Hitchcock's Catholic sensibility. "Hitchcock designed his film to suit two different venues. The British version contained the Bruno-Guy dialogue but not the tag, to avoid ruffling exhibitors and censors who might object to the minister as an affront to the Anglican Church. . . . The final U.S. version, meanwhile, contained the minister tag but not the complete train sequence dialogue—perhaps on the assumption that American audiences would sit still for less talk than their British counterparts, or perhaps because they might have objected to the severity of Bruno's amorality and the extended elaboration of his effeminate charm." The British version ends not with the minister tag but with Anne on the phone with an unseen Guy, relieved to hear that all is well, telling her senator father and her sister Barbara that "Guy feels silly in his tennis clothes," an implication that "he is quitting his tennis career to settle down with her." See Bill Desowitz's article "Strangers on which Train?" *Film Comment*, Vol. 28, Number 3, May–June 1992, Issue 4–5.

In his "Queer Film Classics" study of *Strangers*, Jonathan Goldberg revises the Desowitz account:

> It is now assumed . . . that what Desowitz calls the British version . . . was a U.S. pre-release print. This is what Bill Krohn claims in a commentary on the 2004 two-disc Warner Bros. release. Its jacket labels the two versions as a preview version and the final release. The "British" designation has been dropped from the jacket description. . . . Desowitz assumed that the version he found riskier and more revealing of Bruno's sexuality was possible only if intended for a British audience[.]

Goldberg, *Strangers on a Train*, 41. Goldberg goes into depth about the various cuts demanded by both Joseph I. Breen, who oversaw the Production Code, and individual censorship boards in states such as Ohio and Maryland. Most intriguing was Breen's objection to the excessive violence of the climactic merry-go-round fight between Guy and Bruno. "He may well have been responding to what's hard not to miss (although never acknowledged by him)—how often in their final struggle the two men attempt to strangle each other." Goldberg details the erotic implications of strangling in the murder of Miriam and the near-fatal strangling of Mrs. Cunningham at the senator's party. Goldberg, *Strangers on a Train*, 45.

12. For a discussion of the queer politics of gastronomy and the historical emergence of the figure of the gastronome, see Phillipe C. DuBois's essay "Engendering the Gastronome," in *Masculinity, Senses, Spirit*, ed. Katherine M. Faull (Lewisburg, PA: Bucknell University Press, 2011), 107–130. DuBois notes that "the sexuality of the bachelor gourmand remains diffuse, as

if lingering in queer zones of gastronomic pleasure" (122). While Tony Wendice in *Dial M for Murder* is not a bachelor, he is effectively one by the end; the gourmand Bruno Anthony fits in with the type that DuBois theorizes here.

13. See, e.g., Fanon's *Black Skin, White Masks* (New York: Grove Press, 1967). For a sympathetic queer reconsideration of Fanon's work, see José Esteban Muñoz's *Cruising Utopia: The Then and There of Queer Futurity* (New York: New York University Press, 2009), 93.

14. Charlotte Chandler, *It's Only a Movie: Alfred Hitchcock, a Personal Biography* (New York: Simon & Schuster, 2005), 201–202.

15. Ibid., 196.

16. A leading example of the homophobic dimensions of American psychiatry, Charles Socarides was a pioneer in the movement to "cure" homosexuality through psychiatry. As Ronald Bayer discusses, Socarides was to become, "in the late 1960s and early 1970s, a leading and forceful proponent of the view that homosexuality represented a profound psychopathology." In Socarides's own words, "Homosexuality is based on fear of the mother, the aggressive attack against the father, and is filled with aggression, destruction and self-deceit. It is a masquerade of life in which certain psychic energies are neutralized and held in a somewhat quiescent state. However, the unconscious manifestations of hate, destructiveness, incest and fear are always threatening to break through." See Ronald Bayer, *Homosexuality and American Psychiatry: The Politics of Diagnosis* (Princeton, NJ: Princeton University Press, 1987), 34–38; Socarides quoted in Bayer, 34. Socarides echoes Rohmer and Chabrol in their argument about Hitchcock's views of homosexuality.

17. Goldberg, *Strangers on a Train: A Queer Film Classic* (Vancouver, CA: Arsenal Pulp Press, 2012), 147.

18. Modleski gave a paper entitled "Hitchcock's Queer Daughter," on Patricia Hitchcock's roles in her father's films, in the conference panel that I organized for the 2014 Society for Cinema and Media Studies conference in Seattle. Modleski draws fascinating parallels between Miriam's pregnancy and the status of the pregnant body in the carnivalesque scene, as theorized by Mikhail Bakhtin. Modleski calls our attention to "a double movement by which women are expelled from theory but invade its language as bodily image. Similarly, in his reading of Hitchcock's film, Goldberg allies himself strictly with male theorists while chuckling over the body of the murdered woman."

19. Sabrina Barton writes eloquently about the significance of Miriam's eyeglasses. "Where, by the way, are Miriam's broken spectacles at the film's end? Those missing spectacles function as a loose end, an unrecuperated figure for female insight, for the possibility of reasserting distance from the image and for reading the paranoid projections of male subjectivity." Barton, "Crisscross," 235.

20. Wood, *Hitchcock's Films Revisited*, rev. (New York: Columbia University Press, 2002), 88.

21. Ibid., 89.

22. See Rohy, *Anachronism and Its Others: Sexuality, Race, Temporality* (Albany, NY: State University of New York Press, 2009). Rohy reconsiders nineteenth-century American literature in terms of cultural mythologies of African Americans and queers as culturally backward and primitive, with each group representative of the "early" stages of human civilization. While Rohy critiques Freud for his primitivism and sees his framing of the racial other and the homosexual as atavistic throwbacks, she also gleans what remains useful in his work for queer theory purposes.

23. Reik, *Love and Lust: On the Psychoanalysis of Romantic and Sexual Emotions* (New Brunswick, NJ: Transaction Publishers, 2002 [1949]), 245.

24. Kenneth Paradis, *Sex, Paranoia, and Modern Masculinity* (Albany, NY: State University of New York Press, 2007), 98–99.

25. Kofman, *The Enigma of Woman: Woman in Freud's Writings* (Ithaca, NY: Cornell University Press, 1985); Silverman, *The Threshold of the Visible World* (New York: Routledge, 1996), 33; Freud, "On Narcissism: An Introduction" (1914), *Standard Edition*, Vol. 14: 73–102; cited at 88–89.

26. Barton, "Crisscross," 223.

27. Goldberg, *Strangers on a Train*, 115.

28. Ibid., 115–116.

29. Cowie, *Representing the Woman: Cinema and Psychoanalysis* (Minneapolis, MN: University of Minnesota Press, 1997), 64–65.

30. See chapter 1, "Cruising, Hysteria, Knowledge," on *The Man Who Knew Too Much* (1956), in Greven, *Psycho-Sexual: Male Desire in Hitchcock, De Palma, Scorsese, and Friedkin*, 1st ed. (Austin, TX: University of Texas Press, 2013).

31. Wood, *Hitchcock's Films Revisited*, 91.

32. I have in mind the footnote that Freud added in 1910 to his 1905 work *Three Essays on the Theory of Sexuality*, *The Standard Edition*, Vol. 7: 123–230; cited at 145, n.1. Male homosexuality proceeds "from a narcissistic basis," and homosexual males "look for a young man who resembles themselves and whom *they* may love as their mother loved *them*." Clearly, Bruno's desire is for male otherness even if Freud's insight does shed light on the psychosexual foundations of his desire.

33. Robert J. Corber reads the film as homophobic, taking the shot of Bruno against the Jefferson Memorial as representative. "Although Bruno is dwarfed by the memorial's massive columns and seemingly endless row of steps, the stark contrast between his dark silhouette and the gleaming white marbles makes the government appear vulnerable and unprotected. Bruno is a blight on the nation's political system. His menacing presence on the steps of the memorial amounts to blackmail." Corber, *In the Name of National Security: Hitchcock, Homophobia, and the Political Construction of Gender in Postwar America* (Durham, NC: Duke University Press, 1993), 72–73.

34. Wood, *Hitchcock's Films Revisited*, 347–348.

35. McGilligan, *Alfred Hitchcock: A Life in Darkness and Light*, 1st ed. (New York: Regan Books, 2003), 442–443; Carringer, "Collaboration and Concepts of Authorship," *PMLA*, Vol. 116, No. 2 (March 2001), 370–379.

36. Wood, *Hitchcock's Films Revisited*, 348.

37. McGilligan, *Alfred Hitchcock: A Life in Darkness and Light*, 451.

38. Ibid., 447–448.

39. Mikhail Bakhtin, *Problems of Dostoevsky's Poetics*, ed. and trans. Caryl Emerson (Minneapolis, MN: Minnesota University Press, 1984), 123, emphasis added.

40. Goldberg, *Strangers on a Train*, 134–135.

41. Diehl, "Reading Hitchcock/Reading Queer: Adaptation, Narrativity, and a Queer Mode of Address in *Rope, Strangers on a Train, and Psycho*," in *Hitchcock and Adaptation: On the Page and Screen*, ed. Mark Osteen (Lanham, MD: Rowman & Littlefield, 2014), 113–125; cited at 120.

42. Coviello, *Tomorrow's Parties: Sex and the Untimely in Nineteenth-Century America* (New York: New York University Press, 2013), 201.

CHAPTER 6

1. Edelman, *No Future: Queer Theory and the Death Drive* (Durham, NC: Duke University Press, 2004), 47–48.

2. Luce Irigaray, "Women, The Sacred, Money," in *Sexes and Genealogies*, trans. Gillian C. Gill (New York: Columbia University Press, 1993), 73–88; see also Margaret Whitford, "Irigaray, Utopia, and the Death Drive," in *Engaging with Irigaray: Feminist Philosophy and Modern European Thought*, eds. C. Burke, N. Schor, and M. Whitford (New York: Columbia University Press, 1994), 379–400; Esther Sánchez-Pardo, *Cultures of the Death Drive: Melanie Klein and Modernist Melancholia* (Durham, NC: Duke University Press, 2003), 155.

3. Carol J. Clover's figure of the "Final Girl"—who alone survives the bloodbath and rises up at the climax to face off against and defeat the monster—finds its inaugural embodiment in *Psycho*. See Clover, *Men, Women, and Chainsaws: Gender in the Modern Horror Film* (Princeton, NJ: Princeton University Press, 1992), 233.

4. While Hitchcock's film offers a particularly acute version of it, the concept of the death mother connotes a recurring set of preoccupations in the horror genre across a range of literary and film texts, from Book II of *Paradise Lost*, in which Milton depicts the figure of Sin, half woman, half snake, Satan's daughter, and the mother of their incestuously conceived son Death, to the depiction of Norma Desmond (Gloria Swanson) in *Sunset Boulevard* (Billy Wilder, 1950), to the recent horror films of James Wan such as *Insidious* (2011) and *The Conjuring* (2013), which foreground a monstrous as well as gender-bending femininity. These phobic conflicts and the aesthetic strategies that produce the death mother pertain to male artists primarily. While further work needs to be done on each of these individual artists in terms of this question, I have found examples of the death mother in Ovid, Spenser, Shakespeare, Milton, Hawthorne, Poe, Lovecraft, Buñuel, Billy Wilder, Dario Argento, David Cronenberg, Brian De Palma, Rob Zombie, James Wan, and Hitchcock.

5. See Mitchell, *Mad Men and Medusas: Reclaiming Hysteria* (New York: Basic Books, 2000), 343–344. Mitchell discusses the ban against parthenogenesis as "the Law of the Mother," which has implications for Norman Bates's efforts to make a mother out of himself—to "give half his life to her," as the psychiatrist explains near the end. If the ban against "making babies" is issued by the oedipalized mother, Norman "makes Mother" instead.

6. Fredric Jameson has discussed the practice of disassemblage in Hitchcock's work and ties it to aesthetic practices of the exile artist, linking Hitchcock to Vladimir Nabokov and Raymond Chandler as "the great foreigners, the great European exiles . . . [who] work by disassemblage, taking the American misery apart in carefully framed, discontinuous episodes, sometimes as reduced as individual sentences, which then stand as the frame beneath which their aesthetic hobbies are enshrined." Jameson, *Signatures of the Visible* (New York: Routledge, 2007 [1990]), 144.

7. Julia Kristeva, *Powers of Horror: An Essay on Abjection*, trans. Leon S. Roudiez (New York: Columbia University Press, 1982).

8. Creed, *The Monstrous-Feminine: Film, Feminism, Psychoanalysis* (New York: Routledge, 1993), 29.

9. This chapter builds on and refines my previous work on the death mother in film in my book *Representations of Femininity in American Genre Cinema* (New York: Palgrave Macmillan, 2011). Through rereadings of Freud, Kristeva, and Creed, I argued that a desire for a return to the mother no less powerfully animates film texts than a dread of the mother, the latter being Creed's

focus. *Intimate Violence* explores the death mother motif as a formal preoccupation with cultural implications.

10. Freud, "Three Caskets," *Standard Edition*, Vol. 12: 289–301; cited at 301.

11. Diane E. Jonte-Pace, *Speaking the Unspeakable: Religion, Misogyny, and the Uncanny Mother in Freud's Cultural Texts* (Berkeley, CA: University of California Press, 2001).

12. Friedrich Nietzsche, *Nietzsche: The Birth of Tragedy and Other Writings*, trans. Ronald Speirs (New York: Cambridge University Press, 1999), 48.

13. Green, "*The Dead Mother,*" *Life Narcissism Death Narcissism*, trans. Andrew Weller (London: Free Association Books, 2001), 195.

14. Ibid.

15. For a comprehensive analysis of Perkins's struggles with his sexuality throughout his career, see Charles Winecoff, *Split Image: The Life of Anthony Perkins* (New York: Dutton, 1996).

16. Chion, *The Voice in Cinema*, trans. and ed. Claudia Gorbman (New York: Columbia University Press, 1999).

17. As Brigitte Peucker notes, "When, in *Psycho*, Norman Bates points out that Marion 'eats like a bird,' he stutters as he adds that this phrase contains 'a falsity.' . . . Chewing compulsively on candy corn throughout the film—and thereby linking his own body with that of the woman's or 'bird's'—it is suggested that Norman is trapped in the oral stage, reluctant to sever the prelinguistic bond. . . ." Norman's stutter is part of a continuum of queer affects associated with orality and the broken voice. Peucker, *The Material Image: Art and the Real in Film* (Stanford, CA: Stanford University Press, 2007), 167.

18. *Suddenly, Last Summer* is set in New Orleans in the late 1930s; its plot revolves around the fate of the heroine Catherine Holly (Elizabeth Taylor), a beautiful and emotionally troubled young woman who has been institutionalized after a nervous breakdown. Her breakdown occurred after a trip with her cousin Sebastian Venable to the Spanish town of Cabeza de Lobo, where Sebastian mysteriously died. Catherine wants to tell the story of how and why Sebastian died, but his rich patrician mother Violet Venable (Katharine Hepburn) wants to have her lobotomized instead. An innovative young surgeon, Dr. John Cukrowicz (Montgomery Clift), investigates the case to determine if Catherine should indeed be lobotomized; Violet attempts to bribe the state hospital to ensure this outcome. While some critics have found this film homophobic, it is better understood as a commentary on homophobia, in my opinion. When Catherine finally gets to tell her story, it is a grisly one. Sebastian used both his mother and Catherine as "bait" to lure the young impoverished men who then became his sexual conquests. In a grotesque cannibal orgy, the starving children and young men of the Spanish beach town descend upon Sebastian and devour him as Catherine watches.

19. Spoto, *The Art of Alfred Hitchcock: Fifty Years of His Motion Pictures*, 2nd ed., rev. and updated (New York: Doubleday, 1992), 281.

20. Doty, "How Queer is My *Psycho*," in *Flaming Classics: Queering the Film Canon* (New York: Routledge, 2000), 155–189; quoted material at 180.

21. Doty observes that it is

> no wonder that Lila, sitting in a room full of straight men, remains silent, except for a brief reference to her sister, during the psychiatrist's explanation of Norman's mental illness. . . . The only two close-ups of her during the sequence remind us of why Lila

might be so guarded now when she has been nothing but outspoken and active before this: she has been made to feel that she is hiding "shocking" secrets similar to those that are being exposed about Norman. The first close-up of Lila's concerned face occurs early in the sequence at the moment Dr. Richman [the psychiatrist] says, "He only half-existed to begin with," while the second is timed to Richman's pointing at Lila and saying, with reference to Norman's desire for Marion, "He wanted her." Norman's queer repressions and incestuous desires are, perhaps, warningly, being associated with Lila.

Doty, *Flaming Classics*, 180.

22. Wood, *Hitchcock's Films Revisited* (New York: Columbia University Press, 2002 [1989]), 147.

23. Athena, the Greek goddess of war and wisdom, was not of woman born, emerging instead out of her father Zeus's forehead. Her crucial role at the end of Aeschylus's tragic trilogy *The Orestia*, which narrates the havoc that ensues from Orestes' murder of his mother Clytemnestra for having killed his father Agamemnon and the incessant pursuit of the matricidal Orestes by the Furies, is to side with the man. Athena establishes patriarchal law as such. Carol Clover's Final Girl intersects with this classical female figure. In her autonomy and refusal of sexual objectification, the Final Girl defies patriarchal gender hierarchies. As I have argued in *Representations of Femininity*, she also more conservatively plays an Athena-like role, establishing the father's law in the midst of carnage and chaos.

24. For an extended discussion of the doubling of Norman and Sam and its queer implications for normative heteromasculinity, see Greven, chapter 2, *Psycho-Sexual: Male Desire in Hitchcock, De Palma, Scorsese, and Friedkin* (Austin, TX: University of Texas Press, 2013).

25. William Rothman sees these hands as a poignant momentary invocation of the monstrous mother's capacities for tenderness and love, of a "woman whose illness is a heartbreaking human tragedy." Rothman, *Hitchcock: The Murderous Gaze* (Cambridge, MA: Harvard University Press, 1982), 321.

26. For a well-known elaboration of Freud's views of lesbian narcissism, see Sue-Ellen Case, "Towards a Butch-Femme Aesthetic," *Discourse*, Vol. 11, No. 1, (Fall–Winter, 1988–89), 55–73. Parsing the work of Case, Diana Fuss, and Mary Jacobus on the subject, Steven Bruhm writes, "[L]esbianism in Freud is theorized on a linear trajectory of development and falling back, in which the butch dyke does not assume the (appropriately narcissistic) place of converting her desire for the mother into an identification but rather falls back from this development into an identification with the father." Bruhm, *Reflecting Narcissus: A Queer Aesthetic* (Minneapolis, MN: Minnesota University Press, 2001), 19.

27. Rothman, *Hitchcock*, 323.

28. Lacan elaborates on "the insistence of speech which returns in the subject until it has said its final word, speech that must return, despite the resistance of the ego which is a defense, that is, the adherence to the imaginary misconstrual of identification with the other." See Lacan, *The Seminar of Jacques Lacan. Book 3: The Psychoses, 1955–1956*, trans. Russell Grigg, ed. Jacques-Alain Miller (New York: Norton, 1993), 242.

29. Norman's stutter links him to Melville's Billy Budd, the title character of a work that I have suggested is a crucial queer precedent for many of Hitchcock's works. Billy Budd, the innocent, beautiful, and falsely accused sailor, has one flaw, his stutter. When the villain Claggart accuses him of mutiny, Billy's only recourse is to punch Claggart in the face; the villain dies on the spot, and Billy willingly embraces the death penalty for his crime.

30. De Lauretis, *The Practice of Love: Lesbian Sexuality and Perverse Desire* (Bloomington, IN: Indiana University Press, 1994), 77–78.

31. Wood, *Hitchcock's Films*, 150.

32. Barbara Klinger, "*Psycho*: The Institutionalization of Female Sexuality," in *A Hitchcock Reader*, eds. Deutelbaum and Poague (Ames, IA: Iowa State University, 1986), 332–339; Bellour, "Psychosis, Neurosis, Perversion," in *The Analysis of Film*, ed. Constance Penley (Bloomington, IN: Indiana University Press, 2001), 238–262.

33. Bellour's heterosexist schemas begin with the assumption that the audience is comprised primarily of heterosexual males who regard Marion as a sexual spectacle from the beginning. He does not consider the female or the homosexual audience and that Sam Loomis, played by the hunky John Gavin, is also half-dressed in the first scene (he is shirtless, with his hairy chest and stomach and muscular arms exposed), and that he may provoke equal levels of scopic desire.

34. As feminist theorists such as Luce Irigaray have argued, the umbilical cord and the penis conflate, the privileged focus on the latter a screen for the former's psychic impact as cut. See Irigaray, *Sexes and Genealogies*, 14–18. For a further discussion of the phallic mother and the significance of the umbilical cord in terms of birth trauma (as opposed to the more conventional psychoanalytic narrative focusing on castration fears), see Marcia Ian, *Remembering the Phallic Mother: Psychoanalysis, Modernism, and the Fetish* (Ithaca, NY: Cornell University Press, 1993). For his elaboration of the phallic mother as the child's fantasy before knowledge of castration, see in particular, Freud, "Fetishism" (1927), *Standard Edition*, 21: 152–157.

35. Hitchcock anticipated the effects he created in *Psycho* in *The Lady Vanishes* (1938), in which a maternal presence becomes a signifying absence, and especially in *Rebecca*, in which a perpetual absence has an uncanny presence charged with malevolence, real or imagined. But however much *Rebecca* suggests the presence of the never-seen titular figure, by all accounts an extraordinarily vivid one when alive, she remains sui generis, self-contained and specific to herself, an index of the threats she poses to the heroine, her husband, and, by extension, to patriarchy. The titular figure in *Rebecca* was also an unseen presence, but the death mother's power and sweep are infinitely larger, a metaphor for the dead forms of capitalism as an entity made manifest through form. While Tania Modleski has famously read *Rebecca* in terms of female oedipal development and maternal desire, the film also raises the question of its title character's maternity only to make the answer indicative of her monstrosity. That she is not a natural, human woman—resonances of her lesbian and pansexual typing in the novel—is confirmed by the depiction of her as an anti-mother, incapable of generating life: As her doctor reveals, she has cancer rather than the fetus she believes she is carrying. Clearly, misogyny and homophobia inhere in this characterization, even if *Rebecca* also has a fearsome intransigence that cannot be discounted. Fixed at the point between fascination and revulsion, *Rebecca* treats its titular figure as heroine and monster.

CHAPTER 7

1. Butler, "Melancholy Gender/Refused Identification," in *The Psychic Life of Power: Theories in Subjection* (Stanford, CA: Stanford University Press, 1997), 132–150; quoted passage at 135.

2. Camp and drag could be described as forms of queer resilience as well. Clearly, *Marnie*'s resilience cannot be confused with the ability to transcend her situation or parody it into an alternative mode of pleasure; it is neither camp nor drag. At the same time, it is remarkable how often *Marnie* seems to explore the *forms* of drag, female as well as male: the succession of

outfits from her Athena-like dress at the party where she reencounters Strutt to her cat-burglar outfit immediately after the party, intertextually evoking Cary Grant's "Cat" in *To Catch a Thief* (1955).

3. Rose, "Paranoia and the Film System," in *Feminism and Film Theory*, ed. Constance Penley (New York: Routledge, 1988), 141–158; Edelman, "No Future," in *No Future: Queer Theory and the Death Drive* (2004), 111–154; "Reading Counterclockwise: Paranoid Gothic or Gothic Paranoia," in *Skin Shows: Gothic Horror and the Technology of Monsters* (Durham, NC: Duke University Press, 2000), 107–137.

4. Corber, *Cold War Femme: Lesbianism, National Identity and Hollywood* (Durham, NC: Duke University Press, 2011), 94.

5. The figure of the inviolate male is the subject of my book *Men Beyond Desire: Manhood, Sex, and Violation in American Literature* (New York: Palgrave Macmillan, 2005; paperback, 2012). The antebellum period in particular is notable for foregrounding male characters who keep their emotions, bodies, and sexuality severely off-limits, unavailable to other men, as well as to women. These characters resolutely eschew both male friendship and heterosexual relationships. Prominent examples include James Fenimore Cooper's Natty Bumppo in *The Pathfinder* (1840) especially, Hawthorne's Dimmesdale in *The Scarlet Letter* (1850), and Melville's titular figure in *Billy Budd, Sailor* (1891). I discuss the inviolate and potentially proto-lesbian woman in *Men Beyond Desire*, chapter 6.

6. Knapp, "The Queer Voice in *Marnie*," in *A Hitchcock Reader*, eds. Marshall Deutelbaum and Leland Poague (Malden, MA: Wiley-Blackwell, 2009), 295–311; quoted material at 302.

7. Donald Spoto, *The Art of Alfred Hitchcock: Fifty Years of His Motion Pictures*, 2nd ed., completely rev. and updated (New York: Doubleday, 1992), 343.

8. Walter Raubicheck and Walter Srebnick, *Scripting Hitchcock: Psycho, The Birds, and Marnie* (Urbana, IL: University of Illinois Press, 2011), 74, 105.

9. Wyler's *The Children's Hour* was the director's second version of Lillian Hellman's play by that name about an unhappy student's false allegation of an affair between the two unmarried women who run the school, one of whom actually is a lesbian; Wyler's poignant but bowdlerized first version, *These Three* (1936), heterosexualizes the plot by making the allegation pertain to premarital sex. *The Children's Hour*, like *The Birds* and *Marnie*, has a fair lady, the schoolteacher Martha Dobie (Maclaine), and a dark lady, the schoolteacher Karen Wright (Audrey Hepburn), whom Martha loves. In *Marnie*, it is the dark lady who desires, the fair lady who remains sexually unavailable and non-desiring. Martha Dobie commits suicide at the end of the film because she cannot bear the publically exposed truth of her lesbianism. In *Marnie*, however, sexuality is much closer to an open secret, as Lil's transgressive sexual asides evince.

10. Jodi O'Brien, "Stereotypes," in *Lesbian Histories and Cultures: An Encyclopedia*, Vol. 1, ed. Bonnie Zimmerman (New York: Garland Pub., 2000), 734–736; cited at 735.

11. In the antebellum era, numerous and competing ideologies, ranging from the emergent cult of the self-made man to the literature of sexual reform, focused on masculinity and the proper maintenance of the male body. The literature of the period suggests that one of the ways in which the demands and protocols of these programs were simultaneously upheld and resisted was through a lockdown of male sexuality, as well as emotional availability. Social relationships and sexual possibilities were cut off as dual and equally pressing threats. I find very similar dynamics to be at work in *Marnie's* version of the social order.

12. Marnie's mother is not there in the sense that she is so emotionally unavailable. For a fascinating essay on this subject, see Allan Lloyd Smith, "*Marnie*, the Phantom, and the Dead Mother," *Hitchcock Annual* (2002–2003): 164–180.

13. William Rothman, "The Universal Hitchcock," in *A Companion to Alfred Hitchcock*, eds. Thomas Leitch and Leland Poague (Malden, MA: Wiley-Blackwell, 2011), 347–364; quoted material at 351.

14. In her essay "Self-Posssession and Dispossesson in Hitchcock's *Marnie*," *Hitchcock Annual* (2006–2007): 107–122, Deborah Thomas has written about the film's themes of "possession," how everyone and everything in the film can become a possession, and the "linking of personal relationships to material ones" (113). I would argue that the film is about reification, the turning of its human actors into things that belong to the heterosexual social order.

15. My thanks to Alexander J. Beecroft for his insightful comments about *Vertigo* and this scene in particular.

16. In a well-known essay, Eve Kosofsky Sedgwick inserts Jane Austen's *Sense and Sensibility* into the context of nineteenth-century medical discourse on onanism, suggesting that one possible signifier for autoerotic practice might be the "unstanchable emission, convulsive and intransitive," of Marianne's tears in a nighttime scene between sisters in a bedroom. See Eve Kosofsky Sedgwick, "Jane Austen and the Masturbating Girl," in *Tendencies* (Durham, NC: Duke University Press, 1993), 114.

17. For an analysis of this scene that emphasizes its fetishistic elements, see Joe McElhaney, *The Death of Classical Cinema: Hitchcock, Lang, Minnelli* (Albany, NY: State University of New York Press, 2006), 126–127. McElhaney considers the significance of the fact that the film is organized around a relatively new actress, Hedren, introduced by Hitchcock in *The Birds*, who did not become a movie star, which produces a void in the text. (Originally, Marnie was to have been Grace Kelly's comeback role.) The void aspects of *Marnie* relate to onanism—not in any inherent sense but in terms of the prohibitions against this practice as a reflection of emptiness and the lack of a sexual partner.

18. See Sedgwick, "Jane Austen and the Masturbating Girl," 113.

19. See Margaret Horowitz, "*The Birds*: A Mother's Love," *Wide Angle*, Vol. 5, No. 1, 1982, 42–48, for a reading of the birds as related to the Harpies of Greek myth and expressions of the mother Lydia Brenner's jealousy and rage.

20. The woman's relationship to money is an increasingly important theme in Hitchcock's work, one he began to explore with *Blackmail* (1929) and from the late 1950s and forward. Hitchcock begins to explores the relationship between woman's sexuality and capital with increasing attentiveness in *To Catch a Thief* (1955), *Vertigo* (1958), and *North byNorthwest* (1959), but it is in his trilogy of femininity of the early 1960s—*Psycho, The Birds* (1963), and *Marnie*—that he truly explores this theme in greater depth, with *Marnie* especially.

21. "Queer Studies and the Crises of Capitalism," *GLQ: A Journal of Lesbian and Gay Studies*, Vol. 18, No. 1, 2012.

22. Tinkcom, *Working Like a Homosexual: Camp, Capital, Cinema* (Durham, NC: Duke University Press, 2002).

23. Meg Wesling, "Queer Value," *GLQ: A Journal of Lesbian and Gay Studies*, Vol. 18, No. 1, 2012, 107–125; quoted material at 122–123.

24. Althusser, "Ideology and Ideological State Apparatuses," in *Lenin and Philosophy, and Other Essays*, trans. Ben Brewster (New York: Monthly Review Press, 1972), 121–176.

25. Jasbir K. Puar, *Terrorist Assemblages: Homonationalism in Queer Times* (Durham, NC: Duke University Press, 2007).

26. Winnicott argued that healthy childhood development occurs if the child simultaneously feels the security and reliability of the mother, a constant presence in her life, and the desire to explore the world on her own, to move on from the maternal relationship into an autonomous mode of existence. See Winnicott, *The Maturational Processes and the Facilitating Environment; Studies in the Theory of Emotional Development* (London: Hogarth, 1965).

27. See Jean Genet, *Funeral Rites*, trans. Bernard Frechtman (New York: Grove/Atlantic, 1988), used as a foundation for the antisocial thesis by Leo Bersani in his *Homos* (Cambridge, MA: Harvard University Press, 1995); Edelman, *No Future: Queer Theory and the Death Drive* (Durham, NC: Duke University Press, 2004); and for a queer counter-response to the queer antisocial thesis that critiques, in particular, Edelman's disregard for nonwhite queer aesthetic productions, see José Esteban Muñoz, *Cruising Utopia: The Then and There of Queer Futurity* (New York: New York University Press, 2009).

28. I refer to Doane's book *The Desire to Desire: The Woman's Film of the 1940s*, (Bloomington, IN: Indiana University Press, 1987).

29. Piso, "Mark's Marnie," in *A Hitchcock Reader*, eds. Marshall Deutelbaum and Leland Poague, 280–294; quoted passage at 290.

30. Ibid., 299.

31. Knapp, "The Queer Voice in *Marnie*," 301.

32. See Patricia White's discussion of lesbianism in classical Hollywood cinema and its basis in mother/daughter intimacy in chapter 4, "Films for Girls: Lesbian Sentiment and Maternal Melodrama," in *Uninvited: Classical Hollywood Cinema and Lesbian Representability* (Bloomington, IN: Indiana University Press, 1999), 94–135.

33. Hitchcock's use of rear projection was seen as indicative of his carelessness, failing powers, datedness, and lack of inspiration even by critics as perceptive and supportive as the auteurist Andrew Sarris, an early Hitchcock champion. Hitchcock, Sarris wrote, has "miscalculated his effects. The manner is present, but the magic is absent. His fake sets, particularly of dockside Baltimore, have never been more distracting, and the process shots of Tippi on horseback are appallingly dated. Again, the inability of the leads to hold the foreground imposes an extra burden on the background. Who cared if Rio were in process in *Notorious* when Bergman and Grant held the foreground?" Clearly, *Marnie* represented, for Sarris, a post-studio-system collapse of belief, represented by star charisma (or the apparent lack thereof), as well as one of Hitchcock's art. See Sarris, *"Marnie," Confessions of a Cultist: On the Cinema, 1955–1969* (New York: Simon and Schuster, 1970), 141–144; quoted material at 143. Donald Spoto's movement from supporter of Hitchcock's aesthetic choices in *Marnie* (*The Art of Alfred Hitchcock*) to denigrator (*The Dark Side of Genius*) is worth noting.

In his valuable BFI study, Murray Pomerance, drawing on archival materials, painstakingly confirms once again that the director deliberately strove for the stylized effects he achieved in *Marnie*. For example: "Hitchcock intended Marnie's riding sequences to appear precisely as they do: intermediates between unaffected reality and artful construction." Pomerance, *Marnie* (London: British Film Institute, 2014), 12.

34. I want to thank one of the anonymous readers of this manuscript for alerting me to the link with the "crude prints of ships in the Bates home in *Psycho*."

35. Hitchcock has often been discussed in the context of Edgar Allan Poe, whom he cited as an important influence. The links between both artists come to near-explicit fruition here: the Baltimore setting (where Poe died and is buried); the name Mrs. *Edgar*; the name given her by Jessie, Miss *Bernice*, which evokes Poe's title character *Berenice*. Even Marnie evokes the names of Poe women such as Morella, Annabel Lee, Ligeia in their unusual and lyrical qualities. In *Marnie*, Hitchcock extends Poe's effects of life-in-deathness to a stringent class critique. He creates an effect that recalls Poe's novel *The Narrative of Arthur Gordon Pym* (1838). Several maddened castaways spot a ship advancing toward them that appears to be helmed by a man bobbing up and down in enthusiastic, reassuring greeting. The promise of salvation, the ship approaches them, but when it does, its death stench fills the air, and the castaways realize that the man bobbing up and down is not alive at all but dead, merely given the semblance of life by the carrion bird furiously pecking away at his liver. The similarity between both this ship-of-death scene and the fox-hunt sequence is the revelation of a horrifyingly negative underside to the positively valued.

36. Knapp, "The Queer Voice in *Marnie*," 299.

37. Sedgwick, "Shame, Theatricality, and Queer Performativity: Henry James' *The Art of the Novel*," in *Gay Shame*, eds. David M. Halperin and Valerie Traub (Chicago: Chicago University Press, 2009), 51.

38. Richard Allen observes that surrealism and expressionism both suggest that a "deeper reality" lies behind the surface appearances of the world. Surrealism, however, "displaces the hierarchy of surface reality and shadow world by rendering the unconscious or dream world coextensive or continuous with reality itself." Richard Allen, *Hitchcock's Romantic Irony* (New York: Columbia University Press, 2007), 219. Aesthetically, this sequence is a simultaneous war between and blending of montage and expressionism. But on another level, the entire passage is a paean to surrealism, precisely in its displacement of the hierarchies in "surface reality" and "shadow world."

39. In a direct link to the woman's film genre, Marnie's horse crash evokes Bette Davis's decisive one early on in *Dark Victory* (Edmund Goulding, 1939). Marnie could say the same words that Davis's Judith Traherne, coming to grips with her illness, utters afterward: "That horse didn't throw me—I threw *him*."

40. Marnie's onanistic sexuality is suggested through her expressions of pleasure when she is alone or on horseback. Indeed, it is only when riding Forio that Marnie, lushly smiling, her blonde mane flying in the wind, appears to experience erotic abandon. In my view, Forio symbolizes her desire for self-pleasure rather than intercourse (in all senses of the term) with another person. Nevertheless, the montage of Marnie riding as she escapes the fox hunt infers that her onanistic sexuality is both wildly out of control and a wounded compensation for the social abnegation she suffers within her marriage to the wealthy Mark. Moreover, if the editing and the score and the rhythms of the sequence figure sexual intercourse, as I believe is the case, suggestions of rape are inescapable. One might say, given the narrative, the montage prefigures this idea.

41. See the last chapter, "You Freud, Me Hitchcock," in Robin Wood, *Hitchcock's Films Revisited* (New York: Columbia University Press, 2002 [1989]).

42. The alternative, female oedipal narrative is the chief theoretical basis for Tania Modleski's study of femininity in Hitchcock. See Modleski, *The Women Who Knew Too Much: Hitchcock and*

Feminist Theory, 3rd ed. (New York: Routledge, 2016 [1988]). One could also make the case that Brian De Palma's Hitchcockian thrillers centrally explore this terrain.

43. Sigmund Freud, "From the History of an Infantile Neurosis" (1918), *Standard Edition*, 17: 7–122.

44. On a literal level, what is *not* being represented here is the act of heterosexual sex. I argue, however, that, in its disorganized slew of images and sounds of pain, and, specifically, in the extremely graphic shot of the sailor's hairy legs entwined with the mother's legs, the scene depicts the act of heterosexual sex to the fullest extent possible for a mainstream narrative film of the early 1960s.

45. Tony Lee Moral, who has examined files made newly available at the Academy of Motion Pictures, is another critic who has amply demonstrated that the film, far from being an aesthetic botch resulting from Hitchcock's indifference, weariness, or conflicts with his lead actress, was a deliberately and carefully planned work on the part of the director. See Moral, *Hitchcock and the Making of Marnie* (Lanham, MD: Scarecrow Press, 2013).

46. See Berlant, *The Female Complaint: The Unfinished Business of Sentimentality in American Culture* (Durham, NC: Duke University Press, 2008).

47. "An Interview with Jay Presson Allen," interviewed by Richard Allen, *Hitchcock Annual* 9 (2000–2001): 3–22. Page references for further quotations from this article are cited parenthetically in the main text. For commentary on this interview within the context of a discussion of Hitchcock and feminism, see Tania Modleski, "Suspicion: Collusion and Resistance in the Work of Hitchcock's Female Collaborators," in *A Companion to Alfred Hitchcock*, 177–178.

48. "An Interview with Jay Presson Allen," 20.

49. Ibid., 5.

50. Ibid., 10.

51. In saying this about our own time, I may be on slippery ground, however. In August of 2012, Missouri Representative Todd Aiken, defending his antiabortion stance, offered theories about "legitimate rape" in which he claimed that women's bodies instinctively and automatically defend themselves against pregnancy in cases of "real" rape. These views were immediately controversial, but the fact that they could still be put forth by an educated American in the year 2012 gives one altogether too vivid an understanding of just how longstanding the queasy view of rape as a debatable phenomenon has been.

52. http://oxforddictionaries.com/definition/english/rape.

53. Hitchcock's films of this period beginning with his 1956 remake of his own 1934 *The Man Who Knew Too Much* and including *The Wrong Man, Vertigo, North by Northwest, Psycho*, and *The Birds* deploy the figure of the postwar American wife as representative of women's conflicted relationship to patriarchy. The remake of *The Man Who Knew Too Much* explores, among other subjects, the struggles of the former career woman to accommodate herself to marriage and family and their demands; similarly, *The Wrong Man* treats its own version of what Freud called "the housewife's psychosis," as the film reveals its central drama to be not the story of the wrongfully imprisoned man but, instead, his wife's increasing instability and descent into madness as a result of the strains of his attempts to exonerate himself. Marnie is in many ways a former career woman—criminality her profession—similarly chafing against the demands of marriage and threatening to descend into madness. The wife is an unstable category in which to "contain" femininity, but a serviceable category through which to register the woman's gendered anxieties,

as well as conflicted desires. Most vividly, the films represent the condition of femininity as one of entrapment: brilliantly allegorized in the close-up of Doris Day's Jo McKenna, utterly overwhelmed and alone with her unbearable decision whether or not to cry out and stop the assassination at the risk of losing her child in *The Man Who Knew Too Much*; in the discussion about maddening and inescapable private traps in *Psycho* between Norman Bates and Marion Crane; in another dazzling allegory, Melanie Daniels's literal entrapment in the telephone booth, a flimsy defense against the birds; and in *Marnie*, where marriage is the ultimate trap for capturing the truly "wild" woman. The analysis of the figure of the wife finds ominously archetypal realization in *Vertigo*, with its protagonist's central obsession with another man's wife, who herself appears to be obsessed with an ancestral woman who could *not* be another man's wife. *Marnie* builds on the strains over marital roles and the woman's difficulties in marriage in these films, deepening their resonances and political implications. One of the effects of the focus on the wife or wife-like woman is to cast the heterosexual male lead into relief as a newly available object of desire—and dread.

54. Piso, "Mark's Marnie," 287.

55. Ibid., 288–289.

56. For an excellent discussion of blankness in *Marnie* and other works, see Susan White's essay "A Surface Collaboration: Hitchcock and Performance," in *A Companion to Alfred Hitchcock*, 181–198.

57. For a discussion of the Gothic genre's figuration of such a masculinity, see Cyndy Hendershot, *The Animal Within: Masculinity and the Gothic* (Ann Arbor, MI: University of Michigan Press, 1998).

58. Modleski, "Suspicion," 179.

59. At heart, *Marnie*'s chief subject corresponds to what Thomas Pynchon calls "the praeterite." Grammatically, this phrase refers to the past tense. As Tony Tanner writes in an introductory essay to Herman Melville's 1857 novel *The Confidence-Man*—a text with relevance for *Marnie* as a work obsessed with capitalism's distorting effects on the very nature of identity—for Pynchon, the praeterite refers to "all those discarded, passed over, negated, or otherwise junked by the dominant power systems." Tanner, "Introduction," *The Confidence-Man: His Masquerade* by Herman Melville (New York: Oxford University Press, 2008 [1857]), vii–xxxvii; quoted material at viii.

EPILOGUE

1. Edelman writes, "[T]he threat of the birds achieves its most vividly iconic representation in the two crucial scenes where they single out young children to attack." Edelman, "No Future," *No Future: Queer Theory and the Death Drive* (2004), 111–154; cited at 121; Tania Modleski takes Edelman to task for focusing on these scenes at the expense of feminist concerns: "In all my years of teaching the film and discussing it with people, I have *never* known anyone who finds the most horrifying scenes to be the attacks on children. *Everyone*, male and female, emphasizes the prolonged scenes in which Melanie is threatened or outright attacked—once in the phone booth, where she largely escapes injury, and once in the attic, where she is very nearly killed and ends up, as a result, in a catatonic state." Modleski, "Resurrection of a Hitchcock Daughter (2005)," *The Women Who Knew Too Much: Hitchcock and Feminist Theory*, 3rd ed. (New York: Routledge, 2016 [1988]), 141.

2. "During the film, Melanie wears just three outfits. The one that stands out, and has come to symbolize *The Birds*, is the elegant wool crepe green suit. Worn for a considerable portion of the film, the two-piece (dress and jacket) is accessorized with a knee-length fox fur coat, a tan leather handbag, high-heeled court shoes and gold jewelry." "*The Birds*: Tippi Hedren as Melanie Daniels," in *Girls Do Film*, accessed at https://girlsdofilm.wordpress.com/2013/10/31/the-birds-tippi-hedren-as-melanie-daniels/.

3. Edelman, "No Future," 132.

4. Ibid., 120.

5. Susan Lurie, "The Construction of the 'Castrated' Woman in Psychoanalysis and Cinema," *Discourse*, No. 4 (Winter 1981): 52–74.

6. Modleski, "Resurrection of a Hitchcock Daughter," 130–131; Susan Smith, *Hitchcock: Suspense, Humour, and Tone* (London: British Film Institute Publishing, 2000), 140.

7. Paglia, *The Birds*, BFI Film Classics (London: British Film Institute, 1998).

8. Boze Hadleigh discusses his conversations with Deacon about being a gay actor in Hollywood in *Hollywood Gays: Conversations with Cary Grant, Liberace, Tony Perkins, Paul Lynde, Cesar Romero, Brad Davis, Randolph Scott, James Coco, William Haines, David Lewis* (Fort Lee, NJ: Barricade Books, 1996), 70–74.

9. This passage is taken from chapter 15 of Edith Wharton, *The House of Mirth*, 1st ed. (New York: Norton, 1990), 136.

10. See Modleski's chapter on *Rebecca* in *The Women Who Knew Too Much*.

11. As James Naremore observes, repeated viewings of *Psycho* make us aware of Norman's anguish, which leads us to view Sam's interrogations and Lila's investigations as cruel. Naremore, *Filmguide to Psycho* (Bloomington, IN: Indiana University Press, 1973), 66.

12. Modleski, *The Women Who Knew Too Much*, 46–47.

13. Mulvey's 1975 essay "Visual Pleasure and Narrative Cinema" was first published in *Screen* 16 (3): 6–18.

14. Mulvey delivered this lecture at the British Film Institute's "Birds Eye View" lecture series on March 8, 2010. I have transcribed her words in the video, accessed at http://www.bfi.org.uk/live/video/310.

15. Halberstam, *Skin Shows: Gothic Horror and the Technology of Monsters* (Durham, NC: Duke University Press, 2000), 135–136.

16. On the psychosexual basis of scopophobia, see David W. Allen, *The Fear of Looking; Or, Scopophilic-Exhibitionistic Conflicts* (Charlottesville, VA: University of Virginia Press, 1974).

17. Halberstam, *Skin Shows*, 135.

18. François Truffaut, Alfred Hitchcock, and Helen G. Scott, *Hitchcock*, rev. (New York: Simon & Schuster, 1985), 297.

19. Ibid.

Index